4000m
Climbing the Highest Mountains of the Alps

4000m
Climbing the Highest Mountains of the Alps

DAVE WYNNE-JONES

Whittles Publishing

Published by
Whittles Publishing Limited,
Dunbeath,
Caithness, KW6 6E6
Scotland, UK
www.whittlespublishing.com

© 2016 D Wynne-Jones

ISBN 978-184995-172-2

Layout by Raspberry Creative Type, Edinburgh
Printed by Melita Press, Malta

Picture credits:
Chap 1 6: Chap 7 15: Chap 13 20: Chap 19 16: Chap 18 2: Mike Pinney's original pictures from which these were edited
Chap 5, 14: Wordpictures collection
Chap13, 19: Mike Pinney collection

P240: Edited from an original image by Cathy O'Dowd.

Cover: Traversing a gendarme on the North Ridge of the Weisshorn.

Contents

This book is dedicated to all my climbing partners who helped to make it possible. In order of appearance:

Dave Hicks, Ceri-Glyn Jones, Stuart Potts, Rick Ayres, Denis Mitchell, Charlie Kenwright, Dave Penlington, Dick Murton, Mike Pinney, Jeff Harris, Bob Elmes, Mike Pearson, Pete McCombie, Ralph Atkinson, Jeremy Whitehead, Aidan Raftery, Richard Jones, Andrea Stimson, Pam Caswell, Yvonne Holland, Adele Long, Martin Gillie, Gethin Howells, Graham Hoyland.

Acknowledgements

I should like to thank a number of people:

Geoff Birtles and Ian Smith, who published the articles in *High* magazine which became the basis of subsequent chapters in this book;

Steve Goodwin, who commissioned the article published in the *Alpine Journal* in 2009 that prompted the idea of writing this book to me;

John Allen, for the well-researched chapter he contributed;

Dr Declan Phelan, for checking out the chapter on health issues (any mistakes are mine!);

Ken Wilson, for his appreciation and publication of my photography;

Lindsay Griffin, for his encyclopaedic knowledge and unstinting willingness to discuss alpine matters;

Al Alvarez, for his inspirational and challenging lecture on mountaineering literature at Bretton Hall;

Terry Gifford, for his encouragement to finish the book without having read a word of it;

Mike Pinney, for his inclusive management of the meets I attended, his friendship, and his family's permission to use some of his photos.

Keith Whittles for having faith in the book. Caroline Petherick,, my editor, for her enthusiasm, rigor and willingness to discuss editorial issues.

The book is dedicated to all the climbing partners who helped me complete the quest, but I must also acknowledge the sense of loss occasioned by the untimely deaths of Mike Pinney, Ralph Atkinson and Pam Caswell, who will now never see the book dedicated to them.

Finally I must acknowledge debt of gratitude to my wife, Jayne, whose love of mountains and skiing in particular made family visits to the Alps such a worthwhile experience for us. I am so sorry that she, too, cannot be here to read this.

Overleaf: The Weisshorn from the Bishorn at dawn.

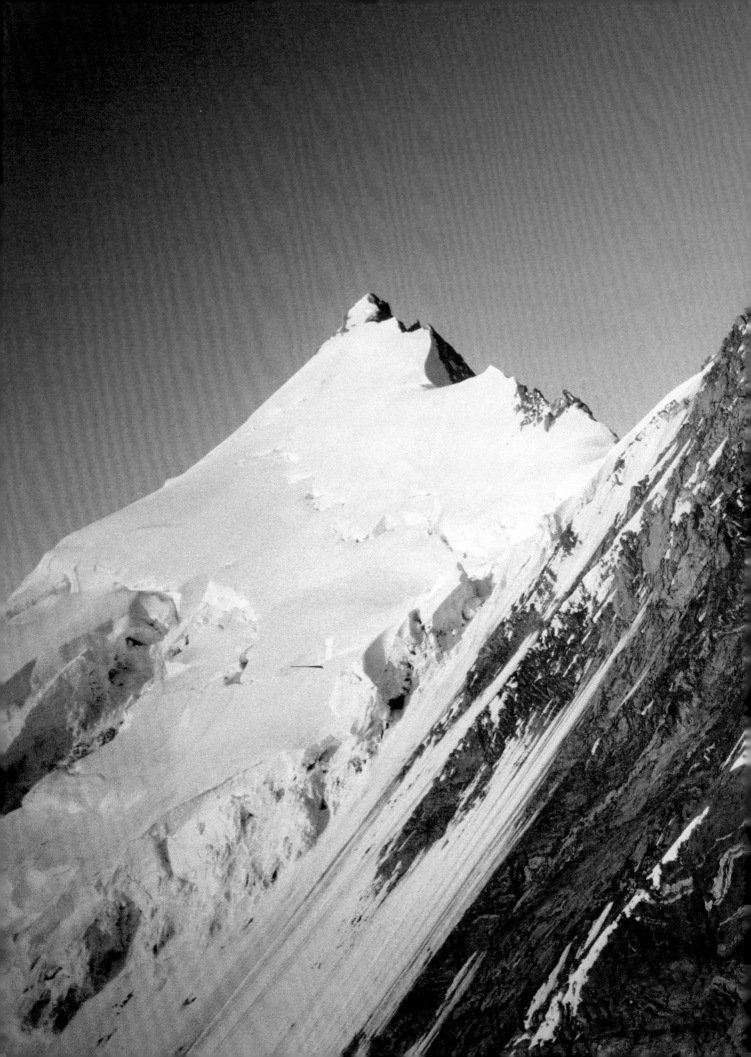

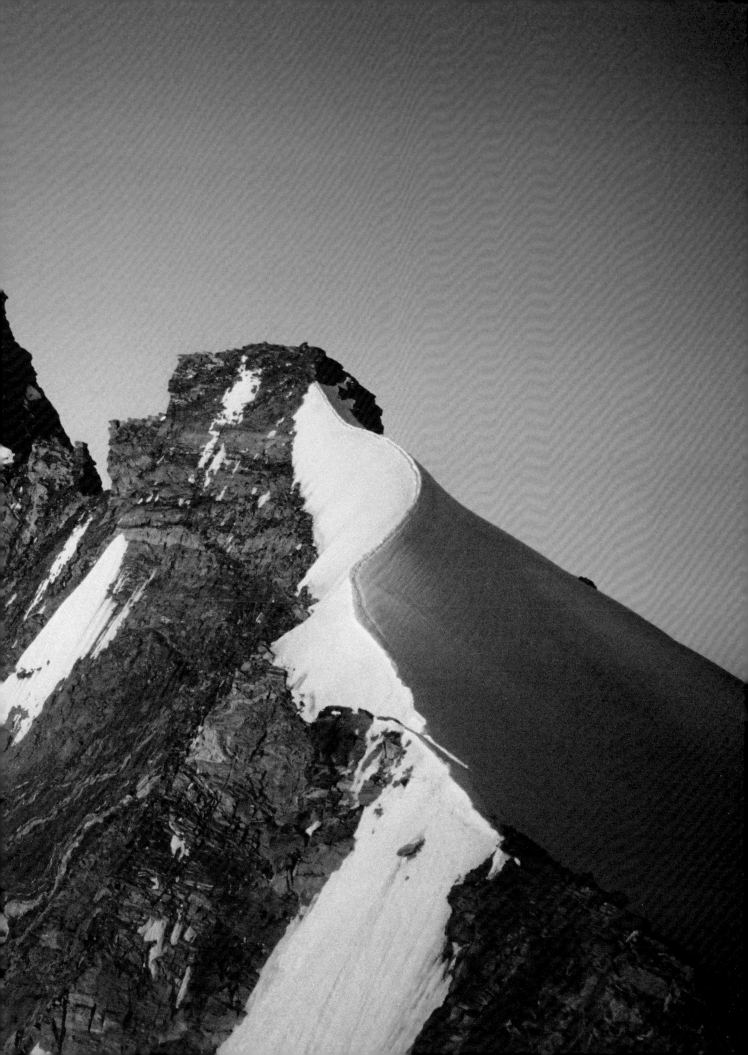

Introduction

This is not a guidebook. It's a story: the story of how I came to climb these mountains and the people I climbed them with. There have been other stories about climbing these same mountains – but none, I felt, quite squared with my own experience of doing so. Perhaps every generation has to define its challenges, its achievements, on its own terms. In that respect, as in most stories, there may after all be some guidance implicit in the tale. Bearing that in mind, I have included some chapters that focus on some of the distinct features of alpine climbing: kit, maps, huts, guides, etc. I hope this helps the general reader with understanding the narrative, and answers some of the questions about alpine climbing that I puzzled over even while I climbed. If nothing else, these chapters remove an unwieldy apparatus of appendices.

However, I must make a distinction between this book and others that are concerned with climbing the 4000m 'peaks'. There is a curious list of these publicised by the Club 4000 based on a UIAA source; it comprises 82 peaks but includes a suggestion that the expanded list may rise to 120 or more. Many of these are not mountains; indeed, some, such as the Aiguilles de Diable on Mont Blanc du Tacul, are no more than gendarmes on a ridge. Others, like the Grande Rocheuse or Aiguille de Jardin on the Aiguille Verte, could be classified as subsidiary tops by a Monroeist – but the more far-fetched listings, such as Mont Brouillard or Pic Luigi Amedeo, are truly hard to find on the bulk of Mont Blanc upon which they feature as insignificant excrescences. When I walked past the Balmenhorn, a bump on the Italian side of the Monte Rosa massif, I decided that certain '4000m peaks' were unworthy of the name. In contrast, the Diable and Jardin ridges are fine routes in their own right and do not need any spurious claim to 4000m status. With all due respect to Karl Blodig and others, there is a quality of obsession that can blind climbers to the many great routes that do not lead to a 4000m summit. Indeed, if Blodig was alive today he would probably be agonising over the fact that his total only reached 76. His achievement should not be hostage to the vested interests of alpine committees. I chose not to let that happen to me; instead I found myself climbing with companions who had adopted the list of fifty-two 4000m independent mountains compiled by Robin Collomb. It can be found in Appendix 1.

At a time when enthusiasm for the Alps may be said to be declining amongst British mountaineers, in line with the steady decline in bed-nights recorded in alpine huts, I believe it is important to recognise that climbing all the 4000m mountains of the Alps is a realistic and achievable objective that will take mountaineers into much wild and beautiful terrain. And these are not just snow plods: every mountain has a worthwhile route on it, and even those with long glacier approaches can become superb ascents, and of course descents, on ski in an alpine spring.

There is not meant to be much biographical detail in this book. The climbers in the story are ordinary people who happen to be doing extraordinary things. We are all capable of doing extraordinary things in particular circumstances, often not of our choosing. Some of us seek out those circumstances. We

cannot all be poets, but I believe each of us has some kind of poem in us once we decide to speak of things that matter. This book is about the mountains, the climbing; that's what matters; in a world in which all costs are calculated but no values are assured, the mountains, the climbing, can only really matter to the climber. As the French guide, Lionel Terray put it, we are 'Conquistadors of the Useless', but as every climber would say, 'that's not the whole story'. I hope this book can add another chapter to that larger story.

Finally, I must thank Steve Goodwin, who commissioned my article '4000m: Climbing the Highest Mountains in the Alps', for the 2009 edition of the *Alpine Journal*. That and ensuing conversations generated the idea of writing this book.

1:
Chamonix beginnings, 1981

Mont Blanc, 4807m. Bosses Ridge and Traverse: PD

Alarm bells rang hollowly in the base of my skull, where nerves were strung, wire-drawn taut. Snow crunched reassuringly under my crampons in strengthening dawn light, but I was unconsciously hanging back, and the rope tugged insistently at the waistband of my harness.

It hadn't been like this before. We had spent three weeks of fine, cold weather finding our way around Chamonix, learning to follow sketchy route descriptions, learning to cut the contents of rucksacks to a bare minimum, learning when to back off – but I had never, ever heard this jangling in my head. Bone-weary, snappy with each other, chilled to the core or woozy with heat, we had been very close to the edge, but I'd never felt such edginess.

Mont Blanc might be the last route for us before home and family life reasserted itself. Fit and acclimatised, we had halved guidebook time to the summit from the Goûter hut. We had to. With minimal spare clothing, there was no choice but to keep moving in a wind with an edge of ice to it. Our rucksacks flapped emptily on our backs, and at even slight halts teeth chattered and hands stiffened with cold. But we could see the funny side of it. Laughter kept us warm as Ceri hopped around with one foot stuck in a leg of his overtrousers; the last item of clothing he had left to put on.

So we'd reached the summit hours before dawn, and finally given up waiting for the light, after freezing our butts off making conversation in poor French with a duvet-clad photographer cuddling his camera and stamping around a frosted tripod. Rather than try to force our way back past parties still ascending the narrow Bosses ridge, we decided on impulse to go for the traverse over Mont Maudit and Mont Blanc du Tacul to the Aiguille du Midi.

Ice reaches depths of hundreds of feet up here, and moves inch by inch like some great slow animal harkening to the dim call of gravity. As it crawls forward it is bent, twisted and cracked over underlying rock, breaking and reforming. And crevasses split its surface and plumb its depths. Polished ice-flesh gleams green and blue near the surface, plunging away into darkness where deep-frozen air is held between palms of ice. There are places where there is always a crevasse.

Winter fills crevasses with metres of snow. As spring sunshine warms the surface, water melts out through layer after layer to trickle away down smooth ice into the depths. Here and there wind-driven spindrift scours a snow surface smooth, freezing in repairs to the spider network of cracks as a crevasse

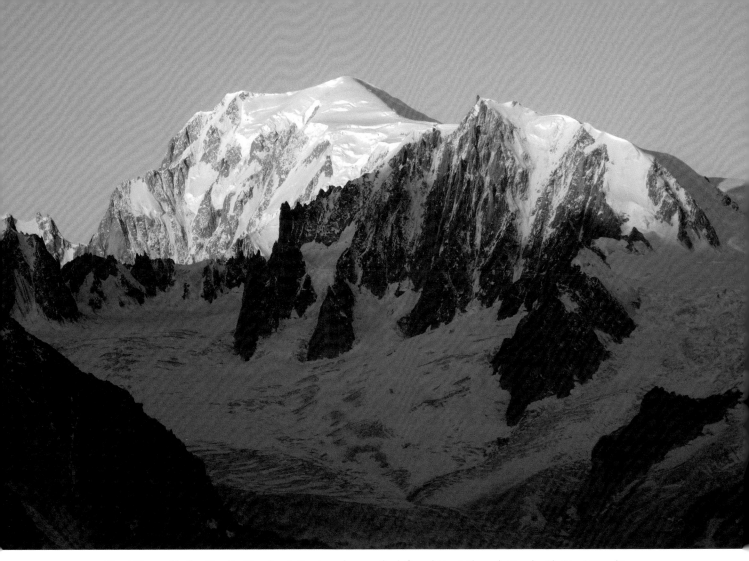

Mont Blanc with the Aiguille Blanche de Peuterey low on the left and Mont Blanc du Tacul with Mont Maudit summit just visible behind on the right.

creaks ever further open, stretching its screen of snow. Day by day, oh so little by little, a crevasse yawns, spreading a polite white hand over its mouth.

And a very cold wind had been blowing out of the east for a long time now, freezing scattering ice crystals into thin white sheets on windward slopes.

In pre-dawn greyness we clicked off headtorches, leaving the summit, heading down snowslopes to where we thought the Col de la Brenva lay. And it was here that the alarm bells started in my head. Partly it was the lack of tracks, partly a feeling that we were drifting too far towards Italy, partly the faint shapes of other climbers I began to see emerging onto a spur way to the left of the vast snowfield we were descending. But mostly it was something else; something that made my skin crawl and find something wrong with the taste of air, setting my teeth on edge.

Dave Hicks was leading, his squat dark shape head-down in a bloody-minded plod that took him through most obstacles. Ceri Jones was tied on to the mid-point, his long stride cruising the descent as it had cruised the ascent. Good friends, good climbers. We were going well, fast, in-line, straight down the tilted white field. Only I found my steps dragging, slowing, as a rose-gold morning infiltrated the air. I was spoiling their rhythm, sensed irritation from the others, and struggled on.

Suddenly it was more than I could bear.

'Hold on!' I yelled, pulling up short.

Ceri sprung the rope a little as he halted and the movement shuttled down to Dave, stopping him in mid-stride.

14

'What the hell's going on?' he shouted.

I waved him closer and we all closed up a little, taking coils of rope into our hands but still keeping distance enough to prevent all three of us finding ourselves standing over the same crevasse.

'Look, I've got a really bad feeling about this. We're sort of heading straight down but there's no sign of anyone having been this way before and we've no idea what's under the surface.'

'Don't be bloody stupid! This is the most direct way. It's too icy for any clear tracks in this light, but it's obvious there's no crevasses,' Dave responded irritably.

'Well, there's people coming up that spur over there,' I pointed to the left, 'and they can't be coming from anywhere else but the Col de Brenva,' a pause for emphasis, 'and coming that way for a reason.'

'It could be them that's lost, you know: it doesn't have to be us.' Dave shivered. 'I don't know what you're bloody worryin' about. It's so early and so damn cold, there's no chance of falling through any soddin' snow bridges.' His irritation was turning easily to anger.

Even raised voices thinned out in all that space as the wind plucked our words away. We could not stop for long.

'All I'm saying is that I think we're a bit off route and that we ought to try to get back on it again. That's not too much to ask, is it?'

Ceri's head had been turning from one man to the other like a spectator at a tennis match. Now he cut in, 'Map and compass?'

'What?' I was still hearing the bells. 'Oh, right.' I began to fumble with my rucksack.

'Bugger that!' Dave snapped. 'If you think you can do any fuckin' better, you lead the fuckin' way!'

'Right. I fuckin' will!' I'd had enough, too.

Reversing the order of travel, I led off on a diagonal traverse towards the left-hand spur. We slowed but established a steady rhythm despite my edginess. Thrusting my ice axe into the uphill slope with my left hand I would kick two steps forward then replant the axe to support the next two steps: axe, kick, kick; axe, kick, kick. Breaking trail like this was easy enough; the unconsolidated snow wasn't too deep. But the alarm bells, though muffled, were still sounding in my head. The spur grew closer. I could see people stopped, leaning hunched over their ice axes, suffering from altitude and cold. It was a long way from the Aiguille du Midi and the cablecar. I maintained my rhythm. Axe, kick, kick … boom!

The explosion physically shook me as I was enveloped in a huge cloud of snow spicules. I could see nothing through the sparkling dust. My mind emptied, I lost my bearings and nothing made sense. But I held on to one thought, an imperative: don't move!

The alarm bells had stopped.

As the air slowly cleared I took in my situation. I was standing on a flake of snow, a wedge on the brink of an enormous crevasse that cracked away for a hundred metres or more in both directions across the slope. Its further edge lay beyond a gap the width of a room. I could not see the bottom. My ice axe was firmly planted in the slope above the crevasse, but between my boots and the axe ran a crack where the flake I stood on was detaching itself from the edge.

'Not explosion: implosion,' the thought formed unbidden.

I had moved my head the absolute minimum to take all this in. Now I looked up, following the line of the rope to where it linked me to the others. I noticed that for some distance its upper surface was whitened with a crusting of snow crystals. Dave and Ceri stood frozen, mouths open, arms hanging loosely at their sides. Neither had me belayed.

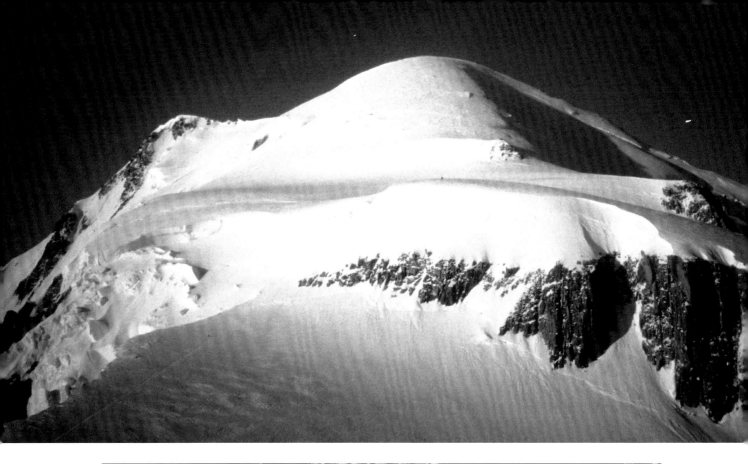

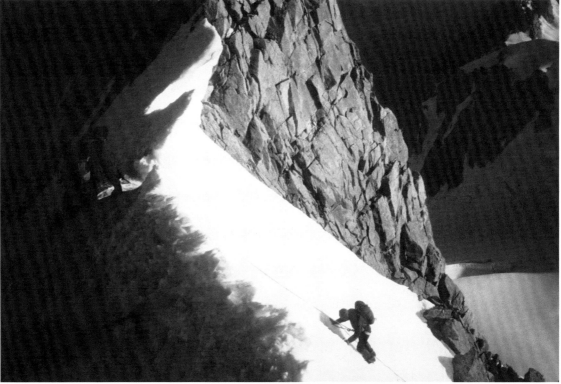

Top: Mont Blanc seen from the Col de la Brenva; the crevasse can just be seen cutting across the upper snow-slope.

Bottom: Down-climbing the Col du Mont Maudit on abseil; the snow stake anchors were that doubtful.

Extreme self-control manifested itself in an exaggerated politeness: 'May I have a belay, please?'

My words broke the spell. Both dropped onto their axes, driving the shafts deep into the snow, and simultaneously taking a bight of rope around the axehead. Only then did I shift my weight onto my own axe and take two big steps off the flake, climbing quickly up from the edge. The flake broke away, whispering into the abyss behind me.

I stopped, breathing heavily. Ceri had me tight; the rope shivering a little at my waist.

'Okay, moving on!' I shouted back up the slope.

Without another word, we cautiously traversed above the upper lip of the crevasse until it narrowed to a fine line, crossed it and then descended the spur rapidly to where a few rocks stuck up through the snow.

From the tracks and sweet papers it was clear that plenty of people had taken a break there. Strengthening sunshine soaked into us and for the first time for many hours it seemed we could relax. The effect on Dave and Ceri was immediate in the sudden need for a toilet stop. I felt strangely calm, sitting on a granite block to one side looking back up towards the summit and the crevasse.

Windswept spindrift was still scattering amongst irregularities in a snow surface, glittering and shining as sunlight explored it. From below, the crevasse could only be made out if you knew where to look.

Suddenly Dave's shadow fell across the snow at my feet. He was standing over me, silhouetted against the sun.

'... Erm ... Sorry about that ... could all've been dead ... no way you or Ceri would've stopped *me* ... going straight down like that ... at that speed ... I'd've been well over it when it went ... I was just going down a snowslope in Scotland in my head ... altitude, I 'spect ... er ... Sorry.' He shifted his feet awkwardly.

'Yeah ... Okay. Let's go, then.' There was nothing more to be said.

We continued the traverse, down to the Col de la Brenva. The wind snatched my glove away as I began to abseil down the Col du Mont Maudit.

But there was no question of taking in the summits of either Mont Maudit or later Mont Blanc du Tacul; we just didn't have it in us. I remember Dave and Ceri on the descent of Mont Blanc du Tacul where the track passed into a crevasse. Two walls of ice towered over them. They did not look happy.

How do I explain that premonition? I don't. But I remain resolutely superstitious.

If you want some science, try the following. Modern cognitive research has shown that the human mind receives sensory input that is vastly beyond the capacity of conscious thought to process. Conscious decision making is therefore selective in its processing of sensory evidence and as such partial, particularly partial to conscious objectives or ambitions. The unconscious mind receives all that input and works differently. The phenomenon of waking up in the morning with the solution to a particularly knotty problem is well known. The unconscious mind seems to have been working away all night to reach a conclusion that had escaped conscious thought yet makes perfect sense once recognised. Sleep permits the unconscious mind to interface with consciousness; that's how we dream. Superstition does something similar: it allows the irrational credibility. Perhaps the unconscious recognises some sensory input that the conscious mind ignores. Whatever – it is no accident that people accustomed to danger, such as seamen and sherpas, tend to be superstitious: they are the ones that survive.

Dent du Géant, 4013m. South-West Face: AD

A day's rest can work wonders. With a good weather forecast and just time for another route, we considered the possibilities. There was no thought of climbing 4000m peaks at that time. Mont Blanc had been inevitable: go to climb in Chamonix and the biggest beast on the block becomes a target, especially near the end of a month's visit. But there was another mountain, sticking a defiant finger skyward, impossible to ignore; the Dent du Géant, seen from so many other peaks, which dominates the Vallée Blanche. My brother-in-law, Stuart Potts, had missed out on Mont Blanc owing to illness, but here was a chance for him to get up an impressive peak. He and Ceri took their time walking over to the Torino hut while Dave and I climbed the Cosmiques arête on the Aiguille du Midi before following them.

Evening cloud wreathed about the hut, draping atmospheric rags of colour around glimpses of the Aiguille Blanche de Peuterey and the Brenva face above while the lights of Courmayeur winked from the gathering gloom below. Rising in the dark, we crunched across the Col du Géant as cold stars twinkled, dispelling any uncertainty about the weather. That icy wind was with us again.

Dave and I were climbing the short couloir that leads from the glacier up onto the mixed slopes of rock and ice that rise to the Rochefort arête. We had been aware that Ceri and Stuart had fallen behind, but now saw Ceri coming up on his own. Rich dawn light was bathing Mont Blanc in a rosy glow, but the glacier bay beneath us was still deep in shadow where Stuart was trudging back to the hut on the well-marked track. His illness had sapped his strength and left him reeling but still determined to get back to the hut on his own so that Ceri could go on.

Climbing as a three, we scratched crampons up rock and ice to the Salle à Manger, and forced down some food in what little shelter there was from the bitter wind. The Dent du Géant towered above. Cramponless and traversing onto the rock, we realised the westerly aspect of the face meant we would not get any sun until much later in the day. I now knew why Rebuffat had advised climbing it on the way back from the Aiguille de Rochefort; for the first and only time in the Alps I climbed encased in a duvet jacket. As we set out to climb the route clean, the granite, smoothed by the passage of countless feet, felt just like ice to our ungloved fingers, which simply went wooden by the first belay. The fixed ropes dangled enticingly.

We'd harboured ideals about free-climbing those beautiful cracked Burgener slabs, but after the first pitch Dave was emphatic: 'To hell with that! We need to keep moving just to keep warm!' There was no dissent.

We swung up the fixed ropes, moving together with the leader placing tape slings at the anchor points or prusik loops onto the ropes themselves until he ran out, at which point the last man led through with those same slings and prusiks he'd collected as he climbed. It still seemed a painfully drawn-out process as the wind plucked at our collars and whistled to numbed ears in our icy helmets.

The slabs narrowed to a point where the short summit ridge began, but even there in the sunshine that insistent chill remained, probing at the seams of our clothing for the warmth beneath. On the summit I risked taking off a glove for a moment to pose holding hands with the scarred Madonna, her head pitted with lightning strike. She seemed a symbol of suffering humanity, yet in the photo there are no reservations in my wide smile, while behind me the Rochefort and Grande Jorasses summits unwind their ridges for other days.

The final step to the summit Madonna on the Dent du Géant.

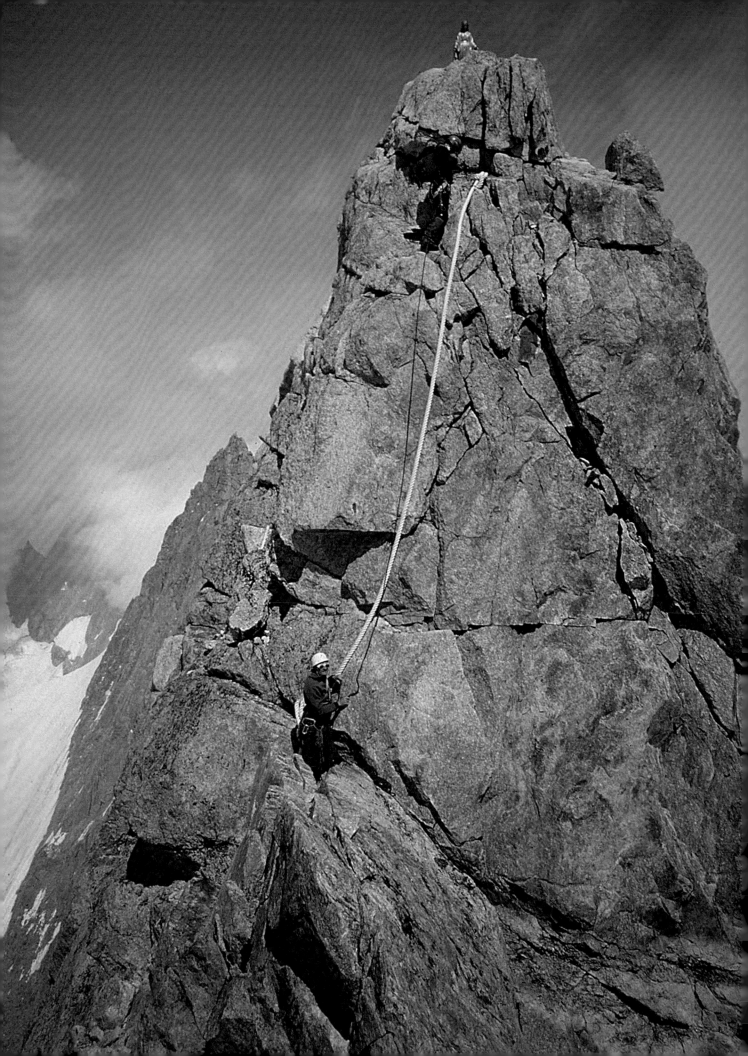

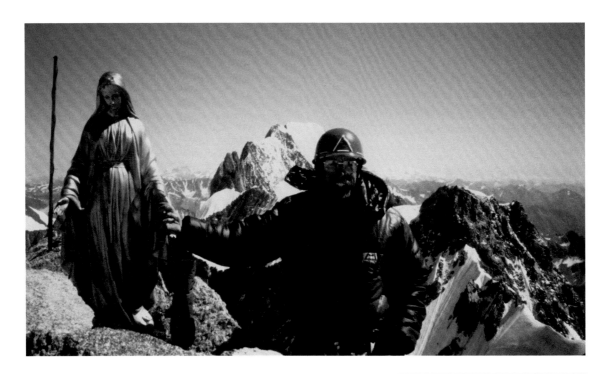

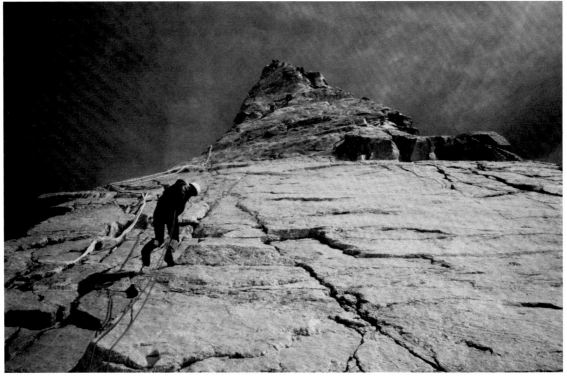

Top: The author on the summit of the Dent du Géant; in the background, the Rochefort and Grande Jorasses.

Bottom: Abseiling down the Burgener slabs while later parties continue their ascents of the Dent du Géant.

Abseiling down the now sunny slabs was only complicated by the need to avoid those parties climbing up, but cemented steel retaining rings generate a certain confidence in one's belays and we were soon back on the snow.

Fired up, we went like trains all the way back to the Torino hut, where Stuart was waiting.

It was Stuart's misfortune to have contracted a particularly virulent form of herpes simplex that spread into his throat and then became complicated by an allergy to penicillin he'd not been aware of. At some point in the trip one of us had developed a cold sore, and the bad habit of taking a swig from one another's water bottles meant that the virus went round all of us before we realised. Stuart never climbed in the Alps again, and Ceri emigrated to New Zealand. But Dave and I forged a sound climbing partnership that took us up many of the Chamonix classics before he retired from climbing at the grand old age of 40. Things were different then.

Postscript

In 2005 I returned to Chamonix with my partner, Adele Long, who had made an attempt on Mont Blanc a few years earlier. It was a season of very poor weather with heavy snowfalls though we managed some acclimatisation on short routes and wet walks. With limited time and little likelihood of any other route being in condition, we decided to try Mont Blanc. It was a fair bet that guided parties, prebooked into the Goûter hut months in advance, would have broken trail by the time we got on the route from the lower Tête Rousse refuge, where we would have to sleep.

Passing the old timber Tête Rousse hut brought back memories of sleeping on tables there in 1981; it is now reserved as a 'winter room' whilst the nearby modern concrete structure towers over it. In the afternoon following our arrival we were able to look out on the north-west face of the Aiguille de Bionnassay where we were told a British pair who had been on the route for two days were adding another chapter to their epic while the guardian hesitated about calling in a helicopter.

Starting from the Tête Rousse adds another 650m to the route so an early start is essential; 1650 metres, half of it over 4000m, has to be treated with respect. The rocks on the steep climb to the Goûter hut were slippery with verglas but snowed up enough for us to kick steps between them, while the tricky couloir, which tends to unload a fusillade of stones just as climbers cross it by fixed cables, was stilled in the dark by a cold weight of snow.

Above the Goûter hut, as expected, a good trail led beyond the tents up through deep snow to the Dôme de Goûter and as dawn broke on the mountain we could see just how many other parties there were on the route. But it's a big mountain and we didn't feel crowded. After so much bad weather the air was fantastically clear at first, with views all the way to the Bernese Oberland beyond the summit of the Aiguille du Midi; it felt strange to be looking down on the Aiguille Verte and Les Droites when we took a break at the Vallot hut. I looked in to see if it was as squalid as I remembered from 1992: it was. Above us the Bosses ridge looked desperately beautiful. It was the first opportunity I'd had to photograph it in daylight.

The climb up the ridge was as straightforward as I remembered it, but the darkness of previous ascents had masked the exposure on the final, thin, nearly horizontal section. Now it was very noticeable as the steep snow slopes plunged away on either side: no place for vertigo. The summit itself was much friendlier, broadening to a platform where people could indulge their desire for group

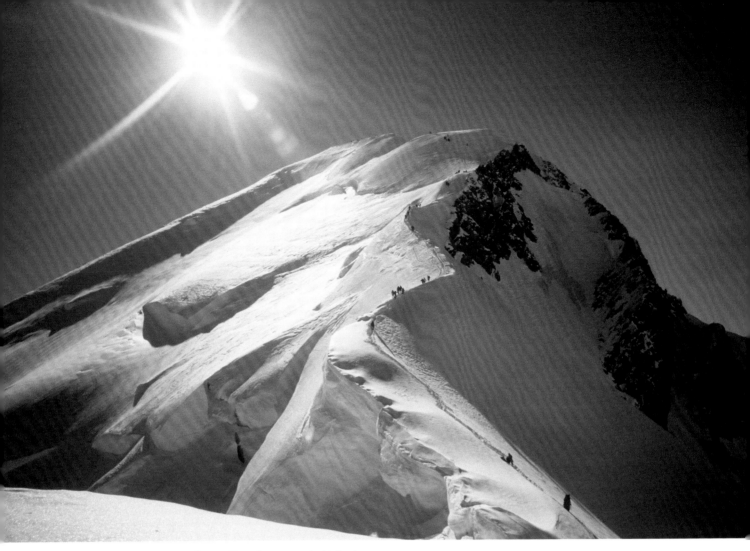

The Bosses ridge of Mont Blanc from near the Vallot hut.

photos. A French climber offered to take our picture, and looking at it today I can see we were well muffled up against the cold despite the sunshine.

Reversing the route was much faster than the ascent had been, struggling against the effects of altitude, but we had to be on our guard against carelessness: we were beginning to get tired. Still, we made good time back to the Goûter hut. It was below that that the trouble started.

The afternoon sun was melting the good steps out of the snow, leaving slushy trenches and slippery wet rock. What with those who had attempted the mountain that day going down and those aspiring to climb it next day coming up, there was heavy traffic. Two lines of ropes and cables protected the route, and it was generally recognised that one line was for ascent, the other for descent. Problems arose when impatient guides ignored that distinction and tried to push their way up the descent route or to overtake by switching from one route to another, shouting loudly and towing their alarmed clients in their wake. Of course that intimidated the novices on other guides' ropes even more, so that bottlenecks developed. Stones were dislodged, adding to the melée and intimidating the punters still further. There was a lot of waiting. So much so that by the time we got to the Tête Rousse hut there was no chance of us catching the last télépherique down to Les Houches.

Neither of us could face the long walk down to the valley in the dark, so Adele went to exercise her powers of persuasion on the hut guardian. He was fully booked and couldn't promise a bed, but we could stay and sleep on the floor. Then he took pity on her – she must have looked as tired as we both felt! – and asked, 'Would you like to have a few hours on a bunk now?' As it turned out we got lucky: a cancellation meant that two bunks became available.

Next morning the weather held as we walked down to the cableway, although cloud was building and it was forecast to turn bad later. I met a British guide of my acquaintance with a party attempting to summit that day. It was 10 a.m. and they hadn't reached the Tête Rousse hut.

While his team walked on I had a few words with him: 'I don't really think there's any chance of getting near the summit today in that depth of soft snow, and I wouldn't want to be caught out up there in bad weather.'

'I know, but it's what they want to do. We probably won't get further than the Goûter, but they have a booking and want to use it.' His tone was almost apologetic.

'Shame, though, to be flogging up here in what's left of the good weather when they could be on a much more satisfying route in the Aiguilles Rouges.'

'Yeah, but who's heard of the Aiguilles Rouges at a London dinner party?'

'Oh, I see. Okay. Well, take care.'

Next day we drove home in the rain.

Mont Blanc is the only 4000m mountain that I've climbed three times, but this last occasion was worth it for the pictures alone.

2:
Kit

If you place three alpinists in a bar the chances are that sooner or later the conversation will turn to the subject of kit. My partner maintains that it is a good job it's a bar so that there is someone to call '*Time!*' Otherwise the conversation could continue indefinitely. She exaggerates. A bit.

The thing is that the issue of kit is potentially never-ending. Every alpinist is forever testing, adapting, modifying whatever interlocking system of equipment, clothing, technique he or she is using at present in the light of new developments, recommendations, technological advances. An alpinist is always looking for an 'edge'. As Terry Gifford puts it in that fine volume of poetry, *The Rope*:

> a secret bit of line
>
> that comes in handy
>
> for only they know what.

It's a hard world up there in the snows.

Much of what follows is just my take on what has to be a continuously evolving situation; a starting point for some, an aide memoire for others. Undoubtedly other alpinists will have other ideas; there's more than one way to skin a cat. That said, some basic principles can be applied.

The one overriding principle in alpine equipment is 'Light is Right.' Continental climbers employ the principle although they have far greater opportunity to gain and maintain acclimatisation to altitude. For the average Brit, living a little above sea level, it is essential. Lightweight kit increases the safety margin in alpine climbing.

There is, however, another lightness that comes into play with alpine clothing and equipment; lightness of colour. Anyone who has stripped off their navy blue base layer to sunbathe with a beer on a hut terrace, then found that it was almost too hot to pick up, will know that dark colours absorb heat. Wearing black in hot sunshine is a good formula for heat exhaustion, particularly when exercise is generating even more heat.

Another advantage of light colours is that (excluding white!) they stand out against the background of snow and rock. In an avalanche, that red-booted foot breaking the surface will be spotted by rescuers when a black one is indistinguishable from rock fragments swept down in the slide. Trapped on a ledge with an injured partner? Then dark colours blend into the rock background, hard for a rescue helicopter to spot.

Aesthetically too, alpine photos can be 'made' by a well-placed figure – but not if that figure, camouflaged by dull clothing, is lost against a dark rock background or mistaken for just another little rock pinnacle.

Some British climbers bring pseudo-environmental ideas from the miniature mountains of home, where the human presence makes a bigger impact. 'Not natural!' they exclaim, favouring greens and greys and forgetting the perfectly natural purples of willowherb and heather, the yellow of gorse and pink of wild roses, or the burning reds of bracken in autumn. Others may embrace camouflage in celebration of a militaristic conquest of nature. But an alpinist cannot afford that kind of self-indulgence. Human figures are dwarfed by the scale of alpine mountains: in case of trouble they need to be seen to enhance their chances of survival.

Turning to details, there are two categories to focus on: clothing and climbing equipment.

1. Clothing

The temperatures on an alpine route can range from a chilly –10°C at 1 a.m. to a sweltering 20-something degrees when descending a glacier at 1 p.m. A layering system allows clothing to be added or removed according to need and should make it possible to climb in comfort. The usual components are: base layer, mid-layer insulation, wind-shirt, a second insulation layer, shell. This has been complicated by recent softshell innovations which seek to combine the windproof and a mid-layer into one thinner, lighter garment.

Base layers were originally known as 'thermals' because they felt warm next to the skin. They are now more valued for their ability to 'wick' or transmit sweat away from the body so that they do not become soaked and dangerously chilling at a halt. These may be all you end up wearing as a concave glacier bowl focuses the sun's rays onto you, so light colours that will not simply absorb that heat but will instead reflect it away, are essential. The idea that base layers should be black so as not to show the dirt indicates a fastidiousness that climbers should be far too sensible to prioritise over their comfort and survival. In the Alps you can always wash your clothes on rest days in the valley, and on expeditions no one will notice.

Mid-layers can be of fleece, softshell, shelled synthetic insulation or even down. There appears to be a wide choice, but the economics of mass production limit what is available: try buying ultrafleece, a supremely hardwearing lightweight fleece, now no longer produced, or waterproof trousers in any colour other than black.

If you can't get what you want in the UK then take careful measurements and order from EU internet suppliers: brands like Millet and Eider are well worth a look. Notable amongst UK manufacturers is Buffalo, which will make up special orders of shelled fleece including your modifications (within reason).

It is worth remembering that two thinner mid-layers have more flexibility than one thick one, and that a windshirt can increase the insulation effect of fleece enormously by cutting out that penetrating wind-chill and allowing the trapped air to retain its heat. Thinner and lighter insulation can be used if a windshirt is added, and wearing the windshirt between layers of fleece will stop them from binding onto each other when taken off or put on (shell clothing can windproof the outer layer if necessary). Most windshirts are now made of Pertex, which is superlight, but I still have a liking for my old Berghaus polyester-cotton hooded one, which feels comfortable next to the skin, doesn't absorb much sweat, and is loose-fitting enough to be a cooler alternative to my base layer when temperatures really soar.

Mid-layering for legs can only really work if each layer has full-length side zips so that layers can be removed without having to remove boots and crampons. Softshell legwear that has adequate

ventilation can be the answer for alpine climbing if it's available in lighter colours, sometimes with darker and tougher knee and seat patches in traditional alpine style, but again it's only supplied by continental manufacturers and hard to get in the UK. Otherwise it's tough poly-cotton or nylon climbing pants, and put up with the chill on alpine starts.

Heads and necks need sunhats and bandanas as well as thin fleece hats that will fit under a helmet and thicker hats for serious cold. A neck gaiter or Buff is good for face protection in storms and can double as a headband. Hands need inner gloves for dexterity that can be overlaid with fleece or similar mitts.

Shell clothing generally only gets used in a storm so it's more likely to be carried than used, and should therefore be as light as possible. If rock climbing is involved on a route then lightness will have to be balanced against toughness if shell clothing is not to be torn to pieces. It must be breathable, and not restricting when reaching for a hold. Jackets should be hooded. Mitts are generally more waterproof than gloves, but the penalty is a lack of dexterity.

Well-fitting alpine boots that are stiff enough to use with crampons, comfortable socks and snow gaiters complete the rig-out.

2. Climbing equipment

This all depends on the route. A helmet that will sustain multiple impacts from rockfall is essential. Most very lightweight ones can be only good for one hit. Harnesses should also be as light as possible. For ski-touring there are some available that resemble nothing so much as a jock-strap with all the comfortable bits missing; I have a friend who has climbed the north face of the Tour Ronde wearing one, but I wouldn't recommend it. Belay devices like the Petzl Reverso that are self-locking can be useful if two seconds might be climbing at the same time, on an HMS karabiner so that you can belay and abseil on an Italian hitch if the belay plate is dropped.

There are lots of crampons that are lightweight but rigid enough for mixed routes. Horizontal front points are supposed to grip better on rock, but vertical points penetrate ice better – so you pays your money and you takes your choice. Anti-balling plates will stop you stilting along on platform soles of afternoon snow that lift your crampon points clear of any bite and threaten to slide you off into space.

There are some beautifully engineered ice axes and hammers around, like the Grivel air-tech series, although it's worth having a pick, like the Evo, inclined steeply enough to do service on a pitch of steep ice that you might run into.

A couple of long slings with locking karabiners are always useful for dropping over rock spikes for runners or main belays, or for improvising a harness if ski-touring without one and unexpectedly needing to abseil. I usually take two prusik loops, one long and one short, that can double up as replacement abseil anchors if any look doubtful, before I start chopping the rope.

It's salutary to remember that a lot of alpine routes were put up with just 100 feet of hemp rope, and increasingly 30m half-ropes are all that are carried on easier alpine routes. These days there are 9mm full-strength single ropes like the Beal Joker that offer additional security for a small increase in weight over the 8mm half-ropes that are often used single on glaciers where the fall stresses are low and doubled on more technical sections of routes. When ski-touring, the main use of ropes is for crevasse rescue, so shorter and/or thinner ropes tend to be used and there is an argument for using static, non-stretch ropes in those circumstances; it's easier to prusik up a non-stretching rope, and the lip of the crevasse absorbs much of the energy generated by the fall.

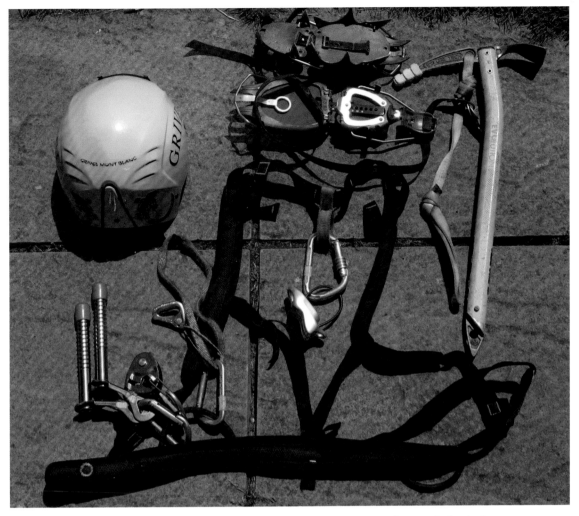

Basic climbing equipment for an alpine snow route: helmet, crampons, ice axe, harness, belay device, crevasse rescue kit and ice screws.

For mixed climbing, routes up to AD-, you can add two short slings with karabiners and two 30cm quickdraws with the lightest karabiners, because longer slings mean less rope-drag on long run-outs even if the gear placements are sparse. For rock protection just six nuts (racked two to each karabiner) – wedges, or hexentrics for their camming potential – are often enough, as most routes tend to have pitons at difficult points or crucial belays. For ice protection an ice screw or two will usually do – titanium if you can get them.

For harder routes, perhaps add a couple more ice screws and quickdraws. If it's an alpine rock route up to about V, add a clip of wired Rocks or Walnuts, three Friends and a few more quickdraws to make up a leading rack. If it's an ice route, cut down the nuts and add a few more ice screws. It's not rocket science.

Crevasse rescue gear, all useless without the rope, is essential if crossing glaciers unless they are completely dry ice with no hidden crevasses. I take a DMM revolver karabiner that behaves better than pulleys, a Wild Country Ropeman or Petzl Microtraxion as an autoblock that will lock the rope between hauling, and a Petzl tibloc that acts like a prusik loop but is neater in action – although I still carry the prusik loops, and you could get away with just two of those.

Everyone needs a rucksack to carry all this to the start of the route, plus your extra layers and emergency kit on the route. That should be 30–45 litres capacity and weigh around a kilo; avoid

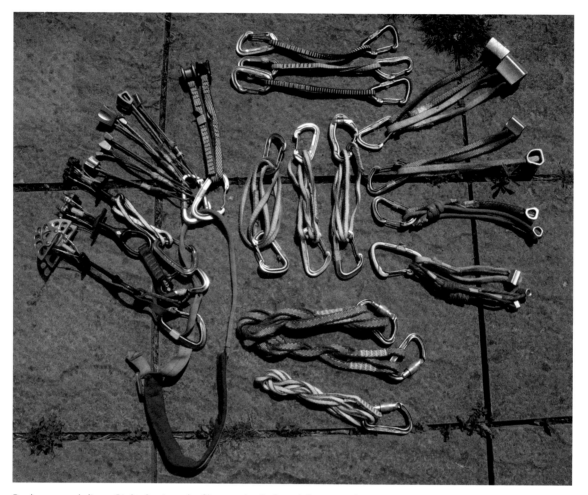

Rock gear and slings. Right: basic rack of hexentrics. Left: rack for more demanding routes: cams, wired nuts and tricam nuts. Centre: 'sling-draws', quick-draws (above), long slings (below), would be carried with the basic snow route equipment too.

those weighed down with 'features', and you won't have to cut off all those bells and whistles to get the weight down when you find you don't use them. Don't go for lots of zipped pockets or compartments, they just add weight; you can organise the contents with featherweight mesh stuff sacks.

Emergency kit should include a medical kit and basic repair kit (e.g. duck tape and a needle and thread). Making your own up is cheaper, and in both cases makes sure you have what you will use. A bivi bag and synthetic insulated jacket will keep you warm when wet, and alive if you have to spend a night out. Most people take a little emergency food, whilst some carry an emergency stove/pan kit to melt snow for water on an unplanned bivi. Planned bivis mean a sleeping bag, sleeping mat, better stove and rations.

For ski-mountaineering in winter and spring, specialised ski-mountaineering boots that can flex at the ankle or have that flex locked out for descents are necessary as well as skis, with skins that stick to the base of the ski for climbing, and ski-poles of course, telescopic if you are going to be doing much climbing. The crevasse rescue equipment can be ditched if no glaciers are expected on the route, but an avalanche transceiver and a snow shovel to locate and dig out a victim are essential additions, and avalanche probes can be useful. Much of the climbing protection is unnecessary in most ski-touring,

but a couple of long slings with locking karabiners and an ice screw can be useful for belays, while a 30m half-rope can safeguard a tricky step.

Ski-mountaineers often save weight by using specialised lightweight alloy axes and crampons that are useless for any technical climbing but can offer self-arrest on snow slopes and security on modest ice. Grivel and Stubai make ski poles with retractable or removable ice axe picks in the handles that can save further weight by removing the need for an ice axe for self-arrest.

Then, when you have all this kit, all you have to do is learn how to use it … which is where training comes in.

3:
To the Écrins, 1982–3

In 1982 I arrived in Chamonix to see the Aiguille de Goûter glowing in the sunset. That was the last time I saw any peak for the next two weeks. Torrential rain kept Dave Hicks and me tent-bound while thunder exploded overhead and the brightness of lightning dazzled us awake through two layers of tent fabric and closed eyelids. With no drying room, even snatched walks in brief interludes of lesser rainfall lost their appeal. So at the first forecast of fine weather, unacclimatised and unfit, we struggled up to the Couvercle hut, planning a training climb on Le Cardinal next day.

After crossing the bergschrund and climbing steeply around rocks into a broad snow couloir, we caught up with a French party ahead of us. The leader told us he was taking his two nieces up Le Cardinal, a route he had climbed before. We pulled ahead and began to bear left according to our guidebook description, but he quickly admonished us to follow him to the right, adding 'I am a guide!' by way of encouragement. Now Dave and I had come across this guidebook confusion between left and right before, so tucked in happily behind as he broke trail.

As the hours passed and we continued to follow the ridge rightwards with no sign of the expected chimney pitch and increasing hesitancy on the part of our guide, that happiness turned to doubt. Cold cloud swagged around pinnacles as we threaded our way between them. Dopey with altitude, we called a halt.

'Should we go back?'

The guide was adamant that it would take too long to reverse the route, but there was an air of contrition as he suggested we find a way back down to the glacier, adding ruefully, 'We are all … how you say … in the same boat now.'

We began to descend corners and broken ledges, hoping for sight of the glacier, hoping for an easy abseil and a sprint back across the snow to the comfort of the hut. The light was failing, then suddenly the clouds were torn aside and we saw the Whymper couloir before us, falling from just right of the summit of the Aiguille Verte. We were a very long way off route. Somehow we had traversed the bulk of the Moine ridge from near Le Cardinal, and now were descending the Verte's south-east face. For a moment the crest of the ridge above the Whymper couloir was gilded with light, then it was gone. We pressed on, cursing, praying for that elusive abseil.

Then we could go no further. Beyond this last ledge the rock plunged straight down to a bergschrund. Hurriedly the Frenchman set up an abseil point with nuts and slings. He tied our ropes together, threaded the abseil anchor and threw the free ends into space. In the gathering gloom the knotted ends swung free over the yawning bergschrund, too many metres short of the snow.

'Now we have no choice,' the guide intoned wearily, 'we have to bivouac.'

Casting about, there was no obvious alternative line of descent and darkness would soon be upon us. He was right. Now this was bad news for Dave and me. Thinking we were only tackling a short training climb we had travelled light: a spare sweater, socks and a chocolate bar was all I had in the way of emergency supplies. Dave caught my eye and muttered, 'Perhaps we can snuggle up with the French girls.'

'There is no room for five on this ledge. You will have to stay where you are.' The uncle's voice floated up from below.

'It's a bit wet up here with this meltwater splashing. Are you sure?'

'Oui!'

Dave and I tied onto a sling draped over a creaking flake, put on extra clothing, such as it was, ate some chocolate and tried to top up our empty water bottles from the trickles and drips from above.

We were wary of sleep: when it gets cold enough you don't wake up. But you can only talk for so long before tiredness takes you.

Then suddenly a rescue helicopter was roaring towards us, the beam of its searchlight blinding me, and I jerked out of sleep, terrified of slipping off the ledge … to stare into the cold disc of the moon just risen above the ridge opposite, while the distant avalanche grumbled into a silence no longer broken by the drip of water.

There was a crackling of ice as I shivered. I remember thinking – *My daughter's going to grow up without her daddy*. No more dreams: no, I was going to get through this night.

Morning arrived and I understood why the sun has been worshipped as its warmth brought fingers back to life, unstiffened limbs. I examined the rock around us for a way off in the early light. Climbing up I reached a gritty ledge system that eventually descended to within a short abseil of the glacier and safety.

That encounter was as close as I got to the Aiguille Verte for many years, but the experience led me to look to the Écrins for better weather than Chamonix, and I decided to take the family.

I think it was climber-poet Ed Drummond who wrote about climbers shuttling between the twin poles of a rock and a soft place. The Alps had given me a hard time twice, and there was no doubt where my soft place was, nor how precious it was to me. Some irrationality suggested that if my family was kept close, like a talisman, they could not be lost to me.

My daughter, Rhian, was four years old – but my son, Rhys, at one year old, would need the sanctuary of a caravan if the trip was not to descend into squalor. Jayne and I took them on a few trial runs in the Yorkshire Dales and Peak District. I convinced myself that carrying Rhys in the papoose backpack was good training.

Dave Hicks was brave enough to accompany us, with a view to climbing with me. We did not anticipate any conflict of interest. He and I had a typically blokeish reticence about personal matters, although he had once told me that his wife had left him, taking their son with her. There was no explanation and I didn't seek one. It was simply a piece of information that might bear upon how he reacted to stress in the mountains, I suppose. We didn't talk about it. (It's not like we didn't talk about other stuff, work, politics, that kind of thing, but nothing too personal, too serious: after all there was enough seriousness out there amongst those looming presences that filled our skies and wore the fingerprints off our hands.)

At home, Jayne and I had an easy-going relationship with two or three other families with young children. Perhaps it was this incipient extended family tendency that meant we made Dave welcome in our family. It's a strange thing about climbing partnerships: you may well not share each other's

innermost thoughts, but there is a bond that neither separation nor the passage of years destroys. Yet it's not really so strange: each of you has trusted the other with your life.

The Écrins heat was a revelation. Height had to be gained early in the day before the sun reached its full strength or the effort became purgatorial. Rhys rode cheerfully in the 'papoose' with breaks to stretch his legs and play, whilst Rhian only once had to clamber into a rucksack, to be carried the last few hundred metres down to our campsite. The children were fascinated by grasshoppers, big as locusts, that kept up a continuous chirring in the undergrowth or whirred through the air to land under our very boots and lie, half-crushed, twitching on the dusty track. When the heat grew too great we wandered the shaded streets of the ancient village of Venosc. The children played naked in dammed shallows where mini lagoons could warm the eddying water enough to take the chill off the glacial torrent that swept past just a few metres beyond. On cloudy days brooding with the threat of thunder, we hiked up to huts for hot chocolate treats as the mist gathered outside.

We were the only English on the campsite at Bourg d'Arud, but despite Rhian's puzzlement as to why the other children didn't speak 'properly' and some agonised appeals to us – 'What does he mean?' – it was remarkable how soon she and her new-found friend Lucien were working it out as they played happily together. She was also very protective of her little brother as he stumbled around, learning new words. I would like to think that they came away from the experience with wider horizons.

Dave and I found the climbing different from Chamonix, too. It was not just the heat; the rock was less reliable and in August there was much less snow around. We climbed the slender rock fin of the Aiguille Dibona, a fitting tribute to that prolific guide, then a mixed route on Pic Coolidge (named after the famous alpine scholar). From there we were treated to fine views of the south face of the Barre des Écrins, and decided to attempt the south–north traverse.

The Barre des Écrins, 4101m. South Face and Traverse via Col des Écrins: AD

The walk in to the Temple Écrins refuge from La Bérarde wanders amiably alongside the Vénéon Torrent, until the last 400m of ascent in just a kilometre of south-west facing slope provides the sting in the tail. Dave and I sweated up this to find the hut crowded and basic, but we managed to secure bed spaces. These hardly seemed worth it when we rose just after midnight to force down a tiny breakfast and totter out into the night. We stumbled up the path that skirts the flank of the south-west ridge of Pic Coolidge into the Vallon de Pilatte, until at about 3000m we met the glacier. Always keeping to the right, we cramponed up the dry ice, thinly snow-covered in its higher reaches, with little to worry us about crevasses. Meanwhile the gradual dawn relieved us of concerns about failing batteries in our headtorches. Leaving the Col des Avalanches to our right, we headed straight for the rock walls of the lower south face. With the hut at only 2410m we had climbed about 1100m and had 600m of serious rock and ice ahead.

The route makes a rising traverse to the hanging snowfields that had so impressed us from Pic Coolidge, but the line was far from clear. Couloirs were used as landmarks in the route description, but all were snow-free and there was nothing to distinguish one rocky gully from another. Initially

Top: The north face of the Barre des Écrins at dawn.

Bottom: The south face of the Barre des Écrins from Pic Coolidge.

there were some signs of the passage of other people, even a piton at an awkward step, but then we reached a small amphitheatre and there was no obvious way out. We tried the likely lines until each in turn became unconvincing, then tried one of the others. This was taking a lot of time, and I remember raging at the injustice of it all. Anthony Burgess in *A Mouthful of Air* quotes an RAF fitter's wartime outburst at a recalcitrant engine, 'The fucking fucker's fucked, fuck it!' as demonstrating the grammatical flexibility of the ultimate expletive. I'm not sure I explored all its resources, but it must have been close.

Finally Dave made a very committing lead that was distinctly harder than the 'pitches of III' quoted in the guidebook, and we could escape right to reach the snow. By then, however, it was later in the day than we had expected and this was a south-facing slope. Instead of cramponing easily up well-frozen névé we soon found ourselves sinking knee-deep in softening snow. To the left, a narrow avalanche chute carried small slides from Brèche Lory: it could have been the melted-out steps of earlier climbers on a variation of the route. The guidebook advised bearing right, making directly for the summit up 55° snow-ice, but as we climbed the snow thinned to nothing and we found ourselves scrambling up precariously balanced rocks.

Dave was leading, and managing to dislodge enough rock to give me some trying moments of evasive action, whilst there was always the lingering suspicion that the whole slope could suddenly become an escalator moving just one way: downwards. I didn't seem to be having such a disturbing effect on the equilibrium of the face. Somehow I had developed a second sense about dispersing my weight, balancing the points of contact – they were too insecure to be dignified as holds – so that my upward progress was not subject to an equal and opposite movement of falling rock. I suggested we swop the lead. Dave looked a bit doubtful but agreed and the crash and clatter of falling stones subsided a little, or at least no longer set my nerves on edge.

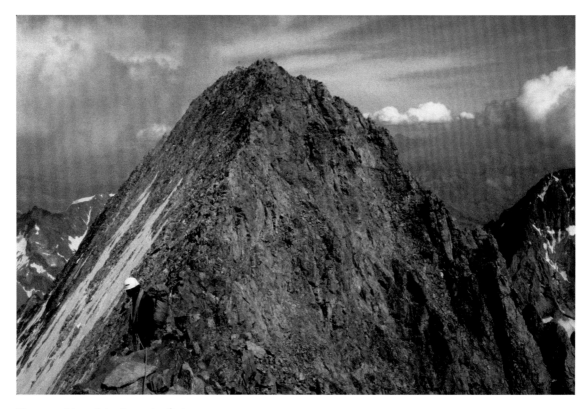

The west ridge of the Barre des Écrins.

Earlier in the season this must make a straightforward snow climb, but for us time stood still in a bubble of concentrated nervous tension so that it was with surprise as well as relief that we suddenly found the summit cross smack in front of us as we gained the ridge.

The view over the many lower but still magnificent mountains of the range – Pelvoux, Ailefroide, La Meije – was remarkable, and even at that distance it was possible to pick out details of the tremendous ridge lines on the south face of Mont Blanc looming perhaps 100km to the north. But there was no time to linger.

Descending the western arête was a straightforward scramble over Pic Lory and down to Brèche Lory, utterly changed from Whymper's description of the first descent in 1864 (they climbed the north face!) The arête seems to have been largely composed of 'unstable blocks … so rotten that the most experienced of our party, as well as the least, continually upset blocks large and small'. The accompanying illustration emphasises the precariousness of their position, and he specifies that when the guide Almer jumped a gap 'the rock swayed as he came down upon it'. Coolidge's suggestion that Almer's leap might have been a sensationalised fabrication to spice up the book after he had failed to find its location on the third ascent six years later sparked off a bitter quarrel between the two great men that lasted until Whymper's death.

It may be that Coolidge's scholarly desire to pin down the facts took him too far into the realms of dispute; 'he could do anything with a hatchet but bury it' (The Times obituary). In the mountains perhaps more than anywhere, change is the ultimate reality. Climbing ridge routes worn by the passage of many boots, I have often noted massive balanced blocks on neighbouring unclimbed ridges much like Whymper's illustration. Perhaps the passage of five men along such a ridge, with the accompanying dislodgement, undermined whatever delicate balance had held those blocks in place before: Coolidge could have encountered completely different features on the route.

A short steep snow descent from Brèche Lory, a jump across the bergschrund, and we were down on glacier. Dismissing the Dôme de Neige des Écrins as 'not worth it', we trudged off on a softening track into the deepening shadows of the north face. Skirting seracs and jumping crevasses, we slanted down the upper slopes of the Glacier Blanc as the track refroze beneath our crampon points. Evening was drawing in as we traversed to the Col des Écrins but the slope beneath the col faced due west, taking full sun. We carefully swung down the cables, triggering gritty snowslides and dislodging loose rock, to reach a wet snowfield and then delicately traverse along its upper edge. Above us the rock glowed gold.

Slipping and sliding across the remnants of the Glacier de Bonne Pierre, we reached the moraine and stopped to eat the last of our scant chocolate bars, but there was no water, just dirty snow. Thinking we'd find water en route, we set off down the long moraine ridge that led to La Bérarde. We were wrong. As night fell we tottered on for hours by the light of the stars, our headtorches long expired, tortured by the sound of running water in the jumble of moraine debris beneath the ridge, but knowing that once we left the path there was no guarantee of safely regaining it. Conversation had been limited for some time, not only by dry throats but by the tendency to dig into oneself in adversity. We reached the car at midnight, found water, and words:

'Want to sleep in the car?'

'No. Let's go home.'

And in my exhausted state I drove back to the campsite.

It had been a 24-hour day.

For many years I thought of it as an object lesson in how difficulties become compounded, building one upon the other towards an epic. I believe it's now termed 'incident creep'. Then I happened to be

Climbing the north face of the Barre des Écrins, with La Meije in the background.

talking to seasoned alpinist Geoff Cohen, who related an uncannily similar experience of the route. Later I encountered Frank Smythe's account of his ascent in *Mountaineering Holiday*: 'We vowed that it was the most complicated climb that we had ever done, and certainly I cannot recollect a climb of similar character in which so much time was spent in route finding.'

Perhaps in retrospect it would have been better to do the mountain in spring, on ski.

Postscript

In 2011, I returned to the Barre des Écrins with a large party of AC and CC members. We climbed the north face via the Glacier Blanc from the refuge des Écrins. It was easy enough to qualify as a training climb, in that we would be spending time on the highest mountain in the range so the acclimatisation for any other route would be more than useful. Unfortunately, at the Brèche Lory there was quite a queue of climbers starting the narrow ridge to the summit, and a bitter wind. My hands stiffened in the cold. After a brief conference with Paul McWhinney, I settled for the Dôme de Neige and descent whilst the snow was in good condition. It was strangely easy to let go. The bonus was the clutch of fine pictures of the mountain, taken near dawn from the Pic du Glacier d'Arcine that we had climbed en route to the refuge.

4:
Training

It used to be claimed that drinking your way into a hangover was good training for altitude because that was exactly how you would feel. We now know better!

When I started climbing, people just went climbing. That was all the training there was. Now, given the British climate, climbers can spend as much time in the gym and on climbing walls as they do on real rock (perhaps more), so that when the weather finally relents they can climb routes that fulfil their ambitious dreams.

Similarly, the early alpine explorers recognised that training was a sensible preparation for climbing in the Alps. John Tyndall records; 'On Sunday the 5th of August, for the sake of a little training, I ascended the Faulhorn alone … London was still in my brain and the vice of Primrose Hill in my muscles,' and later on the Rhone glacier, 'Here we had three days' training on the glacier and adjacent heights, and on one of the days Lubbock and myself made an attempt upon the Galenstock.' We can only guess at the training they may have undergone at home in Britain, yet extraordinarily fast ascents such as Mummery's first ascent of the Grépon in a day from the valley indicate a level of fitness that has to be based on rigorous foundations. Whymper's walks from London to Oxford are a case in point.

The problem is that alpine climbing is radically different from anything in the UK. For example, it's unlikely that a 10-metre pitch (even if it was Grit) would be taken seriously as a route in an alpine context. So training needs to be different.

The main differences in the Alps are:
1. routes will be longer, much longer
2. altitude affects performance
3. snow and ice are frequent features of routes
4. glaciers
5. rockfall
6. the extremes of heat and cold are greater.

Training to take account of these differences falls into two categories, physical and skill-based.

In physical preparation there's nothing to beat TOF, time on feet; 10- or 12-hour days are frequently required to complete an alpine route, but are rarely the norm in UK hill walking. Bob Thomas of the Chester Mountaineering Club used to complete the Welsh 14 Peaks over 3000ft every June, in sandals with thick wool socks to avoid blisters. He told me his time for the course informed his choice of routes when he went out to Chamonix. Similar training walks include the Lakeland 3000ers, the Three Peaks in Ribblesdale, and the Derwent watershed in the Peak District. Backpacking weekend sections of the Pennine Way can add the element of load-carrying to the training programme.

Scrambling over the Pinnacles on the Crib Goch section of the Snowdon Horseshoe, a fine training route.

It helps to weigh the contents of your alpine rucksack and make sure that a comparable load is carried out on the hill in the months preceding an alpine trip. However, carrying heavy rucksacks can result in joint damage on jarring descents. One way of avoiding this on training walks is to carry several litres of water uphill (1 litre = 1kg), then pour it all away for the descent; another way is to make use of walking poles.

Weekends in the hills have to be supplemented by regular daily training during the working week. I began running when first training for the Alps and quickly grew to love it, although now my knees won't take even one run a week so cycling has taken over instead. An evening on a climbing wall and another in the gym just for a bit of variety, and I have a reasonably balanced programme. Of course the wall and gym should give way to evenings out on a local crag as the days lengthen if that's possible. The important thing is to do what works for you but to try to get some real exercise every day. Sex may raise your pulse rate but it doesn't count.

Fitness may help with acclimatisation to altitude but everyone is different: you can only listen to what your body is telling you. In the Greater Ranges the advice is to only gain 500m per day, yet in the Alps climbing usually takes place around 3–4000m whilst valley campsites are generally 1000–1800m. One way around this is to spend more time in huts between 2000 and 3000m; two or three routes can be climbed from the same hut, or a traverse made from hut to hut, helping acclimatisation and saving time on walk-ins.

Dehydration is a major factor in altitude illness, and it has always been a ritual on gaining a hut to settle down to the steady consumption of brews. Carrying two or more litres of water, as one might on British hills, taking a sip from a tube on demand, is a luxury that the alpinist cannot afford. Pacing oneself so as not to sweat too much and training the body to need less water is worth trying during the lead-in to an alpine trip. A mountain instructor I used to work with trained his body to make do with just one piece of fruit during a mountain day and no water at all.

Long days mean food rationing as well, so the body needs similar training to work with several smaller nibbles rather than a big lunch; there's always a decent meal waiting back at the hut or down in the valley.

Most alpine routes involve a very early start to take advantage of the well-frozen surface at night. This can be a trial for the habitual late riser whose metabolism only really gets into gear by mid-morning. Again training can help. In the months before an alpine trip I used to get up earlier and take the dog for a longer walk than usual: not much fun in the dark days of winter, but inspiring on a beautiful spring morning. Some people run in the quiet of early mornings or cycle to work and take full advantage of flexi-time. Of course that means going to bed earlier so there needs to be some adjustment of social life!

Turning to skills, like TOF, there's nothing like 'climbing miles'. During the Easter holiday before my first trip to Chamonix I climbed all the Hard Severes on Shepherd's Crag in 'big boots'. I recall Ardus and Scorpion being quite challenging. A lot of British routes tend to be single pitch and short, so are not ideal training: ten routes on Stanage can leave you with less than 200m climbed. The single-pitch routes may be hard but they are also low, so more gear needs to be placed to avoid a groundfall. For the Alps it's no good climbing hard if you can't climb fast, and that means confidently enough to place minimal protection. Frank Smythe put it in a nutshell in 1929: 'much of the technique acquired on English and Welsh crags had to be unlearnt in the Alps where the slow deliberate movements of the home-trained cragsman are of little avail, and where the watchword is "speed, speed, and yet more speed"'.

It's sensible to drop a technical grade when choosing an alpine route, but also possible to train with long mountaineering days in the UK, linking routes from crag to crag while making your way to a summit and perhaps using only the same half-dozen or so nuts that you would in the Alps. The Ogwen Valley has good examples of such combinations like Tennis Shoe, then Lazarus and Groove Above on Idwal Slabs, a traverse over to Glyder Fawr for Grey Slab, then up to Clogwyn Du for Manx Wall, finishing off over the Glyders with a descent of Bristly Rib. Zig Zag on the Gribin Facet followed by Sub-Cneifion Rib and Cneifion Arête is an easier combination. In the Lakes I recall a fine day with my son before his first alpine season when we scrambled up Sour Milk Gill before climbing Gillercoombe Buttress and finishing the day with Engineers Slab on Gable. There are lots of possibilities, and for days of less settled weather it's worth trying routes like Flying Buttress in Llanberis Pass or Central Arête on Glyder Fawr, moving together as much as possible.

Clocking climbing miles in the evenings may involve continuous traversing on indoor bouldering walls, but I used to prefer soloing up and down routes on crags like Windgather in the Peak: down-climbing is, of course, another skill to practise.

And then there's snow.

Ice axe and crampon skills are vital in the Alps, but there is little opportunity to practise those skills in the UK. Much is made of Scotland as a training ground, but there are many trusting souls who have turned up for a hard-earned week in Scotland only to find horizontal rain or the sort of wind that

blows them off their feet on the tops. It has been argued that even in appalling weather it is possible to climb in Scotland, but that's not necessarily good training. There are so many escape routes with a road, even a pub, within a relatively short walk that climbers (particularly those who have driven 500 miles for a weekend's climbing) can develop the idea that they can get away with risking bad weather and poor conditions in the mountains. This may be true of Scotland, but it can encourage a certain bloody-mindedness that sometimes gets British climbers killed or crippled in the Alps. There's nothing wrong with backing off: as Don Whillans said, 'The mountains will be there next year; the trick is to make sure that you are.'

Given the availability of cheap flights and the relative reliability of alpine conditions it probably makes more sense to head for the Alps for some icefall climbing in winter, or simply factor in some time for practising on glaciers (even a short course) when planning a summer trip. That way Scottish winter climbing could be valued for its own sake on its own terms. If ever there is good snowfall in the UK, however, it is worth finding a suitable slope with a safe run-out to practise ice axe self-arrest.

The one thing well-nigh impossible to practise in Britain is crevasse rescue, for the blindingly obvious reason that we don't have any crevasses. By all means study the theory and diagrams, even set up pulley systems on the flat – but the reality is different. Most climbers operate as pairs, so on a glacier the likelihood of the belayer being able to set up a pulley system while holding a fallen partner is remote. When snow bridges collapse, snow conditions are usually poor and ice rotten. The bottom line is that anyone who falls in must expect to set prusiks to climb out and be grateful that their partner is holding them. Anything else, like a loop of rope with a ropeman or micro-traxion on it, is a bonus. To that end it's worth setting up a rope from a beam in a hall or on a bridge or tree branch in order to practise prusiking. If nothing else it will impress upon a climber the difficulty of the process and encourage a greater wariness where crevasses are concerned.

In *On High Hills* (1926), G. W. Young remarks:

> Climbing is not merely getting up rocks with hands and feet. A good climber must certainly be able to do that. But he must hold at the same time a slippery axe. Also a coil of rope, which he lets in or out as the man ahead may require, irrespective of his own motions at the moment. He must keep perpetually moving at equidistance from the men moving above and below him, watch that neither rope catches, use a changing variety of hand- and foot-holds to the best advantage, and observe, simultaneously, where the man ahead sets hand or foot, so as to lose no time in a fresh search for his own. He must be safe for himself in every movement and at every pause, but also safe for that extra margin which he will need if someone else slips or needs help. These are primary qualifications. For high mountaineering of moderate difficulty, he will need some dozen others; including an eye for country, for angle and for weather, a right economy of effort, and an exact knowledge of himself. For really severe rocks, where only one man moves at a time, a new code has to be mastered; and yet another for ice, and another for snow. The joy of the mountains is a matter of atmosphere and individual temperament; we are not all born with the kind of imagination that can convert it to our health and pleasure. But the joy of climbing is easier for us all to understand. It is the joy of physical self-expression … united to that finer pleasure, the cumulative joy of good combined play.

Clearly there is much to be learnt, so finally, before embarking on any training programme, I would refer a beginner to one or more of the good technical manuals that are available and suggest joining a club or taking a course of professional tuition for practical experience.

Young British climbers are particularly favoured with regard to courses. The Conville Trust funds, in memory of Jonathan Conville, training courses that are organised by Plas y Brenin National Mountain Centre. The Eagle Ski Club awards grants to young skiers who wish to attend training courses in ski-mountaineering. The Austrian Alpine Club, Britannia section, awards grants of up to 50 per cent of the cost of a training course organised by the club, and supports activities arranged by members with a training element, both in alpine climbing and ski-mountaineering.

5:
From Chamonix to Zermatt

For the rest of the eighties, despite repeated visits to Chamonix, the nearest I came to another 4000m summit was in 1986, when Rick Ayres and I attempted the Frontier ridge of Mont Maudit. I'd joined the Chester Mountaineering Club, and agreed to team up with Rick for a two-week trip to Chamonix; he was a fellow teacher heavily involved with the army cadet force at his school, and keen as mustard. We'd acclimatised, after a fashion, with an ascent of the Frendo Spur in less than ideal conditions that involved a bivouac at the top of the initial ramp and another at the deserted Midi cablecar station late the following evening.

Then we were ready for Mont Maudit. Viewed from the télécabines to Point Hellbronner, the Frontier Ridge snakes up from rock pinnacles around the Fourche to the distant summit tooth in a great arc above the vast cliffs and couloirs of the south-east face of the mountain. It has to be the route of choice for an ascent.

Rick and I traversed through the lengthening shadows around the base of the Tour Ronde into Cirque Maudit. The Trident hut was involved in one of its periodic attempts to plunge itself onto the glacier below, so it was the further Fourche bivouac hut that we made for, climbing a 65° snow slope to gain the ridge.

Rick marched to the door and stuck his head into the hut. A slight fug drifted out as he did so, but not for long. He turned on his heel and slammed the door.

'What's up?' I asked with dawning apprehension.

'The bugger's full,' he replied in clipped military accents.

'What, completely? Can't they make room?' I wavered, aware that we were not equipped for an open bivouac.

'Not a chance.'

So without even a blanket we crouched shivering under the alpenglow, brewing up in what little shelter we could find on our scrappy ledge. The ridge filled up around us with others in similar positions. One young woman arrived and immediately stripped off her sweat-soaked T-shirt to replace it with a dry one. I don't know whether I was more taken aback by her hardening nipples or the expanse of gooseflesh. There was no question of sleep, and when a mischievous breeze began sliding icy fingers into the chinks of our clothing at around 2 a.m. we packed up and set off.

Route-finding was the least of our worries as we trod the white edge of darkness, switching from one side of the ridge to the other for the easiest line. At one point we followed tracks down under the cornice into an ice half-pipe. This offered a smooth-walled gallery, gleaming with reflected torchlight and clouded by our breath, along which we traversed before climbing back out onto the crest again.

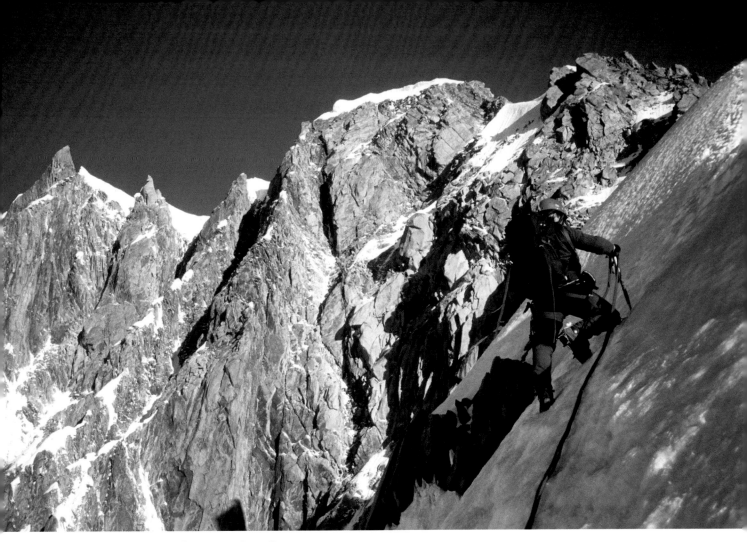

The frontier ridge of Mont Maudit, Kuffner route.

The rock glittered with frost but we made good time as the snow gradually became tinged with the same shade of rose as the cloud filling the valleys.

The climbing was continuously interesting and the views across the Brenva glacier basin superb, but the traverse around the Pointe de l'Androsace proved more testing than expected. The ridge rose to a thin fin of snow, then dropped to the base of the tower where a precarious traverse crossed snow and rock ribs to reach a narrow col beyond. We studiously ignored the insistent presence of the void below.

Above, the sun hit us hard and on steep mixed ground I found myself wishing for a more aggressively angled ice axe as the pick repeatedly pulled out of softening snow when weighted. The sudden jerk and catch at balance was as unnerving as it was wearing, particularly when crampon front points had to be kicked in hard to find purchase in the ice under the melting snow. We slowed noticeably, but toiled on in the heat.

It's a long ridge and with barely a week in Chamonix we were far from acclimatised. Emerging onto the final slopes we could see the traverse track down to the Aiguille du Midi just below us.

A quick calculation revealed that we'd be cutting it fine to make the cable car.

'What do you think?'

'Not keen on another night in the Midi toilets.'

'Mmm … strange that that's the only place in the complex with a heater.'

We traversed off without ever reaching the summit.

No, at that time 4000m peaks were not really on the agenda; it was routes that mattered rather than any particular peaks, and Rebuffat's 100 best routes in particular.

All that changed in 1990. I'd been climbing with Denis Mitchell in Chamonix for some years and we both had a yen for pastures new. Denis's shock of white hair belied his years and an extraordinary level of fitness. He didn't think of himself as a particularly good rock-climber – ice was more his forte – but on the mountain he was absolutely sound. I'd been told his hair turned white quite suddenly during the course of his divorce, but we never talked about it. His ex-wife, the much-married Marian – Elmes as she was then, Parsons as she is now – was a fellow member of the Chester Mountaineering Club who had recently joined the Alpine Club (cf. the thrice-married Lizzie le Blond who had founded the Ladies Alpine Club in 1907.) It was Marian who had initially broached the idea of climbing all the 4000m mountains to us and recommended joining the Alpine Club. We decided to see what Zermatt and the AC had to offer.

We camped at Attermenzen, above Randa, where cars could unload our kit more easily than in pedestrianised Zermatt. It was an open sunny campsite, walking distance from the railway station at Täsch, although that distance seemed to draw out like the shadows at the end of a long day on the hill.

Zermatt itself was exclusive, and it was not just the train-only access that buttressed that exclusivity. Designer clothes shops and jewellers displayed price tags that were obviously aimed at the fur coats that walked the evening streets to smart restaurants or took the horse-drawn taxi option, rather than the likes of us. The town had long outgrown John Ball's description after an early 19th-century visit: 'a crowded assemblage of dank, dirty-looking wooden houses'. Climbing up from the station, despite the occasional gently steaming piles of horse dung, the dominant impression was of cleanliness. Neat, narrow streets of scrubbed, dark-wood houses with tidy window boxes solid with verdant reds and oranges on one side competed with purples and yellows on another. Modernist sculpture lurked on street corners, while chapel spires impaled a cobalt sky with copper-green needles; and always, rounding a corner, the sheer surprise of the impossible Matterhorn, thrust like a spearhead skyward. Around the paths out of town, locals still made hay on tiny mountain fields and tended vegetable gardens; rural roots that reasserted themselves when flocks of sheep and goats were driven through the town centre from one pasture to another, somewhat to the consternation of fashionable strollers, side-stepping the droppings.

Zinalrothorn, 4221m. South-East Ridge: AD

Mountaineering around Zermatt is virtually impossible without climbing 4000m mountains; the place is stiff with them and, with his usual attention to detail, Denis had arrived with a hit list. First on that list was the Zinalrothorn.

A five-hour hut walk of 1700m led up through the scenic Trift Gorge to the Trift Hotel, then through sun-baked pastures to the northern moraine of the Trift glacier. We were glad to slake our thirst at meltwater streams that threaded the pastures in the heat of the afternoon. Sheep had climbed up to old snowfields amongst the moraine to lie there panting until the cold, striking up from below, had revitalised them enough to lick up the trickles of water and graze sparse grass at the margins, their feet still planted on the slushy ice. Above them, brilliant blue gentians dotted dusty moraine ridges.

The hut was at 3198m and, whether it was the altitude or the heat, Denis and I both ate sparingly and went to bed with headaches. Reluctant to waste the effort of gaining the hut, and feeling a little better next morning, we headed off after the other early risers for the south-east ridge of the Zinalrothorn. Taking the lower snow slopes and rocky ribs at a steady pace, we reached the Schneegrat and had the

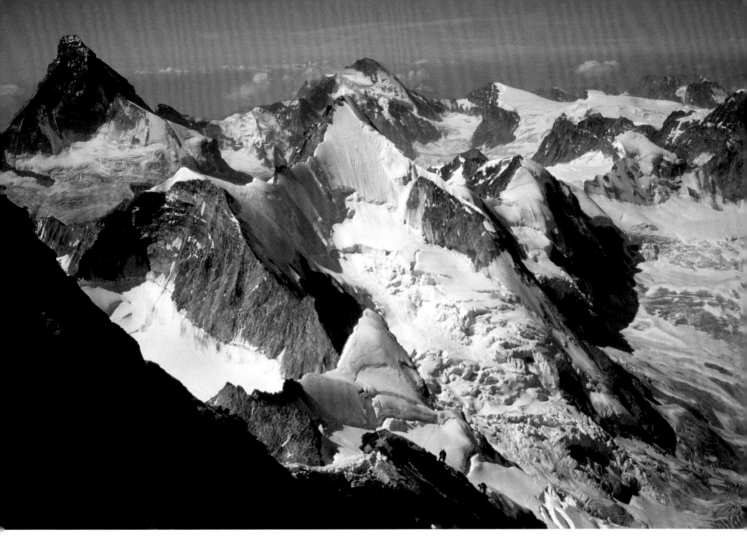

On the south-east ridge of the Zinalrothorn, with the Obergabelhorn and Matterhorn in the background.

presence of mind to take photos of the summit rock pyramid ahead. Some easy climbing on the ridge led to a loose traverse across the south face to gain the Gable Notch on the south-west ridge where solid gneiss meant the climbing became more interesting. The exposed cracks of the Biner Slab were equipped with a couple of pegs, and absorbing climbing meant we forgot our headaches as Denis led up to a platform then on over the foresummit to the summit cross.

Denis smiles broadly in my summit photograph with the Dent Blanche in the background and, away in the distance, the familiar profile of Mont Blanc. We nibbled lunch, sipped water, let the sunshine dry the sweat from our backs, recoiled the rope and felt the headaches subside. Then it was time to descend. I looked down past climbers on the Biner slab towards the Obergabelhorn, our proposed route for the next day; beyond lay the Col de Valpelline and the great ridge linking the Dent d'Hérens to the Matterhorn.

Careful down-climbing led to an abseil from the Gable Notch, and we scrambled back across the south face to the Schneegrat. From there the descent was easy – or would have been had it not been for our pounding heads. Dehydration was amplifying our altitude illness, and every step was like a blow to the base of the skull. We both repeatedly ground to a halt and sat with our heads in our hands, doubled over with pain until it lessened enough to go on.

Eventually we reached the hut, ordered *teewasser*, and felt a little better after drinking. We relaxed on the hut terrace, sunning ourselves and trying to decide whether to stay for another night and an attempt on the Obergabelhorn or to descend to Zermatt. Long drop toilets were situated behind latched doors at one end of the terrace and I needed to pay a visit. The wooden-hole seats had handled socket-lids that were removed for use. Afterwards, as I walked back down the terrace to rejoin Denis, I

was aware of a nagging sense of having forgotten something: something was wrong. Then I realised. I was still holding the toilet lid like a shield as I approached the crowded terrace. That was enough to convince both of us: we went down.

Alphubel, 4206m. Traverse South-East and North Ridges: PD

A rest day spent swimming with the children at a nearby lake, and we were ready for the walk up from Täschalp to the Täschhorn hut. It was short at only one and a half hours, but that suited me as I'd developed some nasty blisters on the descent from the Rothorn in my new plastic boots; these were the days before Compeed, and I was walking with plaster-taped feet. Our objective was to traverse the Alphubel, spend the night at the Mischabeljoch bivouac hut, then continue the traverse over the Täschhorn and Dom.

Denis and I left the hut around 4 next morning for the long, dark walk up moraine debris to the glacier. Once on the ice, we gained the Alphubeljoch easily, skirting a few crevasses and emerging into the sunlight. We then turned north to climb the south-east ridge that snaked up, with minimal cornicing, to an easy rock band at the foot of the summit dome. From there a steeper snow-slope led to the summit plateau, accompanied by heavy breathing and headaches on my part. Quickly over the main summit at 4208m, we headed for Point 4128m at the north-east corner of the summit plateau and the start of the north ridge.

Cloud was swirling in as we started the descent, as if to flag the seriousness of the route. None of the rock looked substantial enough to offer a belay. We kept mostly to the right of the crest, looking down, and moved delicately from loose rock to ice to snow and back repeatedly and with extreme care; there was nothing to arrest a slide down the east flank to the gaping crevasses far below except the remote possibility that flinging oneself onto the other side of the ridge would counterbalance a partner's fall. Unfortunately most of the ridge was far too blunt to encourage much faith in that tactic, and at one point we seriously considered unroping so that if one fell the other would not be dragged off too. After a tense hour we reached the Mischabeljoch and were soon melting snow for drinks in the bivouac hut on the col.

There was a party of four other climbers in residence, but with a hut capacity of ten we were assured of a bed space. This sense of relief added to that following our safe descent of the north ridge and the relaxation, so marked after long hours of exercise, produced a lazy feeling of well-being that was almost audible in the quiet mutter of the stove.

'Ah! Il tombe!' a Swiss woman cried, and the feeling was gone.

As our heads snapped around towards the ridge where she was pointing, the ridge that we had just descended, I caught a brief blur of movement in the corner of my eye, then it was gone. The woman was clearly distressed and one of her team told us she had seen one person slip and pull the other off.

Just as we were getting our things together to traverse over to the slope down which they had fallen, Victor Imboden, a local guide, arrived with the rest of his party. He went straight to the emergency radio and argued desperately and at length to persuade the helicopter service to fly out on a rescue. The problem was that while the cloud was broken with good spells of sunshine at our altitude, a temperature inversion meant the valleys were solid with fog. Helicopter pilots fly by line of

sight and with all the electricity pylons and cables around it was just not safe for them to take off in those conditions.

Later that afternoon we heard the rattling whirr of rotors, and the chopper appeared flying low over the glacier. They were guided to the right crevasse and lowered the winchman repeatedly into the depths before the helicopter flew back towards Saas Fee and Victor and his team left for the valley. It was only later that we learnt both men had died but that only one body could be recovered. I guessed that the other had fallen too fast and too deep, so had been wedged far too firmly in the bowels of the glacier. The thought of that body's lonely ice journey, decades long, from here to its emergence at the glacier snout provoked a shiver. It brought to mind my first visit to Chamonix in 1981. As we practised ice-climbing at the snout of the Bossons glacier, Stuart, with his background of Welsh winter climbing, had found 'sheep bones' that we slowly recognised as a skeletal hand.

Meanwhile the hut had been filling up … to overflowing. There were 12, then more arrived and prepared to bivouac outside; a party of 5 French people arrived who were just planning to overnight before returning to the valley, taking numbers to 20. A guide told them to go back down; they had time and there was just no room for them. They argued, then ignored him, but had to accept that they could only sit on the few chairs or the floor. Later, three Dutch who'd tried bivvying but couldn't take the cold came in to join them, sit around talking all night, then crowd the breakfast table. I woke repeatedly with the noise and heat, suffering from a parched throat.

Täschhorn, 4490m – Dom, 4545m. Traverse S.-N.: AD

At breakfast in the random shadows cast by headtorches, we elbowed enough room for our stove to provide a couple of brews on its last dregs of gas while the midnight talkers crawled away into our vacated bed-spaces. We had risked a small gamble in taking just a mini gas canister for our stove, and it was touch and go whether it would last out breakfast. But it did, and our spirits rose disproportionately at this little victory.

Outside in the chill dawn air, we climbed quickly up loose rocks on the flank of the col to gain the Mischabelgrat and the growing warmth of the new gold light. There was little snow on the transfigured eastern rocks, enriched with colour and pinpoint definition, rising to a wave of white cornice at a shoulder below the Täschhorn summit. Yet all the western flank was lost in a grey obscurity that sank down the Weingarten glacier and filled the valley where my children were still sleeping. Traversing that wave-crest of snow proved a delicate and airy passage, but then we were scrambling up the easy rocks to the summit at 4490m. It was 9 a.m.

We looked down on the Alphubel and its treacherous north ridge while beyond, to the south, the Allalinhorn, Rimpfischhorn and Strahlhorn nodded to us over each other's shoulders. Zermatt still lay in shadow, but to the south-west Nordend and the Dufourspitze jostled the outline of Monte Rosa into uncertainty before the frontier ridge unreeled from Lyskam over Castor, Pollux and all the summits of the Breithorn to the tiny afterthought that is the Kleine Matterhorn. Across the valley to the west was our friend the Zinalrothorn, and north of it the Weisshorn, which had nudged its south face into our pictures on the upper Rothorngrat, and now revealed the turrets and battlements of its north ridge in profile. Amongst them all the ever-present Matterhorn stood like some gigantic gnomon, casting a huge shadow, less useful for telling the time than for orientating our mental map

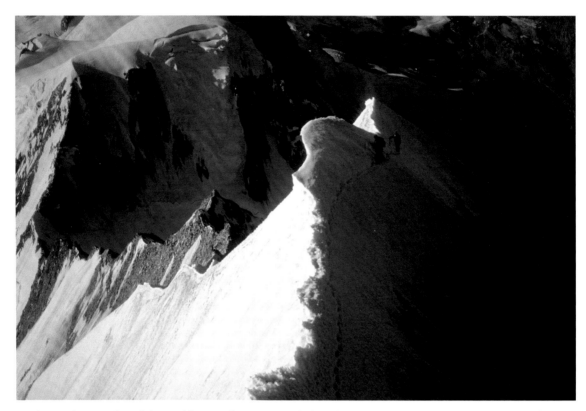

On the south-east ridge of the Täschhorn at the snow crest below the summit. The treacherous north ridge of the Alphubel on the left in the background.

of these mountains. I was beginning to realise that every ascent of one of these giants offered a better acquaintance with its neighbours, an incremental awareness of their different aspects and moods, a growing relationship so that some day they might become old friends. I hoped not old enemies; they were far too beautiful for that.

Writing of the Alps in 1926, G. W. Young takes this sense of a relationship further when he considers its effect upon the climber:

> there is no better instructor than a mountain. Its beauty, its difficulty, its lively suggestion of great and hidden forces, and its never-failing surprise above us, delight and provoke anew our restless spirit of enterprise. A mountain answers to our need for something big solid and worthwhile, against which to measure and discipline our own strength. At the same time, its mystery, its presentation of a natural order more enduring than our own, can provide our instinct of reverence or our craving for belief with images or symbols of every degree or quality of the super-natural.
> (*On High Hills*)

We spent half an hour appreciating the full magnitude of the scene, enjoying the sun and chatting to a guided Dutch couple. They had seemed perfectly competent alpinists, yet were paying for a guide.

Tactlessly, I asked them why, but the guide didn't take offence. They said: 'It is simply that we never get lost that way. We do the routes in guidebook times and never have to worry about running into problems. We only have two weeks holiday every year and we want to enjoy them, want to make sure we climb the routes we want to climb.' It seemed fair enough, but I was pursued by a nagging feeling that somewhere they'd missed the point. Perhaps it was an echo of Winthrop Young's comment;

'There is nothing of permanent value for our lives to be found ready-made and reach-me-down in mountain-climbing, any more than in our other avocations or lasting pursuits.'

They followed Denis and me as we left the summit, soloing down the narrow rock ridge to the snow saddle at the Domjoch, and managing to keep up until the exposed pitch that finally prompted us to rope up again. From then on they fell steadily behind and we never saw them again.

There was as little snow on the Domgrat ahead as there had been on the descent to the Domjoch. The guidebook indicated that this qualified as 'good conditions,' but as holds repeatedly came away in my hands to be tossed towards the distant glacier, I wondered if it would be safer to climb when this rubble was solidly cemented by ice. The ridge was an exposed scramble over several steps, some bristling with pinnacles, but cloud had rolled in just after we left the Domjoch so we had little idea of our progress. There were times when we seemed trapped on a treadmill of crumbling rock held in a grey bubble, and the headaches came to trouble us again. We bumped up against the summit buttress and puzzled dully over the correct line until finally a pitch of good rock landed us beneath the Dom's summit cross – the highest peak wholly in Switzerland.

An Austrian soloist was there before us. He had been forced to bivouac outside the Mischabeljoch hut with nothing in the way of bivouac gear, owing to the overcrowding, and had left much earlier just to keep warm. He told us, 'I had been planning to go on to the Lenzspitze, perhaps the Nadelhorn, but not in this weather.' The picture he took shows both Denis and me grinning ruefully in the viewless murk. We descended easy snow slopes to the north-east, winding around crevasses to cross the Hohberggletscher and reach the Festijoch. Just once we caught a glimpse of the summit through

The author with Denis Mitchell in the 'viewless murk' at the summit of the Dom.

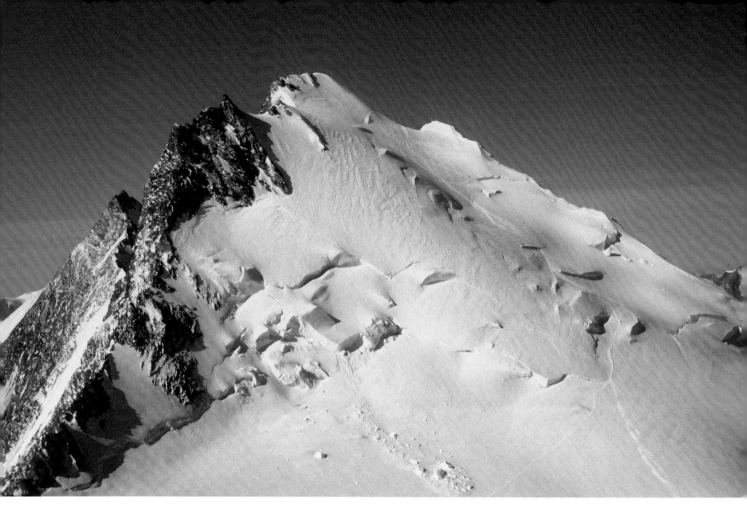

The north face of the Dom.

ragged clouds before the clammy curtains closed again. A very tatty piece of abseil tat offered an anchor to rope down onto the lower Festi glacier from the joch, but we were just too tired to hunt about for an alternative. At least the abseil was short. By then my blisters, which had started to hurt on the Domgrat, were settling into a steady throb. Crevasses turned out to be worse than expected on the Festigletscher, and we came upon a 'halfway' tent pitched on the lower snow slopes. It was a long trudge down to the Dom hut.

Reaching the hut, Denis ordered a couple of celebratory beers. I was surprised; 'That's not like you.' He was notoriously mean with his money.

For answer he pointed out the phrase in the guidebook: 'one of the finest expeditions in the Pennine Alps'. His usual taciturnity gave way to a curiously emphatic form of expression weighted with a residual Weardale accent that burst through whenever he was wound up enough to give vent to his feelings; 'You know, that route, that traverse, it's first class, that … I've been wanting to do that route for a long time.'

I examined my feet: the tape was in twisted shreds that I peeled off to reveal the flesh beneath, wet and raw. I cooled them in the icy water of the washing trough while a skinny Swiss lad arrived, stripped naked and flannelled himself down. A young Amazon who was refilling her water bottle from the feeder spring ignored the Swiss lad but glanced at my feet and started, shock written all over her face. It was a five-hour walk up to the hut and in my condition probably the same in descent. I decided to stop the night, give my feet, boots and socks a chance to dry out, then descend in the morning – damn the expense! Denis walked down alone.

Weisshorn 4505m. Traverse North Ridge (over Bishorn 4153m) – East Ridge: AD

Charlie Kenwright was another Chester MC member who had elected to join us that summer, and when I arrived back at the campsite, there he was with his family. Denis had his sights set on the Weisshorn traverse so it seemed sensible to offer Charlie a chance to accompany us on the Bishorn, just 4000m, to get some acclimatisation: the fact that he could thus give us a lift over to Zinal for the four-hour walk up to the Tracuit hut had, of course, nothing to do with it – or rather, if it did Charlie knew the score.

The sun burnt down on us as we climbed up the well-marked track with the west face of the Weisshorn and the saw-toothed profile of the north ridge a growing challenge above us. I was glad to have decided that from then on I would make all hut walks in trainers, even if it meant carrying them on the mountain as in the case of traverse routes. It had taken several days for my last crop of blisters to come close to healing, and I was soon to abandon plastic boots for alpine climbing despite Denis's enthusiasm for them. Perhaps I just have sweatier feet than him.

We arrived at the Tracuit hut on a Saturday and it was crowded for the week-end. At first we were simply told that we would have to sleep on the floor, but then the guardian relented and found us bed-spaces. The slopes below the hut were haunted by chamois, unafraid of the tourists whose clattering and chattering declared they were obviously not hunters, whilst in the sky above us parapenters were spinning and wheeling in great arcs, sometimes swooping low over the hut with a sputtering of wind-rattled parachute fabric. To the south the Zinalrothorn rose like a rhinoceros horn from the snowy junction of its two northerly ridges, silhouetted against a billowing outpouring of cumulus in an otherwise clear blue sky. An expanse of crevassed glacier spread like a wave-broken sea between the hut and the bright west face of the Bishorn.

We left the hut at 3 a.m., and after three hours of plodding up increasingly steep slopes reached the summit. I'm afraid we did not give sufficient mind to the Bishorn, regarding it as simply a stepping stone (albeit a 4000m one) to the north ridge and traverse of the Weisshorn. In revenge the Bishorn delivered far more and far larger crevasses than expected, so that we soon had to rope up to thread our way through the maze of ice. The original plan had been for Charlie to return to the hut alone, but even with daylight to enhance crevasse-spotting, he changed his mind and decided to wait for other parties to make their ascents so that he could descend in their company.

The Weisshorn summit is almost directly south of the Bishorn main summit, but the ridge between them curves slightly west to reveal more of its rugged profile and east face. This was suddenly illuminated by the rising sun, washed in a ruddy gold, as Denis and I began our descent of the Bishorn's brief south ridge. A sinuous snow arête led up to a shoulder of rock, and from there the sharp rock crest continued over pinnacles and towers to the Grand Gendarme, with the flanks of the ridge falling sheer on either side. The climbing was not much more than grade III, but we roped down a couple of the more precipitous towers; it seemed churlish to ignore the abseil anchors.

Reaching the Grand Gendarme, I misread the guidebook and missed the III+ chimney. I found myself hung up on a wall, the fingers of each hand alternately feeling their way over the rock like a braille reader, in search of a key hold that would decipher the riddle. Denis, at the belay, had realised that my words to him were becoming increasingly incoherent, and suddenly burst out:

Traversing one of the gendarmes on the north ridge of the Weisshorn.

'For God's sake get back down here and get something to eat and drink: you're like a clockwork soldier running down! Just moving in slow motion!'

He was right. We had been going for nine hours, continuously over 4000m for most of that time, and without a break for food or drink: my blood sugar levels must have plummeted. He was not feeling much better himself, but had had the presence of mind to recognise that I was worse, and to foresee the probable consequences of not taking any action. I have always looked back on this episode as an object lesson for a good alpine climbing partner. At altitude you need to look out for your partner as well as yourself. They may be drifting into Acute Mountain Sickness without realising it and you can easily miss the tell-tale signs if you are absorbed in your own sufferings.

Unlike the alpine pioneers who often climbed in parties of three or more, modern climbers usually climb as a pair. As such they must keep their distance to maximise the security afforded by the rope. That distance means there is little opportunity for chatting. Communication is pared down to the essential: for hours a pair will be climbing something like ten metres apart with only the essential advice or instruction shouted above the wind, and the rasping of one's own breathing, or the occasional muttered curse. So it is vital to develop a sensitivity about how your partner is going based on non-verbal clues sometimes as vague as the 'vibe' flowing down the rope to you.

Beyond that, it is good judgement that can decide upon an appropriate course of action and the language that will be successful in securing co-operation. G. W. Young comments on a similar situation: 'the only remedy is to soothe or to startle. The first was impracticable in our situation. I spoke sharply in reproach, but without raising my voice. The experiment succeeded surprisingly. Self-control returned upon the instant.'

Denis and I took a break, ate, drank and rested, while another team passed us, taking the elusive chimney. We followed, to gain the summit of the Grand Gendarme and the snow arête beyond. After that it was just a question of placing one foot after the other into the steps that neatly threaded along the narrow crest of snow as we climbed still higher.

Departing from the summit of the Weisshorn.

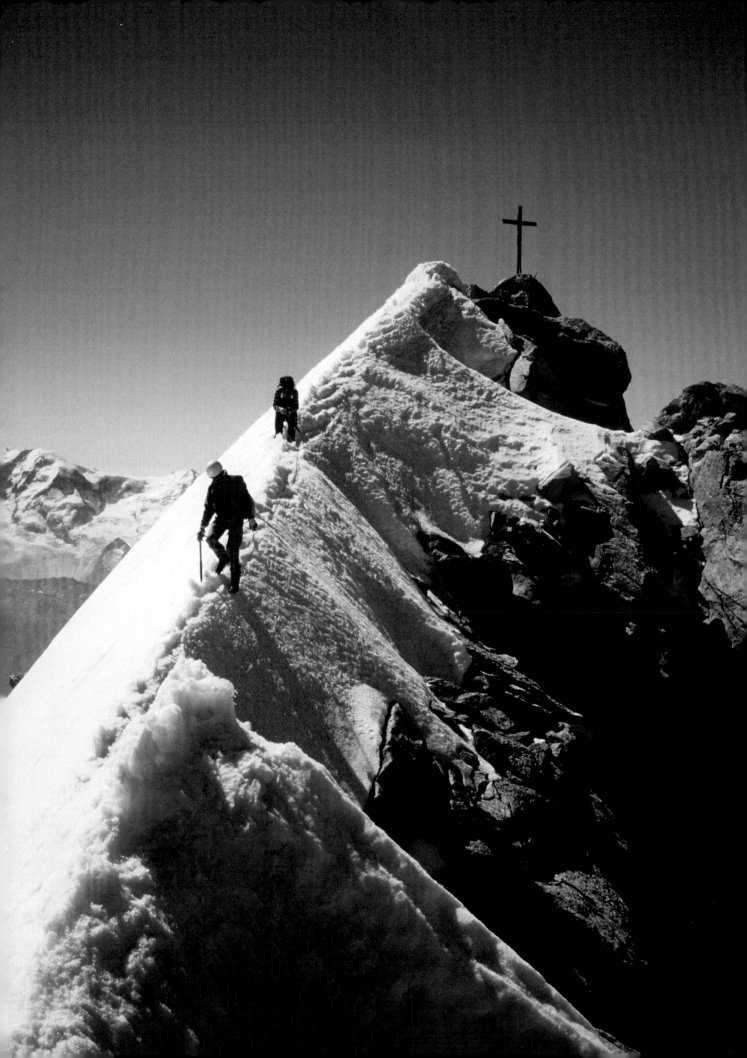

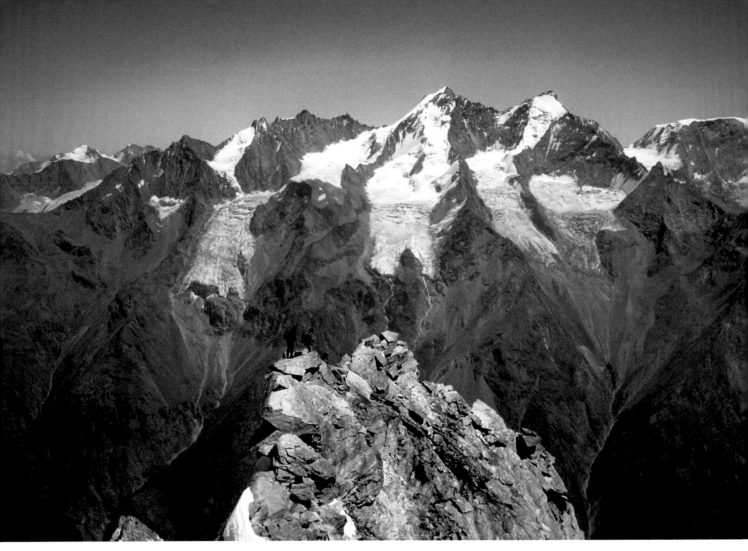

Descending the east ridge of the Weisshorn, with the Dom and Täschhorn prominent in the background.

Denis has a way of coping with altitude: he engages a lower gear and just continues to plod rhythmically on. Now whether I have longer legs or a different rhythm, I don't know, but whatever the reason I found myself repeatedly catching up. I would be staring in fixed concentration upon my boots, trying to avoid tripping over my crampon front-points, trying to ignore the depths of space on either side, trying to make sure the rope between us was not too slack, when Denis's heels would intrude into my field of vision. I would slow and the heels would retreat for a few minutes, then reappear again. Anxiety about losing my rhythm began to feed irritation, tension, tetchiness. We crossed a shrunken shoulder of rock and snow and I glanced up to see the summit close ahead. The tension evaporated in laughter:

'Bloody hell, Denis, I don't know how you do it! I just can't walk as slow as you no matter how hard I try!'

When he turned with a half-smile, I realised how easily this comment could have been received differently. We swopped the lead and he took a picture of me with the other team in the background just leaving the summit.

The summit, at the apex of three elegant ridges and sweeping snowy faces, was very beautiful. The crystal clarity of the air seemed to be annihilating the miles between mountains. Denis reckoned he could make out the Ötztal peaks to the north. Mont Blanc seemed so close and beyond, surely those were the Écrins peaks away to the south. We busied our hands with food and ropes while brooding on distance, until new arrivals made us realise we had had the summit to ourselves for half an hour that had seemed but a few minutes.

Soft snow on the south-east arête made for an awkward, slippery descent, so that we were relieved to gain the rocks of the lower ridge. Airy and interesting down-climbing with two abseils led into a rubble couloir that we quickly left for an improving path down the rocky spur bounding the right bank of the couloir. We reached the Weisshorn hut at 3 p.m., only to find they were out of beer. A soft drink and a rest, drying out our feet and boots in the sun, then we were off down the path to Randa, with me now failing to keep up with Denis in the thickening air.

Obergabelhorn, 4063m. North-East Ridge: AD

A couple of days of rain accompanied Denis's departure, but then it cleared and Charlie and I laid plans for the Obergabelhorn. We made a day of the walk to the Rothorn hut by including our families in the first part up to the Trift Hotel. The Trift gorge roared with its accumulated rainwater, and my children seemed to get on well with Charlie's daughters: they were too engrossed in their play for any drama when we left them with their mothers, to descend without us.

The streams that had threaded the high pasture were now swollen with rainfall run-off and much more melt-water. We crossed them, leaping from stone to stone or water-logged gravel island. The sheep had abandoned what was left of the late snow patches. At the hut I managed not to embarrass myself with the toilets this time, but we were trapped all night with a snorer who must have shaken the very foundations of the building.

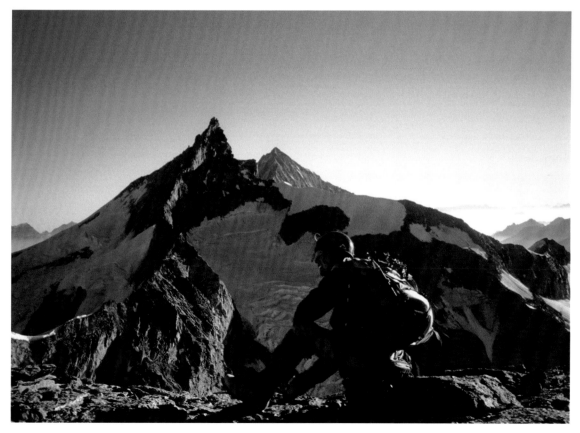

The Zinalrothorn from the Wellenkuppe.

We left the hut at 5 the next morning to traverse the upper Trift glacier south and reach the Wellenkuppe just after dawn via some interesting final rock pitches. The Rothorngrat was defined by a red ribbon of light all the way to the summit while the Weisshorn peered over the shoulder of the Schneegrat. In the violet distance a sea of cloud lapped against the lower slopes of the mountains. We climbed up the short snow ridge to the Wellenkuppe summit, at 3903m not far short of the Obergabelhorn's 4062m, but with a significant saddle between.

Descending the sloping snow plateau to that broad saddle, we then climbed the narrowing snow ridge to the Grand Gendarme. Fortunately fixed ropes assisted our ascent of that shining pillar as it was far too cold for bare fingers to be in contact with rock for long in the bitter north-easterly that was blowing. The steepening summit ridge beyond proved delicate, with fresh snow over ice alternating with unconsolidated sugar snow. On the left the ridge crest was split by yawning cracks where the cornice break-line was opening, while to the right the sweeping snows of the north face plunged into shadow. We rightly took care but progress seemed agonisingly slow.

The summit rocks surprised us with a layback pitch of about III that is probably buried beneath snow in most seasons, and then we were on the snow mushroom between two rocky knolls that is the summit. Mindful of the story of the unlucky Lord Francis Douglas who had collapsed the summit mushroom on the second ascent and sailed into space, we did no more than poke the highest point with our ice axes after making sure we were well belayed.

Reversing the route was slowed by snow softening in the afternoon sun and adding to the risk of a slip and the insecurity of stepping from snow to rock and back. I was reminded of the Alphubel north ridge. The climb back up to the Wellenkuppe was a sting in the tail for Charlie, who was feeling the effects of his first long day at altitude; the rope jammed abseiling off the Wellenkuppe so I had to climb back up to free it. By then the rocks down to the Trift glacier had heated up in the sun and thawed out the ice around them, so were in a disturbingly loose condition.

It was 5.30 p.m. before we regained the Rothorn hut: perhaps we should have completed a traverse by descending the Arbengrat. At least we got down to Zermatt in time for a couple of beers before catching the last train back to Randa.

Fletschhorn, 3993m. – Lagginhorn, 4010m. Traverse: AD

After a couple of days resting and walking, Charlie and Viv, his wife, decided to decamp to Arolla. Charlie was a professional photographer, but working for BP gave him less scope for his creativity than he needed. I remember him telling me about setting up a series of cameras to record the destructive process of an explosion. There was a restlessness about him at this time. On a later visit to Grindelwald he was to disappear for several days without a word, returning to make decisions that would change his life completely.

Fortunately I bumped into Dave Penlington at the campsite and we agreed to go over to Saas Fee for the Fletschhorn–Lagginhorn traverse. Dave was a quietly spoken gentleman who, amongst other climbs, had put up Powder Monkey Parade with Eric Byne at Birchens before I was born. I was itching to know what it had been like to teeter out along that precarious traverse the first time, but in reply to my question Dave paused thoughtfully then said slowly, 'You know, I can't remember a

Traversing the Grand Gendarme on the Obergabelhorn north-east ridge.

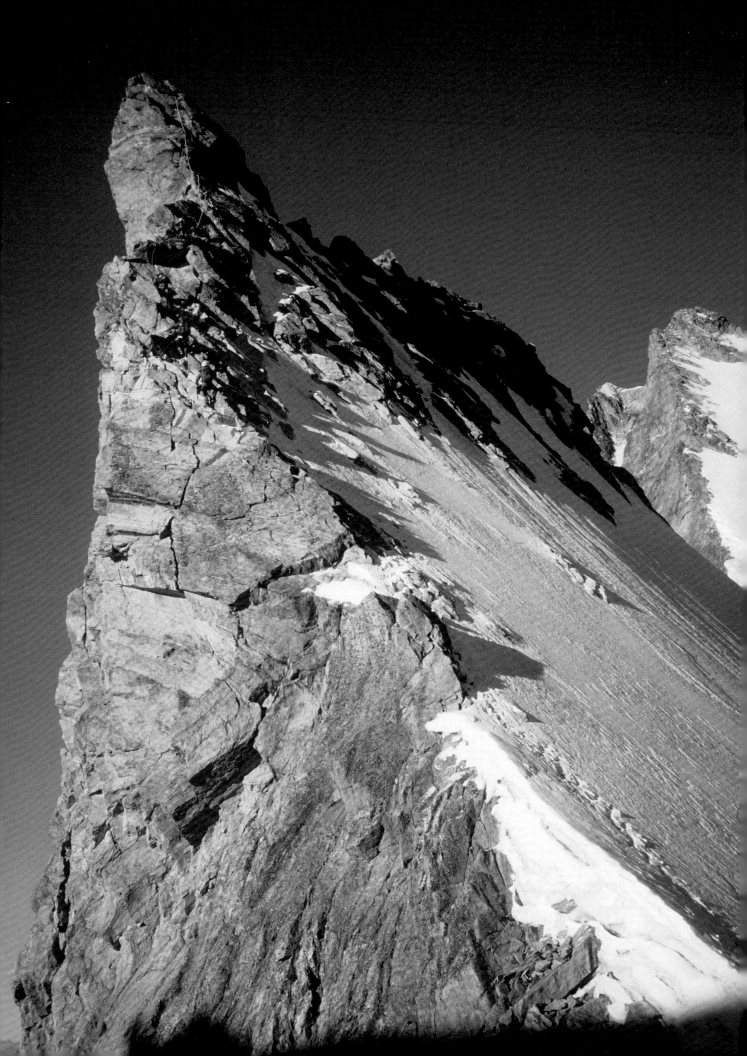

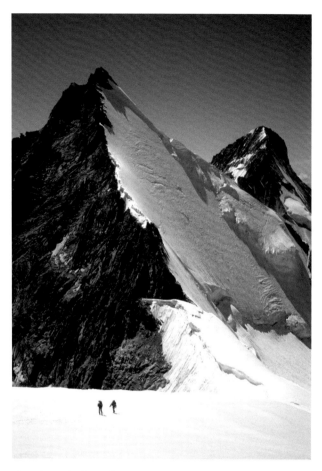

The Obergabelhorn from the Wellenkuppe

thing about it.' He drove us over to Saas Grund and we took the cablecar to the Weissmies hut.

We left at 4.30 a.m. after a night of rain, which was presumably why the hut guardian didn't bother to give us a wake-up call. The track to the Jagigrat petered out in scree and rock brash, but we found our way onto the little Talli glacier, only for me to fall into a crevasse on its further edge. I suppose the mild weather was to blame, but fortunately my rucksack jammed me at waist-depth so I could easily heave myself out. A faint track appeared higher up the flank of the ridge and soon we were enjoying the scramble along the ridge crest towards the snow shoulder. We roped up in an icy wind and I led across the upper slopes of the Grüebu glacier, managing to slip into yet another crevasse. The granular snow on the edges was treacherous enough to provoke a slip but the partially obscured crevasse was never a complete surprise and the slip easily recovered. Reaching the north-west ridge, we climbed a steep snow arête in cloud, to emerge exactly on the summit at 3993m. In the 19th century some enterprising locals, who had woken up to the growing popularity of climbing 4000m peaks, had planned to build a stone plinth on the Fletschhorn that would raise it the 7 metres it lacked to qualify. Fortunately this project never came about.

The cloud began to clear, but only to reveal elliptical storm clouds in the middle distance and a 'storm cap' on the Lagginhorn. We descended the east ridge and snow slopes to the Fletschjoch with some uncertainty despite sunny spells indicating an improvement in the weather; the ridges might be picked out in sunlight, but dark clouds glowered behind. The north ridge of the Lagginhorn rose ahead but its upper reaches disappeared into cloud. A brief conference decided that completing the traverse would be easier than retreat.

Steep snow led up to rocks, loose at first but then sounder. There was ice and a frozen scattering of fresh snow on the shady side of the ridge but the rest of the rock was mostly clear. Rock steps jutted up, taken direct at no more than III, while traces of a track wound through the easier ground between them and space fell away on either side.

At one point I was brought up short. The rope wasn't coming out as I moved. Dave had stopped. He advanced slowly, reeling me in and emphasised a loaded question: 'Couldn't you just go a little slower?'

'Sorry. Of course. Just a bit anxious about the weather.' I was embarrassed, but he was quite right: there was no excuse for lack of consideration.

The north ridge of the Lagginhorn.

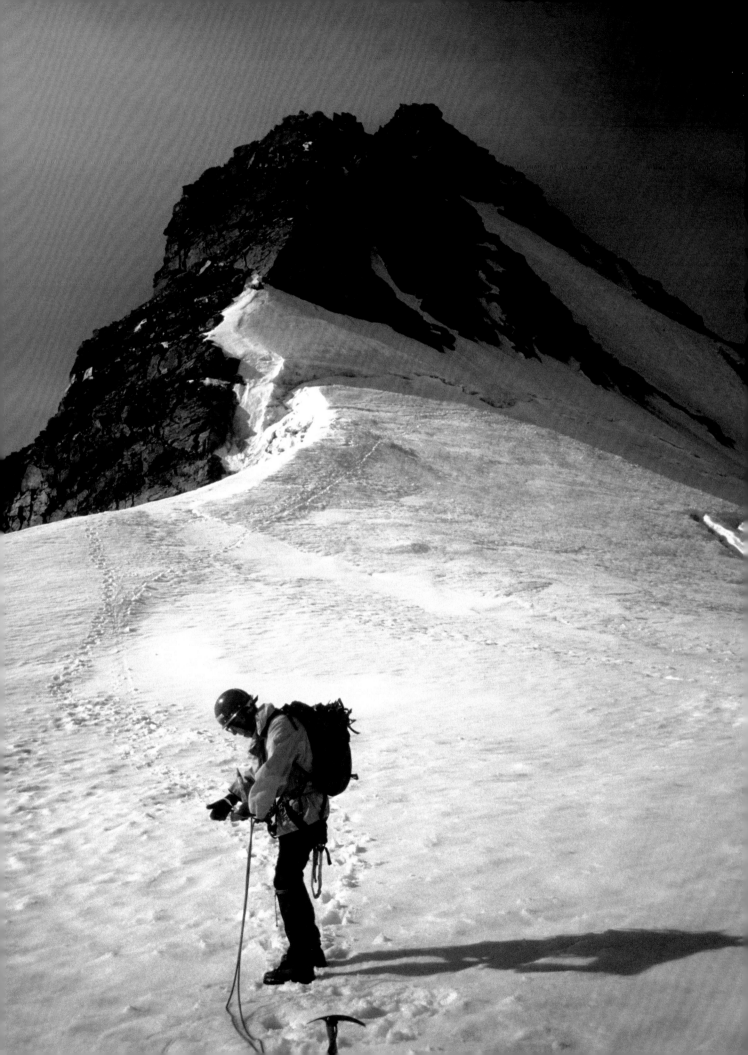

A final snow crest led to the summit rocks and the sky cleared, then closed in again. We didn't hang around. Loose and monotonous, the descent of the ordinary route to the Weissmies hut fully justified our efforts to avoid an ascent that way. Not far from the summit, a brief break in the clouds revealed the Weissmies dramatically lit through a frame of boiling clouds. We reached the cablecar station just as the rain arrived.

Down in Saas Grund, the car park had been cleared for market stalls and Dave's car towed away. When we finally recovered the car he noticed the bumper had been damaged, so it was off to the Kantonpolizei to make a complaint: after all there had been no warning notices yesterday when we'd parked. Dave was probably as angry as such a mild-mannered man can get, but that anger was consumed by sheer disbelief when the local police just explained what had happened then ignored his complaints about the damage: 'You have insurance?'

Back in Randa the clouds rolled in for a thoroughly thundery and wet night. The forecast was poor and it seemed clear that the weather had broken, so Jayne and I took the children on a rambling return to the UK via castles at Sion, walks around Chamonix, and French country towns with vines growing on street corners.

Back in the UK, Denis and I reached the conclusion that our susceptibility to altitude had, at least in part, been owing to the fact that, no matter what the technical difficulty, our routes in Chamonix in recent years had rarely exceeded 3500m. Having skied for years, during Easter 1990, I'd taken my first hesitant steps, or rather turns, ski-touring. The opportunities for additional acclimatisation earlier in the year could not be ignored, so at Easter 1991 we completed the Haute Route from Chamonix to Zermatt.

6:
Maps and navigation

It came as a surprise when I first visited Peru to find that maps had to be obtained in person, with proof of identity, from institutions clearly under military control. Another surprise was the blanks on the map where border disputes had not been resolved. I should have known better; after all the British Ordnance Survey rather gives the game away in its title. The origins of the institution go back to the last Jacobite rebellion when the Scottish Highlands were mapped to enable the English army to subdue the Clans after the battle of Culloden in 1746.

Modern cartography has developed hand in hand with military priorities and the development of alpinism. The change in sensibility that had Wordsworth and other Romantics writing of 'the sublime' with reference to mountains in general and the Alps in particular coincided with the redrawing of the map of Europe as a result of Napoleonic conquests. Napoleon's mapmakers knew that their work was the key not only to the effective deployment of troops and ordnance but also to the effective administration of conquered territories. The military involvement in map-making was a very practical application of the principle that 'knowledge is power'.

The relevance of this to the Alps lies in the strategic position of that mountain range. Situated virtually in the centre of Europe, the mountains represent, par excellence, the concept of 'natural boundaries', with the added benefit that mountain passes are easily patrolled border checkpoints. Unfortunately migrating people did not always recognise those natural boundaries, which meant that communities speaking the same language and with a common culture could be found on both sides of a pass. Patriotic nationalism that had been released during the Napoleonic wars was to collide with the idea of natural boundaries and the machinations of politicians throughout the 19th century. Garibaldi, for example, was outraged by the deal made between the Kingdom of Piedmont and France in 1860 whereby his birthplace, Nice, together with the rest of Savoy, was ceded to France in return for French military support against the Habsburg Empire to secure the annexation of Lombardy and other northern Italian states for Piedmont.

Of the alpine countries we recognise today, only the borders of Switzerland have remained as they were after the Congress of Vienna in 1815. Germany and Italy did not exist in 1815, although the number of German states had been cut from over 300 to 39. Austria was but a part of the rambling Habsburg Empire that included much of central Europe and northern Italy. The cartographers of the Habsburg Empire were used to border changes, had an eye to the main chance, and as a result surveyed neighbouring territories, with or without their neighbours' consent. The Military Geodetic Institute in Vienna had geodetic data on the whole of the Italian peninsula and most of the Balkan provinces of the Ottoman Empire: like the French military, the Austrians

restricted access to this data. Why should they put such hard-earned knowledge into the public domain?

As late as 1894 Martin Conway records in *The Alps from End to End* that when his party advanced up the wrong valley:

> Sentries turned us back, and revealed that the whole countryside is covered with fortified places, from the very sight of which civilian eyes are debarred. Without permissions from high authorities it is impossible to go anywhere in this part of the Maritime Alps.

Difficult to believe when we now cross the same border without even showing our passports – but when the GPS system was first opened up to public access we saw the American military degrade the quality of its signals for similar reasons.

In 1843, Murray's *Handbook* remarks that Piedmont has 'no maps … upon which implicit confidence could be placed'. Martin Conway writes in *The Alps* that the pioneer alpine climbers 'had not even decent maps of the snowy regions to go by. No one knew what was round most upper corners, or whither passes led or how you could get by high level routes from place to place.' In 1864 A. W. Moore records, 'I am sorry to say that a careful comparison of the scene before us with the French map very much shook our confidence in the accuracy of the latter, so far as the chain of the Meije is concerned.' Elsewhere he found, 'exactly where we were it was impossible from the map to make out, as the lay of the land by no means corresponded with the features laid down by either the French or Italian authorities.' Such inaccuracies probably also account for the dependence of early alpine climbers on local guides.

It was in Switzerland that the situation was to improve, and for a very simple reason: its borders and neutrality were guaranteed by the great powers of Europe in the international treaty that followed the Congress of Vienna. But that is not the only reason. In 1838 General Guillaume-Henri Dufour founded the Swiss Federal Office of Topography and remained its president until 1865.

Dufour was a remarkable Genevan who had served under Napoleon and been awarded the Croix de la Légion d'Honneur for successfully defending Corfu against British attack. In the civil war that broke out in Switzerland in 1847, he commanded 100,000 federal troops in a successful campaign of just 26 days that claimed fewer than 100 casualties; despite political pressure, he refused to use excessive force and initiated the use of ambulances to treat the wounded at the Battle of Gislikon. He was a professor of mathematics, and in 1863 he presided over the Geneva conference that established the International Red Cross and led directly to the First Geneva Convention in 1864. Yet it is his topographical contribution that resulted in the renaming of the highest mountain in Switzerland as the Dufourspitze in his honour.

The Dufourkarten set a high standard in cartography that was maintained by subsequent Swiss surveys. Switzerland was the most industrially developed country in Europe after Britain, and this, coupled with its stability, meant that it could afford to place such knowledge in the public domain. French cartographers lagged behind, perhaps because Savoy had only come under French rule after the Battle of Solferino in 1859, in which 40,000 men had been killed or wounded and the legendary guide Jean-Antoine Carrel had fought in the Bersaglieri Corps. This was only two years after the founding of the Alpine Club, so a talented amateur cartographer like A. Adams Reilly was understandably motivated to make his own maps of the Mont Blanc area for members' use. Political stability gave Switzerland the opportunity to advance the mapping of the Alps in the same way as, in R. L. G. Irving's words, 'comparative peace gave Englishmen the opportunity to turn their competitive

instincts to sport, while the peoples of Europe were struggling with each other to alter political boundaries or political regimes'.

Today Swiss maps still set the standard for alpine cartography, with the Skitourenkarte becoming virtually a combination of guidebook and map at 1:50,000, whilst the French IGN Carte de Randonnée at 1:25,000 is equally impressive at the larger scale. Kompass maps seem to have taken on the mantle of the Habsburg cartographers, with detailed maps of Austria and northern Italy as well as former parts of the empire like Slovakia.

In Italy the Istituto Geografico Militare produces maps of the whole of Italy, though unsurprisingly there has been criticism of the accuracy of these: cartography is still run by the military there. As a result, below the Passo della Losetta I was puzzled by the presence of a ruined concrete building about 30m × 10m that was missing from a map of Monte Viso. Was I at the wrong pass? No. It was simply that the military cartographers had omitted any record of potentially sensitive information about the battle-scarred barracks and fortifications built along the French border by Mussolini before World War II. Tabacco maps cover the Dolomites in more detail, and the Istituto Geografico Centrale tries to do the same for the rest of the Italian Alps, although it is largely reliant on military data. Anyone who has doubts about the relevance of military cartography to the Alps should visit the remains of Austrian and Italian fortifications in the Dolomites, which were the setting for a particularly bloody conflict from 1916 to 1918.

In 1892, Conway contributed the following to a handbook on mountaineering by Clinton Dent: 'The main uses of maps to a mountaineer are four. They are useful for planning expeditions, for finding the way, for identifying features in a view, and for recording routes that have been followed.' Little has changed. In planning a route or the linking of more than one route, maps enable us to visualise the route beforehand so that we know better what to expect, what to look out for. It is possible to total up the metres of ascent and estimate where the toughest sections of the route lie by careful attention to the contours, but it's worth checking the contour interval: in Canada, where the interval is 40m, a 30m cliff can be lost between contour lines.

Whole books have been written on the subject of navigation, and it is not my intention to provide an inadequate summary here. Every alpinist should be competent in the use of map, compass and altimeter, so that he or she can take a bearing, keep to it, and change it as necessary. Alpine weather can change quickly from blue skies to blizzard, and a safe retreat in whiteout conditions depends absolutely on such competence. I can remember skiing into a whiteout on my way from the top of the Grand Montets téléphérique to the Argentière refuge. There was a sense of total disorientation, a feeling like floating in space. The only way to navigate safely was to stop while we were still pretty sure that we knew where we were, take a bearing for the Moraine des Rognons, then ski on that bearing until the altimeter read the correct altitude for that feature. The moraine was, of course, covered in snow, but at that altitude we knew that we had to take a new bearing to ski down to the Argentière glacier then skin up to the hut. Simple. Perhaps.

Some people think that they can sidestep such competence by buying a GPS but, whilst the device can be a useful back-up, I've found its accuracy can be variable even back-tracking waypoints put in the same day. On expeditions I tend to use bamboo wands at key waypoints in order to correct any incremental deviation. Sometimes the device is telling me I've arrived when the wand that marked the waypoint can be seen more than 20m away.

Maps can also be used to identify unknown features by taking a bearing on such features then seeing what is on that bearing when it is transferred to the map. That depends again on being sure of where you are, but triangulating your position using bearings from two known features can fix your

A selection of maps from different countries.

position if at all uncertain. Finally, the map is vital in recording the line of an ascent, especially if it is a new route or a variation on the usual one.

One issue remains: the effects of climate change. A quick random survey of a dozen or so alpine maps I own reveals that they record a variety of dates for the data upon which the map is based. The most recent is 2002; the least recent 1975. With the pace of climate change increasing yearly, we have to be aware that alpine glaciers are shrinking not only in length but in volume. The snout of the glacier may be a kilometre further back than recorded on the map – but the height of the glacier's surface will also be less. This means that spot heights recorded on glaciers are no longer accurate. Even if they relate to a rock feature on the glacier, that rock, however massive, will have descended to the level of the glacier ice it rests upon. The best example of this volume shrinkage is recorded on the flights of steps up to the Konkordia hut in the Bernese Oberland, with dates attached to the steps at the height the ice reached at that time. The hut used to be just above the level of the glacier. Now there is a long climb between the two.

Glacial recession has destabilised the margins of glaciers so that even the route onto the Mer de Glace at Montenvers has become much more dangerous and it has been necessary to construct a Via Ferrata to climb up from the Mer de Glace to reach the Couvercle hut. Rock pinnacles lacking support from snow and ice may have tumbled from their perches. Decreasing build-up of ice on routes like the north face of the Tour Ronde may mean that a once convex ice slope is now concave. But none of this may be obvious from any map of the area. What is needed is to look at the landscape with 'geographical eyes', as Harry Moore, my geography teacher, used to say, in order to understand what is going on. The accumulated experience of mapwork is an essential means of acquiring that skill.

Conway comments, 'One man will continually lead wrong when the right way stares him in the face, whilst another will seem to have eyes that will see round corners.' All I can say is that if you are one of the former and no amount of training overcomes your deficiencies, then make sure you climb with one of the latter.

7:
Zermatt to Chamonix, 1991

Zermatt

I was running, sandals slapping the hot tarmac, gaining on the guy in the ripped leathers who risked a scared glance over his shoulder. Then, between one footfall and the next, I stopped.

Clambering out of the sun roof, springing off the buckled bonnet onto the road, shouting, 'You bastard, you've wrecked my car, my bloody holiday!' *I'll kill him*, had been the thought foremost in my mind.

Now I suddenly realised I meant it. Not a good idea. And the children crying, needed me not to do something stupid.

I walked back to where the 'superbike' was wedged under the front wheels of my car, ramming it into the road's retaining wall. The contents of the radiator pooled in the shadow of the engine compartment. There was a spreading stain of oil. Down the road the motorcyclist was slumped gasping over a crash barrier.

Thank God we were on the inside of a bend when he lost control. If it had been an outside bend I doubt the flimsy barriers would have prevented us being tipped down the vine terraces above Martigny, rolling to destruction.

That's the trouble with bikers these days: they all seem to be fat old men in search of a romantic way to die, and none too fussy about who else they take with them. On a recent visit to the Dolomites, driving involved daily close encounters with bikers driving badly, and hold-ups while they got their bikes back onto the road or ambulances arrived to lift them off the tarmac. I wondered how the figures for road traffic deaths compare with climbing deaths in the Alps.

This accident was a reminder that climbing involves calculated risks, driving an act of faith in other drivers, sadly misplaced on this occasion; yet the view of climbing that dominates our culture is that it is more dangerous than driving. Arguably there is less risk when you are self-reliant in a mountain environment than on a road when subject to the potential for human error contained in every vehicle that passes.

By the time the car had been towed to a garage and its contents transferred to a hire car it was late in the day, and darkness was falling as we arrived at the campsite in Randa. This was not a good start to the Alpine Club meet, which I was attending as a prospective member. It got worse.

Soon after we arrived the village was flooded and road and rail links were cut when a huge landslide tore down the hillside and dammed the river. There were no casualties, and the Swiss army soon had a pontoon bridge in place to take traffic over the waters. Fortunately the floods only affected low-lying properties, but it was an awesome reminder of the elemental forces latent in this landscape. And for me there was worse to come.

Lenzspitze, 4294m – Nadelhorn, 4327m. Traverse: AD

Teamed with Dick Murton, a very fit member of the Association of British Members of the Swiss Alpine Club, I took an hour off the guidebook time for the walk from the Hannigalp télécabine to the Mischabelhütte at 3200m. Then, sitting in the sun on the hut terrace, I felt a little dizzy, a little nauseous. I headed for the cool of the boot room and sat quietly taking a time-out on a bench.

Then somehow I was gazing across a dusty grey plain with blurred shapes shifting in the distance, but there was something wrong with it, besides the vague ringing in my ears. Where was it? What was it? A memory hovered at the edge of recollection. Picture puzzles, years ago: close-ups of familiar objects rendered unrecognisable by the angle, the perspective. And then there was the pain, pressure against my cheekbone. Suddenly I realised I was sighting along the concrete floor, my cheekbone pressed into the dust. I must have passed out. It can't have been for long. I sat up, but a French couple wrapped a blanket around me and persuaded me to lie down again: classic first aid that I should have remembered. Passing out was something that had simply never happened to me before.

Later, after Mike Pinney, who was organising the meet, had arrived and plied me with brews, I went up to the dorm and slept until suppertime, although the meal was a struggle and I was back in bed by 9. Woken at 3 a.m. to an unsurprising headache, I was glad of the fresh air as we left the hut an hour later. The original plan had been to climb the Nadelhorn north-east ridge but, reaching the snow, Dick was eyeing the teams starting the east-north-east ridge of the Lenzspitze, one of the hardest normal routes on the 4000m mountains.

'Looks good! What's it go at?'

'AD pitches of III,' Mike replied, a bit too quickly. 'Fancy the traverse?'

I should have said no, should have gone back to the hut. After all, I was feeling rough. But I hesitated just long enough to find myself on the Lenzspitze–Nadelhorn traverse, sometimes known as the Southern Nadelgrat.

The east-north-east ridge proved to be a classic example of sustained mixed climbing. Keeping to the crest we moved together, protecting each other with improvised belays, or simply taking a stance when climbing steep steps or down-climbing the difficult crack off the Grand Gendarme. The rising sun dazzled our view back along the ridge while picking out the route ahead in meticulous detail. On the final snow ridge to the summit rocks we all suffered the effects of altitude although I seemed to be no worse than the others despite my close encounter with the boot-room floor.

We gained the summit at 8.30 a.m., catching our breath at 4294m before descending the easy but snowed-up rocks of the north-west ridge to the Nadeljoch, 80 vertical metres below. To the south the Dom rose shining, with flakes of colour floating about its flanks where parapenters wheeled in early thermals. On a shoulder just below the summit, tiny figures could be seen unfurling more colourful

chutes before hauling their inflating canopies over their heads and running into the air.

The ridge continued to the Nadelhorn on sunny slabs, cracks and short walls, over a series of gendarmes and finishing on a knife-edge to the summit. Crampon scratches testified to the route's popularity earlier in the season. The climbing was absorbing enough to distract us from our headaches although, arriving on the summit, Dick confessed he was 'goosed!' Looking back at the Lenzspitze, we could see three small figures reaching the apex of the north-north-east face, that great sweep of snow or ice that falls from the summit to the enclosing cirque at the head of the Hohbalm glacier.

Descending to the Windjoch proved to be a tedious slippage of loose rock and soft snow, but we crossed the glacier easily enough and followed the path back to the Mischabel hut in gathering cloud. The jolting descent had set my headache banging, but paracetamol and more to drink helped make the decision to go all the way down. It was the right

The south ridge of the Nadelhorn offers some fine rock pitches.

decision: we improved steadily with every metre of descent. But we were still nodding off on the train and bus back to Randa, waking with a start, anxious that we'd missed our stop. Unpacking my sack I realised I'd left my gaiters at the hut: another penalty for rushing my acclimatisation.

Bad weather imposed a couple of rest days. Through gaps in the clouds we could see that a lot of snow had been put down. Days passed in reading or, during sunny intervals, hard-fought games of swingball. After one particularly fierce to-and-fro struggle, Jayne remarked; 'Hmm …. "You only compete with yourself in mountaineering" … Yeah, right!' Dick and I felt suitably chastened as our words came back to haunt us.

With a forecast of improving weather, Dick and I snatched a traverse of the Portjengrat, unusually plastered in snow, but at least it was in better condition than the 4000ers. The preceding night had been stormy and we had the mountain to ourselves; I have a picture of our lonely tracks in the summit snows. The rest day that followed was spent planning a trip to take in the Dent Blanche and the Dent d'Hérens from the Schönbiel hut.

Dent Blanche, 4356m. Wandflue and South Ridge: AD

Dick went ahead on a fine morning while I took a more leisurely approach, walking up to Stafelalp with Jayne and the children, who were fascinated by aged locals haymaking by hand in tiny fields. At Stafelalp the family turned off for a low-level circuit back to Zermatt while I went on, to find Dick had been at the Schönbiel hut for a good couple of hours by the time I arrived.

Goats were pestering people for titbits but were less disturbing than the sounds of domestic strife erupting from the guardian's quarters. Doors slammed, and voices batted insults to and fro before degenerating into a shouting match. Periodically a sullen warden or his wife would emerge to grudgingly attend to their visitors. Climbers appeared to be no more than a nuisance to them, although big spenders amongst the day trippers received a little more attention. The atmosphere of neglect about the hut extended to a distinct shortage of cairns or way-marks through the confusing moraine leading up to the Tiefenmatten glacier when we scouted the approaches to our routes. It seemed a long way to stumble in the dark. We stared gloomily at the dark mass of the Wandflue capped by swirling cloud banks that obscured the Dent Blanche above.

Fortunately the path to the Pointe de Zinal was better than expected, and Dick set a cracking pace to the Schönbielgletscher at 3 a.m. the following morning. At the point where we turned off the path to cross the badly crevassed glacier, I called a halt to strip off clothing soaked with sweat: 'I can't afford to lose water at this rate!'

Our headtorches swept from side to side, playing over the glistening ice as we searched for a way through the crevasses. Eventually we crossed the glacier and climbed up into an even more crevassed bay beneath the Wandflue Cliffs. We gained the rocks awkwardly with little sense of a line to follow through the scree and crumbling ridges; 'Cliffs? These are more like piles of rubble!' Dick grumbled. The stars twinkled impersonally above us and on such a fine night there would be no turning back.

Despite having climbed over 500 metres there was still a lot more height to be gained. Slowly, tediously, we got on with gaining it, although there were moments of acute frustration as the interminable dark treadmill seemed to be getting us nowhere. Then one of those sudden transitions between verticality and the horizontal delivered us, floundering, onto a broad snow shelf at 3656m. We plodded over to the snow crest ahead, cut through a sugary cornice and were on the south ridge of the Dent Blanche.

The route now improved dramatically with a clear line, sound gneiss and tremendous views opening up on either side. We moved together up the crest, flicking the rope over spikes of rock or placing the occasional running belay, until we were just below the Grand Gendarme. This gendarme is usually turned to the left by a traverse and the ridge regained by climbing an icy couloir equipped with steel stanchions for belays and abseiling. Ahead there was a lot of shouting in German and it was clear that one of the guide's clients was well out of his depth, calling for a 'tight rope', a common euphemism for 'haul me up!' He was a big man; far too big for his guide to manage that.

You can tell when someone knows how to handle an ice axe: there is an economy of movement that places the pick precisely into the ice as if it belongs there; then the climber rhythmically steps up and swings the axe again, never striking more than a couple of blows to secure the placement. Instead, the last man above was flailing ineffectually with his axe, hacking good ice to pieces – pieces that came crashing down on me where I huddled in a meagre rock niche, belaying Dick across. I was forced

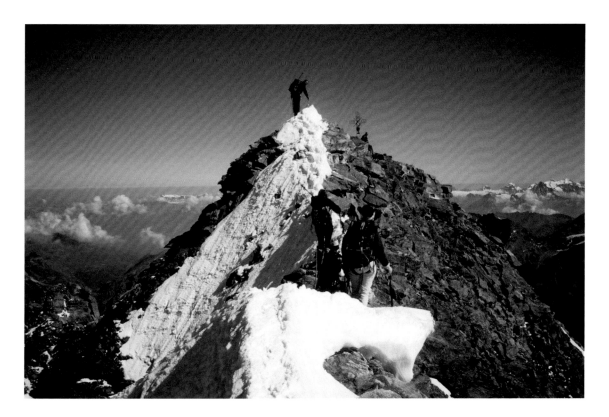

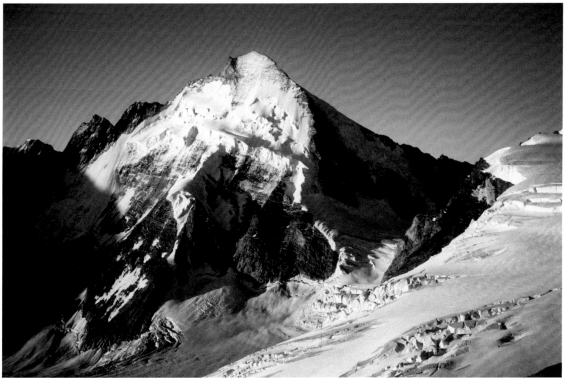

Top: Nearing the summit on the south ridge of the Dent Blanche.

Bottom: The north face of the Dent d'Hérens with the north-west face in shadow on the right.

to politely request the German to desist, or something like that, and perhaps the admonition had a sobering effect as the bombardment became less intense. Once the danger had passed, Dick shot up the pitch on what remained of the ice, crampons scraping the rock. We felt safer after overtaking the German team by staying on the crest of the ridge while they traversed along its flank.

The increasingly snowy ridge offered fine mixed climbing up short steps and along exposed edges. On the final snow section to the summit cross we met Mike Pinney and Steve Town, another Alpine Club member, who had driven round to Ferpècle and started from the higher Dent Blanche refuge. We agreed to meet back at the refuge and make the descent of the Stockji glacier, back towards Zermatt, more safely as a rope of four.

Dick and I approached the summit and I checked my watch: '10.30. I don't believe that!' I studied the offending instrument: the display registered the passage of another minute.

'No, that's right. Seven and a half hours from the hut.'

'But that's spot on guidebook time! I was sure we'd wasted hours climbing all that choss on the Wandflue.'

'I s'pose everyone else does too.'

I glanced back from the summit cross to see Dick at the rope's end, flanked by the Matterhorn and Dent d'Hérens like two great wings on either side. The weather continued crystal clear. In such conditions we lingered over lunch on the summit, enjoying the extensive panorama including the Obergabelhorn, the Zinalrothorn and the Weisshorn to the west.

The descent was delayed by teams that insisted on complicated abseil techniques. One group had snagged their ropes by attempting to abseil a step and traverse along the ridge in one movement, while at the icy couloir another team had joined two 40m ropes but was only making 20m abseils, resulting in a pile of tangled ropes at each abseil point. We eventually by-passed them by the simple expedient of rapid down-climbing: it's often the way.

By the time we reached the lower snow section of the ridge it was so hot that we shed clothing before descending easy rocks and snow to the Dent Blanche refuge. It was 3 p.m.; a 12-hour day.

Dick and I were as impressed as Mike and Steve by the guardian and the hospitality her team offered. A couple of beers later, our plans were revised in favour of staying there for the night, where the atmosphere was so much better and we could be sure of a meal and bed.

By morning Steve's blistered feet were very painful and smelt bad enough to be infected, so he opted to shorten his route out by returning the way he had come, tagging on to another descending party so that Mike could still join Dick and me. At dawn the mountains were bathed in a rosy glow from the beginning as we left the hut and traversed the head of the Ferpècle glacier to the Tête Blanche, then descended its south-east slopes towards the Col de Valpelline. Ahead the great ice terrace that is taken by the Finch route on the north face of the Dent d'Hérens was dramatically lit by the low sun, whilst the west-north-west face still hid itself in shadow.

Turning down the Stockji glacier, I could hardly credit the size of crevasses that I had blithely skied over, completing the Haute Route just a few months earlier when they were still buried under winter snows. To the north, the south ridge of the Dent Blanche reared up to the skyline, defined by the Ferpècle and Viereiselgrat ridges on either side: the mountain looked like some great eroding pyramid. Over the Stockji saddle we followed a path alongside the Tiefmatten glacier before struggling up to the Schönbiel hut through chaotic moraine debris. Random cairns seemed only to add to the confusion, confirming my impression that we stood a real chance of injury finding our way through this stuff in the dark.

Back at the Schönbiel hut, domestic discord still set the tone, and Mike was glad to depart for Zermatt. Dick attempted to book us in for the night, only to be told, 'Later.' After lunch he tried again:

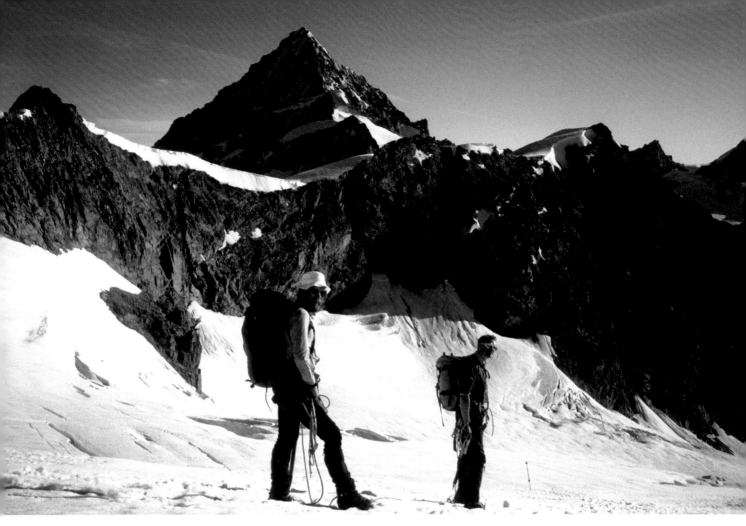

The Dent Blanche south ridge seen from the Stockji glacier just below the Tête Blanche.

'Later, later.' Mid-afternoon we were told the hut was full and we would have to wait until 17.00 before we would know whether there was any room for us. Throughout the time between our first and last requests the warden had been taking telephone bookings for that night yet justified his lack of space for us by stating that we hadn't made a reservation! Anxiety meant our semi-rest day never quite worked out that way.

Dent d'Hérens, 4171m. West-North-West Face: AD

It turned out we did get a bed for the night, and at 3 a.m. we were stumbling down moraine, slowly realising that we were on the wrong track. Retracing our steps to the hut, we picked up the right track and descended into another moraine maze. We decided to cut straight across towards ice glimmering in the distant darkness, but soon found ourselves struggling up banks of earth and piles of boulders, partially obscuring gritty slots in the ice. Stumbling on the traces of a path, we made better time to the old hut site, where we lost it again and eventually scrambled down rubble onto the Tiefmatten glacier.

We threaded our way through crevasses whilst the night remained brilliantly starlit despite an ominously warm wind that had greeted us on leaving the hut. At one point I glanced up to see a shooting star blaze a great streak of light down half my field of vision directly above the Tiefmattenjoch: 'Wow! Look at that!' But it was gone.

We climbed the first icefall on the right to find traces of a track across snow-covered ice, swinging left in growing light and leading to an easy climb through the second icefall. It had been warm work

but we chilled rapidly on taking a break beneath the west-north-west face. I've never been one for 'second breakfasts,' but natural breaks in the route tend to prompt a quick snack while surveying the way forward. Perhaps we were intimidated by the huge ice cliffs hanging in bands across the slopes above.

It was comforting to see a trail up to the right and we followed it into a snowed-up cleft in the cliffs that led out onto a steep traverse left below a great triangular serac. We weaved left, then right through more seracs, some fringed with curious wind-ragged ice formations, before emerging onto a wide sloping snow shelf.

Ahead an ice face rose steeply before laying back at about the same level as the west ridge which it joined to the right. To the left lay tall broken ice cliffs. A trail led to the far right but when we reached the bergschrund it was clear that the snow bridge had collapsed into its depths so we worked back left until Dick could step across onto refrozen ice nodules and up to reach the ice face above.

He led out 25m of doubled rope before belaying to a tied-off ice screw. I followed and led through to the point where I realised the pitch was about twice as long as expected. I put in an ice screw and we undoubled the rope. We were climbing light with only one axe each, and the technique was simple: reach as far up as was comfortable to strike the pick securely into the ice, crampon up as high as possible, and then, resting a free hand on the ice for balance, carefully extract the axe from about knee level before repeating the process.

The ice was of uneven quality, sometimes providing sinking placements but at others dinner-plating repeatedly, hurling broken shards down into the bergschrund below. We felt very vulnerable with just three ice screws between us. More than once, I remember resting my cheek against the ice to bring my centre of gravity more directly over my crampon front-points whilst working the axe out of a particularly stubborn placement; the chill struck into my cheekbone. Then the angle fell back and I belayed to a kind of rock sled on a rubble-strewn ledge of ice. I hoped it was frozen into the ice well enough not to slide. 'Don't fall!' I shouted down to Dick as he started to climb. And he didn't.

We climbed carefully towards the crest of the west ridge, following snow and ice beside the rock until it ran out towards the apex of the slope. Tracks in scree and scratched rock steps led to the foresummit, where the flanking ridges joined to form the airy rock crest leading to the summit itself. There was a guy sitting there, looking a bit spaced out.

'Ça va? You okay?'

'Yeah, I'm okay.' He was English. 'Just can't bring myself to go on. Just one slip … It doesn't bear thinking about.'

'Then don't think about it. Are you on your own?'

'No, my mate's gone on, unroped. I just can't face it.'

'Well we'll tell your mate you're waiting for him, okay?'

He wasn't going anywhere.

I could see his problem: a broken rock pavement in the sky. With all that space plunging away on either side and the huge blue dome above, it was like being in a spotlight on some gigantic stage where your very existence seemed irretrievably fragile. Strange that at street level you wouldn't even consider falling.

We found his mate on the summit preparing to return. The tracksters made it easy. 'He's no better, then?'

'Nope.'

'I couldn't get him to go on, even offered to belay him. And he climbs E1 at home.'

The Matterhorn seen from the summit of the Dent d'Hérens.

72

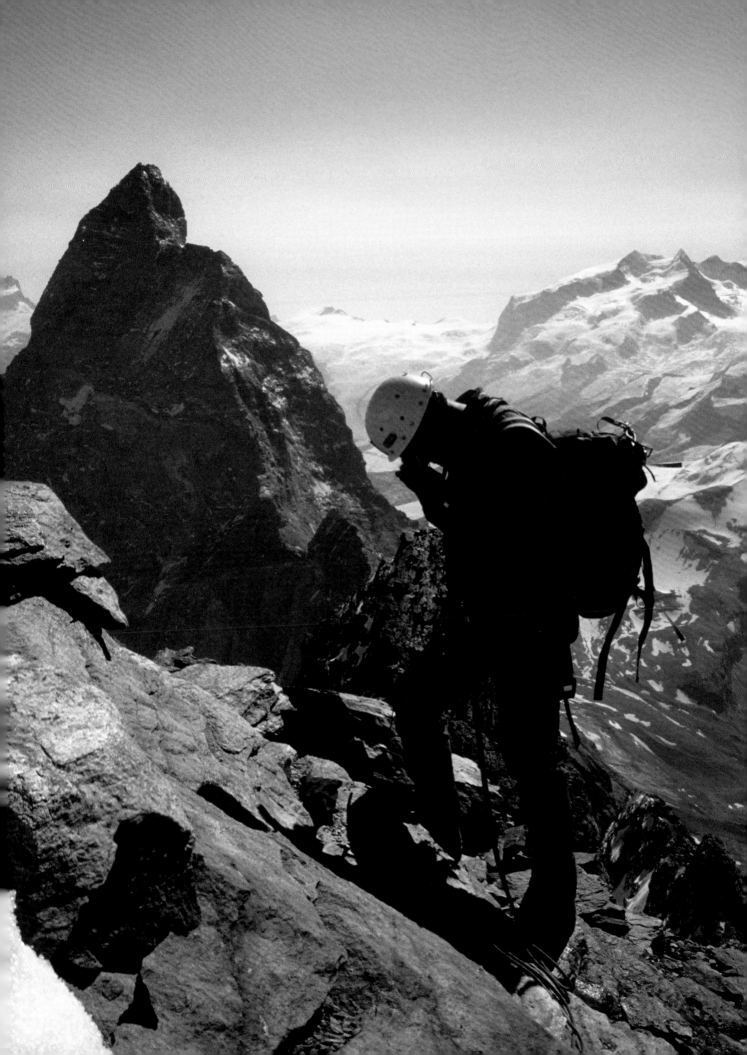

'It's the scale of things out here. Just gets to people sometimes. In Cham I had to lead every pitch of the north-east ridge of the M with a guy on his first Alps trip. He was an E1 leader too. Good luck.'

Dick and I ducked out of the wind onto a small ledge a little below the summit and took in the views down the east ridge to where the Matterhorn's Italian ridge rose from the Colle del Leone. Away to the south the cities of the plains shimmered in a heat haze. Food and drink were priorities, but speed was too. It was only 10.30, but we could see the west-north-west face was receiving a lot more sun than we'd expected.

We descended the rocks of the west ridge, but where the tracks swung left for the Aosta Rifugio we found more tracks going right that led to an abseil sling. Then 25m down was another, but when I reached the end of the rope I was still 7 or 8 metres above the bergschrund. Suddenly a spout of water came streaming straight out of the ice cliff away to my left: there was no going back.

I wound an ice screw into the ice and hung on a sling attached to it while Dick undoubled the rope and let one end down far enough to reach the snow beyond the bergschrund before tying it off on the abseil anchor. I got back onto the single strand, left the ice screw for Dick and abseiled down, bouncing over the bergschrund. Dick then had to equalise the rope, abseil down both strands and belay to my ice screw, tie on to one end of the rope, pull down the rope, then down-climb with me belaying him from below. To make the down-climbing easier he hauled up my axe on a rope's end. The final moves were the most precarious, as he had to simultaneously disengage his tools and crampons from the ice and jump across the bergschrund. The manoeuvre threatened to turn into a back flip but somehow he spun completely around in the air.

During all this time the waterspout had continued to run like a tap and ominous rumblings from below came vibrating up through the ice. We stepped out of the shadows and as the sun hit us, realised that we had to get off the face fast. We weaved around creaking seracs and clambered over ice debris that confirmed the impression that the icefall was changing shape even as we moved through it. It became a race to descend the line of our ascent while it still remained intact. Running down the final soft snow-slope with long bounding strides, we cleared the danger zone and halted, gasping and dripping with sweat. Snow-slides hissed behind us and stonefall rattled threateningly down the black ice and broken buttresses of the Tiefmattenjoch. A fan of debris reached almost to our feet.

I wanted a portrait photo of the face with Dick in the foreground, but could only get the angle right by lying down on the snow in a ridiculous position. It was then that we started laughing.

Retracing our route to the Schönbiel hut was almost relaxing. There were very few people on the terrace as we made a brew and sorted out our kit before descending to Zermatt. When the guardian asked if we were going to stay the night I managed to keep a straight face as I replied, 'Not likely.'

That night the weather turned around and we all spent a couple of days on the campsite playing games with the kids and reading before Dick and Lynne departed for the UK.

Lauteraarhorn, 4042m. South Face Couloir and South-East Ridge: AD

The weather forecast continued to be uninspiring, but Mike Pinney came up with a cunning plan to go in search of better weather in the Eastern Oberland, walking in to the Lauteraarhorn from the Grimsel Pass. Jeff Harris and his wife, Miriam, each took turns to climb while the other looked after

their kids and Mike's plan opened up an opportunity for him too. One of the advantages of AC meets used to be the fertility of ideas growing amongst the group regarding alternatives when conditions were far from ideal for the obvious routes

Next day, after a long drive, Mike, Jeff and I arrived at the Grimsel Hospiz. Hopes of using the ferry to the far end of the Grimselsee sank as we spotted the motorboat up-ended on the dam. We crossed the dam to the northern shore and set off on the path around the lake; it was going to be a long 19km. The Arolla pines were beautiful but the path rose and fell frustratingly so that not even the glorious granite of the El Dorado Slabs, dotted with climbers at the far end of the lake, could make amends.

Getting onto the centre of the Unteraar glacier, we followed it to the waymarks for the Lauteraar hut and laboriously climbed up to that hut as our guidebook suggested. Mike had seemed very snuffly and lagged behind. Arriving, he stretched full length on the terrace with his head in the shade of a drainage hole in the bounding wall while people stepped over him. We were all dehydrated and I'd been running on empty since reaching the glacier. I ordered some soup and Mike soon perked up a bit. Meanwhile Jeff had scouted the way ahead.

'You're not going to like it. You're really not going to like it,' and he pointed out a laddered path that led back down to the glacier, losing all the height we had gained. We could see figures making their way along the central moraine below and it dawned on us that we could have done so too.

'You mean … we've come … all the way up here … for nothing?' Mike spluttered.

There was nothing for it but to descend the ladders and trudge across to the Finsteraar glacier and up this to the junction with the Strahlegg glacier coming in from the right. All the way it was littered with bright blue 35mm cannon shells; blanks of course, although I did check …. by screwing off a nose cone … Doh! I later learned that the Swiss air force includes winter strafing of the Oberland glaciers in its training programme.

We arrived at a crowded Aarbivak hut late and tired. Of course it was crowded; we'd chosen a fine Saturday after a run of bad weather. The largest team in residence was led by an officious Swiss who made us feel most unwelcome, presumably to impress the young girls in his charge with his authority. Mike's sniffing and sneezing had developed into coughing fits that earned him enough sympathy to get bunkspace but Jeff and I were banished to the winterraum. It was something like a 3-metre Toblerone wrapper built of planks, and reminded me of nothing so much as the ark I used to keep chickens in. We had to crawl into it, but once inside found ourselves quite comfortable, if a little damp, as the candles cast flickering shadows on the wooden walls.

Delayed by a long loo queue, we left at 5 a.m., climbing ice then moraine until reaching the stream boiling out of the base of the south face couloir. The Finsteraarhorn glowed above the Nasse Strahlegg ridge but we couldn't linger if we were to climb the couloir before the sun hit it. Rocks on the left took us up to a snowfield that led into the couloir at a higher, safer level. The parties ahead of us seemed to be climbing shattered rocks to the left but we soloed quickly up the couloir. It was much longer than it looked but good névé, if a bit steep where snow slides had rendered it icy. Breaking left near the top over snow and rock we reached a gap on the south-east ridge and emerged into the sun just as the first stones began to strafe the couloir. The ridge unwound before us as we scrambled along its rampart to the summit.

From there, immediately ahead lay the Schreckhorn with the stunning connecting ridge between. To the west the full height of the Finsteraarhorn reared above the glacier beneath whilst to the north-west the Eiger, Mönch and Jungfrau lined up to display their less familiar south faces. We took a break

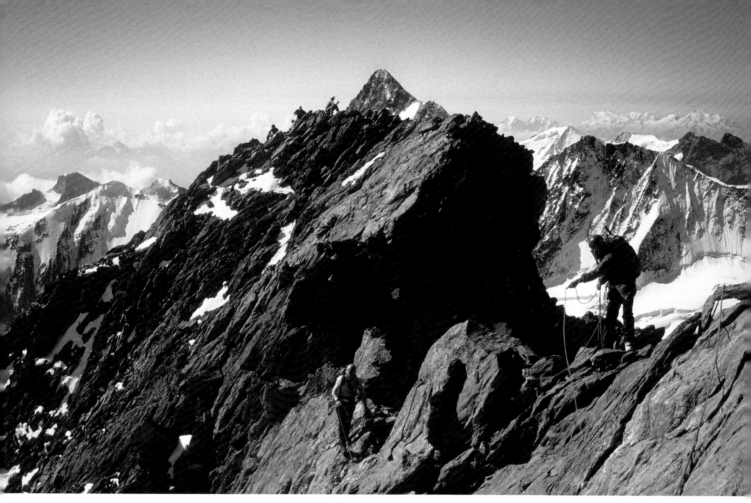

The summit of the Lauteraarhorn with the Finsteraarhorn rising above it in the distance.

and realised that since it was only 9.30 a.m. it might be possible to traverse over the Schreckhorn and return by way of the Strahlegg Pass.

'What do you think, Mike? You're going much better than yesterday.'

'Not sure we'll have time for all that.'

'Worth a try, though?' Jeff asked.

'Let's see how we're going at the Schrecksattel.'

As we started descending the north-west ridge our officious Swiss was just arriving on the summit, which rather put him in his place. Perhaps he shouldn't have spent so much time fastening up the girls' chest harnesses for them.

The Lauteraargrat was awkward in places, requiring some nifty ropework to protect all three of us, but I was really enjoying the climbing until we met a Swiss pair coming from the opposite direction. They told us that the descent from the Schrecksattel would not go as an escape route and there had been snow slowing progress on the rocky south-west ridge of the Schreckhorn. Mike's cough had resurfaced and our pace had slowed; we were still at over 4000m. After a huddled conference we returned reluctantly to the Lauteraarhorn summit. At least our meeting with the Swiss team had been a lot more amicable than that of Gertrude Bell and Fräulein Kuntze and their guides, chilly rivals for the first traverse of the ridge in January 1902.

Descending the rocky west rib of the south face couloir, we strayed into loose gullies before finding our way out onto the glacier, and arrived back to find the Aarbivak deserted. There was time to appreciate its remote position and the simple quiet of the place, but Mike was looking very weary. We decided to stay another night. It was the right decision: a storm rolled in a few hours later and Mike spotted a chamois hesitating at the door to the hut in the slashing rain. Next day we were back at the Grimsel Hospiz in time for an excellent rösti for lunch.

Matterhorn, 4478m. Traverse of Italian and Hörnli Ridges: AD

I had no interest in joining the queues on the Matterhorn: at least one AC team had taken 20 hours on the Hörnli ridge, returning to the campsite with tales of incompetent parties and the inevitable bouchons. In the back of my mind was the thought that I might find the north face in condition one Easter or try the Zmutt ridge late in the season when the slabs above the west face would be less likely to be verglassed. That was before Mike Pinney approached me with another cunning plan.

Now Mike had picked up a bump on the head during his climbing career, so the cunning plan emerged slowly; a rush of explanation between silences as he searched for words. The plan involved taking two days to traverse over the frontier ridge, descend below the south face of the Matterhorn, then back up around the Testa del Leone to access the Carrel bivouac hut. From there we would climb the Italian ridge and descend the Hörnli, traversing the mountain back to Zermatt.

Late that afternoon, Mike and I took the cablecar to Trockener Steg and sauntered over to the Gandegg Inn. In the fine evening light illuminating the north face of the Breithorn, we could easily trace the lines of the Triftjigrat on the west peak and the Younggrat on the east peak.

An early start saw us heading due west across the Theodul glacier with the Matterhorn gilded with dawn above us. The Hörnli was obvious, but we were surprised to be able to see so much of the Italian ridge in somewhat foreshortened profile. An awkward crossing of the Breuiljoch, still icy from the night cold, took us close under the shattered south face; far closer than we would have liked had it been later in the day judging from the stones of all shapes and sizes studding the surface of the

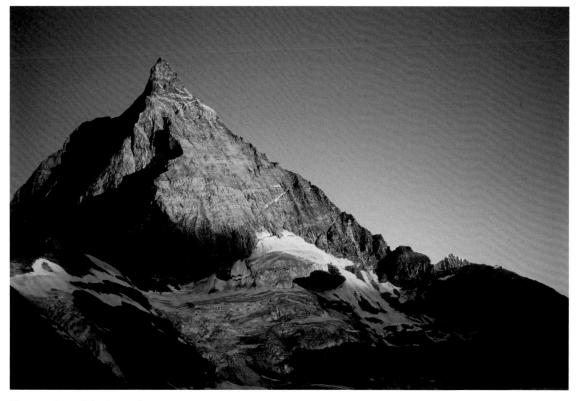

The east face of the Matterhorn.

glacier. I noticed some purple rags and went closer, hoping there were no body parts attached, to find the remains of an alpiniste rucksack, ripped to pieces by its fall.

At the Croce Carrel we followed a scrappy, scrambly path with plenty of evidence of stone-fall that rose in steps and traverses below the Testa del Leone to reach the Colle del Leone. From the Colle the Italian ridge proper rises to the summit. We soloed on up the Seiler slab to the vertical chain that stretches the length of the steep corner near where Whymper's chimney used to be.

The whole of this passage could be termed 'easy ground', but I could not help recalling Whymper's description of his solo exploration of the same ground when he slipped and fell:

> I pitched into some rocks about a dozen feet below: they caught something and tumbled me off the edge, head over heels, into the gully. The baton was dashed from my hands, and I whirled downward in a series of bounds, each longer than the last – now over ice, now into rocks – striking my head four or five times, each time with increased force. The last bound sent me spinning through the air, in a leap of fifty or sixty feet, from one side of the gully to the other, and I struck the rocks, luckily, with the whole of my left side. They caught my clothes for a moment, and I fell back onto the snow with motion arrested. …I fell nearly two hundred feet in seven or eight bounds. Ten feet more would have taken me in one gigantic leap of eight hundred feet onto the glacier below …. scrambling up, I got, not a moment too soon, to a place of safety and fainted away.

He remained unconscious for hours before tottering down to Breuil in the dark with head injuries that permanently affected his memory retention. Sobering stuff.

Whymper comments 'to the present moment I cannot tell how it happened'. I wonder how many times that or something similar has been said. It is almost as if the very ordinariness and easiness of things conspires to ambush us no matter how much we try to expect the unexpected. On the other hand, the sharp appreciation of a difficult position generally ensures that there will be no mishap. Never drop your guard.

The steep corner was a rather tougher proposition; near vertical and slippery with seepage in places. Rather than get the rope out for a 12-metre pitch, Mike and I protected our solo ascents by leapfrogging a couple of long nylon slings through the links in the chain, removing the one below once another had been placed above.

A short scramble further and we arrived at the Rifugio Carrel, 3829m. This is situated below the Great Tower, the

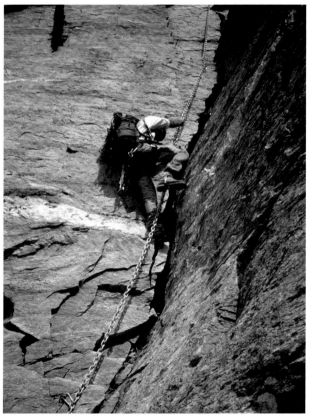

The author swarming up the fixed chain en route to the Carrel hut on the Matterhorn.

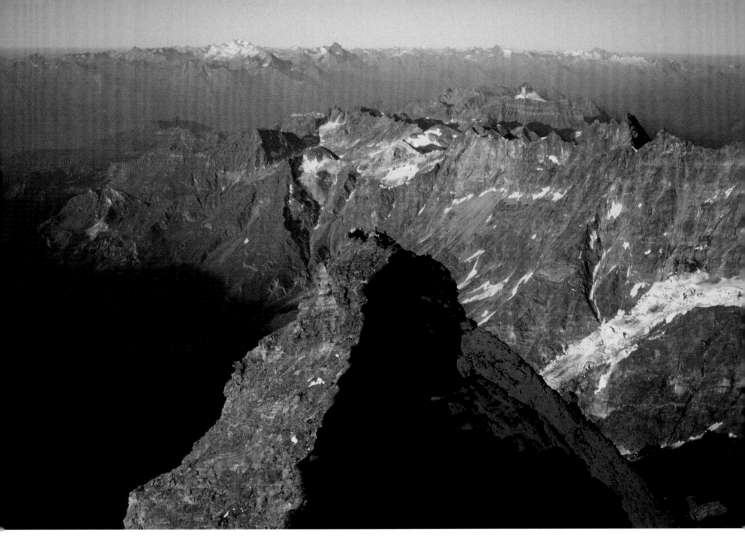

Top: Pic Tyndall on the Italian ridge of the Matterhorn.

Bottom: The Swiss summit seen from the Italian summit on the Matterhorn.

highest campsite used during Whymper's seven unsuccessful attempts to climb the Matterhorn from the Italian side. The breakdown of the supply lift from the Duca degli Abruzzi Rifugio meant there was no warden in residence and thus a general sense of neglect about the place. The ceiling sprouted colonies of mould, and the bunks were damp if not wet. It was quiet when we arrived but filled up steadily during the afternoon. By evening the overflow Savoia annexe was beginning to be occupied. A guide turned up, collecting money from everyone after settling his clients in. There was something shifty about him, and whether he really had any connection with the CAI section maintaining the hut was a moot point.

At 4 a.m next morning I stepped out of the hut into wind-driven clouds. There were no stars, and a storm was putting on a fine display over the Breithorn, huge sheets of lightning silhouetting ridges amidst hanging swags of loaded cloud. Back to bed. Up again at 5: the storm had subsided to an occasional flicker of light and a background grumble, but the cloud was still with us and the wind had increased. Still no stars. Back to bed. At 6 there seemed to be more movement about the hut, so Mike and I ate breakfast and reviewed our options as one or two teams left for the summit. There was no storm now, but still plenty of cloud and the wind was intensely cold. I watched a party of three wait for 30 minutes while the team ahead of them struggled up the chains above the hut with frozen hands.

We could have pushed it, toughed it out, but that wasn't the point: 'Look, we've spent a lot of time and effort getting in position and it makes no sense to me to set off knowing we're not going to enjoy it. I'm not coming back here again and I'd like to make sure that I do enjoy climbing this mountain. From what I've seen far too many people don't and I don't want to be one of them.' Mike didn't need a lot of persuading; he went back to bed. But I stayed up to see if anyone else went for the summit. Most headed for the valley. When I did go back to my bunk I found someone had swiped my headtorch from the pillow where I'd left it.

Hunger turned us out of bed some hours later as a couple of guided teams trailed in having traversed the mountain from Zermatt. They looked wasted. Having to stay an extra day meant we were short of food, so we scoured the shelves for discarded supplies and turned up stale bread, sardines and pasta: enough to survive. What looked like a bent metal cigarette case turned out to be a torch and my spare batteries fitted so I wasn't going to be completely in the dark. Dick Sykes and Daphne Pritchard, two Climbers' Club stalwarts, arrived with a good weather forecast after spending the previous night at the Abruzzi hut. Dick thoughtfully demolished about a kilo of cheese with digestive biscuits while Mike and I tried not to look.

That afternoon the weather cleared up enough for us to go out and scout the route above the hut while no-one else was on it. That was time well spent, as it was quite complicated and nothing like the description in our guidebook. Fixed ropes seemed to have been replaced by solid steel belay rings at the Mauvais Pas foot ledge, and there were cables alongside a much-reduced 'Linceul' ice patch. There would not have been much fun puzzling it out in the dark. I lingered over the view west to the Dent d'Hérens where the long east ridge reared up to the precipitous summit slopes of the north face. To the north, the great saw-tooth of the Dent Blanche rose above the Wandflue cliffs and the Schönbiel glacier, too far away for any figure to be discernible.

'Help! Help!' the cries wavered, shocking me awake.

I was not alone: the entire hut was awake.

'Oh, God! He's falling. Help him someone!' The atmosphere was electric.

I realised the shouting was coming from right next to me and shook Dick's shoulder.

'No! No! Oh God help him! He's fallen!'

'Dick, Dick! Wake up; you're dreaming.'

'He's fallen, he's …. What … oh … oh dear … oh dear.'

I don't think anyone got much sleep after that.

I blame the cheese.

Mike and I were first up the fixed rope above the hut next morning and moved rapidly over the scouted ground below the Crête du Coq pinnacles. I had some help from the handheld torch, but had to climb blind when both hands were needed. There was just enough light to manage without torches by the time we reached Corde Tyndall, so we climbed the wall without the aid of the rope.

Established on the ridge, we could now follow it easily to Pic Tyndall, the high point reached by John Tyndall in 1862 when his guides refused to go further. From there an exposed horizontal section narrowed to a deep notch, the *enjambée*, before the summit block. Snow, lodged on the crest, sometimes surprised us with a slippery verglas margin and the pock-marked snow of the Tiefenmatten glacier seemed a very long way down those icy northern precipices. Following an Italian soloist who must have bivouacked above the hut, we climbed down into the notch then back up, trying to use the fixed ropes as little as possible. I do remember leaning way out backwards, though, to grasp the bottom rungs of the Échelle Jordan where it hung out from the rock, then swinging up its creaking wood and rope frame; Mike, below, had me securely belayed, of course. Above, we met a party in descent as we bore left up a little ridge and on to the Italian summit. Strangely the cross was sited below the summit, and perhaps for that reason gave the illusion that the Italian summit was higher than the Swiss. Nibbling cereal bars, we fixed our crampons since the traverse to the Swiss summit was quite snowy.

From the Swiss summit there was a sense of being borne up on a great wave of rock breaking over the Val Tournache from a breath-taking height. It is the most vertiginous summit I have ever visited. We didn't linger but quickly descended snowy slabs towards the Hörnli ridge. That speed made perfect sense when we got our first view of the ridge: the crowds were like ants, nose to tail up the higher sections where the difficulties increased. At close quarters it all looked like an accident waiting to happen: tired old men who could barely hold their ice axes were being towed up by fraught guides; a roped pair with one axe between them had no crampons; a larger team wearing tracksuits and cycle helmets relied on ski poles and the rope to keep their balance so it was 'one off, all off'. You could see in their eyes that their minds had gone as they clutched desperately at the fixed ropes, terrified lest anyone came too close. This was a world away from the sort of climbing Mike and I were used to. Fortunately it is a lot easier to see alternative lines from above, and we were able to descend around the bouchons, feeling safer the further we were from the queues: on this very ground four of the first ascensionists had fallen to their deaths.

We had taken in coils to leave a fairly short rope between us and just down-climbed, flipping a loop of rope or a sling over a rock or iron spike to protect any tricky passages. A guide who had ignored my greeting suddenly discovered his English when he asked us to flip his rope down after he had lowered from an iron stanchion. As we passed him and his client he remarked: 'I think you perhaps are going too fast for safety.' We just grinned and swung off down the Moseley slab. It had seemed a long way to the Solvay hut and looked further to the Hörnli. The ridge became loose and scrappy and we paused, uncertain of the way. The guide caught up and kindly pointed, 'Rechts – right – onto the face.'

We didn't see him again as we made a series of detours onto scree on the east face, alternating with scrambling nearer the ridge line. There was a continual clatter of dislodged stones from above, but fortunately the route was not steep enough for them to pick up much speed before they grounded.

We came upon an Italian party, who had left Rifugio Carrel the day before and must have stayed at the Solvay hut. As they dithered over whether to abseil or use a last fixed rope, we just climbed past them.

There is something wonderful about going well at altitude. Balance, breathing, the intricate adaptation of body to rock with an efficiency that takes you into a place where it seems you can do nothing wrong. The fact that the consequences of a mistake could be disastrous simply adds to the focus and yet somewhere, somehow, you know that you're operating within your comfort zone. We made the traverse between the Carrel and Hörnli huts in 7½ hours. This was all the more remarkable because Mike had been fighting off a virus when we set out from Zermatt and had been bothered by a cough the whole trip. Dick and Daphne took 17 hours to get to the Hörnli hut, where they stayed the night.

As I packed away the climbing gear I looked up to see a helicopter heading up the ridge for the inevitable rescue. The mountain is an unmistakeable icon, and it is arguable that Whymper himself was obsessed by the thought of climbing it; nonetheless he writes;

> Others will assay to scale its proud cliffs, but to none will it be the mountain that it was to its early explorers. Others may tread its summit snows but none will ever know the feelings of those who first gazed upon its marvellous panorama, and none, I trust, will ever be compelled to tell of joy turned into grief, and of laughter into mourning.

With a death toll of over 500 there is a sad irony to those words.

We came down to learn that my car had been repaired, and I drove the hire car over to collect it. The garage had replaced the whole front with some glass fibre unit into which they had sawn holes for the headlamps. My immediate reaction was to burst out laughing. Clearly the whole job would need to be redone in the UK, but at least it was driveable. Who says there are no cowboys in Switzerland? While I was in Martigny, Mike climbed the Obergabelhorn with Denis before they both headed home. The meet was officially over, but I still had time to climb.

That same evening Bob Elmes and Mike Pearson, two fellow members of the Chester Mountaineering Club who had just arrived from the UK, dropped in for a quick drink, and in the process somehow persuaded me to join them on the Nadelgrat.

Nadelgrat: Dürrenhorn 4035m. Hohberghorn 4219m. (Stecknadelhorn 4241m.) Nadelhorn, 4327m.: AD

The three of us set out quite late from Gasenried for the 4½-hour walk up to the Bordierhütte. On the edge of the glacier I spotted my first ibex in 12 years of alpinism. There used to be far more chamois around Chamonix, and ibex were rare, although in the opening years of the 21st century the position seems to have been reversed. A chamouniard friend has recently confirmed that impression, but added that studies have not yet revealed why.

There were two more ibex outside the hut. Far more heavily built than chamois and with massive horns, they looked like they could do each other significant damage. There was some stiff-legged invading of each other's space before, rather reluctantly, they reared up on their hind legs and hung for a moment before crashing down, clashing horns with a resounding crack. Both stood stunned for a short interval, then one half-reared before thinking better of it. Turning away from each other, they returned to licking at the salt smears supplied by the guardian as though nothing had happened. Bob remarked on the ibex to the guardian, who replied, 'Steinbock? Ja, wildfleisch ist gut,' and winked.

At that time it was still acceptable at Swiss huts without self-catering facilities for climbers to bring food for the guardian to cook for a small charge. In practice, it often meant he would shelve the offering and serve somewhat smaller portions of the regular hut fare, an acceptable arrangement all round. Not here. When I handed him my dehydrated meal he flung it down on the counter and launched into a tirade: 'Who did I think I was? How could I expect him to make a living if everyone did that? Did I know how much fuel cost, etc. etc.' Much of this was in German and only half-understood by me at best, but Bob's excellent command of the language not only filled me in later but eventually managed to placate the guardian so that I did get a meal that night after all. Unusually, during the meal there was no free water: instead expensive drinks had to be ordered from the bar. Realising this, I felt decidedly less guilty about the dehydrated meal, although both could have been symptomatic of problems with making ends meet at the hut. A guardian's life is not an easy one.

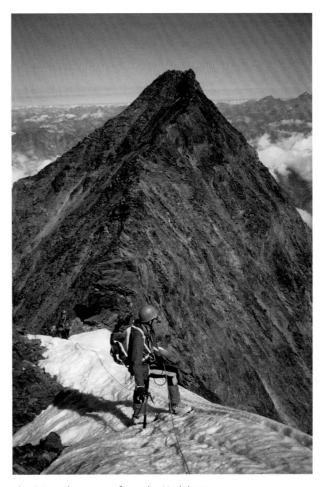

The Dürrenhorn seen from the Nadelgrat.

Crossing the Reid glacier proved easier than expected in the dark early hours before red brush strokes of cloud appeared against the yellow-green, pre-dawn light, shading to mauve over our heads. Broken seracs reflected slivers of silver close by whilst beneath us the valleys were filled to the brim with cotton-wool cloud. At first sight of the wide couloir leading to the Hohbergjoch, the rock was glowing red-gold, but the snow was seamed with grey ribbons of stone flowing down and over the short ice cliffs above the bergschrund before fanning out into broad aprons below. Not an encouraging sight.

The guardian had advised climbing rocks 50m to the right, but these looked very loose and the guidebook suggested joining rocks higher up, so we set off up the ice. A steep step of dirty ice above the bergschrund proved awkward enough with just one axe and the occasional stone buzzing past like an angry bee. The sheer volume of stonefall had worn deep gutters into the ice, polished to a slick sheen or cluttered with debris, so we climbed an ice rib between two of them. At the top of the rib I hammered in an ice peg and traversed right to the rocks across water-ice, crusty with refrozen flakes of rotten ice and rough with grit. As Bob came level he called up to me, 'Take a picture. My wife doesn't believe I can hack it on this sort of route.' It was a glimpse into marital relations that I had absolutely no intention of pursuing.

We then climbed a loose rake or the shattered rib to its left all the way to the crest of the ridge just above the saddle of the Hohbergjoch on the Dürrenhorn side. There, with some relief, we took a well-earned break before leaving the rucksacks behind and completing the rock scramble to the summit

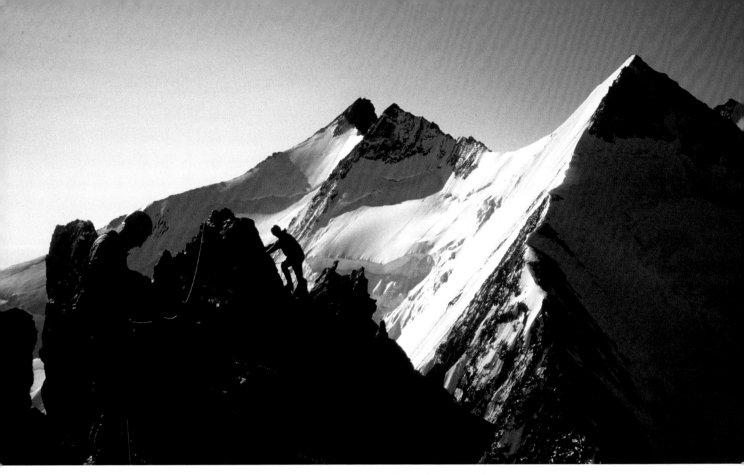

On the Nadelgrat with the Hohberghorn, Stecknadelhorn and Nadelhorn ahead.

of the Dürrenhorn. With increasing glacial recession it's more common these days for climbers to traverse the mountain from the Galenjoch to the north, the line followed by Mummery, Penhall, Burgener and Imseng on the first ascent in 1879.

From the Dürrenhorn, the sharp edges of the long ridge ahead of us were etched against the sky, summit after summit. Back at the sacks in less than an hour, we descended to the col before climbing rocks and a steepening snow ridge above a collapsing shelf of crevasses breaking into seracs far below. More steep, mixed climbing led to the summit of the Hohberghorn before an easy descent to the Stecknadeljoch. The pinnacled ridge ahead was turned on the right, traversing a series of loose rock terraces to regain the ridge crest for the final ascent to the Stecknadelhorn's summit (4241m but lacking the col depth to be one of Collomb's independent mountains.)

A short rocky descent and we were back traversing an undulating white crest from one minor point to another along shallow half-moon scoops of snow between them. A jutting gendarme provided more interest, taken direct before continuing along the mixed ridge to a final steep scramble up the rocky crest onto the summit of the Nadelhorn. This was the first 4000m peak I was to climb twice. Cloud was bubbling up in the distance and gathering in wisps out of the air around us, whilst Bob had had quite enough for his first route of the season, so we headed down the north-east ridge to the Windjoch. The wrinkling north face of the Lenzspitze was looking much the worse for wear, with long grey fans of snow scattered with black stones at its foot.

We descended to the Mischabelhütte, where the guardian didn't remember me passing out, although I did remember leaving my gaiters there. Bob's German came in useful again.

'Gaiters? What colour?'

'Red and blue.'

'When was that?'

'29 July.'

The guardian pursed his lips and looked doubtful, then shrugged and led me to an unmarked door which he carefully unlocked. 'See if you can find them.'

Bob and I looked inside. He whistled, 'Blimey!'

The storeroom was absolutely full of kit – waterproofs, fleeces, axes, crampons – everything you might need on an alpine peak, and enough of it to equip an expedition or two. Eventually I found my gaiters amongst a dozen or so other pairs.

Back outside we soaked up the afternoon sun while our sweaty kit was spread out to dry. A low, regular beat grew louder, disturbing my doze. I tried to ignore it, then realised: chopper! And heading this way. I nudged Bob awake: 'Better gather up our kit before it gets blown away by the downdraft. Where's Mike?'

'Don't know.'

We'd just collected our last few bits of kit when the helicopter was on us, clattering its rotors and swirling a mixture of clothing, dust, grit and debris away amongst the rocks around the landing site, while we ducked for cover. The pilot dropped off some boxes then lifted into the air in a violent crescendo before dropping away to the valley. Mike spent a fair amount of time recovering his property from the surrounding landscape.

He and Bob planned to make the Lenzspitze–Nadelhorn traverse next day but by then I needed to be on my way to Chamonix. We shook hands and I walked down to Saas Fee again, taking the bus and train back to Randa and arriving at 9.30 p.m. Full circle.

Chamonix

That was not, however, the end of the season. I was meeting a friend in Chamonix for his first visit to the Alps; Gerald Davidson had arrived early and done some walking to acclimatise. He was keen to climb Mont Blanc but I thought we'd better try something lower first. Unfortunately, he was very ill on the Aiguilles Dorées; so ill in fact that he decided just to walk and valley crag with his partner for the rest of his trip. That left me fit, acclimatised, and lacking a partner for the big peaks.

Some days were spent with the children on the luge, walking the Balcons, or swimming in the cold, cold outdoor pool, turning onto our backs to gaze up at the spires of the Chamonix Aiguilles.

Then Bob and Mike turned up with a better forecast for Chamonix weather than there had been for Zermatt. Rhian and Rhys were pleased to see them: there was always some wordplay and teasing. My son had taken longer than his sister to get into reading, but on this trip he became immersed in Roald Dahl's *BFG*. On finishing it in on the Argentière campsite, he closed the covers and declared, 'I'm into thick books now,' before turning back to the first page and starting over. At some point they had overheard Bob ruefully describing Mike as a 'fit bastard', and, since he was tall, Mike became the BFB. Children sometimes display more tact than we give them credit for.

Aiguille de Rochefort, 4001m – Dôme de Rochefort, 4015m. Traverse: AD

With such a good weather forecast, ambitious plans were laid for a traverse of the Rochefort and Grandes Jorasses ridges over two days, with a night at the Canzio bivouac hut. Unfortunately, leaving

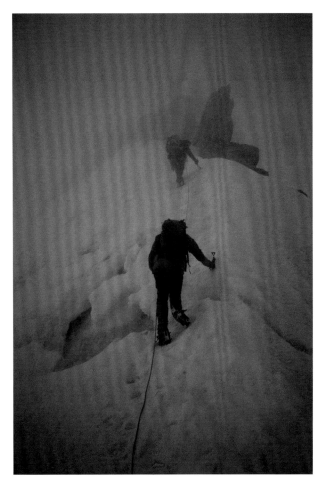

Bad weather on the Rochefort arête.

the Rifugio Torino at 4 a.m., we were greeted by dense cloud blown on an icy wind. Since this had not been forecast and there was no hint of a storm, we decided to 'give it a go'. We could always turn back if the weather became worse.

There was a husky camp then in summer residence on the Col du Géant, providing sledge rides for trippers who came up on the cablecar to Point Hellbronner, the dogs cheerfully sleeping in the snow. Warily skirting the associated mess, we plodded, heads down, across the glacier and scrambled up the broken slopes of the Dent du Géant. There were encouraging breaks in the cloud that allowed moonlight to play over rock and snow around us but recent warm weather and the lateness of the season meant the rock was more unstable than usual. We reached the Salle à Manger in the lee of the Dent du Géant itself and took stock: no better but no worse. We cranked on our crampons and set off along the ridge.

It was narrow but not sharp, and there was not a trace of the famous 'cream roll' cornice. The edge of snow was punctuated by little rock knolls we had to scramble over, and there was a steep ice section by a rock step with an abseil point, but good steps had been cut in the ice, so abseiling proved unnecessary. Braced against the wind and bundled with extra clothing we were each shut in on ourselves concentrating upon the simple business of placing one foot after the other into old steps worn in the snow. The blowing grey curtains would suddenly open onto plunging slopes of snow and rock on either side, but for the most part the sense of space was muffled in obscurity.

For much of its length the ridge appeared to be a strip of grey snow-ice stretched along the all too evident underlying rock. Climate change was only just entering public debate and with no real sense of urgency – but, looking back, the state of the arête in August 1991 first alerted me to the danger: this was an issue that needed taking seriously

The final rocks leading to the summit of the Aiguille de Rochefort were often loose, but with careful use of good holds we made our way easily enough to the summit. The weather was largely unchanged: if anything a little cloudier and windier, but with no sign of major deterioration. We decided to press on to the Dôme de Rochefort and make the final decision there.

We could easily have ended up on Mont Mallet, but puzzling over the map and compass in the mist got us across the snow plateau and onto the correct ridge where mixed ground broke the narrow snow edge into sections. The summit rocks were very loose with confusing traces of alternative routes,

all variously unpleasant, and much longer than anticipated from below. At 10 a.m. on the summit there was still time to go on to the Canzio hut, but the weather was no better. Finding some shelter we decided to give it half an hour while we debated what to do.

We all wanted to go on, but the weather forecast was clearly wrong and we didn't know how far wrong. We had to locate a series of abseils to descend from the Calotte de Rochefort to the Col de Grandes Jorasses, and that could be difficult in this visibility. Meanwhile the wind had grown stronger, the cloud denser, and tiny snow-ice crystals were condensing out of the atmosphere around us before melting onto our hands or clothes. We decided to go back.

Reversing the route, the weather cleared briefly near the Aiguille de Rochefort summit, providing tantalising glimpses of the whitened Grandes Jorasses emerging from the cloud. I left Mike and Bob, who were intent upon climbing the Dent du Géant; I'd done it once before with cold hands, and had no desire to repeat the experience. Three Irish lads who had just come down from the Dent were kind enough to offer me their company and a rope across the glacier back to the hut.

I waited four hours before Mike and Bob appeared, too late to get the cable car down. We ate most of the bivouac food which we'd carried all day, then decided to walk down to Courmayeur in the dark. This is not often done, and we were soon to find out why.

From the cablecar station an exciting traverse through scaffolding led to a steep spur littered with debris and dotted with ruins. We scrambled and stumbled over rock and rubble in almost total darkness until a full moon rose to our assistance at about the same time as I found the first faint traces of a path. Frustrating? Exasperating? All I can say is that I nearly exhausted my expletives.

It was 1.30 a.m. before we reached the car, and Jayne awoke with a shock as I crept into the tent later still.

Mont Blanc du Tacul, 4248m – Mont Maudit, 4465m – Mont Blanc, 4807m. Traverse: PD

We all slept most of the following day. Sometime that afternoon Bob and Mike wandered over to put to me a proposition inspired by the full moon of the preceding night: 'How about traversing Mont Blanc from the Midi by moonlight?'

'Yes; we could take in the summits of Mont Blanc du Tacul and Mont Maudit en route. It would be safer climbing at night, and the moon was like day last night. It would give us more time for a long route like that, too.'

'Mmm, when?' I was doubtful.

'Tonight.'

'But we've only just got up!'

'Exactly.'

'You know what you two are? Lunatics!' But I was persuaded. 'We could carry on over the Bionassay and finish over the Dômes de Miage. I've always fancied that.' What's a little more lunacy when there's so much of it about?

'Okay. Why not?'

We hadn't actually unpacked from the previous trip, so it was just a question of getting some snacks together and catching one of the last cablecars to the Aiguille du Midi. Coffee and croque

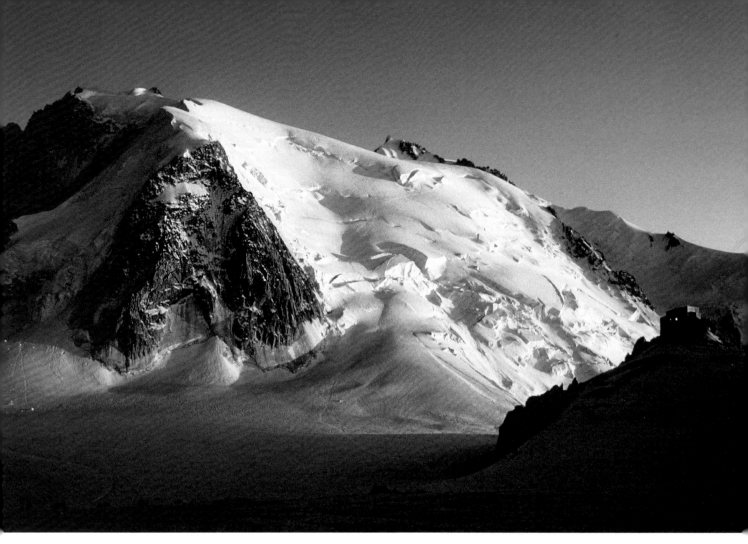

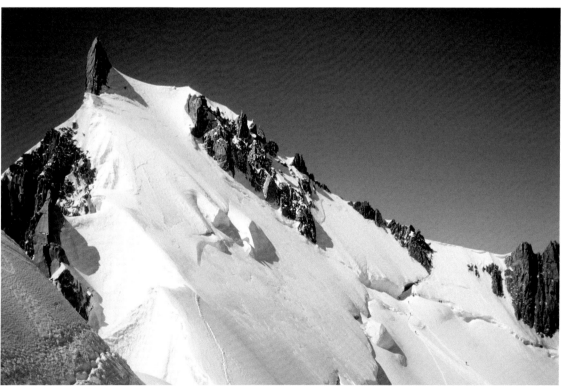

Top: Mont Blanc du Tacul at sunset, seen from the Aiguille du Midi before setting out on the night traverse of Mont Blanc.

Bottom: Mont Maudit with climbers lower right on the traverse to Mont Blanc, and the north-west ridge of the night ascent in profile.

monsieur set us up for the start and we wandered out to the viewing terraces to take photos of Mont Blanc du Tacul bathed in the light of a fantastic sunset.

Leaving the ice cave exit from the Midi station, we found the snow reassuringly crunchy descending the arête, but remained roped up to cross the Col du Midi. As darkness gathered we came across a snowman someone had lingered to make that day. I suddenly tired of the tug of the rope at my waist.

'Hey guys, I'm feeling really focused and I think I'd like to solo the route. I don't think there's any danger of hidden crevasses at these temperatures and in these conditions. What do you think? I can wait for you at the Vallot and we can decide what to do next then.'

'It's your call if you're prepared to take the risk. We can keep an eye out for you in case anything goes wrong.'

'Yeah … Okay. Let's meet at the Vallot.'

'Thanks, guys.' And it was decided.

What was a little more lunacy in the mixture? In fact there is something very special about being thrown entirely onto one's own resources; an intensity of concentration that lifts the experience onto another plane. Tyndall writes in 1861:

> As a habit going alone is to be deprecated, but sparingly indulged in it is a great luxury …. And so, at rare intervals, it is good for the soul to feel the full influence of that 'society where none intrudes.' When the work is clearly within your power, when long practice has enabled you to trust your own eye and judgement in unravelling crevasses, and your own axe and arm in subduing their more serious difficulties, it is an entirely new experience to be alone amid those sublime scenes … You contract a closer fellowship with the universe in virtue of your more intimate contacts with its parts.

Toiling up the initial slopes of Mont Blanc du Tacul, I was bitterly regretting the decision to leave my ski pole behind; there would be a lot more use for it ahead. Then suddenly there was a ski pole lying by the side of the track. It's impossible to regard such things as anything less than good omens, though I was soon to wonder about that as I hurried over the precariously wedged ice blocks that bridged a giant crevasse, ritually reminding myself that there was little chance of movement at that time of night. I avoided stumbling up the rutted track broken up by those descending the route, by cramponing its margins. The trail weaved its way through ice cliffs and crevasses, at one point traversing under an overhanging serac, fringed with a curtain of icicles, up the north-west face to the épaule. There I swung east along a narrowing ridge and over a few rocks to take a break at the summit cross and admire the colours twinkling from so many stars. It was 10.30 p.m.

The moonlight illuminated the snow valley between me and the dauntingly steep slopes of Mont Maudit as I cut down direct to rejoin the trail, jumping a crevasse on the way. Pushing on, I recalled descending that way ten years earlier and the later disappointment Rick and I had shared, traversing off Mont Maudit's summit ridge after climbing the Kuffner route. It was good to think of tying up those loose ends.

Turning a serac buttress, the trail rose steadily up steep snow, around seracs and over quite sizeable crevasses by good and not-so-good snow bridges. Shadowed from the moonlight by the bulk of the frontier ridge, it was half-way along this section that my torch battery ran out so that I was forced to change batteries largely by touch; fumbling with fingers chilled to the bone in the strengthening wind. Towards the Col du Mont Maudit the slope noticeably steepened with a delicate traverse leading to a final steep ice pitch equipped with abseil stakes.

From the col, I followed the north-west ridge to the summit. The climbing was thoroughly enjoyable with thin snow ridges linking rock outcrops which were turned on the right or taken direct. It was good to be moving well over mixed ground without the constraints of rope or partners' pace, but there was no room for error, which somehow added to the 'lonely impulse of delight.' Finding a sheltered spot just below the summit, I took another refuelling break and watched cloud building amongst the peaks below on the Italian side. The monochrome summits were illuminated by sudden isolated flickers of lightning.

As I scrambled down rocks and a long snow slope to rejoin the trail at the Col de la Brenva, the moon seemed to yield a more intense light and I noticed a large lenticular cloud had risen above the rest over Italy. It trailed several flashes of lightning but there was not a sound beyond my breathing and the wind rattling my Gore-Tex. The cloud came no closer, as the wind was blowing from France. And blowing colder too! My knees had tightened up on the descent and now the climb up from the col was simply not generating enough heat, so I had to stop and add overtrousers and overmitts to my shell clothing. Despite this, cold leaked in like a trickle of icy water wherever another layer or a better overlap was needed. It was important not to become overdressed and end up sweating away my strength, but equally necessary to avoid being worn down by continuous cold that was already making my face feel tight and uncomfortable with incipient frost-nip.

Old and new trails interlaced up the flank of the summit snowfield, around crevasses or over well-frozen snow-bridges. The moon cast deep black shadows so that checking for crevasses became a habit: Bob told me later that at one point he had shouted 'Crevasse!' to Mike and leapt over a black shadow that turned out to be a path! It was a long hard pull, and I consciously synchronised my breathing with a rhythm in the use of axe and pole, allowing a pause for breath at each point where I swopped axe and pole over as the trail moved from zig to zag. Up and up, losing track of time, suddenly the slope fell away in front of me and I realised I was on the summit ridge.

Over to the left lay Mont Blanc de Courmayeur, and a sudden interest in how the weather was developing in Italy, combined with the feeling that I might as well add an unclimbed top to my unclimbed peaks led me into a fine mixed scramble along the connecting ridge. Altitude results in some strange states of mind. Reassured about the weather, I reversed the route, before heading up onto the narrowing Bosses ridge.

Stepping carefully along the crest, I stopped at the highest point just to let the realisation sink in that I was the sole person on the summit: a real 'top of the world' feeling. There was only the ever-present sound of the wind as silvered ridges and cloud-hazy valleys spread like ripples outwards over the map of Europe and distant headtorches found their way out of the Refuge les Grands Mulets far below.

I descended easily to the Vallot hut where the squalor was something of a shock after the cold purity of moonlight. People were sleeping wherever they could find a space, whilst others getting ready to leave walked over rucksacks and sleeping mats in crampons. There was scattered litter and it stank, but at least there was shelter from the wind while I nibbled breakfast and waited for Bob and Mike. They turned up an hour and a half later, at 6.30 a.m., and we agreed that the Bionnassay extension made sense. I'd had enough of the Vallot, so left them to warm up and carried on.

Over the Dôme de Goûter, I headed down the ridge towards the Col de Bionnassay, passing teams climbing up the Aiguille Grises route from the Rifugio Gonella. An attenuated east arête of the Bionnassay was more or less in its notorious 'knife edge' condition; the more substantial sections I took at a crouch, balancing myself with axe and hands against the pluck of the wind. Where the ridge

narrowed to a blade I was forced to make slow and uncomfortable progress 'à cheval', at least until a strong sense of foreboding stopped me mid-shuffle.

What was wrong? Weather was holding. Wind was no stronger. Was it the snow? Leaning carefully to one side, I could make out that the arête I was cheerfully straddling was holed right through at several points. I inched gingerly backwards to safe ground.

The only way to carry on would be to traverse the ice below the rotten crest, but it was so steep that ice screws would be needed for protection. Well, when Bob and Mike arrived we'd have three of them, so that looked feasible. I waited for the lads to arrive, and when they did I explained the situation:

'So if one of us leads, places an ice screw midway then uses another for the belay that means three ice screws will do.'

'Ah.' They didn't seem very enthusiastic.

'Well?'

'Ah … yes … well. That's not going to work.'

'Er … why?'

'Well. We haven't got any ice screws.'

'What do you mean, "We haven't got any ice screws"? I've got an ice screw and I've just soloed the route.'

'We left them out to save weight.'

There was a long moment in which the only sound was the wind.

'Okay. Game over.'

We climbed back up to the Dôme de Goûter, had a picnic above the Goûter hut in a sheltered spot with fantastic views of the north-west face of the Aiguille de Bionnassay, then plodded down to Les Houches. We had to take turns to wake each other up on the bus back to Chamonix, but it had certainly been a night to remember.

Two days later I was home.

8:
Guidebooks

For the earliest explorers of the Alps there were no guidebooks any more than there were reliable maps, hence the dependence on guides. Gradually information began to be compiled to provide the earliest alpine guidebooks. These were travel guides intended for the independent traveller to find the means of transport and accommodation with which to explore what were still secluded alpine valleys. The two most famous of these were *Murray's Guide*, published by John Murray in London in 1838 and *Baedeker* – actually *Die Schweiz. Handbuch für Reisende, nach eigener Anschauung und den besten Hülfsquellen bearbeitet* by Karl Baedeker – first published in German in 1854, although subsequent editions were published in English in 1863 and 1867. Revised editions of both guidebooks continued to be published into the 20th century. They both described notable excursions but were in no way climbing guidebooks.

In 1843, Professor J. D. Forbes published *Travels through the Alps of Savoy and Other Parts of the Pennine Chain, with Observations on the Phenomena of Glaciers*; it was the product of Forbes' extensive travels through the Alps recording scientific observations but also crossing high snow passes and ascending several peaks. The book was a blend of travelogue and scientific textbook that became an inspiration to scientists and mountaineers alike and was, to some extent, responsible for developing a style of climbing that somehow blurred the distinction between the two. Coolidge said of Forbes, 'Few men, if any, have ever known the whole of the Alps better than he did, while none did while he was in his prime.'

The naturalist and politician John Ball, first president of the Alpine Club, also edited the first journal of the club, entitled *Peaks, Passes and Glaciers*, in 1859. The journal under his care was clearly envisaged as a medium for pooling information about the exploration of the Alps that had been undertaken by members, a kind of informal guidebook. Later editions adopted the simpler title of the *Alpine Journal*, and it has continued to be published right up to the present. Clearly, however, it was not systematic enough for Ball, who produced his *Alpine Guide* in 1863–68. His stated intention was 'not to conduct his readers along beaten tracks but to put them in a position to choose for themselves such routes as may suit their individual tastes and powers, to give advice as to what is best worth notice, and to show what is open to the prudently adventurous'. The alpine climbing guidebook had arrived.

The Alpine Guide went through a number of revised editions over the years, until in 1892 Conway and Coolidge collaborated on a Zermatt guidebook. This collaboration continued with a guidebook to the Pennine Alps, later extending the series to cover other alpine areas. By 1896 Whymper had realised the income potential and brought out a Chamonix guidebook which was followed in 1897 by a separate one for Zermatt. Whymper detailed peaks, passes, the names and tariffs of local

guides, facilities including railways and hotels, some background information about the area and the climbing, and excursions covering a range of difficulty. These guidebooks sold well, going into 16 and 17 editions respectively.

To some extent this is a measure of the increasing trend towards guideless climbing, but despite the endeavours of Girdlestone, the Pilkington brothers and F. Gardiner, climbing guideless remained controversial. First Fred Mummery, then George Finch were blackballed by the Alpine Club, principally for their advocacy of guideless climbing and the search for challenging routes. Coolidge claimed that he 'cheated Mummery into the Club', by interfering with the blackballing process.

In 1946–7 new guidebooks were published in France, edited by Lucien Devies, the president of the Groupe de Haute Montagne, a cutting-edge French climbing association. They were detailed and up to date, and their quality may account for the popularity of the Chamonix area amongst British climbers. In the 1980s I can recall Bob Thomas of the Chester MC, fluent in French, coming up with some very interesting variations on routes after hunting through the latest editions of the Guides Vallot. In the 1940s these guidebooks tipped the balance decisively towards guideless climbing, a tendency reinforced by the Alpine Climbing Group guidebooks of the 1950s.

In 1952 the Alpine Climbing Group was formed as a result of dissatisfaction with the conservatism of the Alpine Club which was thought to be responsible for the stagnation of British climbing during the inter-war years. Tom Bourdillon was the first president of the ACG, and its membership reads like a roll-call of the best British climbers of the post-war years. One of its early commitments was to produce guidebooks of selected climbs from the *Guides Vallot* translated into English for British climbers who had missed out on learning French. Edited by Ted Wrangham, these guidebooks helped open up the Alps to many outside the charmed circle of the Oxford and Cambridge University Mountaineering Clubs so inextricably linked to the AC. However, in the 1960s the ACG began to encounter financial difficulties that threatened the continuing production of these widely acclaimed guidebooks. In 1967, after some tense horse-trading, the ACG merged with the AC on a five-year trial basis that was confirmed in 1972. The guidebooks to selected climbs in the main areas of the Alps went from strength to strength right up to the present, the most recent being a guide to the 4000m peaks.

Today there is a wide range of alpine guidebooks covering all the alpine ranges. Many are available only in the language of whichever alpine country in which they happen to be published, particularly with respect to ski-touring guidebooks, but multilingual publications with route descriptions in French, German and English are increasing. The various areas are not uniformly covered: Chamonix, as the most popular climbing centre, has almost too many guidebooks, whilst the Bernina and Bregaglia are only covered in English by an Alpine Club publication. Gaston Rebuffat's *100 Finest Routes in the Mont Blanc Massif* is the only one of the 100 Finest Routes series to be available in English, but the series does cover the other alpine regions pretty well in a format that is useful for more leisurely planning of a summer campaign at home, armed with an appropriate dictionary. Topo guides offer international symbol-based descriptions, but lend themselves more to rock routes than mountaineering routes.

The internet provides up-to-the-minute information on conditions and routes being climbed on websites such as Camptocamp. However, it's worth remembering that, as with so much on the internet, such information can never be 100 per cent reliable. That is also the problem with all guidebooks, but especially so with those relating to the Alps. Leslie Stephen wrote in 1870, 'nothing can be less like a mountain at one time than the same mountain at another'. Whymper wrote the following about the Italian ridge of the Matterhorn in his notes to the Preface of the 5th edition of *Scrambles Among the Alps* (1905):

Some English language guidebooks.

In August 1895, I ascended the S.W. Ridge as far as the base of the Great Tower … More than 30 years had passed since my last visit, and I found that great changes had taken place in the interval. The summit of the Col du Lion was lower than it was formerly, from diminution of the snow; and the passage across it was shorter than it used to be. For the next 150 feet or so of ascent there was little alteration, but thence upwards the ridge had tumbled to pieces, and many familiar places were unrecognizable.

No spot on this ridge is more firmly fixed in my recollection than the Chimney. Only a remnant of it was left – more than half the Chimney had disappeared; and from that point upward everything was altered. Difficult places had become easy and easy places had become difficult. The angle in which a thick knotted rope is now dangling, which is now one of the steepest bits of the ascent, did not exist in 1864.

The Alps are youthful mountains in geological terms, and are subject to increasingly aggressive erosion as climate change takes effect. A 'dry' winter will result in completely different conditions from those experienced after a winter of heavy snowfall, and those seasonal changes can themselves change from week to week and day to day as the weather changes during a climbing season. In alpine guidebooks it is just not possible to provide the level of detail or accuracy found in British rock climbing guides, which are tailored to a more stable geology and less extreme weather conditions.

G. W. Young records (*On High Hills*):

We found one day that an unusual coating of hard snow enabled us to scamper about over the unchancy slabs of the west face of the Dent Blanche. We reminded ourselves that the west face of the Rothorn had remained unclimbed by reason of a similar slope of slab; and we argued that the same aspect and structure should be susceptible of

the same snow condition. A few days later, accordingly, we crossed the Trifthorn from Zermatt, ran down the snow dunes to the western base of the Rothorn and found our prediction triumphantly vindicated:- there above us shone a gleaming wall of hard snow mounting from bergschrund to summit ridge.

He goes on to describe 'the easy gratification of that [first] ascent' which was entirely the result of the unusual conditions. Without those conditions the face would have remained unclimbed for much longer. There is a lesson here about the selection of routes: if conditions aren't right for a route, don't do it. Failure to observe this practical principle has been the reason for many an epic.

George Finch, in *The Making of a Mountaineer*, gives an exemplary description of his meticulous ten years of reconnaissance and planning to overcome the difficulties involved in making the first ascent of the north face of the Dent d'Hérens in 1923 – but however much research and planning is done before the season commences, it must all be up for review in the light of prevailing conditions.

Guidebooks in English specifically relating to the 4000m alpine mountains are worth special mention. *The High Mountains of the Alps Volume 1: the Four-Thousand-Metre Peaks* by Helmut Dumler and Willi Burkhardt, published by Diadem, with additional photography by British climbers and much editorial effort by Ken Wilson, is an inspirational coffee-table classic that is good for advanced planning and general browsing. *The Alpine 4000m Peaks by the Classic Routes*, by Richard Goedeke, published by Baton Wicks, is more like the sort of guidebook that might be carried on a route but is limited by its concentration on the easiest routes on each mountain, which are not always the most enjoyable. *The 4000m Peaks of the Alps* by Martin Moran, published by the Alpine Club and revised in 2012, was probably the most up-to-date guidebook available until *4000m Peaks of the Alps – Normal and Classic Routes* by Marco Romelli and Valentino Cividini, was published by Idea Montagna (Editoria e Alpinismo) in June 2015.

9:
Saas Fee;
ski-mountaineering, 1992

After an ill-fated introduction to skiing in 1979, I finally got the hang of it and spent the 1980s fulfilling my ambition to ski black runs fast, with style. Skiing became the focus for family winter holidays and led to some ridiculously good fun off-piste once my wife began working and we could all afford to go.

Then for Easter 1990, Paddy Feely, another Chester MC member, got a group together to 'try out this ski-touring malarkey' and we met up in Chamonix, to potter about in dubious weather, working out the basics of ski-mountaineering. I recall there being some debate about whether we should leave the skins on or take them off in descent! An excursion to the Vignettes hut, where we were pinned down by a blizzard for three days before escaping back to Cham and that was it. But the following year, Ralph Atkinson, a climbing partner I'd met in Wolverhampton, Denis Mitchell and I completed the classic Haute Route in six days of good weather that included an ascent of the Pigne d'Arolla: travelling through stupendous mountain scenery coupled with the excitement of off-piste skiing – I was hooked!

It didn't take me long to realise that making ascents on ski would be one way of removing the more obstinately glacial of the 4000m mountains from the catalogue of drudgery. Not only was the kick-glide of skinning uphill a smooth, fast action, but routes that took hours to ascend could be descended in a matter of minutes on ski with a great deal more fun to be had on the way. An Easter ski-mountaineering trip would effectively add two weeks to the alpine season, providing further opportunities for 4000m ascents. What was there not to like?

Pete McCombie and I had climbed routes in Chamonix during the summer season and he too wanted to break into ski-mountaineering. In 1992, he, Denis and Malcolm, another teacher and climber, joined me for a trip to the Bernese Oberland. With its huge glaciers, the Oberland lends itself to ski approaches to the relatively short summit ridges of most of its 4000m mountains, but its westerly position means that the massif is often the first high ground that weather fronts hit, so orographic precipitation goes with the territory as we found out.

Driving all night, we arrived in Grindelwald in time for breakfast at the excellent Hotel Glaciers, meeting Jeff Harris and his team who had arrived earlier and booked us into the dortoir. They went skiing while we settled in and caught up on some sleep: there was not much to Grindelwald at that time, despite its reputation; second-rate climbing stores and a few gift shops were about it.

Next day we drove around to Lauterbrunnen and took the cablecar up to the Schilthorn, scene of some remarkable stunts in the James Bond film *On Her Majesty's Secret Service*. A warm-up run and then we skinned over the Hundshorn, puffing a bit in deference to the altitude, before skiing off-piste back to the valley via a large snow basin.

Cloud and light snow meant no touring the following day, but Jeff's team skied the pistes and it brightened up in the afternoon. That evening they decided to head off to Chamonix where there was access to free accommodation in a friend's caravan. I was surprised when Malcolm suggested we should go too, because there was no room for us in the caravan and no 4000m peaks to ski; after all, that was what we were there for. Next day another dubious weather forecast turned out better than expected as we skied the Lauberhorn area, with magic moments dropping into chutes between rock outcrops under the Eigerwand. Pete confessed to some lack of confidence on the steep stuff, but we could wait for him.

More snowfall meant the high peaks would be out of condition, so we drove up to the end of the snow-ploughed road and skinned up to Steingletscher village instead. Heavy snowfall continued as we followed the road, skinning through tunnels turned into eerie ice caves, their mouths stopped with snow but accessed by body-width cuttings through the drifts. In places we had to climb awkwardly over avalanche debris blocking the road. At Steingletscher the Alpin Center winterraum was open and actually led into the main building with background heating and water left on. They should have been open for business, but no one was home. A guided party descending from another hut stopped by to ask us about the conditions on the descent to the roadhead and we were able to reassure them that the tunnels were passable. We ate our lunches in the shelter of the winterraum before gently schussing back to the car.

In such conditions we were unlikely to climb any major peaks from Grindelwald, but the subsequent debate about where to go instead really plumbed the depths when it was suggested we go to Chamonix 'for a weather forecast', then on to Serre Chevalier, a 500km journey, 'because it's always better weather further south, that's why my mate Andy's going there next week'. In that case I wondered how the snow pack was ever established in the southern Alps and, since we had no planning in place for what touring we would do in the Écrins, I remained unconvinced. Argument fed on frustration, and one person's idea of debate seemed to be to ridicule the ideas of anyone else. It was the first time in the mountains that I'd encountered personnel problems which prevented the team reaching effective decisions, and this was despite the basic agreement that we should move.

Finally Denis and I came up with the idea of relocating to Saas Fee, which we reckoned should benefit from being in the rain (and snow) shadow of the Oberland. After more argument we reached a grudging agreement, although when we encountered some light snowfall on our way up to the Goppenstein tunnel there was 'I'd get as far away from here as possible' from the back seat.

A mixture of cloud and sunshine met us in the Rhône valley when we emerged from the tunnel, but at Saas Fee it was cold and sunny. Denis and I sorted out some accommodation, only to get complaints about the cost and the cold. More argument was only ended by the proposal to at least have a go at the Weissmies next day.

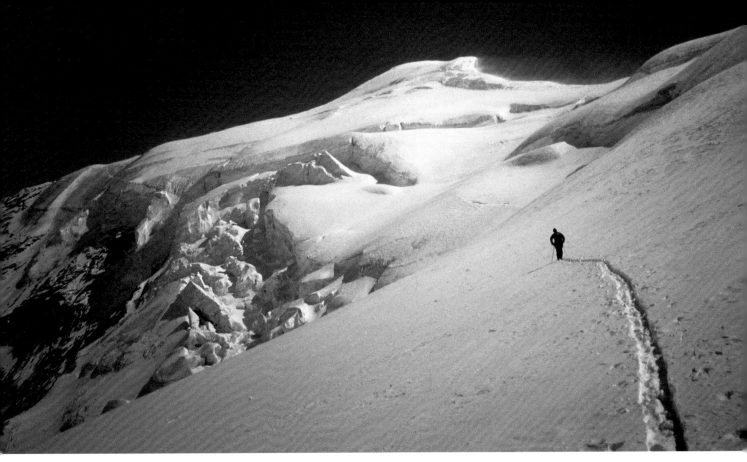

Breaking trail towards the summit of the Weissmies.

Weissmies, 4023m. Trift Glacier and South-West Ridge (Triftgrat): PD

There had been some snow showers earlier in the week in Saas Grund, so when we took the Hohsaas lift to 3000m we found a few inches of snow on a firm base. The sunshine was encouraging, but a bitter wind made us wary of windslab as we climbed the Geissruck spur behind the lift station. The plan was to cross the Triftgletscher basin higher up, then climb steeply up the icy Triftgrat opposite to what seemed to be the crux of the route at a deeply crevassed section with ice steps above.

A lovely powder slope led down into the basin, but when Malcolm and Pete arrived they were clearly tense and anxious about avalanche danger. Denis and I thought there was insufficient build-up to be dangerous, and mid-argument a local lad with his girlfriend caught up with us and confirmed that reading of the conditions. We all carried on across the basin to ascend the shining spur, but then the couple decided that breaking trail at this altitude was too much like hard work, wished us good luck, and turned back.

Denis led at first, then let me take over breaking trail. We had to be careful not to take too steep a line and to try to break a clean-cut trail, otherwise unconsolidated snow might slip away from under the edges of our skis. I reached what seemed to be a bergschrund and worked my way along its lip, searching for a crossing point, until I found myself below a very steep ice cliff on the edge of nothing: I worked my way back. It is surprising how much more amenable a crevasse bridge will appear when you know there is no alternative. The snow bridge in question led abruptly up from the lower lip of the bergschrund onto a short rising traverse to the right around the vertical ice above.

I strapped my skis onto my rucksack and was just about to step off the lip when Malcolm and Pete arrived. Pete's doubts about the snow were being reinforced by Malcolm's alarmist comments. He seemed to be trying to inject sufficient drama to develop a sense of crisis, shouting up to me 'Probe that with your ski pole or you'll be 50 feet down that crevasse!' as though I hadn't done so already.

I gave the snow bridge a few hefty thumps with my axe to demonstrate its solidity then climbed on to it. Taking my full weight, its true nature was revealed as with a muffled crump it settled more securely into the crevasse: it was a wedged block detached from the ice step above. The shock on Malcolm's face almost made me laugh and with no further evidence of movement I climbed quickly round to the small snow bowl above the ice. From there I could hear the outraged comments and vehement persuasion being exercised upon Denis: 'It's stupid to go on …' etc. etc. To his credit, Denis listened then made up his own mind and crossed the bridge after giving it a reassuring whack of his own.

Above the small ice cliff we could put our skis back on to break trail on a leftwards slanting traverse up glacier shelves to the summit ridge. As we did so we could see the small figures of Malcolm and Pete skiing down. Increasing icy sections and wind-carved sastrugi eventually persuaded us that we would find the ascent less awkward without the skis, so we left them cached in a patch of deeper snow. We each adopted different strategies to cope with the conditions; Denis reverted to axe and crampons while I chose to kick steps with ski poles for balance. Gaining height, we were more exposed to the bitter wind that buffeted and bowed us beneath its power. As the altitude slowed our pace, feet began to feel like lead and fingers became wooden, completely unfeeling, to be flexed back to life with excruciating 'hot-aches'.

At a slight saddle, I stopped to fumble my crampons on and swap one pole for an ice axe to climb the final summit slope. The wind was even stronger, driving spindrift into our eyes, leaving us gasping for breath, but it was a great adventure. I remember seeing Denis approaching the summit with plumes of spindrift being torn from it and thinking that it looked positively Himalayan. We were the only ones on the mountain, and each of us was very alone, isolated in our shell suits in a very personal struggle with the elements.

Just below the summit we managed to tuck in under the cornice and put on extra clothing for the descent; then it was over the top to take a few summit photos, braced against the wind and shouting

Skiing down from the north-west slopes of the Weissmies.

to make ourselves heard. My nose had gone completely numb, the drip at its tip frozen solid. We rapidly descended to the skis that even more rapidly took us back to the bergschrund. The bullying wind and snow-covered sastrugi conspired to throw us off-balance but, however challenging, it was skiing on top of the world.

Reversing the crevasse crossing was easy, and below that we picked a good line down the Triftgrat leaving nice, even wedels in the snow. Crossing the Triftgletscher higher than before, I found old avalanche debris, hidden under new snow, and took a bruising fall on its unexpected solidity; like finding concrete blocks under feathers. But nothing could detract from the superb skiing as we worked around to the right, skirting crevasses in perfect snow, to reach the long piste back to the middle station. By then there were no cablecars running, so we skied down diminishing tongues of snow in golden evening light until the snow ran out completely and a short walk took us back to the valley. It was 7 p.m. on a very Good Friday. Next morning was cloudy with light snow showers and a forecast that read 'fine, then changeable'. This proved a recipe for more agitation about heading for Serre Chevalier, but eventually we all boarded the Felskin lift to spend a few days at the Britannia hut. Rising out of the valley mist into blazing sunshine, we realised that we had wasted most of the day in ill-tempered argument when we could have been skiing in perfect conditions above the temperature inversion. By then it was too late to do anything more than traverse to the hut and settle in.

Strahlhorn, 4190m. Adler Pass and West Ridge: PD

We were out at first light on Easter Sunday, into a glowing hard-edged morning with that familiar cutting wind, heading up to the Adler Pass. We made good time skinning up easy slopes through frozen ski tracks raised above the windswept snow base like crazy railway lines. From the pass we could continue on ski to within 50m of the summit of the Strahlhorn, although icy stretches meant that some of us were more comfortable walking in crampons.

The same problems with altitude and cold that Denis and I had encountered on the Weissmies caused more discomfort here, but the weather remained fine despite some threatening lenticular cloud. From the summit the whole of the Monte Rosa group seemed huge and unfamiliar from this angle under a sky marbled with thin cloud. As Karl Blodig put it:

> I had expected much of the view from the Strahlhorn, yet it offered infinitely more, above all the simply overwhelming sight of the eastern precipices of the Monte Rosa massif … The Liskamm, the Zwillinge and the Breithorn are, in the shadow of this massif, not really shown to best advantage but we were agreed that we had never before seen the Matterhorn looking so slender, so ethereal.

Denis and I skied off the summit, finding an exciting drop over an edge straight into a steep traverse and on through the icy patches down to regroup near the Adler Pass. There we all lunched in meagre shelter by the exposed rocks at the head of the pass, muffled against the wind but peeking out of our hoods at the Dent Blanche and Obergabelhorn framed by the pass. Skiing back to the Britannia hut, we encountered variable snow – some excellent, some very heavy – which needed careful reading, but were soon facing the final short steep pull up to the hut. That evening we shared a table with an Italian couple we had met on the Adler Pass who kindly shared their spiced Easter cake with us.

The Strahlhorn from the Allalingletscher.

Rimpfischhorn, 4199m. Via Allalinpass and Rimpfischsattel: PD

A similar start on Easter Monday found us back on the Allalingletscher but forking right to climb more steeply up to the Allalinpass at 3564m. From there we had to descend around two western spurs of the Rimpfischhorn before reaching the final long climb up to the 4000m Rimpfischsattel. A pair from the Täschhornhütte joined us where the two routes met, and an element of competition seemed to creep in as the pace increased. I managed to beat them to the saddle, but they were both into the snow couloir leading to the summit by the time we had all arrived and sorted out gear.

We soloed the couloir but Pete complained of 'feeling geriatric' about the more awkward mixed traverse out of the couloir and onto the summit ridge, so we fixed a rope across that section. Beyond, we were able to solo more mixed ground, passing the pair who were pitching it, to reach first the fore-summit, then, after a slight descent and further mixed climbing, the main summit. A prominent painted rock and a cross chiselled into a nearby slab confirmed we were there. Time to grab a quick lunch looking down onto the icy trail up from the Adler Pass to the summit of the Strahlhorn and beyond to the panorama of Zermatt peaks from Nordend to the Matterhorn.

In descent we let the other team go ahead to use our rope, then found another pair coming up who also appreciated its presence: 'You are real English gentlemen,' they commented with just a trace of humour. Of course it was not going to be there on their way back. Coiling the rope, we booted easily down the snow to the Rimpfischsattel.

From there we skied down to below the first spur, using aggressive jump turns to overcome breakable crust: it seemed to work most of the time. Then we took a higher line, skittering across ice

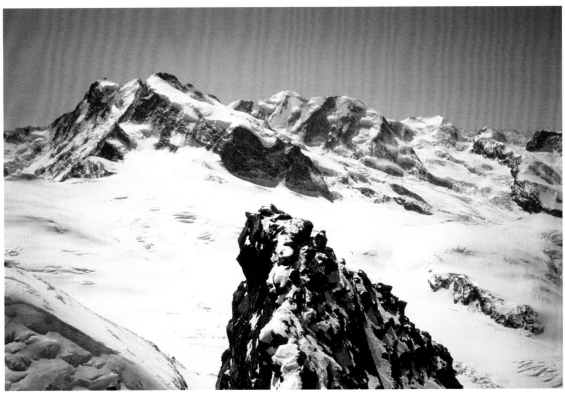

Top: Skinning up to the Rimpfischhorn with the Täschhorn, Dom, Lenzspitze and Nadelhorn in distance.

Bottom: The view of the frontier ridge from Nordend to Pollux, looking south from the summit of the Rimpfischhorn.

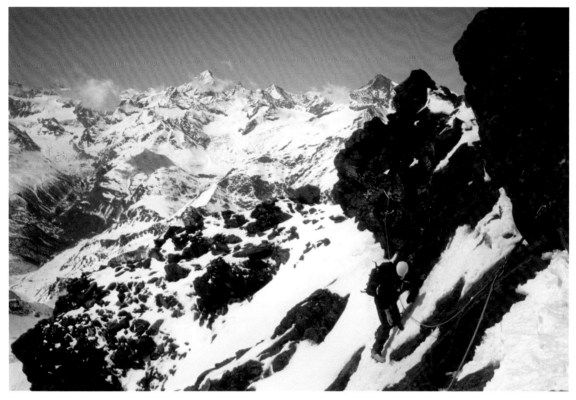

Descending the tricky traverse on the Rimpfischhorn.

onto névé, before jumping off the upper edge of a crevasse onto a steep traverse line. Pete found it all a bit challenging so changed to crampons and carried his skis: more secure, perhaps, but much more time-consuming.

We waited, then schussed just below new avalanche debris to a short climb, stepping up the flank of another spur, thereby avoiding a considerable loss of height. On new ground I spotted a good line with just one patch of ice that caused little difficulty before we could all ski easily down hard névé, dodging sastrugi, to reach the Allalinpass. We regrouped, then ripped down steep slopes back to the Allalingletscher; great fun. By then the route back to the hut had been virtually pisted by the numbers skiing back from the Adler Pass.

Back at the hut, the wind had picked up a bit, but otherwise the weather seemed set fair so we stayed another night.

Allalinhorn, 4027m. Via Feejoch: F

Tuesday was fine again but, with no weather forecast from the apologetic guardian, we had no idea if it would continue that way, so cautiously opted for a day on the pistes of the Feegletscher. Denis and I also decided that we would squeeze in an ascent of the Allalinhorn if possible. There was no need to leave very early, because we could hitch a ride on the Metro Alpin to the Mittelallalin station.

Denis and I left the funicular station to climb around a couple of collapsed seracs to a steep zig-zag traverse. The slope gleamed icily and in places the track was barely wide enough for two skis side by side. Leaving our skis at the Feejoch, we climbed the last icy slopes in crampons to reach the summit, gasping

with the altitude and cold. It was noon. We found some limited shelter from the wind to take lunch and feed scavenging yellow-billed choughs, fluffed up against the chill, then strode back to the skis.

Just above the Feejoch we came upon a family group with a very young ski-mountaineer roped between his parents. He seemed to have skinned up to the Feejoch but was then staging a sit-down protest about climbing to the summit on foot. There was no tension, just resigned amusement from the parents. I tried a few words of encouragement, 'It's not far really. You'll be fine,' but he was probably too small for his English to be good enough to understand me. They start them young in Switzerland.

We took a last look at the Matterhorn with the distant Grand Combin behind it, then clicked into our skis for an exciting descent, through great blocks of fallen ice and crevasses you could drive a car into, to regain the piste. An easy ski down to the Mittelallalin station meant we kept our 2 p.m. rendezvous with Pete and Malcolm, dumped our sacks, and spent the rest of the day skiing.

The upper runs held perfect snow, with interesting off-piste variations down through seracs and crevasses that telegraphed their presence and condition. Lower down, the snow became slushy. As the lifts closed down around us, we collected our packs and started the long, cold run back into the pooling shadows of Saas Fee.

We checked in to our hotel at Saas Grund for a much-needed shower and night's rest, to find a good weather forecast for the next three days. Despite having only three more days before we had to drive home we seemed incapable of agreeing on a common objective. When, 'I think we should go to Chamonix,' came up again, despite being surrounded by superb mountains, I'd had enough.

'Okay. That's it. I'm going home. I'd rather do that than put up with any more arguing.'

'Well, I know it's your car, but …'

'That's right, it *is* my car and that's what I'm doing. You don't have to come if you don't want to.'

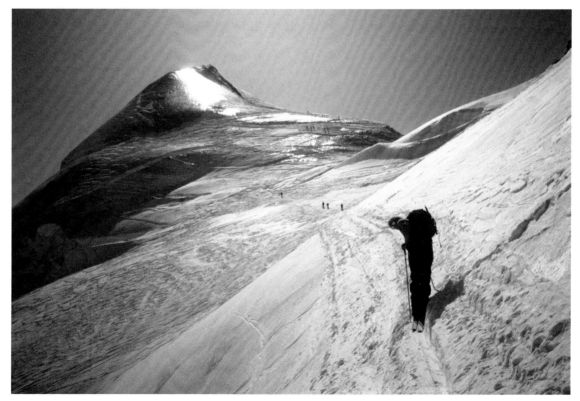

Skinning up the Allalinhorn towards the Feejoch on the right.

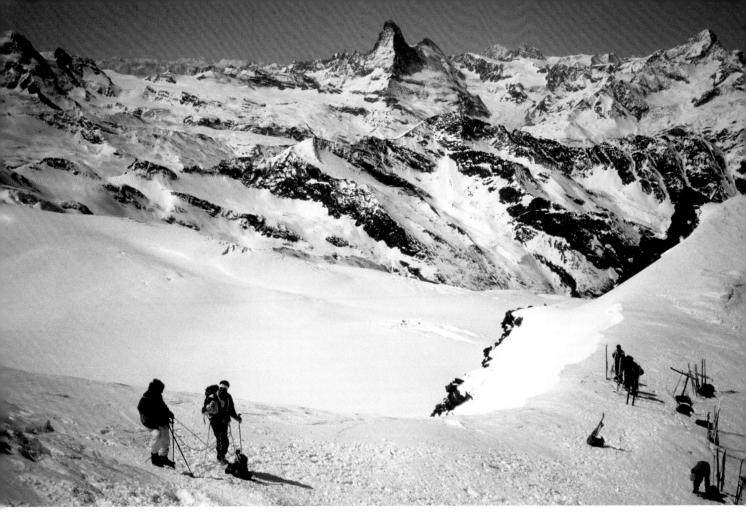

The view west from the Feejoch on the Allalinhorn.

And that's what we did.

The trip had been harder than expected but I shouldn't have been surprised. The Haute Route involves operating mainly around the 3000m level, whilst skiing 4000m peaks involved a lot more hard work and commitment. It wasn't just the additional altitude; more extreme weather and a greater variety of snow conditions were encountered. Wind and ice had been recurrent problems.

There was also the business of team management. Summer alpinism just means getting along with your climbing partner, but avalanche danger when ski-touring means there is only safety in sufficient numbers to be able to search for and dig out a victim; a team of three is the bare minimum. The group dynamics of the trip had been something of a trial. Should I have made sure that we were all skiing at the same level? Perhaps I hadn't made it clear enough that I was planning a trip ski-mountaineering on 4000m peaks rather than just going to do a bit of touring, but I didn't think so. Had I been less than patient with another team member's alternative agenda? I later became aware that he had been having a bad time at work and I too was having a rough ride at home. I knew 'no battle plan survives contact with the enemy', but it was a lesson to me that there was no guarantee a team would all sign up to the planned objectives or itinerary once in the field, particularly if one of them was pushing another agenda.

On the plus side, the actual days out had been superb and I could not have wished for better ascents and descents of the four peaks we had climbed. Leslie Stephen is probably the first to rhapsodise about the Alps in winter:

> Starting, for example, from the loveliest of all conceivable lakes, where the Blumlisalp, Jungfrau and Schreckhorn form a marvellous background to the old towers of Thun, one comes under the dominion of the charm. The lake waters, no longer clouded by

turbid torrents, are mere liquid turquoise … As the steamboat runs into the shadow of the hills, a group of pine trees on the sky-line comes near the sun and is suddenly transformed into molten silver; or some snow ridge, pale as death on the nearest side, is lighted up along its summit with a series of points glowing with intense brilliancy, as though the peaks were being kindled by a stupendous burning glass. The great snow-mountains behind stand glaring in spectral calm, the cliffs hoary with frost, but scarcely changed in outline or detail from their summer aspect. When the sun sinks, and the broad glow of gorgeous colouring fades into darkness, or is absorbed by a wide expanse of phosphoric moonlight, one feels fairly in the outer court of dreamland. (*The Playground of Europe*)

Overstatement? Perhaps, but this trip fairly confirmed my impression that these mountains look just stunning in their winter raiment without the black ice and stonefall that can turn them ugly in a dry summer.

10:
Huts

I had stayed in huts in the UK in mountain areas, converted cottages and the like, usually run by a club based in a city within reasonable travelling distance. They were rough and ready, self-catering and self-managing, with basic sleeping, washing and cooking facilities. My first alpine hut was the Krefelderhütte on the Kitzsteinhorn, more like an hotel, with its restaurant and comfortable bunk beds: 'It's a hut, Jim, but not as we know it!' Only when sitting on the wooden toilet seat on the second floor was the impression of luxury dispelled: the wind came from a quarter that directed it straight into the downpipe, propelling on the updraft a powerful waft of ammonia. Tears trickled down my face, as if I was peeling onions, until I could escape the smallest room.

Luxury had taken some time to develop. As a young teacher with more debts than income, I had slept in the straw of Williams' barn just north of Idwal Cottage on the old road to Bethesda in North Wales, while some UK club huts were originally derelict buildings in which club members had regularly dossed. In the Alps, transhumance – the practice of farmers moving up to mountain pastures with their herds in summer and back down to the valleys in winter – was a key factor in the provision of huts. Originally the word 'alps' referred not to a mountains but to high pastures where basic timber and stone farm buildings provided shelter, initially for the farmers but later for wandering mountaineers. In *Going Walkabout in the Alps* in 1954, Tom Price writes,

> further up the valley I come to a long cowshed with a little living-hut at one end, up steps. It is open. Outside a metal pipe discharges a jet of pure mountain water into a trough. In the hut there are box beds, one with straw; a neat pile of wood lies outside. The time is four in the afternoon. This is clearly the place for me. [At another cowshed he is fed by] a patriarch [who tells him that] They stay up here … for three months making butter and cheese and living on milk products and maize.

As late as 1979 in Austria on one such alp, I recall securing the last bed in a spacious bedroom shared with three other climbers, the farmer and his wife, whilst latecomers bedded down in the hayloft overhead.

In the Alps there was also the tradition of the hospice. Often monastic, or at least set up by monasteries based in the valley below, they were sited at or near the head of major passes. Some idea of the importance of transalpine trade routes can be gauged by the fact that the first alpine tunnel was excavated in 1482. The Buco di Viso was 76m long and continued to link the Po valley with the Queyras, now in France, when the summer route over the Colle delle Traversette was blocked with snow. Mountain weather and avalanches could make such passes lethal, so hospices offered a refuge to wait out a storm. There was a Roman road over the Grand St. Bernard Pass, although any buildings were ruined by 1050 when St. Bernard of Menthon founded the hospice there, followed by another

Rifugio Vittorio Emmanuel II.

on the Petit St. Bernard a few years later. The canons that ran the hospices not only offered refuge and hospitality but actively patrolled the passes in search of those in distress, breeding and training the St. Bernard search and rescue dogs to help in the task. The tradition continues to this day.

Both the monastic and the transhumance traditions were very spartan, but as the sport of mountaineering became increasingly popular in the 19th century, climbers used transhumance trails to access the mountains, and local entrepreneurs realised there was a demand for accommodation on the high alps; local people began to modify the cowsheds to that end as well as opening new hotels in the valleys. The pioneers of the golden age of alpinism often write of high prices charged for very basic services and facilities. Whymper refers on more than one occasion to having to 'pay dearly for …. a lordly bill against which all protest was unavailing'.

Then in 1863 the newly formed Swiss Alpine Club opened the first club hut, the Grünhornhütte on the Todi, followed by the Trift hut near the Dammastock. In the following decades the national clubs of other alpine countries were to follow suit in an explosion of hut building. By 1888, Baedeker could comment in his *Guide to the Eastern Alps*:

> The numerous Club Huts erected within the last few years … have done much to
> increase the pleasures and decrease the discomforts of the higher ascents. These huts
> are generally well fitted up, and contain mattresses or hay-beds, woollen coverlets, a
> small cooking-stove, cooking utensils, plates, and glasses.

Comfort indeed. Over the years these club huts were developed and expanded, with a guardian often in charge during the busy summer season.

Most huts used to climb the 4000m mountains will be of the guarded variety. Open from late June until late September, with regional variations, they offer a place to stay on the night before a climb.

Those run by the national alpine clubs are usually adopted by individual local sections based in major cities like Geneva, Lyon or Milan. In the eastern Alps, cities like Prague that were part of the Austro-Hungarian Empire before the First World War maintained their support for huts in Austria despite the emergence of an independent Czechoslovakia. There are also private huts in popular areas operating basically the same systems.

Booking huts in advance is only common courtesy so that the guardian has a better idea of how many people to cater for that evening. Although no-one with a membership card for any of the alpine countries' national clubs will actually be turned away, a place for the night could well mean nothing more than the floor. The exception is the Goûter hut on Mont Blanc that is now usually fully booked a year in advance by guided parties, and there is an assumption that that fact is so well known that people can be turned back to the Tête Rousse hut below.

On arrival at a hut it is important to change into hut shoes (since boots are not usually allowed inside), hang up axes, crampons and ropes in the anteroom or outside, then check in with the guardian. He or she will usually allocate a bunk number for each person and record climbing plans in order to group people rising at a similar time in the same dorm and assist any search and rescue mission that may follow the non-return of a party. Guardians may well be the ones to initiate a search and are a fund of information on the current condition of routes in the area, so it's well worth keeping on the right side of them.

Bunks may be in pairs or blocks but often there is just a long sleeping shelf or two, known as a Matratzenlager in German-speaking areas. Larger huts may offer two- or four-person rooms, a significant feature of private huts in the Dolomites. Bedding is usually only a pillow and blankets, so the use of sheet sleeping bags is increasingly encouraged for hygiene reasons and may be compulsory at some huts; a silk sleeping bag liner weighs very little and packs up small. A head-torch is useful in finding the way to the toilet, and earplugs will help give a reasonable night's sleep. Early English climbers railed against the continental aversion to fresh air, hence the traditional struggle over whether the dorm window would be open or closed, but in my experience continental climbers have now so thoroughly embraced the fresh air principle that a raging gale can be blowing in the window and out the door of dorms without most of them turning a hair. There is usually somewhere to wash, if only at the water trough outside, although these days a few huts even have showers. Toilets can be anything from the traditional long drop to modern eco-loos.

In French huts there are usually self-catering rooms, but in Switzerland or Italy these are few and far between, and gas stoves are the only ones permitted inside. It's not much fun cooking outside a hut! In Swiss huts, guardians used to cook food that climbers brought for a small charge but this practice is now rare. The communal dining room serves as a general relaxation area outside evening mealtimes, when the demands of serving a hundred or more hungry climbers with limited staff and kitchen facilities can be stressful all round. Food is good and plentiful. This is where many guardians make most of their living, as the levy paid to the parent club takes the lion's share of the bed fees.

The guardians of the Rifugio Boccalatte were Lucy and Luke, an interesting couple speaking good American because he was from Maine, though she was Italian. They told us they worked at the hut in the summer, then in winter at the Italian Antarctic base which paid better because there was nothing to spend any money on. In 2002 they explained to me that they had made a bid to the CAI to secure the guardianship of the hut but then had to deliver the terms of the bid in cash payments over the year in question. It was a slim profit margin and before they took over, the hut had been without guardians for a year or more. At a time when there is a small but steady decline in hut nights spent in

Weisshornhütte.

all the alpine countries year on year, it makes sense to sign up whenever possible for demi-pension and support the guardians in their work. Some huts do good business with day trippers who walk up for lunch, but these tend to be the more accessible ones, less important for high alpine routes.

Hot water is usually the cheapest item on the menu, so it is worth bringing some tea bags/coffee etc to make rehydration more pleasant after a long hut walk. Breakfast can be only a hot drink left in a flask and some bread and jam, although other huts will provide muesli and cheese spreads, and perhaps biscuits, as well – 'full English' breakfasts have an almost mythical status. It's usually possible to get a flask or bottle filled with *marchtee* for the hill during breakfast, particularly when ski-touring in spring. Most huts provide snacks and lunches from midday to about 5 p.m. for climbers staying on for another route or stopping off for a meal on their way back to the valley, or walkers just up for the day.

It's simpler to pay for the stay the night before leaving, and there is always a substantial discount for members of alpine clubs. Scouting the route during the afternoon of arrival day can save a lot of blundering about in the dark next morning; and since some huts are placed in spectacular positions to avoid stonefall and avalanche dangers, particular care may be necessary to avoid the embarrassment of having an accident within minutes of leaving a hut.

Unguarded bivouac huts are also found, particularly on the approaches to harder climbs in Italy, where they may be small wooden shelters for perhaps six people; in less frequented areas it just isn't worthwhile maintaining a guarded hut. Unguarded Swiss huts are usually more substantial, whilst in France the most famous one of all is probably the Vallot hut established on its present site in 1898. It

has not always been unguarded: in 1939 Frank Smythe records, 'a hut keeper has been installed at the Vallot hut and home comforts may be enjoyed', although after one night, 'we paid a staggering bill' before they 'sallied forth onto the snows of Mont Blanc'. More recently the Vallot has been officially designated as an emergency bivouac shelter for 'climbers in distress' who may have completed long routes on the south face of Mont Blanc in difficult conditions. It was completely renovated in 2006, though that is hard to believe from recent internet photos.

The state of repair or level of equipment in bivouac huts is never certain, and can only be checked by visiting the local guides' office or directly contacting the section responsible for their upkeep; hopefully the information will be up to date. In the Aarbivak in Switzerland there were even spare gas canisters, whilst in other bivouac huts blankets were a bonus – but realistically, food, fuel, stove, pan and eating utensils may well need to be taken up. In most unguarded huts, the honesty box is being superseded by forms for mailing fees to the section responsible for the hut.

Few alpine huts are guarded in the depths of winter, although with the increasing popularity of ski-mountaineering more are opening in March and April, sometimes only at weekends. At other times and in many cases, 'winter rooms' are left unlocked, or there is an arrangement to collect a key from a local custodian; check at the guides' office or with the section. Winter rooms are very similar to bivouac huts; basic shelter with no guarantees. There's no guarantee of even finding some huts that become buried under heavy snowfall. They may be separate, locked off, sections or floors of larger huts, or an annexe that may be the old hut, or primitive wooden structures reminiscent of chicken coops.

Equipment will be similar to that needed for summer bivouacs, but a lightweight sleeping bag will do if a bivouac sack is used to protect the down from the inevitable dampness of blankets that can be piled over it: a thin sleeping mat will prevent dampness penetrating from below.

Bivouacking outside huts is generally frowned upon. There was a time when Brits had a bad reputation for such behaviour, and I remember stories about guardians running a hose over the rocks surrounding their huts after dark. It wasn't so much the soaking as the subsequent icing that was the point. It seemed a bit extreme until I was reminded that they depend on business for their livings, and if the surrounding rocks were soiled with excrement and scattered with rubbish, who was going to be keen to visit their hut? The cost of a night at a hut is often no more than basic B&B in the UK. Huts have indeed provided life-saving refuge in times of need and it would be sad to lose them out of sheer meanness.

I have bivouacked on routes too remote to be served by a hut, usually when I could hide the kit and return to carry it out, but it has never been much fun toting the extra weight on an actual climb, whilst the romance of the bivouac is much exaggerated and mostly retrospective. Any suggestion that it's safer to be carrying all that extra kit is flatly contradicted by the accidents that befall slow parties descending glaciers late in the day on account of the loads they are carrying. On AC/CC meets there was a common saying: 'Carry bivvy gear and you'll have to use it.'

Huts can be crowded at weekends and partying parties can turn in inconveniently late, but the principle that light is right still holds good and huts are one way of achieving that.

11:
Chamonix, 1992

In the summer of 1992 I was moving house and could afford only two weeks on the AC meet in Chamonix. Denis and I caught the midnight ferry, and during the crossing I sat in the stern and brooded over the spectacle of electrical storms tearing into Kent. Sheet lightning shimmered and rolled like multiple bomb blasts amongst layers of cloud, or the night would split open as a crack of hereafter light joined earth to air. We drove all night and arrived in Argentière by noon.

Rain greeted us, so we joined an impromptu meet excursion to Martigny to have a look at the Braque exhibition; with changing art exhibitions, Gallo-Roman archeological exhibits, a vintage car collection and a sculpture park, the Fondation Gianadda was always a good wet weather option. We helped ourselves to a few apricots growing near the car park, but the rain made sure that we didn't see much of the mountains. Back at Argentière, running for the shelter of the shower block, I literally bumped into Steph Brett, a Belfast lass I'd climbed with in Wrexham but rather lost touch with once she'd returned to Belfast. It never ceases to surprise and delight me every time this happens: that 'small world' feeling, or is it fate? Steph told me there was plenty of snow about, and a member of her team had reported the Whymper couloir in good condition.

Throughout the 80s I had come to Chamonix with a list of snow routes but always too late to find them in condition, so this was an opportunity not to be missed.

Aiguille Verte, 4122m. Whymper Couloir: AD

Next day Denis and I took the train to Montenvers and made our way up the Mer de Glace and the steep track that led to the Couvercle refuge, somehow losing my sunhat en route. The guardian confirmed that the couloir was being climbed, but stressed that as it faced south we needed to be off it before midday. Giusto Gervasutti's account of his epic on the route is a dire warning: 'I still consider it something of an achievement that we managed to descend without mishap while the avalanches continuously thundered past all round us.'

To avoid avalanche, early rising was essential: 12.30 a.m. We were away by 1.15 a.m., but it was a warm night and soft snow dragged at our boots as we laboured up the glacier. We discussed leaving the route for a day in hopes of a freeze the following night, but in the end decided, 'Let's just have a look.'

At the complicated bergschrund the snow was still a bit soft, but at least there was no water running down the ice: 'Worth a try?'

'Why not?'

Denis crossed the bergschrund on the right at its narrowest point and climbed steeply up to traverse awkwardly along its upper lip then back towards rocks. I followed in the darkness as we took a subsidiary couloir on the right then crossed a rib left to gain the main couloir. The snow steadily improved, with water ice and sugar snow becoming good névé as we gained height and the cold intensified. Not wanting to lose time pitching the route, we soloed on, becoming very tired as altitude took its toll on our unacclimatised bodies.

Suddenly we heard the crash and rattle of stonefall from the Grande Rocheuse to our right. The cannonade was funnelled away from us, down the approach couloir, but there had been another pair some way behind us on the glacier. Now there was a lot of shouting. Then quiet.

'Are you okay? Ça va?'

There was another shout or two, but we couldn't make out the words. Then, after an anxious wait, in the half-light we saw the pair back on the glacier, retreating.

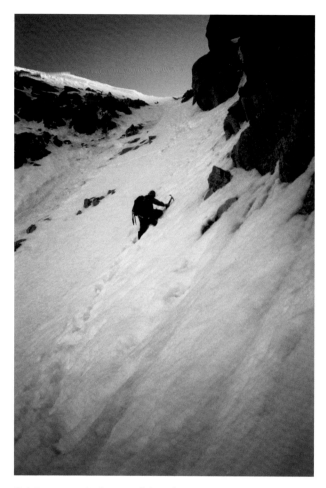

Soloing towards the top of the Whymper couloir.

Somewhere near this point Whymper's first ascent party had encountered hard ice and taken to the rocks on the left of the couloir, crossing the face diagonally to join the Moine ridge just below the summit.

On we went, up the couloir, the front points of our crampons biting into the névé, the picks of our axes penetrating the snow to lock into good ice beneath. Each of us was able to work to his own rhythm, confident in his ability to climb without the rope. The top of the couloir came almost as a surprise when we popped our heads above a thin snow parapet to look down the precipitous north face into a shadowy Argentière basin. We roped up for the delicate summit ridge, itself like a white hawser strung in blue space.

From the summit we could look east down the Jardin ridge to where the rising sun silhouetted a distant Matterhorn above the cloud-filled valleys of Italy, then west down into the Chamonix valley, where our 'green needle' was casting a long shadow on the low cloud. But there was no time to lose; we needed to be back on the glacier before the sun came around to set off stonefall or avalanche in the couloir.

Quickly reversing the ridge, we started back down, but the couloir's snow was already beginning to soften. Crampons scraped on the ice beneath so that there was less of the confidence in down-climbing that we'd had on the ascent. Fortunately there were fixed abseil points on the south-east side and we made full use of them to speed our descent. Isolated stones fell, then scattered handfuls.

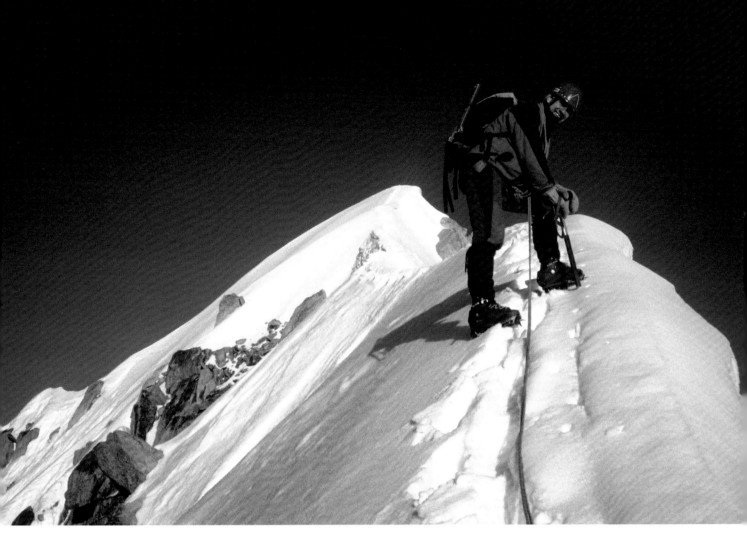

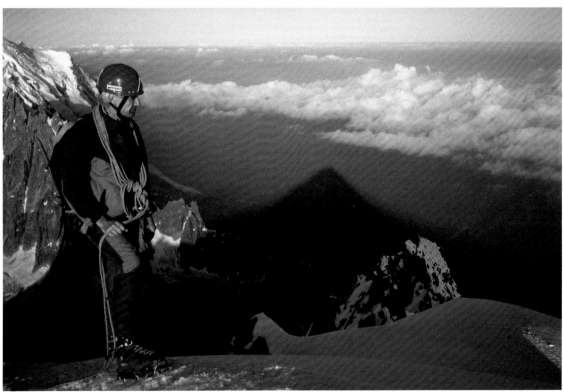

Top: Roped up and braced against the wind on the summit ridge of the Aiguille Verte.

Bottom: The Aiguille Verte casts a long shadow over the Chamonix valley as we reach the summit.

I narrowly escaped having my ear pierced by a small fragment that came humming by but was deflected off the rim of my helmet.

At the foot of the couloir we could now see a huge avalanche cone dirtied by recent, gritty, grey sloughing. There would soon be more as the fusillade of stonefall increased. But after a delicate bergschrund crossing we were out of it. We could relax on the easy walk back to the refuge, arriving at 12.30 p.m.

The guardian was pleased to see us after the report of stonefall from the pair who had retreated after their close call.

'They did not think it was you who made the stones fall, but it was very close to them. And they did not want to risk any more. They go down to the valley.'

We dithered a bit about whether to stay and attempt Les Droites next day but the guardian didn't think anyone had climbed it yet that season and we were tired enough to care: who needed the additional problem of route-finding in the trackless snow through the crevasses of the Talèfre Glacier? We packed up, descended to the valley and took a day off.

It had been a very different aftermath when Whymper made the first ascent. His team arrived back at the Couvercle boulder bivouac to find their porter had eaten all the food and was taking down their tent, believing them dead. Returning to Chamonix there was a near riot of local guides who had convened a meeting to discredit the ascent, most likely because Whymper had climbed with Swiss guides. Fortunately gendarmes successfully dispersed the crowd before things got nasty, and Whymper noted: 'Needless to add, Michel Croz took no part in this demonstration.'

Aiguille de Bionnassay, 4952m. North-West Face: AD

Denis suggested we take a look at the north-west face of the Aiguille de Bionnassay, so we phoned the Tête Rousse refuge to confirm that the route was being climbed and that there was space at the hut. I also phoned home, to be given a bad time about the house move. Somehow that made me more focused as we made our way to Les Houches to catch the cableway and tram. Walking up to the hut past a herd of chamois, we could see the Aiguille Verte dominating the view to the north-east.

The old wooden hut had a distinctive atmosphere, and brought back memories of sleeping on a table before climbing up to the Goûter refuge 11 years earlier. From just east of the hut there was a grandstand view over the glacier de Bionnassay to the north-west face that reared up opposite. It was possible to trace the line of the route, a great slanting snow ramp, in the early evening light. It looked icy in the lower reaches and a marked avalanche runnel grooved the centre of the ramp below the seracs, but finding our way through those seracs and up the steep final slopes would be the real challenge.

We left the hut at 2 a.m., finding the night a little warmer than we'd hoped, descending to the glacier where the snow was softer than expected and the only tracks seemed to belong to the party of three ahead of us. There was no sound of falling ice or avalanche coming down the face so by headtorch light we set off up the avalanche cone at the foot of the ramp.

At an icy section the route steepened up to more than 50°. We had roped up for the glacier crossing and kept the rope on for the start of the climb but now it was snagging on frozen snow bollards and rocks studding the ice in the darkness. We were moving together, well within our capabilities, with no possibility of natural runners and no time to place and remove unnecessary ice screws, so there seemed little point in keeping the rope on. Frank Smythe is willing to praise the rope's use in building

the character of the team as well as offering the chance of catching upon the most unlikely nubbin and by that means arresting what might otherwise be a catastrophic fall, yet in 1939 he describes a team on the Brenva spur where 'the rope was a curse rather than a blessing and merely ensured the death of both climbers in the event of a slip by either'. Denis and I inclined toward the latter view and the rope was stowed.

We followed the lights of the party ahead straight up the avalanche chute, our front points squeaking into good ice, until they encountered impassable ice cliffs. Beams of light probed the darkness between the glimmering seracs as we struck off on a likely line to the right, winding up through the ice cliffs and taking short pitches of about 70° steepness. Eventually we reached a terrace beneath a huge ice cliff stretching across the face. If we were where we thought we were, the cliff should narrow to nothing on the left, so we worked our way in that direction as whispering falls of snow and ice crystals slid off the lip above: I worried about what they might be working up to. It wasn't quite 'nothing', but after a long traverse left, a short step allowed us to break out onto another snow terrace above the cliff.

I thought we'd cracked it at this point, but then realised the terrace was the lower lip of a wide crevasse, splitting the face across and barring access to the slopes above that led to the summit ridge. Again we tracked left until the crevasse narrowed to an easy crossing, although the slopes above were at that point at least 50°. Denis suggested pitching it, but with the summit in sight I couldn't be bothered. I was to regret this when relentless front-pointing set my calves screaming and I was forced to cut narrow resting ledges in the ice with my axe. The summit was further than it looked. At least the ledges meant I had the leisure to take a couple of pictures as the ice shaded from pale purple to pink in the dawn.

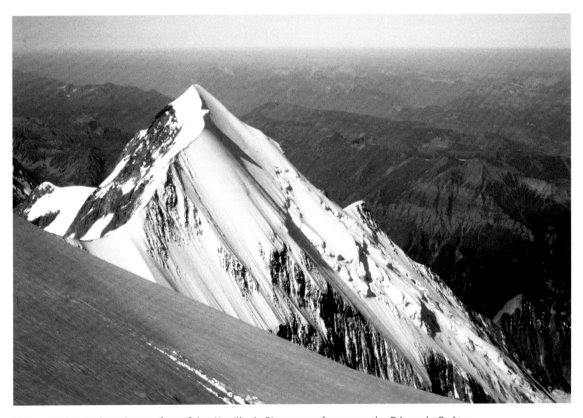

The east ridge and north-west face of the Aiguille de Bionnassay from near the Dôme de Goûter.

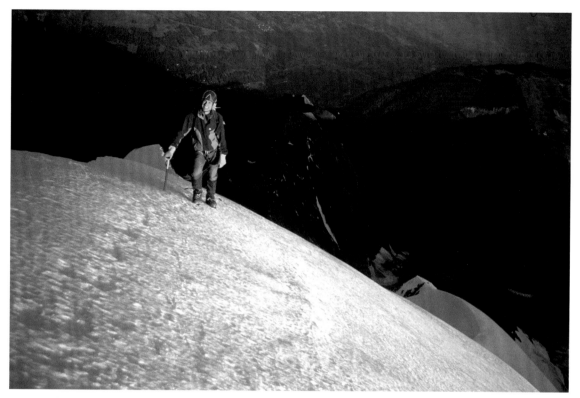

Morning light reaches the upper Tricot ridge not far from the summit of the Aiguille de Bionnassay whilst the valleys are still wells of darkness.

We broke out onto the summit ridge at an outcrop of loose rock where we took a brief rest. The party of three were by now following us some way behind and let us know their feelings in no uncertain terms about the occasional stone we inadvertently dislodged. The dawn light was emphasising the exposure of those final slopes and they had stayed roped up: it must have taken its toll on their nerves.

Above the outcrop the summit snow ridge stretched out, steep and tiring but very scenic as the dawn lit fires in the sky and eventually picked out Denis's figure on the shining arête with the valley all in shadow below. After so many hours of climbing in the dark, aware of little beyond the pool of light cast by the headtorch, we reached the summit as the peaks around us shouldered their way into the light.

We found we could linger on the descent of the east ridge, where the knife-edge filigree arête of 1991 had become a thoroughfare we could easily walk along, linking the Bionnassay to the Dôme de Goûter. We sauntered down to the Col de Bionnassay, taking pictures of the strange corniced shelf jutting out to the north that was observed from the summit on the first ascent by F. Crauford Grove: when the clouds parted, 'we could see the marvellously thin arête fall away in a huge curve … (and) a glorious flying buttress that appeared absolutely semi-circular … the most terrific thing I had ever seen in the Alps'.

From the Col de Bionnassay it is over 400m up to the Dôme de Goûter past the Piton des Italiens, and tiring work on what one thinks of as a descent route, but the higher we climbed the better the snow conditions we encountered. On the way down from the Dôme to the Refuge de Goûter there were fine views of our route so that we could work out the line we had taken in darkness; the north-west face seemed much steeper than the ramp of the route had suggested now we could see it in profile. We were back at the Tête Rousse hut by noon, and there was even enough snow to glissade part of the descent to the tramway station.

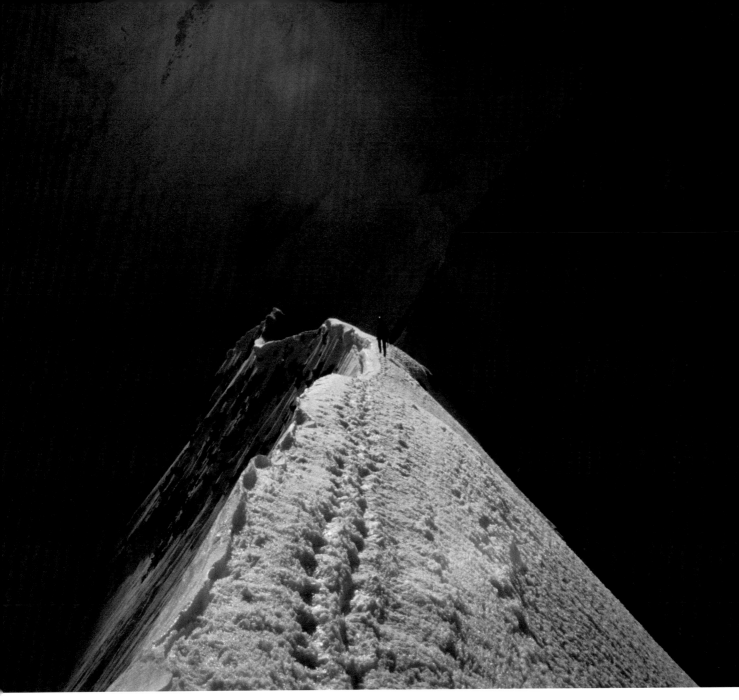

Descending the sharp east ridge to the Col de Bionnassay.

The good snow conditions encouraged us to think of an ascent of the north face of the Triolet which had been on both our lists for some considerable time. When we got to the refuge d'Argentière, however, there was a shock in store for us: looking at the face, the upper half of the Triolet appeared to be in good condition but below that it was stoneswept ice. In fact the whole of the Argentière basin looked as if it had a tideline, with pristine white snows above and gritty black ice below. We both picked out a possible line that might go, and I think if either of us had been willing to push the issue we might have gone for it, but the guardian's lack of enthusiasm tipped the balance. Since there was no other route we wanted to climb from the hut in those conditions, we had a long evening walk back to the valley. The guardian was strangely cheerful about the loss of business: I think we made the right decision.

We resigned ourselves to normal service having been resumed with regard to snow conditions, so next day went up to the Trient hut to traverse the Aiguilles Dorées, a superb day out. Over the rest days that followed it was soon clear that Denis had been thinking about another 4000m peak: the

118

Aiguille Blanche de Peuterey. His theory was that the good snow conditions at altitude would make the Peuterey arête to the summit of Mont Blanc a straightforward continuation from the Blanche rather than a hazardous extra. He can be quite convincing, and I was in a strangely careless mood so didn't need much persuading.

Aiguille Blanche de Peuterey, 4112m.
South-East Ridge and Traverse: D+

Next day we drove through the Mont Blanc tunnel into Italy and left the car in the Val Veny before walking up to the Rifugio Monzino. Despite failing to get our rucksacks sent up on the service cableway, we made good time on the route, to reach the hut in two hours. And what a hut! Its individual bunks with drawers and cupboards for kit, free running water and working showers were really exceptional in huts at the time. Strangely, the showers had no curtains in what were mixed-sex facilities; perhaps it was a water conservation tactic. There wasn't much English spoken, but we managed to establish a wake-up time of 2 a.m. and it turned out not to be too much later.

At 4 a.m., we were stumbling up the moraine and onto the Châtelet glacier by torchlight. Somehow we managed to climb an awkward and completely unnecessary rock step between two snowfields, missing an easy gully, to reach the Col d'Innominata. Three abseils took us down the other side of the col to the lower Frêney glacier. This contorted chaos of ice gave me my first inkling of the seriousness of the undertaking. If you can tiptoe in alpine boots and crampons, we did, with bated breath, through the crumpled crevasses and poised seracs, crossing the glacier to escape up steep ice that was pock-marked with rockfall and grooved by stonechutes.

The Schneider couloir proved nearly as worrying: no snow, just wet gritty rock and rounded holds that all sloped the wrong way and were inclined to shift in our hands or tumble from under our feet. There were no cracks in which to place nuts for runners, and no pegs; later we both confessed that more than once it had occurred to us to wonder why we were roped together (probably because we didn't feel we had time to take the rope off!) *Pace* Frank Smythe; I don't think either of us felt we benefitted from any character-building. Near the top of the couloir, Denis dislodged a block that bounced past me with a smell of mineral burning as I dodged to one side. Miraculously the rope was undamaged.

At the notch at the top of the couloir we climbed up a little ridge then traversed unstable scree and rubble, passing an occasional cairn, although there seemed to be an easy rake and traverse from another ridge just below. Perhaps that was the route from the Craveri bivouac hut in the Brèche des Dames Anglaises. We continued a rising traverse across undifferentiated broken spurs that fell apart around us whilst loose material of all shapes and sizes crashed down vague gullies for no apparent reason. It reminded me of the stacked insecurity of a slag heap. The guidebook descriptions had become a little vague at this point, too, referring to taking 'about the third' of these 'rubble ribs'.

G. W. Young writes:

> The common forms of mountain ill-temper are two: the blaze of unreasonable anger, as elemental as our environment; and the groundless resentment, accumulating slowly under long strain, which feeds upon silence and the vanity of self-control.

In my case I think the latter led to the former as the tensions of the climb accumulated, and I burst out: 'I fucking hate this! *About the third* – what sort of a guidebook description is that? And who could

119

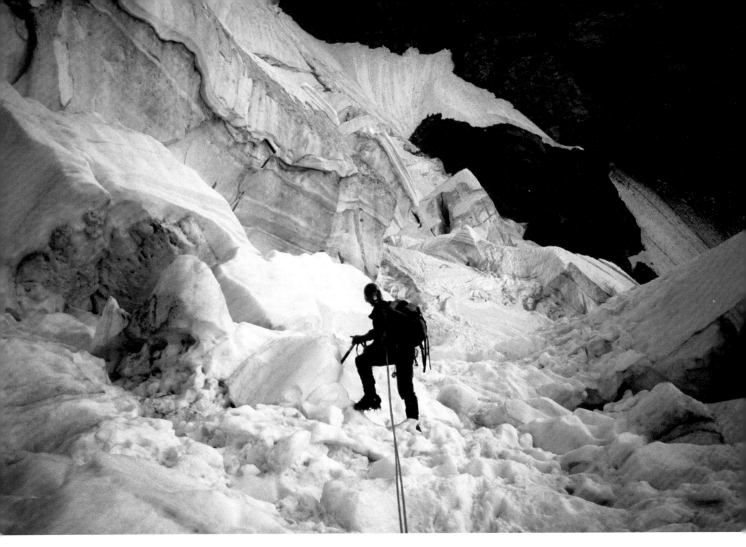

Top: Crossing the lower Frêney glacier from the Col de l'Innominata to the Schneider Couloir.

Bottom: Climbing the rubble towards the summit ridge of the Aiguille Blanche de Peuterey.

count them anyway amongst all this sliding shite? Fuck it, fuck it and fuck it again!' I kicked a rock and it duly spun off into space down the Brenva face.

Denis wisely suggested, 'Let's take a break,' and my anger, in Young's words, 'was blown to bits by its own spontaneous combustion'. Fortified with a little food and drink, we continued our slipping and sliding, stumbling and climbing until we reached the crest of the south-east ridge and better rock. Clouds were floating about Punta Gugliermina as we looked back along the ridge and down onto the Frêney glacier far below. Further along the ridge, we abseiled into a gap then climbed back up to the rocky crest and continued to follow it, more cheerfully, until it turned to snow approaching Pointe Seymour King, 4107m. Despite the height it was deep sugar snow overlaying ice; we had no option but to continue, post-holing insecurely above the precipitous north face to reach Pointe Güssfeldt, 4112m.

By now we'd lost track of which was the highest point, but were very sure we did not want to come this way again so doggedly went over the third of the summits, Pointe Jones, 4104m.

Finding abseil points, we made a series of abseils down loose gullies and an icy slope to the Col de Peuterey. There we came upon the scene of what had clearly been some kind of epic. There was an abandoned rope with half of its sheath missing, another with overhand knots tied in series down its length, an abandoned ice axe, coffin-shaped slots cut into the snow and a huge encircled cross stamped out in the snow, presumably to guide the approach of a helicopter. We could only guess at what might have happened.

Fortunately at that time I had not read Walter Bonatti's account of his desperate retreat in 1961 from the Frêney pillar in which four climbers lost their lives during one of the longest storms ever recorded on Mont Blanc. Even so, swags of cloud were being blown in on a strengthening wind and something prompted me to take the abandoned ice axe.

We'd had a chance to take a look at drafts of the yet unpublished new Alpine Club guidebook to the Mont Blanc massif. This mentions an excellent bivouac site below the large gendarme at the top of the Grand Pilier d'Angle, and our plan had been to overnight there. That way the snow/ice ridge to the summit of Mont Blanc would be in good condition next morning after a night's frost. But unfortunately the Grand Pilier d'Angle looked anything but amenable: steep, stone-swept black ice, with the remains of tracks lost in the accumulated debris. None of the guidebook alternatives looked reasonable, and that extra ice axe could prove very useful, but as we scanned the face a flurry of stones rattled and bounced widely down it. Denis suggested going to the right and we started out on his line until an ominous roar heralded another slide of rubble that just missed us. That was enough for both of us. Another guidebook had advised 'digging a snow hole will buy time to consider the remaining options': we could bivouac on the col and go on in the morning.

Finding a sheltered spot, we started digging, but soon ran into hard ice. Each of us tried different places but with no better result; the coffin-shaped slots we achieved looked as though that was the best we could hope for. We were going to have a very bad night.

As we talked this over, the idea of descending the Rochers Gruber was gradually becoming more attractive: 'After all, we've climbed the Blanche and it could take longer than we thought to get on to the Peuterey arête with all this ice about.'

'It's a pity but there's only bivvi kit for one night out and we might not make it beyond the Vallot. The prospect of staying there with no food or fuel isn't exactly appealing.'

'Well in that case perhaps we should try and find the start of the abseils in the last of the light and bivouac on rock on that side of the col. It'll be a bit warmer than lying on snow all night.'

'Yeah … okay. That way, we can make an early start in the morning.'

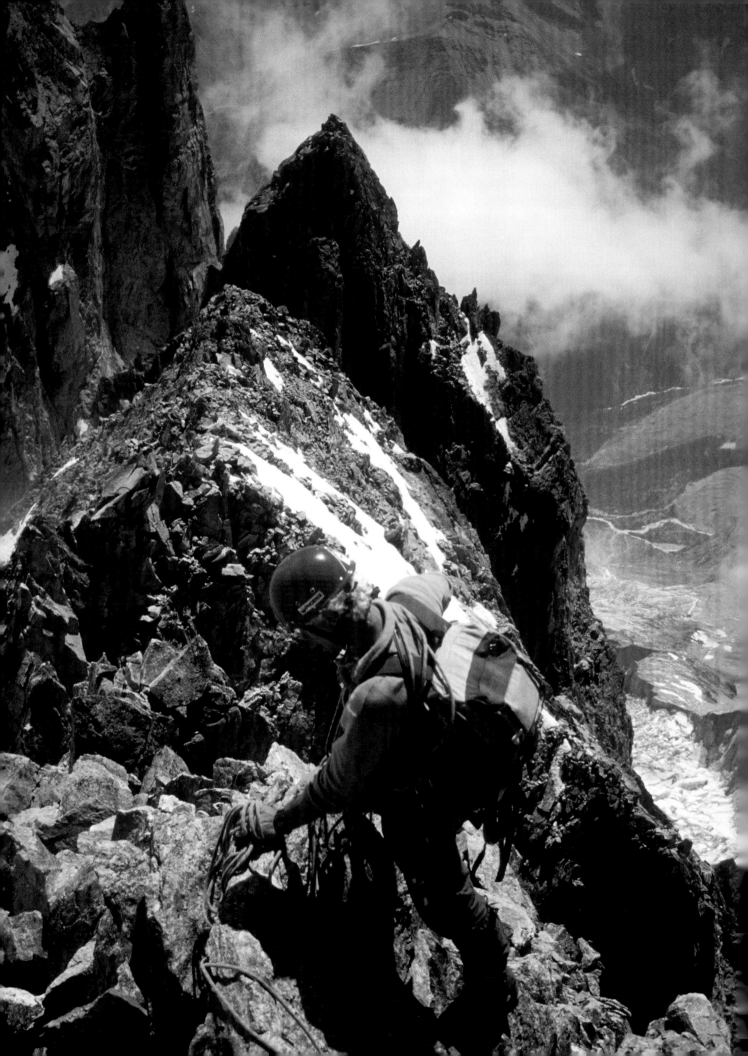

Near to the first abseil point there were convenient rock ledges that we could use for our bivouac, but even then we only dozed fitfully during the night. My wet feet became very cold despite the bivvi bag, although at one point I was woken by uncontrollable shivering to find my feet toasty warm … unless it was a dream.

Several visitors came by in the night. The designer of my duvet jacket called in to see how it was performing and commiserated with me over my cold feet. A guidebook writer stopped by and I gave him a piece of my mind. No women unfortunately; a cuddle would have been appreciated although I was in no state for anything else. There were no stars.

By first light, windblown cloud was whipping past us out of the obscurity, banishing any residual ideas of going on to climb the Peuterey arête. Sometimes you just have to know when to say no in the mountains. Bonatti had prepared meticulously for all his climbs on the Grand Pilier d'Angle, yet on one occasion even he spent half an hour staring at the buttress in the moonlight before: 'I was surprised to hear myself saying "No, I don't want to leave my hide up there." So we turned back.' It's not a question of cowardice. G. W. Young comments on the removal of a Victorian legacy post-1918:

> the war years have produced one slight change. In difficult or dangerous undertakings men of action have always had to take 'nerves' – their own or their company's – very thoroughly into consideration; but it was thought indelicate to allude to them publicly, in forecast or reminiscence. It is now conceded that they may form a necessary part of the natural [sic] of a man, not inconsistent with manliness or even with heroism.

Scratch rations and a welcome brew eased us back into action. We packed rucksacks and started abseiling.

It was a tense and time-consuming business. The first man down would abseil slowly, looking out for a flash of coloured rope or tape that would be the next abseil point. They had been placed wherever they could be fixed, so were not necessarily in direct line with the previous one. At one point I was practically at the end of the rope with no sign when I spotted a weather-stained sling well right and above me. I had to run back and forth across the face at the rope's end, working up enough momentum to pendulum within range to grab it. Then of course there was the awkward business of getting belayed and not letting go of the ends of the ropes; not only would that make things easier for Denis to reach me, but the last thing I wanted was to be left standing at the belay while the ropes dangled out of reach if Denis was hit by a falling stone. At another point I backed off an overhanging ledge to make an entirely free abseil, dangling in space metres out from the rock, to find the rope's ends just touching the ledge beneath.

Down on the glacier it was like bomb alley – so much stonefall was coming off the Aiguille Blanche. I remember looking up and seeing blocks the size of cars arcing between gendarmes before crashing into gullies, feeding stonechutes in the ice. We kept strictly to the centre of the glacier, lucky that huge avalanches had poured off the Frêney face and down the icefall from the upper Frêney glacier, filling up the crevasses with more snow than would be expected at this time of year. This meant we could leap from the raised upper edges to the lower lips of widening crevasses, safe in the knowledge that if we fell short we were not going to disappear into the bowels of the glacier. There was, however, one crevasse that required a good run-up and, while flying through the air for longer than anticipated, seemed to me something of a leap of faith.

On the south ridge of the Aiguille Blanche de Peuterey looking down towards Pointe Gugliermina.

Seeing traces of an old trail, we crossed to the right of the glacier and followed it to the foot of the Col d'Innominata. I led heavily back up to the col and we abseiled down the other side, then 'boot-skied' the soft snow of the Châtelet glacier all the way back to the moraine. At the first little stream we stopped and drank brew after brew. Calling into the Monzino hut, we met a pair of climbers who had turned back from the Schneider couloir owing to stonefall: we hoped it hadn't been triggered by us. Leaden clouds weighed upon the heights, yet we walked down into valley sunshine.

We had been lucky to reach the summit of this most difficult of the 4000m mountains at first attempt. Some have made multiple attempts before succeeding, while I know others who are still trying. Yet back at the campsite, I had to confess that the Aiguille Blanche de Peuterey was the only 4000m route that I really hadn't enjoyed. Perhaps we should have bivouacked at the Dames Anglaises or climbed the north face, although it was not likely to have been in condition. Whatever; the thought of that being our last route before returning home left a bad taste in the mouth, but during a much-needed rest day I thought we could do something about that.

During our last possible climbing day the weather forecast was for cloud in the afternoon then rain later so I persuaded Denis to go up into the Aiguille Rouge early enough to climb a TD rock route. The healing power of sun-warmed rock coming to hand in move after move should never be underestimated; the climb went perfectly and we drove home well satisfied.

That was the last alpine season in which Denis and I were to climb together. Over the next few years we found we had different 4000m peaks left to climb, and I was becoming distracted by the Greater Ranges. Then in 1998 he suffered a serious head injury whilst climbing at the Roaches in the Peak District, and it is a tribute to his tenacity and determination that after rehab he fought his way back to fitness so that in 2001 he eventually completed his ascents of the 4000m mountains.

12:
Alpine weather

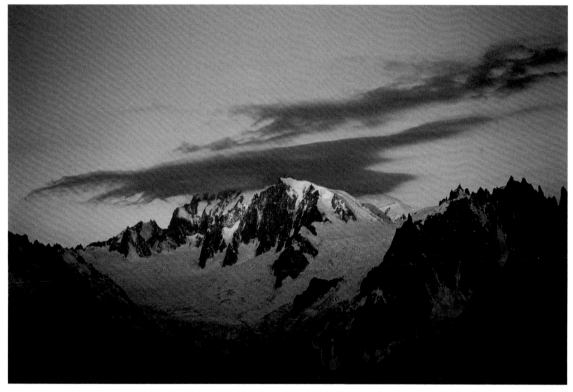

A bad weather cap on Mont Blanc.

The weather in the Alps in summer is generally much better than on the western seaboard of Europe, benefiting as it does from the influence of continental stability as high pressure systems build over central Europe. Long sunny days feature in my memories of alpine seasons, sunbathing on rest days when the children were small. Lingering by a mountain torrent on some high walk or the shifting shadows of pine-forest always offered relief when the heat became too intense. Shade stays cool in the mountains, and fresh breezes come with the territory. When the children were more mobile, the Lac Blanc in the Aiguilles Rouges was a favourite destination for them to play on the accumulated snows of the still-frozen lake - in T-shirts and shorts! However, the range does not entirely escape the influence of wet westerlies, and in a bad year the eastern Alps are often more likely to have

good weather. Some climbers prefer the better snow conditions of June or more settled weather of September to the traditional climbing season of July and August.

But it must never be forgotten that alpine weather can and does kill. The length of climbs and the lack of easy escape routes can make a storm on an alpine peak a very serious matter. The higher altitude means lower temperatures, greater exposure to the elements and the chance of more sudden and violent changes in the weather. A determined party can be led to the brink of disaster, as Moore records in 1864 on the Dom:

> At length an icy gust of more than ordinary violence, which seemed to drive all the breath out of our bodies, caused us to pause and reflect upon the possible results of further persistence. The appearance of the party was rather curious, every one being so completely covered with snow that he was scarcely distinguishable from the slopes on which he was standing, Morshead, who was blessed with a beard, presenting a particularly remarkable aspect. Amidst the roaring of the storm it was not easy to interchange ideas, and to stand still long was to be frozen, so, when even the undaunted Almer admitted that the battle had turned against us, and that in such weather we could not reach the top, there was no further discussion, and at 10.00 am we turned tail, and fled precipitately … had we persevered for a quarter of an hour longer, the expedition would have resulted in a serious disaster.

In *On the Heights*, Bonatti recounts sobering encounters with storms on Mont Blanc, none worse than the purgatorial retreat from the central pillar of Frêney in 1961 in which four men died. Had they stayed where they were, all might have perished.

The eeriness of an alpine thunderstorm can be unnerving; George Finch describes checking the weather outside a hut:

> Snow was falling and the atmosphere was charged with electricity. Holding up my hand and spreading out the fingers resulted in a curious noise as of the tearing of linen, and, in the darkness, from each fingertip issued a blue stream of light. The chimney pipe of the little hut stove was thrown into relief by an aureole of bluish light, especially intense at the top.

Years ago I recall meeting an acquaintance in Chamonix whose beard was charred down the middle: a discharge had earthed on his metal jacket zip as he watched blue tongues of flame flickering from points of rock before making up his mind to retreat from the route. J. H. Bell's *Progress in Mountaineering* was not without some reversals like his retreat from a climb in the Aiguilles Rouge of Arolla: 'A lofty rock ridge is not the best place to occupy when there is thunder about, the ice axes sizzling with the electric discharge and one's hair standing on end.' During a storm on my first visit to the Alps I decided to park my buzzing axe at a little distance from me, spearing it into a nearby snowpatch. Unfortunately, without the weight of my arm behind it, it failed to lodge in the snow and bounced off down the slope, turning cartwheels. Axeless, retreat was a nerve-wracking affair through the mounds of hailstones and last reverberations of thunder.

In winter the stakes can be higher. George's brother, Maxwell Finch, describes a winter's night out on the Todi which resulted in one of his friends having most of his toes amputated, whilst 'More serious was Morgenthaler's fate. Nearly all his fingers had to be amputated at the first or second joint and the remaining ones will probably always be stiff.' More recently, Jamie Andrew, trapped on the Col des Droites and inaccessible to rescue owing to the strength of the winter storm winds, suffered the loss of hands and feet as a result of frostbite, whilst his climbing partner, Jamie Fisher, did not survive.

In a bad storm serious avalanche conditions can develop as snowfall accumulates even as the party attempts to extricate itself from its predicament. Normal practice is to delay making a route for a least a day after significant snowfall to allow the freeze–thaw cycle to restore at least some stability to the snowpack. Even then, if the signs are bad there is never any disgrace in turning back; as Jeremy Whitehead used to say, 'The mountains usually give you fair warning before they kill you.' Avalanches are enormous engines of destruction that can occur after new snow, winter or summer.

Fresh snowfall can also obscure crevasses and disguise the weakness of snow bridges even when the crevasse is obvious. Rock routes can look as though they are clear of snow from below and encourage an ascent until a certain altitude is reached, when the lying snow has to be cleared from every handhold before it can be used. As the time taken to climb the route lengthens and height is laboriously gained, meltwater refreezes to verglas and the trap is sprung: benightment and an unplanned bivouac or a long hard descent in the gloom is the best you can hope for. Trust me, I've been there. When the high peaks are out of condition it's time to go valley cragging, for at least a day or two.

Fortunately the computer modelling of 21st-century weather forecasting has made huge progress when compared to the Grindelwald tourism official who, when asked for a weather forecast, replied, 'Just take a look out the window.' Chamonix always scored with climbers because of its detailed weather forecasts pinned up at the guides' office next to the church. Weather forecasting websites can be accessed in huts with wifi and on enabled mobile phones so that the latest amendments to forecasts can help with planning the following day. The accuracy and availability of modern weather forecasts is a powerful incentive to make the best of the conditions and a deterrent to taking a chance on them.

Despite that advantage, we can never forget that 'the mountains make their own weather', and forecasts can be wrong; it is important to have a sense of how the weather is developing and whether or not it is fulfilling the forecast description. A temperature inversion can leave a team languishing in the damp chill of a valley when the heights are bathed in sunshine, and in the same way damp weather at 2 a.m. can clear to a fine day after dawn. As a rule, though, it's not wise to set out on a route if the snow is not frozen underfoot when leaving a hut at 2 or 3 in the morning. Common sense is always the best touchstone, but we've all been tempted and a few have even got away with it.

Northerly winds generally indicate fine weather, though they can be very cold, whereas warm southerly winds, especially the strong Foehn winds from the Mediterranean, soften the snows and can produce clouds and rain even at altitude. Even if there is little wind in the valleys, streamers of spindrift blown in plumes from peaks and high ridges are a sure sign of a wind that may blow climbers off their feet. A violent blustery wind in clear weather can indicate a change is on the way but may be followed by a calm interval before the new weather pattern takes over.

Just as in the plains, a red sky at night suggests good weather on the morrow, whilst a red dawn threatens bad weather. In *Climbs and Ski Runs*, Frank Smythe records a 'green ray sunrise' on the Schreckhorn:

> The dawn was wild and hurried, and scarcely had the sun's first rays lit the snow wall
> of the Fiescherhorner when it was superseded by a weird greenish glow … None of us
> had seen such a sunrise … Everywhere we looked the green colour predominated. It
> was a portent beautiful but evil. We were foolish to disregard it.

Later the party was overwhelmed not once but twice by incredibly sudden and violent storms. Smythe reports that while retreating:

there was a blinding glare and a terrible explosion. I received a stunning blow on the head as if I had been sandbagged. For a second or so I was completely knocked out, and but for the rope, which I had previously fastened securely around a rock, I might have fallen and dragged the party to disaster. When I had recovered my wits sufficiently to move down, fits of trembling supervened and it was only with difficulty that I could control my limbs … We were in imminent danger of being blown off the mountain, and for minutes at a time we could barely cling on, while the wind roared by beating us with hail and snow until we were sheathed in ice from head to foot.

Isolated thunderstorms are not uncommon, especially in the afternoon during periods of otherwise good weather, and can usually be avoided by choosing shorter routes or making earlier starts, but what Smythe experienced was something else.

Cloud patterns can give advanced warning of weather changes. Wisps of high cirrus mares' tails high in the sky with unravelling of vapour trails show building water vapour at altitude before a weather front arrives. Imminent bad weather can be signalled by gathering lenticular or 'fish' clouds, particularly when they hang on the flanks of mountains and rise or fall rather than drifting away. They may mass into caps on prominent peaks: Mont Blanc is notorious for wearing a cap when bad weather is on the way. On the other hand, cumulus clouds, often a sign of good weather, can build into anvil-shaped storm clouds presaging afternoon or evening thunder.

If the worst happens, and despite a good forecast and keeping an eye on the signs you do have the misfortune to be caught out by bad weather, George Finch gives some useful advice when commenting on an accident on the Mur de la Côte on Mont Blanc;

in September 1870 ... eleven people were caught by a snowstorm. Instead of fighting their way out of its clutches, they sat down to wait until it passed. All were frozen to death. In a snowstorm on the mountains, as in war, safety lies in action. It is far better to do something, even if it be the wrong thing, than do nothing but sit and wait.

That has to be balanced by the knowledge we now have about how 'incident creep' can lead to an accumulation of small errors or mishaps, finally reaching a tipping point into disaster. Bad weather is capable of turning a minor injury to one climber into a disaster for the team. Moreover a party equipped with a good ripstop nylon group shelter, or snow shovels that can be used to dig a snow hole in winter, may choose to sit out a storm in relative comfort. It's a question of judgement – but bad weather will leave no doubt that such judgement is being exercised in adversity.

13:
From Grindelwald to Zermatt

In 1993 Jayne and I decided to take the family to the AC Grindelwald meet. Our marriage was breaking up, but we didn't see why the children should be denied the chance of having another summer with their friends in the mountains.

The climbing began when Mike Pinney and I decided to warm up on the Wetterhorn. We walked up from the Hotel Wetterhorn to the Gleckstein hut in pouring rain: grim, head-down stuff, wondering if it would really clear up next day. We were still wondering when we reeled out of the hut at 4.30 a.m into a damp night without a star in sight. By the time we broke through the cornice on the summit ridge, above valleys boiling with cloud, we were in hard sunlight with a wind that strung the rope out in a curve between us. To the south-west the Eiger and the Mönch rose sharp and snowy above cloud level, whilst due south the Schreckhorn looked very wintry in a sky wispy with high cirrus.

The Wetterhorn is an historic peak. Alfred Wills' ascent in 1856 is generally considered to initiate the golden age of alpine climbing, and he was clearly moved by the experience:

> We felt as in the more immediate presence of Him who had reared this tremendous pinnacle, and beneath the 'majestical roof' of whose deep blue heaven we stood, poised, as it seemed, halfway between the earth and sky.

Mike and I just felt lucky. And cold.

Jungfrau 4158m. South-East Ridge: PD+

After a rest day and despite the unsettled weather, on 28 July Ralph Atkinson and I took the first train to the Jungfraujoch. Always the ladies' man, he struck up a conversation with two 'Southern belles'. Their make-up was immaculate, but they seemed to have little idea where they were or where they'd been.

'Are y'all goanna climb Mont Blanc from the top?'

'Er, no.'

'Are you sure?'

Our hopes of clear weather at the Joch were unrequited and we hung around for an hour until glimpses of the Jungfrau encouraged us to give it a go: 'Why not? It's all good acclimatisation.'

We slid down and across the Jungfraufirn to pass below a rock buttress at the foot of the Rottalhorn ridge through worryingly wet snow above some huge crevasses. Then we cut back right to the crest above the rocks, up a steep snow slope, and followed the broad ridge until just below the Rottalhorn.

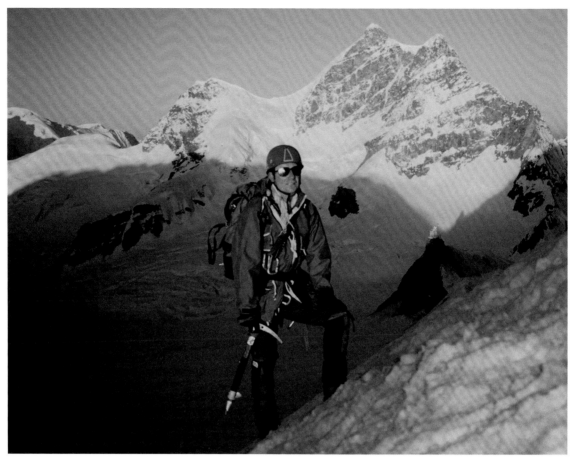

The Jungfrau seen from the Mönch.

There a traverse right led us directly beneath the corniced Rottalsattel. Until then the cloud had obligingly risen with us as we gained height, with views down the Aletsch glacier and back towards the Jungfraujoch, but as we climbed steeply up to the notch in the cornice we found ourselves immersed in cloud and, gaining the saddle, were swept up in the skirts of a howling wind.

Backs to the wind, we put on crampons. The snow was still rotten, and gusts came close to taking us off our feet as we climbed right up the flank of the ridge in near-zero visibility. Ralph was doubtful about going on but I thought we could try to carry on for a bit 'in low gear', and sorted out the rope for a full 50m run-out. We had reached the first of the steel belay stanchions when a figure loomed out of the murk.

It was David Christmas, closely followed by Dick Carter, two AC members who were also attending the meet but had spent the previous night at the Mönchsjoch hut with two friends. A shouted exchange revealed they had retreated once but then climbed back up, pitching the route from stanchion to stanchion, and taking two hours to get to the summit. Ralph and I passed them, moving together, clipping runners onto the stanchions and swopping leads just once when the leader ran out of gear. We reached the summit in 45 minutes, realising only when the ground began falling away in front of us. A hastily thrown snowball confirmed the drop ahead, so we took a couple of pointless photos then fought our way back down.

Our crampons were balling up with the deepening soft wet snow, leading to occasional slips. I was in the lead somewhere between belay stanchions when one of those slips became a messy slide.

There were moments of complete disorientation when it seemed the storm filled my eyes and seemed to have broken into my head. Then the ice axe bit into a patch of firmer snow and arrested my flight, assisted by some tension from the rope. I lay for a second, spitting snow, then, kicking crampons deep into the soft surface, I climbed over to the next stanchion. It was the only fall I was to experience on a 4000m peak. Battling on to the Rottalsattel we descended through the notch into another world: out of the wind we could at last exchange a few words and the descent became less desperate. Ralph had been completely unaware of my slide; he couldn't even remember the rope coming tight.

We picked our way through new avalanche debris on the traverse back to the Rottalhorn ridge, and briefly explored the alternative of descending rocks, but it was unknown ground and conditions could deteriorate so we slid back down snow to the glacier basin; at least it was fast.

All that was left was the long haul back up to the Jungfraujoch and on to the Mönchsjoch hut. It was a gruelling experience in afternoon snow, with a slide back down for every two steps up, but spurred on by anxiety: we feared the station staff might lock the access tunnel doors, barring us from our cache of hut supplies. Fortunately, although the train had stopped running when we arrived, those doors were still open and we recovered our stash. A brief rest and we trudged lamely on to the hut, arriving just in time for dinner.

Mönch 4099m. South-East Ridge/East Ridge: PD

Ralph was whacked after the ascent to the hut, my boots were soaking, and we both felt like just going back down to the valley next day. Then Dick Carter gave us a very favourable prognosis for climbing the Mönch, which began to change our minds. An excellent Chinese meal (most unusual hut cuisine!), together with a good night's sleep buried under a mound of blankets while the wind whipped through the dorm, meant that we didn't just roll over and go back to sleep when the alarm went off at 5 a.m.

We were away by 6.10 into a glorious dawn with the lightest sacks we could manage. I carried the rope as we soloed in crampons up good crisp snow and over rocky outcrops on the south-east ridge. It rose steeply at first then gradually laid back to a nearly horizontal section leading to the snow summit. I was well placed for photo-opportunities, with Dick's team ahead and Ralph behind providing good foreground figures in both directions. The views in the rich morning light were gorgeous, with hard edges of nearby ridges contrasting with the hazy shadows of lower mountains beneath a misty temperature inversion away to the south. In marked contrast to the previous day, the twin summits of the Jungfrau stood out clearly, although it is from the Schilthorn that the mountain looks most like the reclining body of a young woman.

The arête became very narrow in places where the consequences of a slip didn't bear thinking about, and the route has something of a reputation for nasty accidents, so I shouldn't have been surprised when I heard a hesitant, 'Dave …' I turned back and saw Ralph had stopped dead with one of those sharp sections ahead of him.

'What's up?'

'Err, I don't think I can do this.' His tone was reflective, surprised. Not a hint of panic.

'Well, it looks okay all the way to the summit from here and I thought that bit was fine, really. Do you actually want me to get the rope out just for this section?'

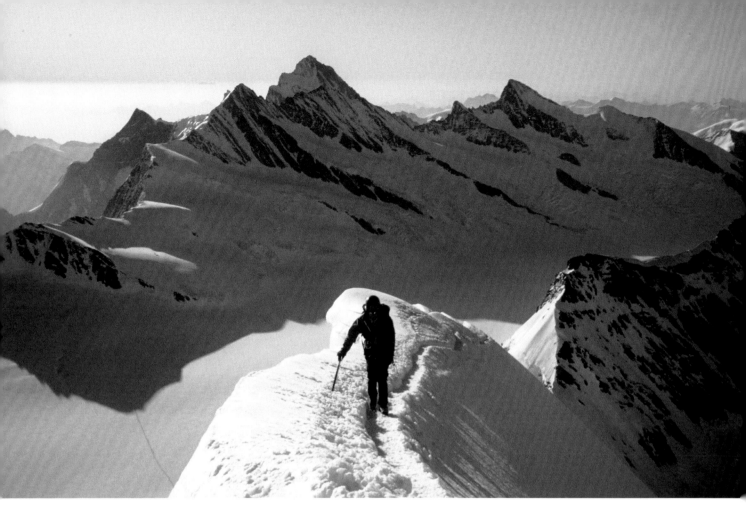

Top: Ralph Atkinson on the south-east ridge of the Mönch with the Fiesherhorn, the Finsteraarhorn and the Grünhorn across the Ewigschneefeld behind.

Bottom: The Grindelwald campsite, the author reaching for a beer, Daphne Pritchard, Jeff Harris to his left: Miriam Harris and Jayne Wynne-Jones opposite.

There was a pause for thought.

'No. Okay. Just give me a minute.' And then he was across. All headology, as it was being called at the time.

On the summit, once more the wind caught us; this time a keen northwesterly that drove us back down the route to hunch and snack in the shelter of a few rocks just below. Ninety minutes from hut to summit.

Ralph made short work of the descent, carrying the rope, so we were back at the hut before 9 a.m. despite my knee giving me some pain. In January I'd torn ligaments and damaged cartilage in an extravagant fall on the Tour glacier but intensive physiotherapy had given me the chance to regain sufficient fitness and confidence to join the meet at Grindelwald. An awkward twist on the descent from the Gleckstein hut had irritated the injury and now it was playing up again, but a rest at the hut while we packed our sacks was enough for me to saunter easily back to the Jungfraujoch just in time to miss the 10.30 train.

An hour and three-quarters down on the train was longer than it had taken to climb the Mönch. At one point I awoke to see half the people in the carriage were fast asleep and soon rejoined them; there's nothing much to see shut away inside the Eiger. The afternoon was spent with the children at the campsite pool.

Forty-four climbers had arrived on the meet, so rest days were pretty sociable despite plenty of people being up on the hill at one time or another. The kids could usually summon up enough adult support for playable cricket teams although the afternoons tended to be spent cooling off at the pool. That, however, had its own hazards.

Fat horseflies flew low over the water to target swimming heads. The only defence was to respond to the first tickling of a bite by instant submersion, leaving the flies to sink or swim, but for many of us it was too late and itchy bumps formed on ears and foreheads.

When the pool was less crowded another predator appeared on the scene. House martins would cut down fast to near water level to pick out the flies then swing up, narrowing past poolside spectators. As they skimmed in over the water their white undersides turned blue, reflecting the blue of the pool. Swimmers had time to register a shrilling shadow, a flash of blue, and flinch as the birds scythed horseflies out of the air next to their heads.

It's easy enough to see how martins would work out the harvest supper at the pool, but what puzzled me was whether the horseflies had done likewise.

Schreckhorn, 4078m. South-West Ridge: D-

On the night of 30 July a storm blew in, *donner und blitzen*, with much hammering of tent pegs reguying flapping canvas on the campsite. Bedraggled teams trailed in all morning, wet and disgruntled, caught by the storm on attempted ascents, and with much low, fresh snow, this fairly put paid to any plans to climb up to the Schreckhorn hut the next day. However, a fine morning and a better forecast were enough for Mike and me to take the lift to Pfingsteg on 1 August. The track to the Shreckhornhütte began wide and safe, but then narrowed to what must have been a nerve-wracking traverse before the safety nets and stanchions were installed. We felt sufficiently stretched to take a refreshments break at a little *buvette*, but the service was lousy so we soon pushed on, spotting chamois in scrub below the path as we did so.

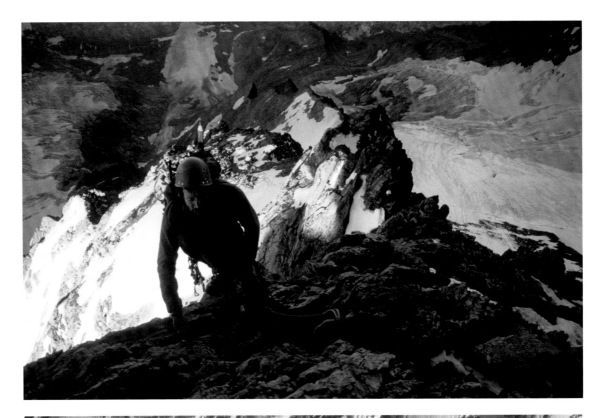

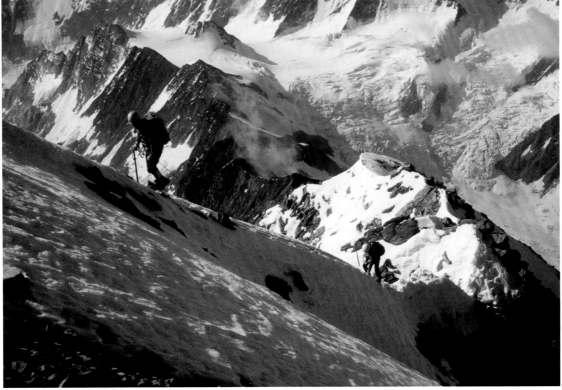

Top: Mike Pinney climbing the south-west ridge of the Schreckhorn.

Bottom: The final snow ridge to the summit of the Schreckhorn.

The track went on, undulating along a shelf above the Unter Grindelwald glacier, round corners above Und Ischmeer and up ladders on the rocks of Rots Gufer. Beetles crawled like incandescent jewels amongst grit and tough grasses while harebells and tiny antirrhinums blew in clumps or hid in sheltered corners. Forget-me-nots with some pink mutations amongst the blue were scattered like handfuls of confetti. At one point the path practically ran under a waterfall. The intimidating Fiescherwand with its huge cornice dominated the view, though the Eiger gradually revealed the extent of its ridges, and the summit of the Finsteraarhorn stood out above the upper icefall as we advanced.

In four hours we reached the hut. Yes, the Schreckhorn had been climbed but no one was back yet. The guardian looked at us dubiously when he read our nationality on our OAV cards as we booked in: 'Some of your countrymen have been here already this season. You are sure it is the Schreckhorn you wish to climb?'

We recalled that one team had taken 27 hours on the route and the guardian's parting comment to them had been, 'There are some one-day routes you might try on the Faulhorn.' There are only walks on the Faulhorn.

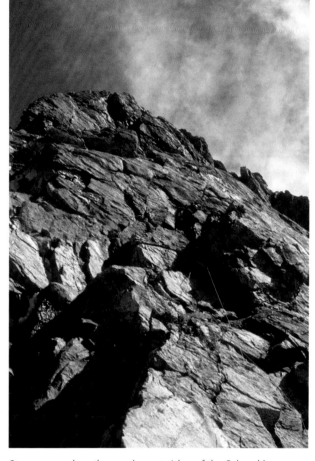

Steep ground on the south-west ridge of the Schreckhorn.

'Yes, we're sure.' It seemed undiplomatic to remind him that the first ascent of the south-west ridge in 1902 had been made by three unguided British climbers, Wicks, Wilson and Bradby. Instead, we grabbed some sleep before the evening meal.

Woken by fireworks at midnight we realised, of course, it was Swiss National Day, but soon dozed off again. Up at 2 a.m., we were out by 3 into a night that was too warm to be comfortable but light enough for me to get by with a fading headtorch. We let a guided team work out the path to the ruins of the Strahlegghütte then up the Gaag valley, catching them at the glacier. If snow conditions are good it's possible to turn off below the hut ruins and go up on snow to within 200m of the glacier. A tall cairn is supposed to mark the turn-off, but the fork was indistinct and we all missed it in the dark.

Once in the glacier bay of the Schreckfirn we swung high above the crevasses on good snow, passing below the Schrecksattel to reach an obvious snow ramp running up to the shoulder on the south-west ridge. At its foot the inevitable bergschrund was filled with avalanche debris so we crossed it easily, climbing quickly over snow and rocks to get established on the ramp. Good steps led up until we reached brittle ice and traversed left at about one-third height to follow rocks to the shoulder.

There we took a short break to eat and drink, take in the views and watch other teams following us up the route. The foreshortened rock buttress where we were heading loomed above.

We moved together, on up the ridge, making use of the odd natural running belay, occasionally taking a stance where the leader encountered a tricky section, as morning light began to touch the rock. Technically it was no more than III on good rock, with verglas to add spice to the ascent. A bit of a pinnacle, a couple of short borderline–delicate snow saddles, and we reached the summit snow ridge, steep but straightforward. We were first on the summit, in six hours from the hut.

There were great views of the Wetterhorn and Finsteraarhorn, but we didn't linger as a cutting wind had sprung up that stayed with us all the way down. The guided Swiss team arrived, took pictures and signed the summit book with us before they went on to try the traverse to the Lauteraarhorn. Just as we were leaving, a German team tried to persuade us to join our rope with theirs for longer abseils on the descent, but we slid out of that and set off on our own: abseil points at 20m intervals were quite enough on a ridge, however steep.

We abseiled and down-climbed to the shoulder, passing some Italians en route who were pitching the climb and taking far too long over it. Next day we heard that they had run out of time and turned back a couple of hundred metres from the summit. Meanwhile, I realised that I was succumbing to Jeff Harris's cold, which he had thoughtfully been passing round the campsite. My head throbbed, my nose streamed and I was seized with fits of sneezing. Cloud blew in as we trudged down the glacier and it became a real effort for me to keep going, but the softening snow was a delight to 'boot-ski' down, and in daylight a path appeared across the rocky scree so we still reached the hut in six hours from the summit.

The Swiss pair had given up on the traverse to the Lauteraarhorn and descended from the Schrecksattel, risky but quicker than us, so they were waiting at the hut. This was the line of the first ascent by Leslie Stephen, Christian and Peter Michel and Ulrich Kaufman in 1861; it remained the normal route for 50 years but is now rarely climbed because of the ever-increasing risk of stonefall and avalanche. The guide gave us full credit for being first on the summit, thereby reclaiming some credibility for British climbers in the guardian's eyes. But I was burning up. Daphne Pritchard and Jane Gamble , two very experienced climbers, turned up to keep us company as we booked in for another night, although I soon retired to the dorm where I lay cooling in the breeze from the window, listening to the hollow cracks of clashing horns as steinbock squared up to each other outside.

As the light faded I burrowed into blankets and spent a dream-tossed, sweaty night. By morning I felt well enough to force down some breakfast and walk out, slowly, with aching joints. We stopped at the little buvette to refuel and watch a waterfall weave a ribbon of rainbow out of sunlight in the gorge below.

It took me five days to fully recover, days in which the weather remained fickle and some people gave up and went home. Ralph, Daphne and I went bolt-clipping in the local gorge on a fine afternoon and there was a meet party to raise morale that coincided with the Grindelwald Swingfest. Garlanded and streamered, cows were paraded past the campsite, to a great clanking of bells. In the huge marquees, mighty wrestlers drank foaming brews from equally massive cowbells or set them ringing under the ranks of other bells that recorded decades of competitions, hanging from the roof tree back down the tent. There were accordions and oompah bands, dancing, and grilled beef and bread.

The following day there was a distinct feeling of lethargy on the campsite, but Andrea Stimson and I were soon heading off to Zermatt. With only a week left of the meet and dubious weather, Andrea's

climbing partner, Nick, had already left for home. Andrea had climbed the Grand Combin with Jeff Harris while I'd been ill, but although we'd done a fair amount of eating, drinking and swimming in the same crowd, she and I had not climbed together. Knowing a little of Andrea's reputation on rock and that she'd been on expedition to Peru the previous year, I was a bit apologetic about the route I had in mind: 'It's just a walk in the snow really.'

The plan was to traverse the frontier ridge from Nordend to the Breithorn. I figured the weather would be better further east and was due for an improvement, but many of the other climbers on the meet had done enough of the peaks involved to be doubtful about taking on the commitment of the full traverse. Fortunately Andrea had not climbed much in Zermatt, so all of the route would be new to her. The drive over saw us having the sort of conversation where you try to work out what your new climbing partner will be like on the hill, although with our backgrounds there wasn't likely to be a problem; it's not like we were some unknowns who'd picked each other up on the web.

Gradually over the next few days it emerged that Andrea had been suffering from the trauma of dealing with the deaths of two members of her Peru expedition the previous year. The lads had fallen from a ridge on their chosen mountain before Andrea or her partner had been even reasonably acclimatised, and much of the detail of repatriating the bodies and dealing with less than helpful Peruvian officialdom had fallen to her. This year she wanted to climb within her comfort zone and the meet had seemed ideal.

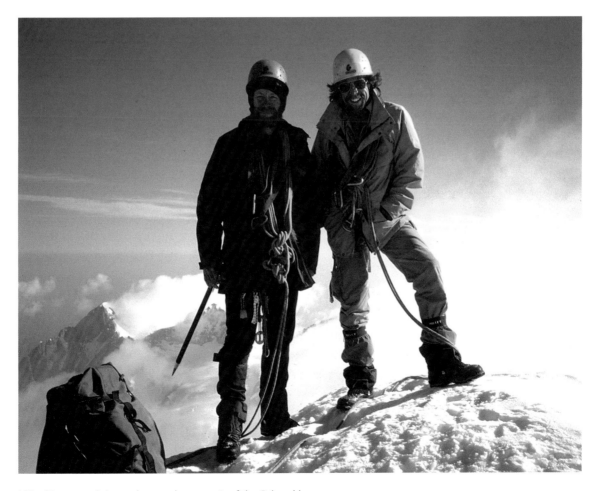

Mike Pinney and the author on the summit of the Schreckhorn.

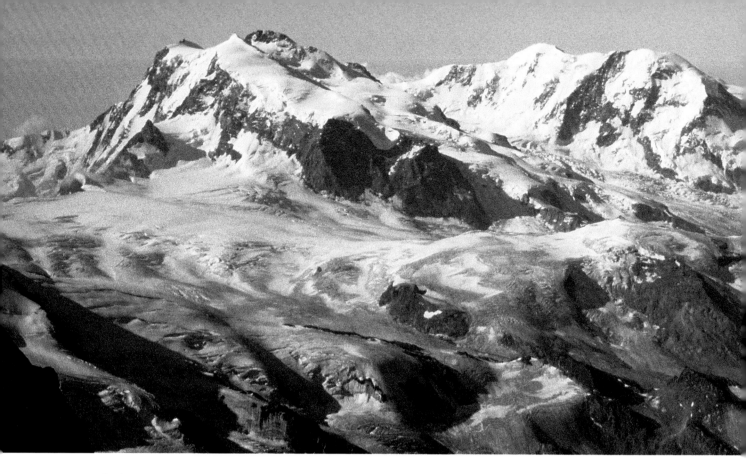

The frontier ridge in its entirety from Nordend to the Breithorn.

That night was spent in the Hotel Bahnhof, run by Paula Biner for many years after the deaths of her father and brother, famous guides. She found me a bunk, but Andrea had to settle for a mattress in the office. Andrea had the better deal: the dorm was full of Japanese tourists who didn't understand the routines and crashed out on any bunk, barricading themselves in with mountains of luggage. My allocated bunk was occupied by one who took refuge in an insensibility not even the most vigorous shaking could dent. I, however, spent an anxious night on a vacant bunk wondering if the owner was going to turn up at any moment.

Next morning we caught the Gornergrat railway to Rotenboden and walked easily up to the Monte Rosahütte, carrying morning papers for the guardian. The weather was cloudy with drizzle, but despite this we dumped our gear at the hut and scouted the tracks onto the glacier. When we returned to the hut, it was to something of a financial crisis; Andrea's purse had disappeared. She thought it had been palmed by someone after she put it down in the boot room, since she had exhausted all other possibilities to explain its disappearance. It didn't take much calculation to work out that I didn't have enough money to cover all our costs at the huts en route so the whole enterprise appeared to be at risk. Andrea was really upset and informed the hut staff, but there was little they could do except ask each team as they booked in if they had seen it. We sat and worried.

Then the British guide Smiler Cuthbertson turned up with a client, Hazel; they had just climbed the Dufourspitze in cloud. His advice was to make as much fuss as possible: Andrea should go round asking everyone in person if they had seen it and make no attempt to conceal her distress. It was good advice: about an hour later an ancient Briton found the purse on the floor of the winterraum, a place Andrea had meticulously searched already. Its contents were intact: clearly someone's conscience had troubled them once the consequences of their actions had become clear.

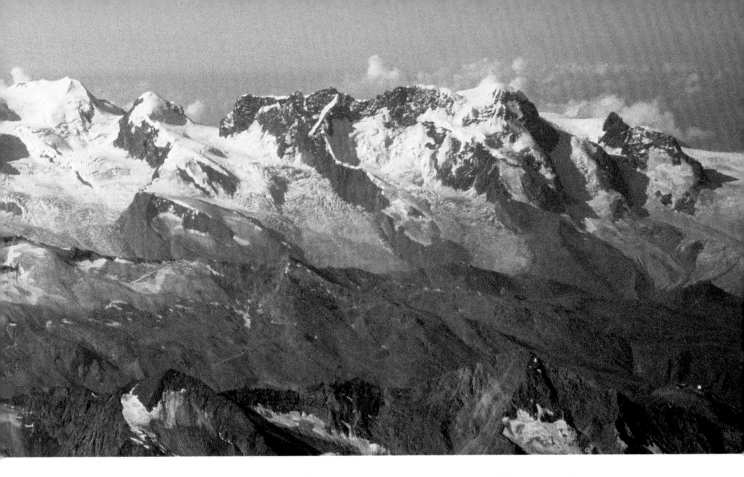

Nordend, 4609m. – Dufourspitze, 4634m. – Zumsteinspitze, 4563m. – Signalkuppe, 4556m. Traverse: AD

Andrea and I were up before 2 a.m., but there was no hot water until 20 past, and then one of the urns seemed to have a clogged nozzle. Food consisted of meagre pack-ups, so we congratulated ourselves on having carried up our own breakfasts; obviously the warden didn't like alpine starts. Despite the disappointing breakfast we were still away before 3, our breath clouding about our heads in the torchlight.

The Monte Rosa hut stands on the Plattje, an island of rock at the confluence of the Grenzgletscher and the Gornergletscher, and we had to find our way off this and onto the Monte Rosa glacier to the east that peters out into a small lake just north of the hut. Stumbling up moraine-scattered rock that didn't look a bit like it had in daylight, we located the glacier track in about an hour. We passed cautiously through a crevassed zone, which cracked ominously underfoot, before slogging up a series of rises as the sky turned pink in the half-light. It was hard work and my rucksack felt too heavy. As we caught our breath we were passed by the Brit who had found Andrea's purse. He greeted us cheerily and Andrea commented under her breath, 'He's a fit old bugger isn't he!'

A panorama of peaks from the Weisshorn to the Breithorn emerged from the darkness to the west of us as we too climbed towards the light. The recent bad weather had left a depth of fresh snow that dragged at our feet, and from the Satteltolle at around 4200m, where the path to the Silbersattel turns off east, we were breaking trail; most people head for the snowy west ridge of Dufourspitze. A bitter wind had grown in strength as we'd toiled up in the shadow of the frontier ridge and despite the exertion I felt an increasing chill creeping into my spine. I stepped up the pace in an effort to generate more heat but with little success as the wind increased with altitude.

Reaching the Silbersattel, we climbed easily along the snowy west side of the south ridge of Nordend, on the edge of Italy and in sunshine at last; but there was no warmth in it. The wind had

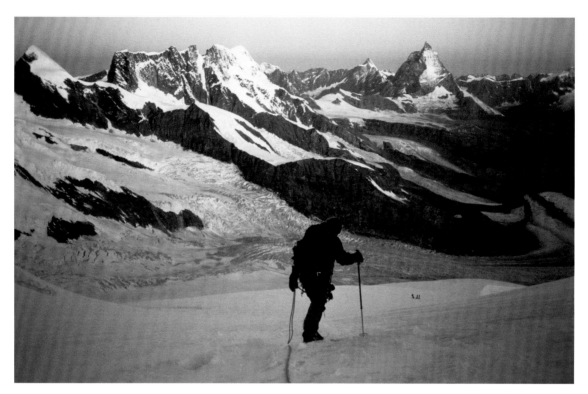

On the Monte Rosa glacier at dawn.

strengthened. There was some interesting mixed climbing up the final rock step, but my hands and feet were numb with cold by then so I wasn't fully appreciative of its quality. We reached the summit at 9 a.m. To the north the frontier ridge lost height as it snaked away towards the Strahlhorn, but beyond, the Rimpfischhorn, Alphubel, Täschhorn and Dom rose majestically in the morning light. To the south, the north flank of Dufourspitze was probably no more than 200m above the glacier but looked impressively steep, while the north ridge appeared tough even from here. Back at the Silbersattel, I put on every stitch of spare clothing as two other teams followed our tracks over to Nordend.

We were exposed to the full force of the wind as we attempted the north ridge to the Grenzgipfel of Dufourspitze. A concave slope of hard brittle ice fell away precipitously over the huge east face, providing no secure placements for ice axes or the front points of our crampons as we took turns trying to reach the rocks above. A pair of nerve-wracking slides, barely retaining balance as crampons scraped down the ice, coupled with the realisation that the ice steepened and became more brittle as we gained height, persuaded us to back off. We worked our way back west along the foot of the north flank, until we reached a steep shallow couloir system falling from the ridge just east of the summit. It looked like tricky mixed climbing up thin ice and rock, plastered with fresh snow where it hadn't been blown off.

Andrea led up a snow-ice streak to a delicate leftwards traverse to another ice streak and a convenient belay. I led through into a narrowing boot crack filled with unconsolidated snow that was more of a hindrance than a help to jamming my feet into it. A tracery of cracks in the slab to the right allowed me to lodge the pick or adze of my axe to aid upward progress, while the occasional peg or a bit of tat supported our belief that this was a climbable route. I crossed a sketchy rib leftwards to reach better snow in an upper branch of the couloir that led more steadily to the summit ridge. We

Nordend from Dufourspitze.

both found the climbing testing and appreciated each other's leads, which boosted confidence in the partnership.

I'd warmed up with the effort of climbing the couloir but suffered from uncontrollable fits of shivering whilst belaying, and despite emerging into the sunshine of the summit I was still having difficulty keeping warm. As we ate lunch on the summit, I puzzled over the huge carbuncles of ice defying gravity on the north face of Liskamm, but the shivering continued. I realised I'd been travelling light as usual but this time probably too light: I was suffering from incipient hypothermia. Despite a big hug from Andrea it was still an effort for me to get going again.

Tired, and feeling the effects of altitude, we took extra care traversing the exposed rocky ridge to the Grenzgipfel and down to the Grenzsattel; Andrea's regular checks that I was not drifting off into hypothermia were much appreciated. The ridge was quite crowded by now, with climbers from both the Monte Rosa hut and the Margherita hut on the summit of Signalkuppe creating two-way traffic. A ramshackle party of Italians included a woman à cheval on a 'knife-edge' rock section, gripped out of her mind and being roundly berated by what can only have been her husband. The rest of the group had belayed themselves to more comfortable perches to have a fag and occasionally join in the shouting in a desultory fashion. We passed delicately through their ropes and around them; best not to get involved.

After a brief break for a drink at the Grenzsattel, we slogged up soft snow steps over Zumsteinspitze and on up the apparently interminable snow slopes of the Signalkuppe to reach the Margherita hut at 4.30 p.m. There we were told that we would have to sleep on the floor – and water was SF4.50 per litre!

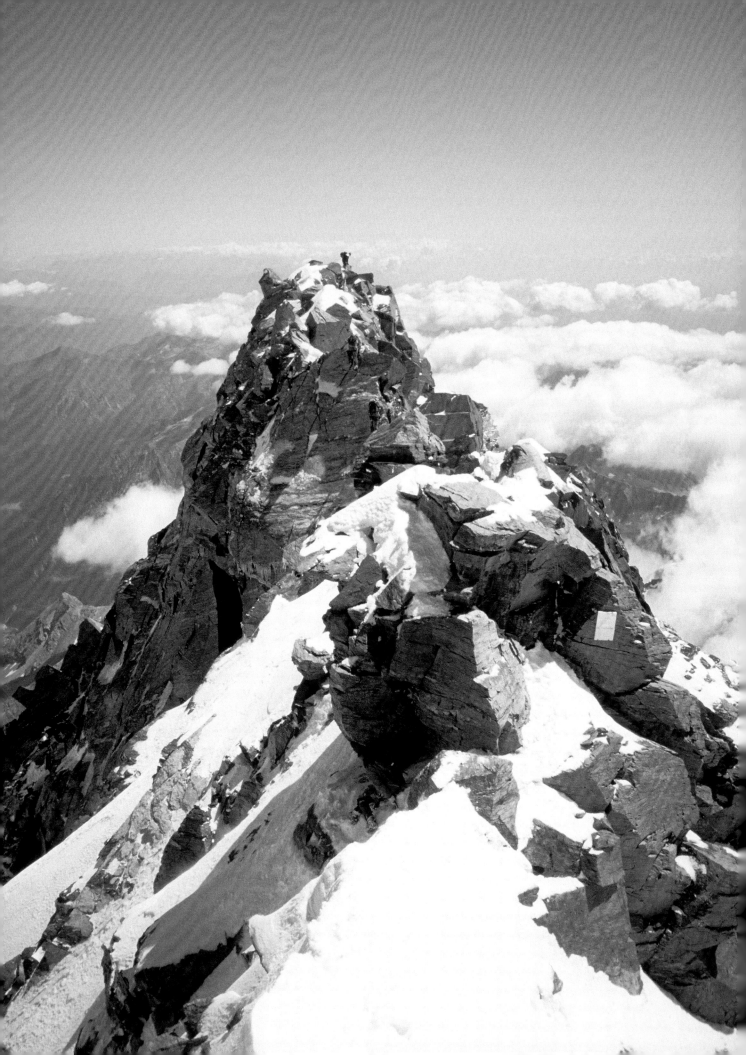

We were both tired and feeling the effects of being at 4556m. I went very slowly through my hut arrival routine, repacking my rucksack and clustering stuff that needed drying where I could be sure of finding it again, before getting down to some serious rehydration, never mind the expense. For the first time since leaving the Monte Rosa hut I felt really warm, but the place was packed and stuffy. Andrea felt headachy and nauseous but I managed to persuade her to eat enough to settle her stomach, and the food was actually quite good.

There was a team of medics in residence on the top floor of the Margherita hut. They periodically conduct a hypodermic sortie in search of deep arterial blood to assist their research into the effects of altitude. If you're not suffering before they get to you, you will be afterwards. Fortunately we had been forewarned by Miriam Harris, who'd had a particularly nasty reaction, nearly requiring evacuation, so we steered well clear of them. Others suffering from the altitude went upstairs for a consultation and emerged looking ashen. Vampires in the attic?

The sun set in a blaze of glory between the Matterhorn and the Dent Blanche with

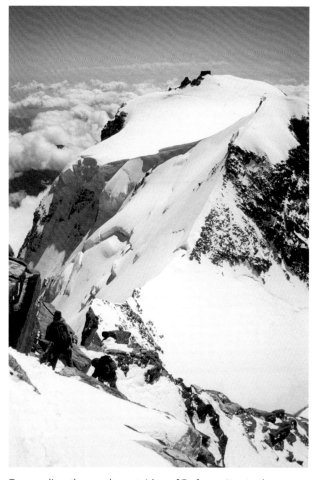

Descending the south-east ridge of Dufourspitze to the Grenzsattel, with Zumsteinspitze and Signalkuppe beyond.

just a few wisps of cloud low down on the horizon, promising another fine day. Tables were cleared out onto the terrace and mattresses distributed on the floor with practised efficiency at 9 p.m., although, as more and more floor space was covered, I became convinced that once I had been jig-sawed into place the only way to the loo would be by trampling my fellow sleepers underfoot. I took a sleeping pill, specially carried for the occasion, and let unconsciousness take care of the problem.

Parrotspitze, 4436m. – Piramide Vincente, 4215m. – Liskamm 4527m. – Castor 4228m. Traverse: AD

At 5 a.m. we breakfasted with two French climbers who had followed us onto the summit of Dufourspitze. They had been going very well, but looked dog-rough that morning.

'We didn't sleep much. Bad dreams. And I feel sick all the time,' said one, leaving the table in a hurry, clutching his stomach.

The Grenzgipfel from the summit of Dufourspitze.

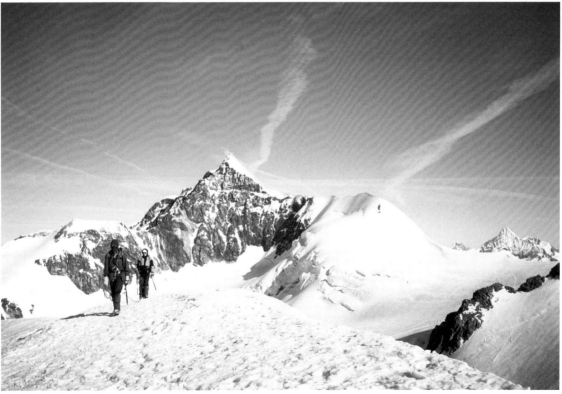

Top: Dawn at the Margherita hut.

Bottom: Liskamm seen from the summit of Piramide Vincent.

His friend said, 'I think we need to go down. There is no point in going on to Liskamm if he is so ill. It is too dangerous.'

There was no improvement as they prepared for the day ahead, and when we left at 6 a.m. they had decided to return to Zermatt as quickly and easily as possible.

Andrea, on the other hand, was looking as good as ever after a night's rest. Outside the hut, the sun rose clear and golden above an expanse of cloud that covered the Italian plain and valleys below us, lapping against ridges rising to the frontier crest, but the wind was neither as cold nor as strong as it had been. We stood on top of the world in the dawn light, tracing the succession of snowy ridges that lay ahead of us. Andrea turned to me and grinned; 'Okay Dave, take me for a walk in the snow.'

We made our way down steepening snow to the Seserjoch, then up an easy snow spur to the Parrotspitze summit. Descending again, we hardly noticed the Ludwigshohe or Corno Nero as we contoured round the Balmenhorn and down to Colle Vincente. There is no way these three insignificant bumps qualify as some of the highest mountains of the Alps.

An easy snow slope led up from the colle to gain the summit of Piramide Vincente from the north. The views of the sweeping south face of Monte Rosa were superb: it rose like a great wave, streaming snow and rock, with Margherita surfing its crest. A couple of Italian climbers had followed tracks up from the Gnifetti hut with neither map nor guidebook, and now needed some assistance to find Punta Giordani; it's that insignificant. We pointed them in the right direction before descending to the track up to the Lisjoch.

From the Lisjoch we climbed the east ridge of Liskamm up an initial softish snow slope, an airy, near-horizontal section, and final icy exposed step to the summit. It took under two hours. We had just ducked out of the wind for a snack when a party of three Germans arrived having traversed from the west summit. One snapped us as they left, but just as he started to descend the initial rocks he tripped over his crampons and pitched head first into space. There was a sickening thud as he landed heavily and slid away down the north side of the ridge before the combined efforts of his companions managed to bring him to a halt. Fortunately they were below the rocks and had leapt onto the south side of the ridge, hurriedly getting down into the snow and bracing themselves against the pull from the rope. It came tight on them but they weren't pulled down after him. He hung for a while, getting the breath back into his lungs, before climbing awkwardly back up to the ridge crest, belayed from above. Bruised and shaken, he brandished his undamaged camera, hanging like

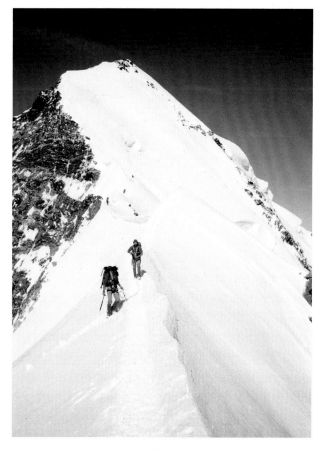

The east ridge of Liskamm with the summit above.

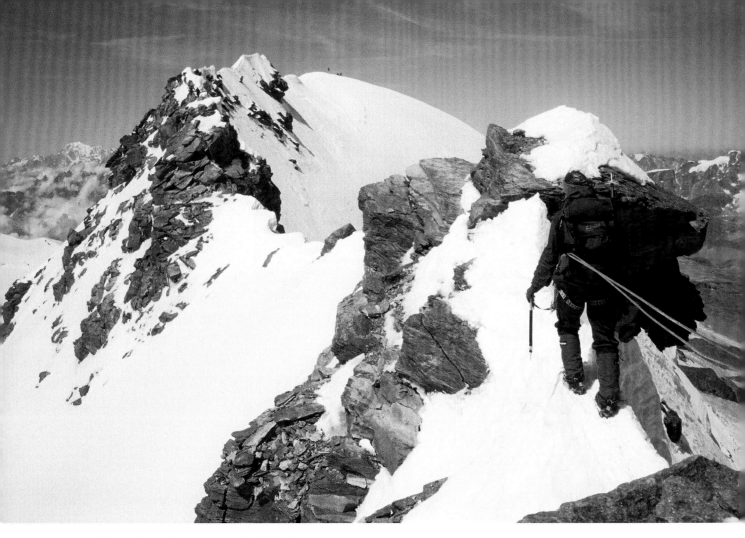

Traversing to the west summit of Liskamm.

a talisman about his neck, with an amazement he wanted to share: then he took a picture of his companions, still hunkered in the snow.

This was a reminder that Liskamm has something of a reputation for accidents. The ridges are particularly prone to cornice build-up, and the contending north and south winds have been known to produce a distinctive double cornice that is particularly difficult to read when traversing the mountain. The east ridge had been kind to us but it remained to be seen if the traverse of the Grenzgrat to the lower, western summit would be as accommodating.

It turned out to be more delicate, with some narrow sections and tricky climbing over rocky knolls approaching the western summit, but there was no sign of the infamous double cornice; in barely an hour we were there, eating lunch and looking back over the expanse of the upper Grenzgletscher towards Dufourspitze, Signalkuppe and our route of the previous day as high cirrus streamed in the sky. The wind had dropped steadily, so that before we set out again we stowed warm hats in favour of sunhats excavated from the depths of our rucksacks.

An easy descent of the west ridge to the Felikjoch was followed by a very tiring ascent of the east ridge of Castor in snow with the texture of gritty granular sugar. It was the heat now that troubled us, and Andrea was unhappy about the idea of going on to attempt Pollux that day. On the summit of Castor we realised that we had been climbing at over 4000m all day; in fact we had not been below that height since reaching the Silbersattel the previous morning. Two Italian climbers pointed out a new hut at 3420m, perched on a rocky eminence much higher than the Mezzalama hut, and gave us directions as to the best approach. I was anxious about whether we would have the time the next day to climb Pollux and traverse the Breithorn, but agreed to go down.

From the summit ridge we descended steeply to a very big step across a treacherous bergschrund melting quietly in the afternoon sun; mini-slides of slushy snow slipped from the bergschrund's upper lip to disappear into its maw. Continuing down the wet west face of Castor we reached the Verra glacier below the Zwillingsjoch. From there a very wet slide down the glacier took us to the Lambronecca rocks, where the hut is situated. Then it was known as the Lambronecca refuge, but 20 years later has acquired the additional name of Refuge Guide d'Ayas. It is very well situated for access to the frontier ridge and has excellent modern facilities, although we slept in a very stuffy dormitory with no windows that we could find. It was also expensive enough to have put an end to our traverse if Andrea had not recovered her purse.

Over a beautifully cooked meal of lamb and lemon, Andrea and I chatted to two other climbers, Mario and Mario, who were also planning to climb Pollux on the morrow.

'I'm worried about whether we will finish traversing the Breithorn in time to catch the Kleine Matterhorn cablecar back to Zermatt,' I confided.

'Ah, that is no problem. The last departure is at 16.30. You will have plenty of time.'

'But we want to traverse the whole frontier ridge. All the summits. That'll take a lot longer than just getting over to the highest in the west.'

'That is different. And the weather … it is forecast to get worse in the afternoon,' the Marios added helpfully.

Consulting the guidebook, a rapid calculation established that we ought to be able to make it, but the weather forecast added another dimension to my anxiety. With success so close it would have been a shame to miss out on the full Breithorn traverse that had only been completed for the first time in 1884 when J. Stafford Anderson, with guides Ulrich Almer and Aloys Pollinger, took ten hours over the route. Fortunately, since both Andrea and I were so much more relaxed and confident about climbing together, the deadline had more of the spice of a challenge than the intimidation of a threat.

Pollux, 4091m. West Face: PD – Breithorn, 4165m. Traverse: AD

By 5.30 a.m. we were crunching back up the now-frozen slush of the Verra glacier, branching left to climb steeply up its flank onto the plateau of ice below the west face of Pollux. We dumped our rucksacks and rope on the Schwarztor below the steep snow face that fell from the summit ridge to the east, high above us, where a half-moon still hung gleaming. Soloing up out of cold shadow and into cold light, we gained the summit by 8 a.m. The full extent of the Breithorn ridge lay before us, from the Roccia Nero to the west summit, steep and rugged in the stark sunlight. The rock steps barring the way to the central summit looked impressively vertical, and the Younggrat in profile was etched against a background vista that included the Dent Blanche and Obergabelhorn.

As we descended into shadow again, I was suddenly spooked by the iciness of the steps we had climbed in the west face and turned to face in for the descent, but Andrea just cruised on down. We collected our sacks and crossed the Schwarztor, but the initial snowslope of the Roccia Nero was suffering from exposure to the early sun and trails of fallen snow formed flutings that began under a fringe of cornice and ended in cones of debris at the foot of the face. It was too avalanche-prone to climb direct.

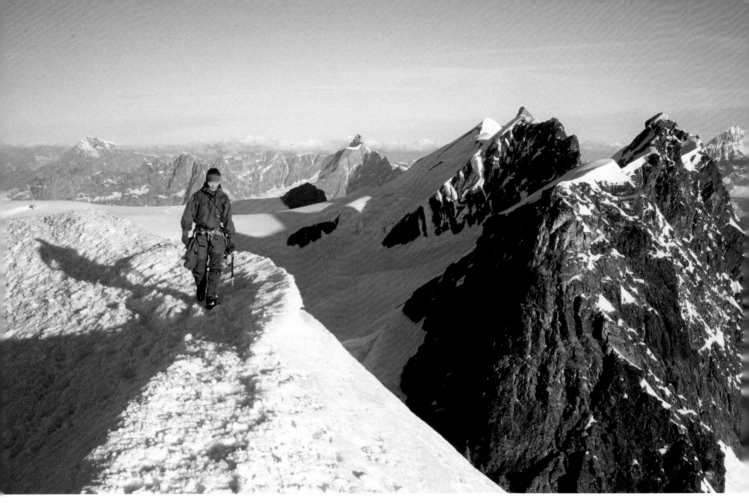

On the summit of Pollux with the Breithorn summits beyond on the right.

We slanted left up softening snow to the rocks of the Volante e Rossi bivouac hut, greeting a pair of climbers in residence in passing. Breaking a trail through more rocks and snow, we got established on the glacier spur leading to the crest of the frontier ridge. This was harder going than it had looked from below, but we still managed to reach the crest by 9.30 and follow it right to the summit of Roccia Nero for the views back towards Pollux. The ridge to the west of us looked as impressive as it had from the summit of Pollux, but we were in good time and with a guidebook estimate of five and a half hours for the traverse, I was now more confident about getting back to Zermatt that day.

The almost-level snow ridge led to more mixed ground and we scrambled over rocks to traverse Gendarme 4105m, also known as Breithorn Twin East. We climbed down to the snow ridge leading to the eastern summit or Breithorn Twin West over more mixed ground. From there a short abseil led to a corniced snow saddle and on to the rock steps of the central summit.

At the first rock step we caught up with eight Swiss climbers who had been stopped by the difficulty of the rock. The guidebook simply stated 'Climb the first (step) direct III+', but there was no obvious direct line and it all looked much harder than III+. The Swiss had tried a few lines without success and we dutifully did likewise before I located a good leftwards rising traverse that was probably the alternative 'on the left across a rocky flank'. The Swiss followed us up to the top of the first step and on to the second step that went at about III, but we steadily drew ahead. Andrea and I moved together, trying to make sure there was always one runner between us until the leader ran out of gear, at which point we swapped the lead. It was delightful, varied climbing with cracks, traverse lines, knife edges, creaking flakes and bits of snow, all in a superbly exposed position above the precipitous north face. The third step was climbed close to the crest, which narrowed to a sharp ridge of rock spikes and snow approaching the summit. It was climbing in a stunning situation with

the Monte Rosa group in the background to the east, and the Swiss team obliged by keeping sufficiently in touch to remain photogenically within camera range.

The promised afternoon cloud closed in from the west as we gained the central summit, but we briefly dropped below the cloud base, descending snow to the saddle beyond. There we checked each other's compass bearings before climbing back into the ceiling of cloud up a broad spur that narrowed to a fine snow ridge leading to the main western summit of the Breithorn at 4165m. There, a reception party of one Japanese and a Swiss couple (in fell boots with spring heel grips) shared our elation at completing the route. It was 1.50 p.m., so there was plenty of time to get to the cablecar. The Swiss gentleman took a picture of us on the summit in the clag; one of those shots that could be anywhere if it wasn't for the look of pure delight on our faces.

With no reason to hang around, we slid off down a slushy track to emerge under the cloud again and slog over to the Kleine

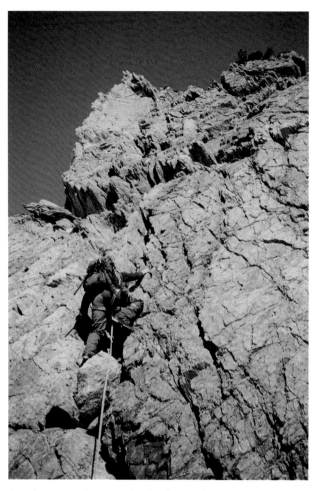

A rock step on the east ridge leading to the central summit of the Breithorn.

Matterhorn by 3 p.m. That sense of elation continued so that not even 45 minutes stuck in the broken down Trockener Steg lift could dampen our spirits. A Japanese party seemed to have the right idea when they just sat on the floor of the cablecar and had a picnic. Despite the tiredness and sense of loss as we descended from the heights, there was a shared feeling of having achieved something special.

It was drizzling by the time we called back at the Bahnhof hotel to let Paula Biner know that we had been successful. Horse dung was leaking brown trickles into the gutters and the mountains had shrugged back into the clouds as we crossed the road to the railway station: a perfectly timed route.

Driving back to Grindelwald, we met heavy rain in Kandersteg. I had a day of rock-climbing with the kids before the weather closed in for good and it was clear the meet was over.

1993 was my last big season in the Alps. I had climbed thirteen 4000m mountains, bringing my tally to 43, and with only nine more left to climb the rest seemed well within my reach. Ironically that seemed to remove any sense of urgency about the task. Moreover those three days almost continuously at 4000m on the frontier ridge had opened up the prospect of longer, higher routes. In the next seven years I spent only one summer climbing in the Alps. Instead I climbed Kilimanjaro,

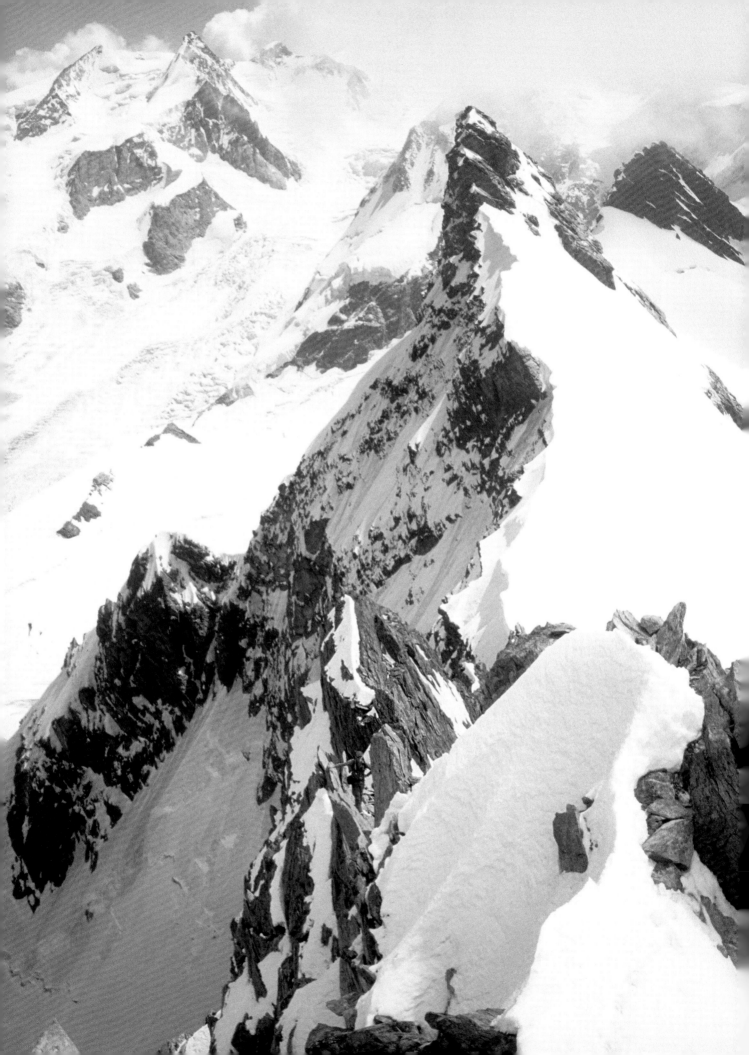

one of the summits of Mount Kenya and Denali in Alaska, failed on 7000m Saraghrar in the Hindu Kush, and twice went on expedition to Peru, climbing peaks of 5–6000m, including first and first British ascents. Easter ski-touring in the Alps also gave way to ski tours in Morocco and the Caucasus, and even desert rock climbing in Wadi Rum. Divorce and increasingly difficult working conditions had made me question many of the assumptions underlying my life; there was 'a world elsewhere'.

A very happy pair on the western and highest summit of the Breithorn after completing the three-day traverse of the frontier ridge.

Left:: Looking towards Monte Rosa down the east ridge from near the central summit of the Breithorn.

14: Ski-mountaineering

Skiing down to Konkordia.

Skis have been used for thousands of years to enable people who live in snowy areas to get about in winter. They simply distribute the skier's weight over the surface, sliding over the snow rather than wading through it. Prehistoric skis have been found at Honne and Kalvträsk in Sweden, whilst a rock carving dating back to 2500 BC on the Norwegian island of Rödöy shows a figure on very long skis carrying a bent pole that may have been used to assist his progress. There are references to skis being used for military purposes during the medieval period in Scandinavia. Olaus Magnus, the Archbishop of Uppsala, in his *History of the Nordic People*, 1555, provides detailed descriptions including the first references to skins:

> The underside of the ski is covered with soft reindeer skin … these people managed
> to ascend mountains and rush down the steepest valleys which otherwise would have
> been completely inaccessible to man … They climb up from the valley by zig-zagging
> their way up the side of the mountain, negotiating difficult terrain and crevasses until
> they reach their goal.

Perhaps one of the most interesting historical records is that found in an account by Valvasor, the Governor of Carniola, in *Die Ehre des Herzogtums Krain* (*The Glory of the Earldom of Carniola*), published in Laibach (now Ljubljana) in 1689. He describes a 'rare invention' of the local Slovene peasants:

> They take wooden boards twain, broad the half of a working boot and of the length of about five such boots (15cm × 150cm). At front such little boards are bent and curled upwards; and in their midst stands a strap of leather wherein to place the feet. Of these boards a man hath on either foot one. Thereto doth the peasant take in hand a strong stick, which he placeth under his armpit, leaning thereon strongly backward, so steering himself down over the steepest of hills. Whereby I can best describe he shooteth or flieth downwards.

In 1930 research on the Bloke plateau south of Laibach, roughly corresponding to the historical Carniola, revealed that similar short skis were still being used in just such a manner. Unfortunately in 1942 the Italian army occupied the area and demanded that all skis should be handed in to the authorities to deny them to the Resistance: the locals in turn preferred to deny their skis to the Italians, and made a bonfire of them. Very few of these ancient short skis survived. However, generally the steepness and greater height of alpine mountains coupled perhaps with a greater emphasis on herding cattle rather than hunting meant that there was no widespread skiing tradition in the Alps.

The coming of the railways to alpine valleys, and indeed via tunnels beneath passes, improved access to the Alps in winter, so that by 1883 Lizzie Le Blond could publish the first book devoted to winter mountaineering, *The High Alps in Winter*. Previously inaccessible alpine resorts, with new winter rail services, became attractive to rich consumptives who could benefit from the clear air as a treatment for their tuberculosis. Writers like J. A. Symonds and Robert Louis Stevenson were two such cases, whilst Arthur Conan Doyle's wife's illness led the couple to winter at Davos. Stevenson and Doyle found the place dull and, like many others with time on their hands, looked for amusement offered by winter sports like tobogganing, skating and curling. This was later to be commercially exploited in a curiously English upper-class way by Henry Lunn, who organised his tours under the auspices of the Public Schools Alpine Sports Club, which he founded in 1903. Perish the thought that his enterprise might have anything in common with Cook's Tours!

In the mid-19th century the people of Oslo, then known as Christiania, developed an increasing interest in winter sports and turned to the locals of Telemark for instruction; Sondre Norheim was an inspiration and a key innovator. This resulted in the development of skiing, particularly 'cross-country' skiing and ski-jumping, but it did not spread to the rest of Europe until the publication of the German edition of Fridtjof Nansen's *First Crossing of Greenland*, in 1891. The book was widely read and Nansen's enthusiasm for skiing generated what Zdarsky was to call 'Nansen Fever'. Nansen was later to be awarded the Nobel Peace Prize for his work for refugees at the League of Nations following the First World War.

In the wake of Nansen Fever, in Davos, Doyle was to write:

> as our life was bounded by the snow and fir that girt us in, I was able to devote myself to doing a good deal of work, and also to taking up with some energy the winter sports for which the place was famous. In the early months of 1895 I developed ski-running in Switzerland.

Whilst he was certainly not the first to use skis in Switzerland, there is some justification for his claim. Having taught himself to ski, Doyle, accompanied by the Branger brothers, made the first ski traverse of the Furka Pass from Davos to Arosa (15 miles). His enthusiasm is obvious: 'it is a delightful experience, gliding over the gentle slopes, flying down the steeper ones, taking an occasional cropper'. After the

first wave of enthusiasm, however, there was an ebbing of the tide as the unsuitability of Norwegian equipment for the Alps became clear. So much so that when the Richardson brothers arrived in Davos in the 1901–2 season they were told the terrain and snow was not suitable for skiing; fortunately they persisted and founded the Davos English Ski Club. The Richardsons were also to found the Ski Club of Great Britain in 1903, which broke new ground for the English in that it required no qualification, had a modest subscription, and admitted lady members (an innovation that the Alpine Club was not to introduce until 1974!).

Meanwhile, at Lilienfeld, Mathias Zdarsky was developing a ski technique with shorter skis and a binding of his own invention. At the Black Forest School, Wilhelm Paulcke was developing a modified Norwegian style that was further developed by Hannes Schneider at the Arlberg School near St. Christoph. The stem turn succeeded the Christiania and the Zdarsky as a 'two stick' style was championed by George Bilgeri, soon to be succeeded in turn by the swing turn, and the parallel swing, developed by Toni Seelos, to cope with increased speed as skiers competed in races like the Kandahar at Mürren (founded by Arnold Lunn in 1911).

Early alpine skiing was, by definition, ski-mountaineering, in that the skier had to climb up on ski, or carrying skis, as well as descend. This is all the more remarkable, since sealskins were not generally in use until after 1900. In January 1896, Wilhelm Paulcke led a team that climbed the first 3000m peak in the western Alps, then in 1897 went on to traverse the Bernese Oberland from Grimsel via the Oberaarjoch hut, the Grünhornlucke, the Konkordia hut and then down the Grosser Aletschgletscher to Belalp; the very first extended alpine ski tour. This was akin to the sort of summer tour that alpine pioneers had devised, where the crossing of a difficult pass was regarded as highly as the ascent of a peak. A. W. Moore's *The Alps in 1864* records the first crossings of the Brèche de la Meije and Col de la Pilatte on equal terms with the first ascent of the Barre des Écrins. Modern climbing has little or no interest in crossing passes, however difficult, and ski-touring seems to have inherited this tradition by default.

In March 1898, Oscar Schuster and Heinrich Moser climbed Monte Rosa, the first 4000m peak to be skied. With the advent of skins, during the first ten years of the 20th century the Finsteraarhorn, the Mönch, the Gross-Fiescherhorn, the Allalinhorn, the Grand Combin and Mont Blanc were all to be skied. By 1908, George Finch was to climb the Mönch, using skis, at the age of 16 with no sense that there was anything exceptional about it. Looking back on his experiences there and on the Jungfrau in 1914, he comments:

> There is much to be said for winter mountaineering. In summer, if one wishes to climb the Jungfrau or any other similar mountain, the ascent of which involves a lengthy walk on snow-covered glaciers, one must start very early, well before daybreak; otherwise, the sun will have softened the snow so much that the ascent, and still more the descent, will be most laborious. On skis and in winter, this nightmare of a long and wearisome trudge in soft snow hardly exists. The return from a climb, especially, is a simple and almost effortless affair. Again, fewer people by far climb in the winter season, and, if one so wishes, one's solitude need not be disturbed.

Frank Smythe is more lyrical when he describes a powder snow descent of the Gespensterhorn in 1928:

> Neither Mcphee nor I have any illusions as to our lack of skiing skill, yet slopes that had taken us nearly two hours to ascend were descended in a few minutes of joyous running. Like wraiths we flitted down our peak, first in the sun, with the parted snow flying up behind in a million scintillating points of light; then over an edge, plunging

Skinning up to the summit of the Grünneghorn with views of the Aletschhorn and Grosser Aletschfirn leading to the Lötschenlücke.

into a cold well of shadowed glacier, swinging now to the right, and now to the left, and then in one swift straight rush. Has the world a greater magic to offer than that which lies latent in the slender wooden runners? Theirs is the poetry of motion to command at will.

However, mechanisation was on the way. Skiers soon learnt to use the rack and pinion railways as a means of gaining height easily and quickly, to access more downhill running. By the end of the 1920s, the number of ropeways, chair-lifts and drag-lifts had increased to the point where downhill skiers outnumbered touring skiers, in part because hut capacity had not increased to accommodate any more touring skiers. Those increased numbers of downhill skiers in themselves created the hard snow pistes as they skied the same runs repeatedly, whilst 'real snow' was left to those touring.

The history of the 20th century has seen increasing applications of technology to skiing regarding uplift as well as boot and ski design. This has brought huge economic development to previously impoverished areas as the expansion and democratisation of skiing has gained ground. Yet in the 21st century ski-touring has never been more popular, as skiers now turn away from crowded pistes.

In practical terms, being able to ski 4000m mountains makes the prospect of climbing all 52 far more realistic: the winter season offers more time for the project, and winter conditions make for fine

days out on what might otherwise be uninspiring routes. Obviously learning to ski is essential, but that tends to lead to off-piste skiing as skills develop and from there it is a relatively small step to ski-mountaineering for anyone with summer alpine experience.

The equipment may seem discouragingly fiddly at first but practice makes perfect, and there are only really two main differences from downhill skis. One way or another, bindings are hinged at the toe, with a mechanism to lock the heel down or release it depending on whether one is climbing (released to lift) or skiing (locked down): most bindings also have some kind of step that can be flipped into place to make climbing more comfortable by raising the 'at rest' point of the heel on steep slopes. The modern skin is no longer a sealskin selected for a nap that allows it to be stroked easily one way but provides resistance against such stroking in the opposite direction; instead we have synthetic materials that duplicate that nap and are self-adhesive rather than needing to be clipped or strapped onto the ski. With skins applied to skis, steep slopes can be zig-zagged in time-honoured fashion, and in icy conditions ski crampons (harscheisen) can be attached. Besides the cleated sole, touring boots have only one difference compared to downhill: an ankle-locking lever for skiing down that is unlocked to allow the boot to flex back for comfort in ascent.

An avalanche transceiver and metal-blade shovel are essential; the transceiver to locate anyone buried in an avalanche and the shovel to dig them out. Learning how to use this equipment effectively is a vital part of any training course introducing climbers to ski-mountaineering, although an inspirational reference book like *Ski Mountaineering* by Peter Cliff is always useful. But the final word deserves to be left to Sandy Irvine, Mallory's partner on Everest: 'I don't think anyone has lived until they have been on skis.'

15:
From Aosta to the Oberland, 1995

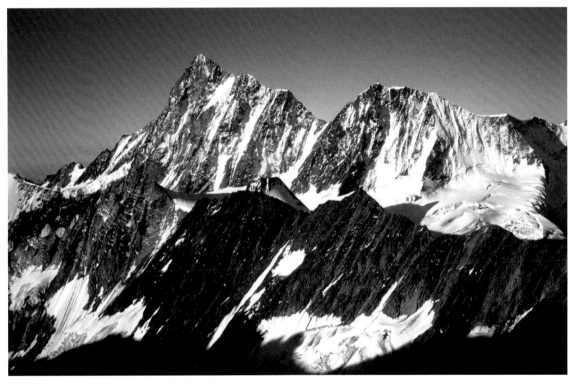

The Finsteraarhorn from the Lauteraarhorn.

In 1995 the Bernese Oberland once again exerted its magnetic attraction as a ski-mountaineering venue. I had been disappointed in 1992 but the opportunity to make a tour that included ascents of the Aletschhorn, Grünhorn, Fiescherhorner and Finsteraarhorn was too appealing to be ignored. Ralph Atkinson and I had arranged to travel out at Easter, and just a few weeks before that I had a phone call from Malcolm asking if we had room for him. The last trip with Malcolm had been something of a trial, but I was aware that we had both been coping with difficulties at work on that occasion and was therefore prepared to give him the benefit of the doubt. Three was a safer group than two with regard to avalanche danger and crevasse falls, and I took pains to detail the proposed itinerary and objectives to him.

On 8th April we caught the 9.30 p.m. ferry, drove overnight and were in Chamonix for breakfast. The plan was to drive over the Col de Forclaz to Martigny and up the Rhône valley to access the

Oberland via the ski station of Bettmeralp, but Malcolm and Ralph both expressed doubts about whether they were ready to dive straight into a big tour, especially one with a night at a bivouac hut to start: 'Can't we warm up on something easier first?'

'What about the Vallée Blanche while we're here?' Ralph had never skied down the Mer de Glace.

'Chamonix is the best place to hang out, and my mate Andy is going to be skiing here later so we could always hook up with him.'

My original plan seemed to be in danger of being shelved in favour of Chamonix day tours. 'Well, the plan has always been to tour in the Oberland, which of course needs commitment, but the weather is really good so we don't want to be hanging around the valley doing easy day tours when we could be making the best of good conditions at altitude,' I explained. 'What about doing the Gran Paradiso from Pont? That's a good big hut with a straightforward ascent, and at least it's another 4000er followed by a rest day travelling.'

Gran Paradiso, 4061m. West Flank: F+

I bought a map, which was duly consulted before agreement was reached, and we drove through the Mont Blanc tunnel and down the Aosta valley. At Pont in the Valsavaranche, I had an unpleasant surprise: I'd forgotten to pack my skins. By a quirk of fate Ralph found that he had mistakenly included his narrow Nordic skins with his regular alpine ones; a lucky accident that meant I could use those rather than give up on a good weather forecast and go shopping. By the time we had skinned up the steep icy track to the Rifugio Vittorio Emmanuel II, I was questioning what sort of luck it had been. Transitions from flattening the ski to edging on ice all too often were accompanied by a rapid backwards descent as the narrow skins lost purchase on the surface: I didn't half swear!

The hut is named after the Italian king whose hunting reserve was donated to the state by the last king of Italy, creating the Gran Paradiso National Park. The spreading horns of the male bouquetin in protected herds showed how they had thrived in the absence of hunters, and we could watch them happily nutting each other on the slopes above the restaurant window. While taking in the views of Ciarforon, an Italian pointed to a circling bird of prey: 'Gipeto!' I was later to find out it meant the lammergeyer, the rare bearded vulture; the long tail gives it away but I didn't know that then. The hut is a comfortable one, a bit like a giant silver air raid shelter, but bunked in under the domed metal roof we had a cold night. We left it at 7.15 a.m. into a grey morning with cloud hanging on the ridge across the valley. Harscheisen were fitted to the skis from the start to cope with the icy surface; a surface hard enough for each of us to lose traction and slide back with a scraping of metal at one time or another. The higher we went the worse were the sastrugi; half-obscured in new snow, they hooked skis under their ledges or tipped us off-balance on the sculpted surface where their wind-eroded forms clustered.

At the first steep section Ralph decided to carry his skis, but as he swung his sack back onto his shoulders one of his harscheisen skittered away down the slope and it was an hour before he recovered it and regained our previous high point. I waited, shivering, while Malcolm went on slowly. At the next step Malcolm and I also gave up and tied skis onto our sacks, plodding on in hopes that we might find a better line for the ski down. Some skiers appeared out of the snowfall, weaving through sastrugi with an occasional drop off the downslope of the larger ones that took them by surprise. Other skiers could dimly be seen taking steeper lines out to the left.

The altitude and the weight of the skis sapped our strength, and Ralph wanted to turn back three times before finally leaving his skis, standing sentinel-like in the snow, to continue on foot to the top. The sun toyed with us, promising to break through the whirling cloud, then betraying us to grey obscurity and blowing snow, although it never became very cold. I suppose that's why we continued. The final 200m was a struggle, and we left our remaining skis where others had established a depot about 70m below the summit. From there we soloed up the slope and along the rocky ridge, protected by a cable for its final few metres to the block on which the Madonna stood in the pelting snow.

Climbing down to the skis, we decided to try skiing down but soon regretted it. Our tracks had been wiped out by new snow that had also filled in the spaces between sastrugi, so turning was an act of faith, all too often betrayed into twisting falls as skis hooked around the hidden ice sculptures beneath the snow. When we

The author next to the Madonna on the Gran Paradiso.

found slopes steep enough to have shed their snow, hard ice left us the alternative of some desperate edging. Visibility was down to zero at times: at one point we found ourselves on the edge of a steep drop that looked nothing like anything we had encountered in ascent. Eventually we gave up, loaded skis back onto our sacks and stumped down on a compass bearing.

It took three hours to get back to the hut, which, combined with a seven-hour ascent, added up to a pretty hard day. The guardian looked apologetic when we asked him about the weather next day:

'Good forecast, but it was the same today. You could traverse to the head of the valley and make a more enjoyable descent to Pont in good weather.'

None of us fancied the icy track down in failing light, so we stayed another night; if nothing else it would be good acclimatisation.

We slept in till 8 a.m, then set out on a beautiful morning; 200m of ascent and a scrappy traverse led to the long valley descent, restoring confidence in our skiing ability despite the legacy of aching legs from our efforts of the previous day. At Pont, we sunbathed and dried clothing while chamois grazed the roadside grass just a metre from the car.

Aosta was shut until 3 p.m., so we hung around the Roman remains until I could buy some new skins. More reservations were expressed about the Oberland, and Ralph seemed anxious about his fitness. He eventually owned up to having had some back trouble earlier that year, but that was later. Once again I looked for a compromise and suggested a night at the Valsorey hut before an attempt

on the Grand Combin. We drove through the Grand St. Bernard tunnel and took a room at Bourg St. Pierre. Next morning I went for the breakfast croissants but after breakfast, as we were getting ready, I detected a certain reluctance about the proceedings.

'Come on. I know we've got all day, but at this rate we won't get to the hut for ages and that last slope up to it can avalanche in the afternoon sun.'

'Well, yes, we've been thinking … perhaps it's a bit too ambitious to go for a long route at this stage when we took so long on the Gran Paradiso,' said Malcolm.

'I'm not sure I'm fit enough for it at the moment,' Ralph added.

'Right. Look. I thought we'd talked this through yesterday.'

'Well, we've changed our minds.'

I reassembled the remains of my good temper. 'Okay. This was only planned because you didn't want to go straight in to the Oberland. There's nothing else we can do today so let's just drive over to Randa and see if we can sleep on the floor at Jeff's apartment. Then if the weather forecast is still good let's stop pratting about, wasting the good weather, and get up to the Mittelaletsch bivvi as planned.'

'Yes, well, we'll have to stop to buy food for the bivvi hut.'

'You mean you haven't brought bivvi supplies.'

'Well I wasn't convinced we were going to bivvi.'

I said nothing but the term 'wishful thinking' came to mind.

I'd had an invitation from Jeff Harris to drop in on his family skiing holiday if we were in the area, and this seemed like a good opportunity to do so whilst giving Malcolm and Ralph another recovery day. It worked: a sociable evening, entertaining Jeff's friend, Chris Raves, who was nursing a dislocated shoulder, was followed by a trip over to Bettmeralp where the Seilbahn broke down, leaving us at the middle station, worried about whether it would be repaired in time for us to get to the hut. The realisation that I had forgotten my prescription sunglasses tipped the balance in favour of another night at Randa when the Seilbahn company agreed to refund our tickets. Jeff and Miriam were just a little surprised to see us again.

Aletschhorn, 4195m. South-East Flank: PD

Finally on 13 April, we made it to the top of the Bettmeralp lift system. The views up the Grosser Aletschgletscher to Konkordia were vast and wild as we turned our backs on the crowded pistes and skied along the ridge towards Reid. Doubling back, we descended easily to the glacier almost directly below our starting point. A direct line would have been more exciting, but what use is hindsight?

We skinned up the easy margin of the glacier before crossing it diagonally towards its junction with the Mittelaletschgletscher. There were vague tracks winding through huge snow-filled crevasses, their edges upholstered by cushions of snow, sometimes descending into the shallower ones to find a way through. At the junction more tracks led across a slushy slope raked with avalanche and dotted with stonefall. We got off it fast.

A short break for a drink, and then we skinned on up the first step to reach a long flat section with a couple of modest rises that led to the final 500m pull up to the Mittelaletsch bivouac hut. It had been snowing in Randa that morning, but the weather had cleared to a fine cool day with enough of a breeze to prevent overheating with the exertion. As we climbed, the Aletschhorn gradually revealed more of itself, with fine views of its rocky south face and hanging glacier above.

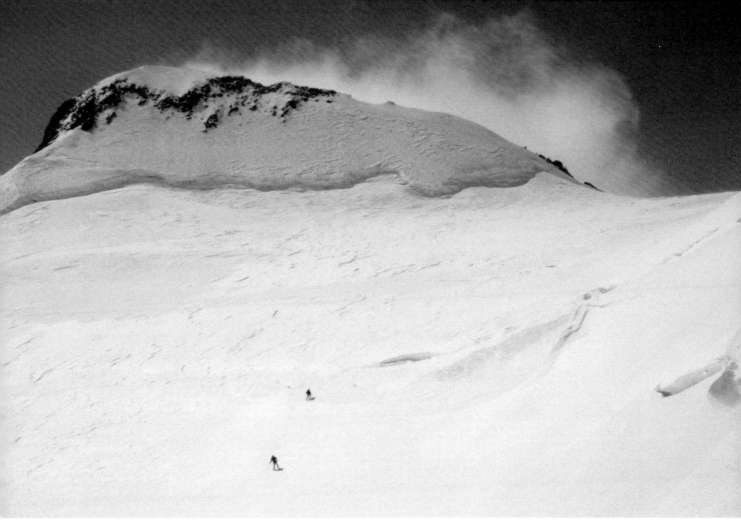

Skiers turning back from the summit ridge of the Aletschhorn with its streaming spindrift plumes showing the strength of the wind.

The hut was a neat hexagon with bunks around the walls, table and chairs in the middle, and a cooking area and cupboards flanking the door. It slept 12, but there was only one other occupant, Roland, a Swiss, who seemed to have a similar tour of 4000m peaks in mind. We spent the evening melting snow, eating, drinking and planning for the morrow before turning in for a very cold night.

In the morning we set off at 6.15 a.m. with harscheisen on from the start, but still slipping on armour-plated ice. Occasional chilling gusts side-swiped us as we gained height. We were more or less following Frank Tuckett's route of the first ascent in 1859, though with none of the phosphorescence of the snow that he had noted in the hours of darkness during his much earlier start: 'at every step we made a circle of light about two inches broad surrounded our feet'.

Malcolm arrived at the Aletschjoch with the news that Ralph had turned back about 150m below, too tired and cold to carry on. Exposed to the full force of the wind at the col, Malcolm and I strapped skis onto our rucksacks to follow the narrow ridge left to the first snowfield below the foresummit. Sheets of spindrift curled up over our heads, turning the views north hazy. All tracks had been blown out on the snowfield and as we crossed it, back on ski, we needed to brace ourselves with ski poles to avoid being blown over by the worst gusts. I lost an overmitt, whipped away by the wind, and from then on needed to wrap that hand in a spare sock and periodically pound some circulation back into it.

At the foot of the rocky ridge leading to the foresummit, we took shelter in a sort of bergschrund just before the snowslope turned around the ridge and gave access to the col beyond. The wind still occasionally swept in upon us, but with sufficient respite to allow a snack and the exchange of a few comments on progress so far. Malcolm was emphatic: 'I'm going back.'

I had seen Roland ahead on the summit ridge beyond the col, battling against the wind but making progress. 'Well, if we leave skis here and keep to the lee of this ridge we should reach the col all right, then up the little snowfield and along the summit ridge, which we'd have to do on foot anyway. It's not far. I'd like to at least try it if Roland has managed to get that far.'

'No. It's madness to go on in this wind. We should turn back now before it gets any worse.'

I thought about it for a moment, 'But there's no sign of it getting worse, and I think we can make it.'

'I'm NOT going on.'

'Okay, okay. Well, rather than separating, what about waiting for me here where there's some shelter and we can ski back together? I'll turn back if it gets any worse and it's not far to the summit.'

'NO! You must be mad to think of going on in this. I'm going back NOW, and you can come or not as you like.'

I took another look ahead: 'Roland has nearly reached the summit.'

'But he's Swiss.'

I didn't get it. 'What's that got to do with anything?'

'Well, he's better than us.'

It took a few moments for the implications of what had been said to sink in. 'Right. I'm going on, then.'

'What? You mean I have to ski back on my own?'

'Either that or wait for me: it's your decision.'

The summit cross and book, Aletschhorn.

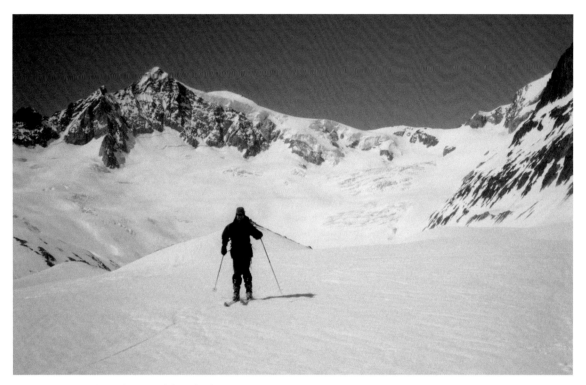

The Aletschhorn from the Mittelaletsch glacier.

'You're insane, you are. Completely bloody insane.' And he turned his back and prepared his skis for the descent.

There was some shelter in the lee of the foresummit, though I had to crawl at times to find it, but none on the crossing over to the summit ridge, where I dropped to my knees and hung on to my ice axe in the strongest gusts. Roland passed at a distance with a wave but unable to exchange any words, descending to where he had left his skis on a lower line. At the next bergschrund at the foot of the summit ridge I took shelter again, to add another fleece layer and sip a little mint tea from my flask. The summit ridge was snow at first, and I had to flatten myself against it to avoid being picked up bodily by gusts that came howling at my back. Higher up, there were good rock spikes to hang onto when the wind threatened to rip the glasses from my face. It was slow going.

A snow ridge curled up to the summit cross, creating a wind scoop in its lee. To my surprise the air was completely still there and I spent half an hour writing in the summit book and taking in the incredible scenery, gathering my strength for the descent. A few balls of cloud were being batted across the range, but there were utterly clear views down onto the Mittaghorn and Ebnefluh. It was midday.

Climbing back down to my skis, I saw three other skiers reach Roland's high point on ski. They must have followed his tracks but decided to give the summit a miss and enjoy the ski down. Fair enough. The skiing was fabulous, descending the snowfield from the bergschrund where I collected my skis. There were a couple of crevasses which I 'cowboyed' over from their raised uphill edges that the wind had scoured clear: 'Yeeha!'

The narrow ridge back to the Aletschjoch provided an exhilarating exercise in side-slipping a traverse with occasional jump turns adding to the excitement. Through the thin mixture of spindrift and cloud blowing over the col, I could see Roland climbing the ridge to the Dreieckhorn on his way

to traverse that summit and ski down to Konkordiaplatz. My team had discussed that option with him, but decided it would be too big a day for us.

The steep ski back down to the hut was superb, with a dusting of spindrift on névé sun-softened enough to be firm but forgiving. It took just an hour from summit to hut, where Malcolm and Ralph were waiting. I ate some soup and bread while they explained that they thought that as it was only just after 1 p.m. we should skin up to the Konkordia hut. That would save us another cold night at the Mittelaletsch hut, so I went along with the change of plan. There was no interest in following Roland over the Dreieckhorn.

The ski down to the Grosser Aletschgletscher only took an hour on what was essentially one long schuss, but skinning up to Konkordiaplatz was desperately hard work in the teeth of the wind, and I realised that the struggle on the summit had taken more out of me than I'd thought. It's a long glacier, and we climbed all those ladders to the Konkordia hut only to find that there was no space in the main hut: we were consigned to another cold night in the winterraum, listening to the wind whistling in the eaves.

Next morning was fine with a little cloud but still that bitter wind blowing. We had planned to climb the Grünhorn, but Ralph wasn't feeling up to it so we opted for an easy day, crossing the Grünhornlucke to the Finsteraarhornhütte. We could always try for the Grünhorn on our way back via the Fiescherhorn, or on our return to the Konkordiahütte. Later that day Roland turned up, having climbed the Grünhorn and Fiescherhorn en route. Like us, he planned to climb the Finsteraarhorn next day.

Finsteraarhorn, 4273m. South-West Face, North-West Ridge: PD

We rose at 5 a.m. that Sunday, after a hot and restless night in the crowded dorm, to find it was snowing, so went back to bed. At 6 a.m. people seemed to be moving, so we got up too, although conditions seemed little changed. Then in the early light it was possible to see clear across the glacier through the fine snowfall; better still. the wind had dropped completely. Tiny snow crystals glittered as they fell out of the lightening sky and it seemed likely that above this cloud the sun was shining; our plan to climb the Finsteraarhorn was back on the agenda.

Then Malcolm fell into conversation with a Swiss skier who claimed to have heard a bad weather forecast. Most of his party were planning to ski out down the Grosser Aletschgletscher via Konkordia. The guardian couldn't confirm this forecast, but sudden panic set in with rumours of a metre of snow in the valley – we had to get to Konkordia and get out of the mountains before we were trapped!!

I remained sceptical. We had plenty of time and if we were going to sit out a spell of bad weather there seemed little point in going back to the Konkordia hut to do so. Outside there was even more sunlight filtering through the hazy snowfall. We wasted time arguing about what to do, with Malcolm putting increasing pressure on me to 'escape the storm'. Meanwhile Roland quietly left for the mountain. More allegations of insanity finally tipped the balance, and I packed up to climb the Finsteraarhorn alone. It was 8.30 a.m.

Once that decision had been made, Malcolm and Ralph agreed a plan whereby they would go over to Konkordiahütte and spend the night there, then go on to the Hollandia hut, then out down the Lötschental if the weather did not improve. If it did improve, they would climb the Grünhorn,

but if it got worse they could ski back down the Grosser Aletschgletscher the way we had come. That meant I could ski over the Grünhornlucke to rejoin them that evening if I got back from the Finsteraarhorn in time, or catch them up the following day, even if it meant a long haul all the way to the Hollandia hut. I noted key bearings and altitudes for the route on the Finsteraarhorn before Malcolm left with his map.

As he turned to go he asked, 'Oh, and can we have the car keys?'

I gave him a long steady look.

'If we get down before you it'll be easier for us to get about, and you won't be using it.' But he began to look uncomfortable.

'Swiss public transport is excellent, and that car is the only fixed point of reference we have if we continue to be separated. If you drive it off somewhere I'll have no idea where you or the car are, and no means of getting in touch with you. If you make it down to the valley before me, leave a note of where you're staying under the windscreen wipers.' (Mobile phones were a rarity at that time.)

The summit ridge of the Finsteraarhorn emerging from cloud above the Hugisattel.

'But …' He had his arguing face on again, and I'd had enough of it.

'No. I'm not leaving the car keys with you, and that's final.'

Out in the gently falling snow, it seemed warm and still enough for me to even shed my windproof jacket, skinning steeply up to the top of the spur to the left of the hut. Thereabouts the angle eased as I reached Col 3616m after a couple of hours. The wind had picked up enough for me to fetch out the shell clothing again, finding it difficult to get a hat on; my hair had become encrusted with frozen snow. Crossing the icy scree of the col on foot, I was immediately confronted by a narrow snow corridor between ski-eating crevasses below and a massive serac looming above. I stepped into skis and threaded my way out onto the main glacier very carefully indeed.

Climbing the easy glacier to the Hugisattel at 4088m was helped by the long rock boundary of the glacier falling from that saddle and continuously visible as a navigation 'handrail' to the right. The lack of anything resembling a view meant that I had nothing to distract me from scanning for any hint of crevasse danger as I 'planked' up the trackless snow.

At the Hugisattel at about 1 p.m., I was gearing up for the ridge above when Roland appeared out of the mist to relate his experience of a windless ascent into clear blue skies. We shook hands and took pictures of each other grinning in the snow. As I started climbing he skied away, his image gradually fading into the blowing snow, for all the world like a TV image becoming obscured by static.

165

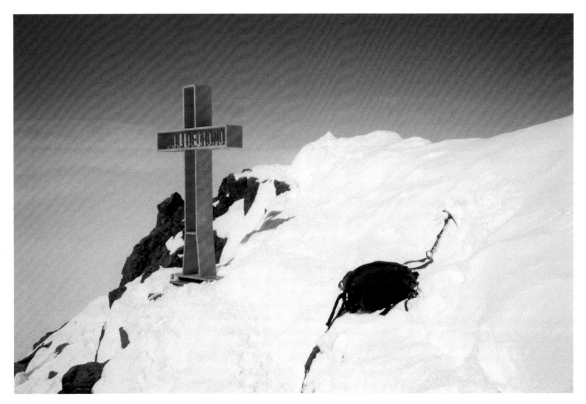

Summit cross, Finsteraarhorn.

The ridge was continuously interesting mixed climbing, made more challenging by the new snow and altitude. Solo, it required intense concentration to avoid a slip, and I revelled in the heightened awareness this brought; at one instant I became utterly focused on the unique crystalline structures of tiny snowflakes landing on my gloved hand. Cloud came and went while the wind began to freshen, so I was not as lucky as Roland. From the lonely summit, an amazing view across a sea of cloud left me guessing at the very tips of mountains islanded then lost in the cloud-shifting distances. The sun's warmth was an unexpected blessing.

At 2.30 p.m. I was back at the Hugisattel, exchanging greetings with two Swiss skiers who were heading for the summit. I dug out my skis and plunged off into the blowing cloud. The snow was in heavier condition than earlier, with icy sections complicated by hidden debris, but with traverses, side-slipping, and linked turns when snow and visibility permitted, I was soon back at Col 3616m. There was only one occasion on which I'd had to throw snowballs to be sure of the ground ahead in near-whiteout conditions. Visibility was particularly good from the col down, with fresh powder on a firm base providing some brilliant skiing. I was back at the hut one and a half hours after leaving the Hugisattel, drying my kit and rehydrating, but too late to go on to Konkordia.

A stormy night gave way to a Monday morning of cloud and wind, but the weather seemed to be clearing so I supposed that Malcolm and Ralph would probably have a go at the Grünhorn. In these conditions I thought it likely I could traverse the Fiescherhorn and ski down the Ewigschneefeld to Konkordia, so set off north, up the Fiescherfirn. Reaching the icefall in good time, I ran into deep new snow, but the weather had cleared further with a snowy Hinter-Fiescherhorn emerging from curtains of cloud. There were no tracks, and breaking trail in sometimes knee-deep snow was exhausting work. At 3600m I was already considering giving up when the wind changed, blowing cloud and snow down from the heights ahead and into my face. That was the tipping point. I turned my back on the

weather and poled heavily back down towards the glacier in deteriorating visibility. As I crossed a hidden crevasse, one of my ski poles broke through into the space beneath.

Below the icefall, good powder skiing took me quickly down the Fiescherfirn to a point where I could skin easily up the Grünhornlücke. At the pass I took a break for a late lunch in a sheltered sunny niche as the weather had improved again, with the Grünneghorn clear above me. An icy rattling descent to Konkordiaplatz, and I was soon climbing the ladders to the hut. There I found a note:

Sunday Mid-day

Dave

Have gone on to Hollandia. Will stay there tonight. If weather turns Ok will probably climb Abenflu - then possibly stay Monday night - then ski down. If weather not good will ski down Monday if possible or stay until conditions allow.

We shall leave a message at information office 'Brig' and under car windscreen to let know where we are.

M + R

This change of plan left me uncertain whether to follow them or not. Why hadn't they stayed at Konkordia on Sunday night as planned? How was it that the weather had been bad enough to put them off climbing the Finsteraarhorn but not bad enough to stop them going on the long trek to the Hollandia hut? How would they have regarded the weather that morning? Good enough for the Ebnefluh or not? I had a shrewd suspicion they were back in the valley by now. I tried to get the guardian to phone the Hollandia hut to find out if they were there but whether it was my poor language skills or some other communications problem, nothing came of it. I spent the night at the hut.

Next morning several parties were setting out for the Grünhorn under a lowering grey sky, but there was no snowfall so I thought I might as well tag on behind and see if something could be salvaged from the day before skiing out via the Hollandia hut. As we crossed Konkordiaplatz and began the ascent of the Ewigschneefeld, black clouds began

Skiers starting up from the Hugisattel after stashing their skis.

massing above the Jungfraujoch with a solidity that was almost palpable. The wind increased and one of the leading parties turned back. I stopped to weigh up the situation. To the west the Lötschenlücke seemed an equally dismal prospect. 'Time to cut and run,' I thought, and headed off down the Grosser Aletschgletscher. Planning to go north or west, I hadn't noted any points going south from the map at the hut, but we'd come up from near the end of that glacier and how complicated could it be?

The sky greyed and snow showers pursued me, but the skiing was mostly just a long easy schuss through splendid scenery with a prospect of the Valais ahead in distant sunshine. Perhaps we could get some routes in there as we had the last time I'd been chased out of the Oberland by bad weather.

As I neared the end of the glacier I spotted some ski tracks leading into a little snow valley beyond the glacier snout and followed them. It was fine at first, skiing around boulders and down little drops, but lower down the walls closed in, becoming more gorge-like. The strength of the water flowing beneath the snow had washed sections away and I skied carefully along snow-shelves on raised banks, sometimes scrambling across wet rocks to gain a better snow shelf on the opposite bank. It didn't feel right, but there were still traces of tracks and I kept hoping the route would improve.

I was crossing polished boulders at the head of a minor waterfall which disappeared into a deep hole in the snow below, when one of the rocks shifted; the skis, strapped to my rucksack, tipped me off-balance and I was over. Luckily the skis wedged themselves firmly between rocks and I fell no further but, caught in the soaking spout, I was stuck like a turtle on its back. Suspended above the watery snow-hole, I had somehow to regain my footing before releasing the skis or I would fall and drown between ice and rock, trapped in the darkness below.

I still cannot remember exactly how it was done but somehow I must have twisted around to grasp the rocks and free myself. That was enough. I had to get out of this. I struggled back the way I had come, wading through the stream in places, regardless of waterlogged ski boots.

Back at the snout of the glacier, I cast about for an alternative route and discovered faint traces of a track climbing the left bank. Eventually I reached Reid and skied down slushy pistes to catch a cablecar back to the valley. There one of the frequent local trains took me a couple of stops to the Seilbahn car park. Tucked under a windscreen wiper was a note:

Dave

Monday 11.00

It's beautiful weather here!!

At Hollandia they said 3 days poor weather so we came down.

Rather than hang about here waiting, it seems sense to go to Chamonix on the grounds that we "promised" Ralph a trip down the Mer de Glace etc.

We will go to Andy's apartment in the Balcon de Savoy? – Big posh obvious block as on map (I'm not certain of the name).

Overleaf was a crude sketch map. The only feature that I recognised was the hospital. The note continued on the map:

We will probably stay in a gite! eg at the * in the woods between Cham and Les Praz.

I think it's called Robinson – with funny sculptures in the Garden.

Hope your trip went well and hope to see you soon!!

Malcom.

I was shocked. I suppose I'd expected the same standard of care for a climbing partner that I'd experienced on AC/CC meets when if anyone was overdue on their return from a route there was a palpable tension on the campsite and much debate about whether or not to alert mountain rescue services. People didn't just swan off to another country. It was Tuesday, and I had returned to the valley on the date planned even if not much else had gone according to plan. I found I had absolutely no desire to follow them to Chamonix.

Instead I drove back over to Randa where I met Miriam and her daughter, Jenny, in the lobby of their apartment block. I couldn't speak at first, just hugged them. They took me up to the apartment where they all kindly offered to take me in for a couple of days of relaxed piste skiing in an atmosphere that put laughter back into my life. Then I wanted to go home. To my own family.

I drove to Chamonix, found the gîte; no note, and no knowledge of any English guests. I tracked down what appeared to be the best bet for Andy's apartment block: Reception was locked. What was I supposed to do now? Walk the streets of Chamonix in hopes of bumping into them? There seemed no other option, so that's how I spent several hours before, to my amazement, there was Ralph walking down the main street. They had taken a room in a backstreet hotel and there could be a bed for me!

'Sorry. I know it's only Friday but I'm going home now. I'll bring the car round to pick up your things in an hour.' And I went for a coffee.

They hadn't skied the Mer de Glace either.

Postscript: Gran Paradiso

In June 2012, with Graham Hoyland, film-maker and author, I visited Chamonix in search of some acclimatisation and skiing practice before a trip to ski Mount Elbrus later that month. We had several days walking in the rain to trigger some acclimatisation, but hopes of getting high on Mont Blanc were frustrated by poor snow conditions. I had lunch with a friend who lives in Chamonix, and she recommended the Gran Paradiso, which was where the guides were taking groups booked for Mont Blanc.

Graham and I drove over to Pont and walked up to the Victorio Emmanuel II refuge in two and a half hours with skis and boots on our packs. The refuge had been enlarged with a bank of portakabins and we were allocated to one of them, but it was pleasant enough and the food was good.

We left at 6 a.m. and carried skis for 20 minutes before finding enough continuous snow for skinning. Icy névé required the use of harscheisen, but the glacier was easy enough, if steep in places. Graham had had enough at about 3600m, but was happy to ski down alone, with me following after I'd summitted; there were plenty of people around on such a fine day.

I found the last few hundred metres enough of a struggle myself, but left skis about 30m below the summit ridge and climbed up with axe and crampons. I had to wait while guided parties created heavy traffic on the narrow rocky crest and could fully appreciate the exposure that had been lost on

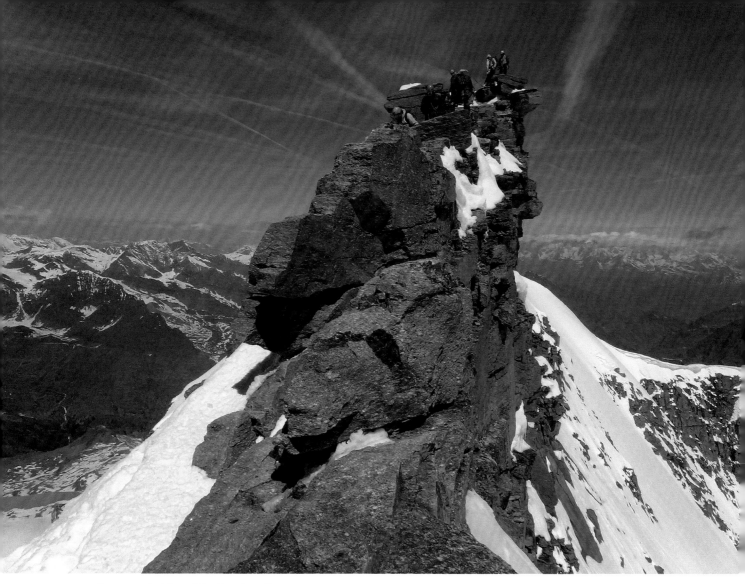

The summit ridge of the Gran Paradiso.

me all those years ago in the swirling snows of my previous ascent. There were hazy views of Ciarforon and Grivola, with Mont Blanc looming large to the north-west.

Returning to the skis, I left at about midday and was back at the hut in 45 minutes. The ski descent on superb sun-softened snow was a delight, not least on account of the envious stares of parties on foot who stopped to watch as I glided past while they faced the prospect of continuing to plod down for hours after I was drinking beer in the sunshine on the hut terrace.

We stopped another night at the hut, as it was likely to be the best acclimatisation we could get before flying home two days later. And, yes, we did summit Elbrus.

16:
Guides

Q. How can you tell there's a guide in the room?
A. He'll tell you.

The early alpine explorers used guides for the simple reason that there were no reliable maps. Whymper describes them as 'pointers out of paths and great consumers of meat and drink but little more', and John Ball in 1845 described his guide after one climb as 'regularly knocked up. It was not, he declared, from fatigue, but from mortal anxiety, *grosser Angst*, that he was now in a sort of collapse, unable to eat or extend himself in any way.'

Yet in 1821 the Compagnie des Guides de Chamonix was the first in the world to try to regulate qualifications and payment, although still, at first, largely for just pointing the way and porter duties. The compagnie may have been presented as an exercise in quality control, yet John Tyndall in his *Hours of Exercise in the Alps* records in 1871, 'Anxious to avoid the inconvenience of the rules of the Chamouni guides, my aim, from the first, was to render myself as far as possible independent of their assistance.' This and further comments by Hinchcliff and others suggests the regulations were more for the benefit of the guides than their clients, and there are elements of the closed shop about these organisations evident even today.

I know of at least one well-qualified young mountain instructor who gave up aspirations to be a guide when the standard of rock climbing required was raised to 'comfortably leading at E2'. He was excellent at managing groups and there seems little point in excluding people of his calibre from leading ski tours or classic alpine routes because he can only lead HVS on rock, particularly when practising guides who qualified some years ago may actually no longer be able to lead HVS, let alone E2. Will existing guides be submitting themselves for reassessment to revalidate their qualification? Somehow I don't think so, yet doctors have to do so. Another expedition leader who, without formal qualifications, has successfully guided clients on 8000m peaks including Everest, was refused entry to a British UIAGM training programme on the grounds that he had not done enough British rock climbing!

In Britain we have no tradition of guides in the exploration of our mountains – Coleridge traversed the Old Man of Coniston and Hasket-Smith climbed Napes Needle alone – but in the Alps, guides were involved from the start. Whymper was to develop great respect for guides like Carrel, and Lesley Stephen, in *The Playground of Europe* (1871), states unequivocally:

> The true way at least to describe all my alpine ascents is that Michel or Anderegg or
> Lauener succeeded in performing a feat requiring skill, strength, and courage, the

difficulty of which was much increased by the difficulty of taking with him his knapsack and his employer.

In the same year Tyndall can be seen wavering:

> I had the pleasure of meeting a very ardent climber, who entertains peculiar notions regarding guides. He deems them, and rightly so, very expensive, and he also feels pleasure in trying his own powers. Very likely it is my habit of going alone that causes me to sympathise with him. I would, however, admonish him that he may go too far in this direction, and probably his own experience has by this time forestalled the admonition. Still if skill, strength, and self-reliance are things to be cultivated in the Alps, they are, within certain limits, best exercised and developed in the absence of guides.

By 1895, however, in *My Climbs in the Alps and the Caucasus*, Mummery could be scathing about the client–guide relationship:

> The pseudo mountaineer can, it is true, almost wholly avoid … dangers. Accompanied by guides who know every step of the way, he is led by a sheltered route, or, if none such exists, he is told this fact before he starts, and can alter his plans accordingly. But the repetition of an accurately timed and adjusted performance, under the rigid rule of the guide as stage manager, does not commend itself to the real mountaineer. His delight and pleasure in the sport are chiefly derived from the very uncertainty and difficulties which it is the main function of such a guide to eliminate.

Later the young Lionel Terray's guide

> entertained a strong interest in the waitresses in the alpine huts, whatever their age or appearance. In order to return as quickly as possible to these dreams of delight, we almost ran up our climbs, and where I didn't climb fast enough for his taste he would drag me with the rope … I made hardly any progress that season.

Claire Engel is too critical, though, when she asserts in her *History of Mountaineering in the Alps*, 1950, that,

> Devising new climbs required imagination and foresight. Hardly any route was ever discovered by local peasants when not prompted or led by their patrons, and they usually did much to prevent the latter having their own way.

Tyndall records that his party on the first ascent of the Weisshorn were pursued by men from Zinal anxious to maintain local honour by anticipating or following his party onto the summit. On the Lauwinen-thor he notes:

> Just as we touched the snow a spring bubbled from the rocks at our left, spurting its water over stalagmites of ice … Lauener pointed out to us the remains of the hut erected by him and his brother when they attempted the Jungfrau, and from which they had been driven by adverse weather.

Christian Klucker's *Adventures of a Mountain Guide*, 1932, covers the period from 1874 to 1918. In the book, we find him meticulously correcting the mistakes that his employers like Norman-Neruda and Anton Rydzewski had made in their accounts of climbs published in the SAC or other journals, and he comments critically on their performance or judgement at times. He is constantly on the lookout for new routes that he might add to his programme for suitable clients, and makes use of a

Guides dressed in traditional costume parade in Meiringen to commemorate 100 years since the death of Melchior Anderegg. The float represents Anderegg's Führerbuch in which his clients wrote their testimonials to his service. A copy was donated to the local museum to mark the occasion.

treasured telescope for detailed reconnaissance. When guiding Whymper in the Rockies he records his disappointment in their achievements during the 'fruitless' trip and shrewdly speculates that 'it may be that Edward Whymper was handicapped through his agreement with the Canadian Pacific'. Perhaps this was the first example of a climbing party's activities being influenced by its sponsors! Klucker is a notable exception to the rule that it was not the peasant guides who recorded the history of climbing in the Alps, but their employers.

Continental climbers think nothing of hiring a guide for a weekend's ascent or two, and mountain walkers have been known to express incredulity at the notion of going guideless on the alpine giants. Nonetheless, historically, as British climbers were increasingly drawn from working-class backgrounds, and particularly since the breakthrough in standards of climbing from the 1950s onwards, the employment of guides has declined. Whether it be shortage of cash or a greater self-reliance, the majority of British alpinists would no more think of hiring a guide than of joining the Foreign Legion.

I have encountered some guides who were affable, considerate, even helpful, and others who were arrogant, inconsiderate, and reckless to the point of endangering not only their own clients but other parties around them. Some guides seem to think the badge entitles them to rights over a mountain or route that pre-empt those of mere mortals who happen also to be climbing that route. Perhaps if the badges prominently displayed a unique identifying number, like police officers, then there would be some redress for those who have their runners clipped by a guide or even removed to make room for his own during an overtaking manoeuvre. Nothing will slow you down more than the sight of your runners dangling uselessly from the rope!

However, the predicament of the guide who is prepared to tie onto a rope with a stranger on the basis of how much money that stranger is paying deserves some sympathy. It is bound to be a

stressful responsibility, and may result in unfortunate stress management tactics. Julius Kugy in *Alpine Pilgrimage* (1934) comments on Daniel Maquignaz:

> Like Bonetti, he fell an early victim to drink. The combined efforts of his favourite employers, Farrar, Rey and myself, all failed to rid him of this vice …If I urged him to think of his children, he would thank me with tears in his eyes, and depart full of good resolutions. Farrar, so I heard, had a sharper and perhaps more successful way of dealing with him. On the eve of departure, wherever temptation might prove too strong, he simply locked him up.

And on the eve of the first ascent of the Aletschhorn in 1859, Tuckett records:

> Bohren commenced a series of songs or one long epic (I don't know which), which with the occasional assistance of Bennen he continued to keep up without one moment's cessation till morning, as Victor, who was excessively disgusted at having to listen to what he did not understand, informed me afterwards.[Victor was French.] I should not wish to be uncharitable, but by way of parenthesis I may remark that we brought a bottle of rum with us in case of need, which bottle somehow slept near Bohren, and had partially evaporated (perhaps from the intense cold) before morning, how I do not pretend to explain … [later, on the ascent] Bohren was indisposed … and declared at times he could go no further [whilst even the famous Bennen] suffered greatly from difficulty of breathing, and neither of them was quite right till the following day.

The assumption that a guide can safely take into the mountains people who are not competent to be there on their own could be considered optimistic in the extreme. The rising rate of attrition amongst Chamonix guides was pointed out to me by a friend who advises the Compagnie de Guides on the kind of heuristic traps that lead to mismanagement of risk. A good example of the danger was provided by a guide I encountered on a ski descent of the Envers du Plan variation on the Vallée Blanche. An hour or two earlier he had, despite 20 years guiding the route, fallen into a crevasse. Fortunately he was unhurt but had been unable to climb out because the enclosing walls overhung by about a metre. His two clients had neither the equipment nor the skills to extricate him from his predicament, so sat uselessly in the snow above. Finally he managed to call in a rescue party from the Midi station by radio. He was very lucky. But he was also rattled, and in the poor visibility suggested that it might be a good idea if my obviously well-equipped party joined forces with his for the rest of the descent. Having been roundly told off by other guides for following their tracks 'too closely' we could hardly believe our ears, but who could blame him? As he said: 'An accident can happen to anyone.'

Guiding is a risky business, and one in which the way that clients are encouraged to assert their 'rights' in the modern spirit of consumerism arguably adds to the risk. In recent years there have been increasing reports of guided ski-touring parties being avalanched in conditions that would have confined me to the hut if not to the valley. Sometimes the guide has been one of the victims, and clients have been left struggling to decide how to conduct an adequate search and rescue procedure in his absence. It is not just a case of calling in a helicopter – they often won't fly in bad weather – but every minute's delay in digging a victim out of an avalanche increases the risk of death. Evidence points to pressure being put upon guides to deliver (regardless of the conditions) by clients who assert what they imagine to be their rights in ways more appropriate to the supermarket than the mountain.

Coolidge, in attempting to list the ideal qualities of a guide, included:

> the faculty of preserving his presence of mind if and when a crisis arises; the strength of will, regardless of any possible consequences in the future to his professional reputation, though only amongst silly people, to decide upon retirement if he deems it desirable.

It seems the 'silly people' may have the whip hand these days.

One guide involved in preparing clients for Mont Blanc ascents freely admitted that he had serious misgivings about what shepherding a train of 'numpties' up the peak has done to this mountain specifically and the perception of mountaineering in general. In this context it is particularly disturbing that the media focuses so assiduously upon such misguided stunts as Ranulph Fiennes' guided ascent of the Eigerwand. Fiennes himself readily admitted in a Radio 4 interview that he had no business being on the north face of the Eiger, and was very nearly responsible for the death of one of his team, yet the media message was emphatic: you can have a bad heart and suffer from vertigo, but a guide can get you up one of the toughest climbs in the world. A disingenuous figleaf of decency was maintained by claiming it was 'all for charity'.

A consequence of such thorough-going commercialisation of mountaineering is that you may find yourself climbing a route in company with rich but incompetent climbers whose only qualification to be there is the guide at the sharp end of their rope. Still more worrying, the 'numpties' may think they have the right to 'call the shots'.

Neither the Alpine Club in assessing qualifications for membership nor most alpine climbers assign the same credit to a guided ascent as to one made guideless, but there seems to be a conspiracy of silence surrounding this in the media. Perhaps if no ascent was credited to a climber unless it was made guideless, this would strengthen the guides' role in training and put a stop to the rampant commercialisation of mountains from Mont Blanc to Everest. Perhaps not.

One thing is certain: you will not climb the highest mountains of the Alps without encountering guides, and whether they give you tips on your route or barge past you in the dark, assist with a crevasse rescue or block a route with a cat's cradle of ropes and terrified clients while waiting for a casualty to be helicoptered out, it is as well to be prepared for them.

17:
Two Oberland excursions

1. 1999

In 1998 Jeremy Whitehead, one of the grand old men of British ski-touring, had joined me on an early trip to the Russian Caucasus after border controls were relaxed in the wake of glasnost. Despite the unsettled weather, we enjoyed ski-touring in a setting distinctly different from the Alps. Knowing I still had a couple of 4000m peaks left in the Oberland, in 1999 he invited me to join him and Richard Jones, a vegan Buddhist friend, on a pre-Easter visit. I mentioned the trip to Aidan Raftery, a fellow member of the Innominata Club, and he also joined us.

We arrived in Grindelwald in cold clear weather, so took the train to the Jungfraujoch despite the doubtful weather forecast. I peered out of the window at the Eigerwand station, down the Eiger's north face, sheathed in shadow and snow-spattered ice; it looked intensely cold. From Eismeer, the next station up,, the Schreckhorn and Lauteraarhorn dominated the rugged horizon under a clear blue sky. Leaving the top station, we passed the observatory on the Sphinx, then skied on down the Jungfraufirn to the huge glacier basin of Konkordiaplatz. After travelling all night, I don't think any of us were very stylish.

The ladders leading up from the glacier to the Konkordia hut.

At the base of the buttress below the Konkordia hut I noticed that since 1995 a builder's ladder had been lashed to the lowest step of the long steel staircase attached to the rock in order to reach it from the glacier. The ladder flexed alarmingly as we climbed it, and there was an awkward transition from ladder to steps, from the inside to the outside of the angle where they joined, but more alarming was the acceleration in the pace of glacial recession. We were pleasantly surprised to find there was another British party at the hut, Jem, Giles and Fay.

Sunday dawned fine but there was more cloud and a spindrift wind keeping temperatures down. We decided to go for the Grünhorn before the weather broke, following the line of the ski route marked on the 1:50,000 map. There were no tracks, so we wound up around big crevasses with seracs stacked above them, feeling slightly groggy owing to the altitude. This landed us on an ice shelf too far to the right of the icefall that seemed to have grown in size and complexity below the Grünhorn–Grünegghorn col. An attempt to outflank the seracs further right, climbing steep snow and ice on foot, failed to access easier ground. It was too late in the day to backtrack and search out a route to the left, so we had no option but to retreat while clouds of spindrift rendered views of the summit hazy. Breakable crust alternated with bands of powder and the occasional icy step as we skied down through the crevasses.

Next day's weather was just good enough for us to lower our sights and skin up Kranzberg via the flank of its south-west ridge, leaving our skis when the ridge narrowed to a corniced edge. Views of the Grünhorn from the summit confirmed that the glacier was less broken to the left of the icefall that descended from the col. We skied steeply down from the ridge, finding ice just softened enough to hold edges, and light powder all the way back; good skiing although at one point the whole slope disappeared under a flowing blanket of knee-deep spindrift so that we skied by feel, unable to read the snow beneath our skis.

Gross Grünhorn, 4043m. South-West Ridge from Ewigschneefeld: PD

The following morning was cloudy with some snowfall, so we set off to attempt the Trugberg. At first the weather deteriorated with thickening cloud and wind-driven snow. I almost turned back, but decided to go on for 30 minutes to 'see how it goes' and the weather actually brightened up just about level with the turn-off to climb the Grünhorn. While Jeremy caught up, Aidan and I debated the idea of going for the Grünhorn instead of Trugberg; 'It'll be okay if we stay more to the left.'

'It's the time that worries me. We took so long getting into the icefall last time.'

'We'll just have to see what Jeremy thinks.'

When Jeremy arrived he warmed to the idea if only to get as far as the col, so we went for it.

I broke trail nearly all the way in bright, cloudy haze with occasional sprinklings of snow-flakes. We skinned up directly to where we had branched right under an ice wall, but this time bore left, stepping up delicately over a steep snow bridge that merged into a ridge between crevasses. Beyond, the crevasses remained complicated and once there came a deep boom from the depths that stopped us all in our tracks, but we found a way through without mishap.

There was about 30cm of deep soft snow often overlaying hard ice, so that I found harscheisen really useful. Aidan had no harscheisen, so I gradually pulled ahead as the slope steepened. We had

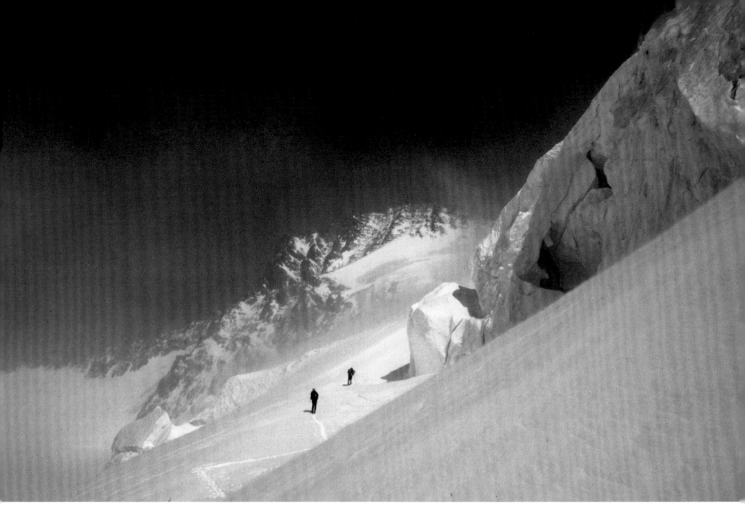

Trying to find a way through the seracs to the Grünhorn.

already established that each of us would go on as far as he wished then turn back, and I had warned that I was unlikely to turn back if I thought the summit was in reach. 'That's okay; we won't wait for you,' was the cheerful reply.

As I stepped awkwardly up a steep ice patch to gain the easier slope that led to the col, I realised I was committed to the summit: after all it was unlikely that I'd persuade anyone else to come up this way for a third time!

I reached the col and took shelter in a corniced crevasse that had opened up between the rocks of the ridge above and the snow below it. Looking back, I could see the others far below and knew that I would be on my own on the ridge. I estimated an hour to the summit and back, but hadn't realised how snowed up the rocks would be, with ice lurking beneath the snow.

Wind, sun and cloud played about the ridge as I made for one false summit after another. Each rock outcrop looked like the last, only to lead to another just that bit higher, ahead. It began to feel like the elements were playing with me and at first I could see the funny side but as time went on the game became increasingly serious. Finally I plodded along a short snow ridge to the next rock outcrop and could see the continuation ridge falling away through the grey of cloud coming and going; this was it, at last. I had taken an hour and a half to get there, so there was no incentive to spend any more time than necessary to take a quick photo and about face. Fortunately, I made the descent much faster, stamping down my tracks. There was only one moment of anxiety, when my crampons skated on ice and I fell flat on my back on a ledge in the crest of the ridge. I was very aware of the space about me and stayed absolutely still for a moment, before slowly, deliberately, rolling over and getting to my feet.

Back at the skis, I wolfed an energy bar before sliding back down my tracks. Visibility was variable; I had to ski through the crevasses with extreme care. There was no sign of anyone who could offer assistance,

so I simply could not afford to make a mistake. Anxious or not, the descent through grand glacial scenery became more and more enjoyable, with my doubts about the route dispelled as a number of tracks appeared. Though this had been the route of the first ascent in1865, it was obvious why it was no longer used in summer; the same glacial recession that had left the Konkordia hut high above the glacier had steepened the snowslopes on the west flank of the Grünhorn and riven them with crevasses.

As the daylight faded my left hand became very cold, with one finger more like wood than flesh and blood, but there was no time to stop and re-warm it. I gave the schuss off the Ewigschneefeld everything, scarily rattling over ice ruts but desperate to reduce the plod across Konkordiaplatz as much as possible. As I came up to the ladders, Jem and Giles shouted encouragement and came to meet me when I reached the top of them.

'Did you do it?'

'Yeah.'

'Well done!' Everyone was pleased to see me back safely, and although they had eaten there was still plenty left for me.

We woke to snowfall although the glacier below could still be seen. Richard was not feeling so good and I was still recovering from the Grünhorn climb. There was no enthusiasm for another mountain, but later that morning Jem's group decided they would skin up the Grosser Aletschfirn to the Hollandia hut. The idea of a glacier trek began to appeal to Richard and Aidan. Jeremy and I remained doubtful about setting off late in conditions that could worsen, but after lunch agreed to set out and see how it went. Unfortunately it went quite well at first; we made good progress and my misgivings seemed unfounded. Then the weather closed in.

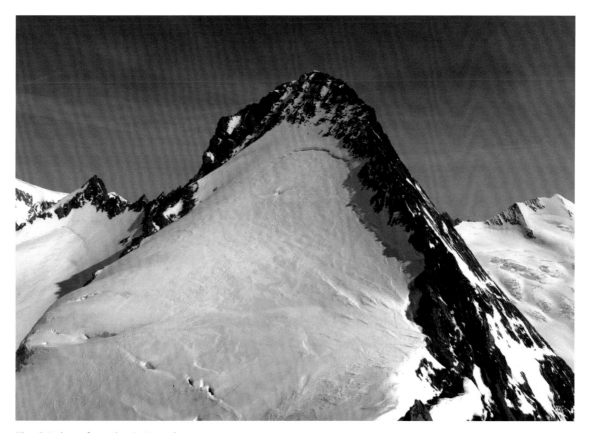

The Grünhorn from the Grünegghorn.

Jeremy and I agreed that it might be better to take a bearing on the buttress beneath point 3178m at 3060m altitude rather than work on a bearing for the Lötschenlücke, but I suppose we just abdicated responsibility and let Richard and Aidan get on with it in the face of their overwhelming enthusiasm. One skinned ahead while the other kept checking that the first was on the bearing, but with any landmarks having disappeared into the whiteout I couldn't help feeling that we were drifting off course. Most people are right-footed so when they think they are walking a straight line they tend to veer to the left, which is why it's possible to walk in a circle when lost in featureless terrain such as deserts and ice caps.

The snowfall increased and deepened substantially the further west we travelled towards the Lötschenlücke and the hut. For hours it seemed we were breaking trail through knee- to waist-deep snow, and then it was further to go back than to go on. Darkness fell as we pushed on obsessively, convinced the pass was not far away and longing for the comfort and safety of the hut. Aidan tried a tentative whistle but gave up, realising it would be muffled by the wind and snow, and who would be out listening in this anyway? All the while we puzzled about the complete absence of any lights from the hut.

The fall line of the slope we were climbing had a northerly aspect rather than the easterly one that would mean we were climbing up to the Lötschenlücke. Jeremy worked out that we must be on the north-facing slopes between the Aletschhorn and the Sattelhorn, which confirmed the drift left as we had skinned up the glacier. If we traversed right until the slope regained an easterly aspect we should be below the pass and could climb up to the hut. We duly started traversing but the aspect didn't change. There must have been further to go than we'd thought.

We stopped with avalanche debris below us and little snowballs trickling down from above. We needed to get out of this fast, and reversed course. But not fast enough. Before we were quite clear, at the tail, Richard and I were caught in a small avalanche. A great wind, laden with snow, flared the torchlight like a halo about my head and swept me off my feet. I swam with the flow, trying to keep my head up and nose and mouth clear, dog-paddling until I came to rest. Immediately both Richard and I began vigorously thrashing about, freeing ourselves from partial burial before another slide hit us or the snow concretised.

I'd had enough. 'Right. No more struggling in the dark in avalanche terrain. I reckon we should get back down to the flat of the glacier and dig a snowhole. By morning we should at least be able to work out where we are.'

There was no dissent.

A careful descent took us clear of unstable slopes and we quickly dug down about two to three metres into the snow; next came the tunnelling into the wall of the pit. Beyond the small entrance hole we excavated a more capacious snow cave, pushing out the debris to be shovelled up to those on the surface who in turn deposited it far enough away from the pit to avoid infilling.

We all took turns at different jobs, although those of us with glasses found that inside the cave we were working blind as our lenses fogged completely. After about four hours we had a cramped but adequate refuge. While the others sorted themselves out in the cave, I checked the ski poles were marking our location and semi-roofed the pit with skis, as much to keep them to hand as to keep the snow out. The digging had kept us warm, but as I waited, somewhat longer than expected, the chill of inactivity began to make itself felt. Finally I wormed my way inside and wriggled into my bivvi bag.

Though it was cold, our combined body heat kept the temperature above freezing in the constricted space of the snow-hole. Unfortunately it wasn't warm enough to melt the contents of our

water bottles as I found when I tipped mine back over my mouth and gained nothing. We catnapped and dozed for about four hours until a faint grey light began to reveal that snow had drifted into the pit, reducing the size of the entrance. It was curious how reluctant everyone was to make a move.

The light strengthened so I struggled to the entrance and forced my way through the accumulated snow. The icy blast instantly froze my damp overmitts to a crackling solidity. Clambering out of the pit, I could see the hut perched to the right of the Lötschenlücke. Snow was still falling so I quickly marked an arrow with a ski pole in the snow, indicating the direction in case visibility was lost.

'I can see the hut!' I yelled into the pit, and one by one the others slowly emerged.

Aidan led off, breaking trail with his new fat skis that didn't tend to sink so deeply beneath the surface as the traditional thin skis the rest of us were using. Even so it took us three hours to cover less than two kilometres to the hut, and we all had to take turns to break trail, swapping leader like a team of cyclists.

We were spotted by Jem, Giles and Fay, who shouted directions for the final climb to the hut and were joined by the guardian to break trail for us down to the marker post. It was a huge help. I had not had a drink for many hours or eaten more than one energy bar and a frozen apple. Skinning was just a question of operating, keeping going.

As we reached the hut it became obvious why there had been no lights; great banks of snow had drifted over all the windows. Inside we could dry our wet kit and warm ourselves in a 'small room' shuttered off from the main salon, whilst consuming litres of hot sweet tea. The guardian sorted out a meal for us and we slept until evening.

The next day was beautiful; cold and clear. I couldn't help thinking that if we'd stayed at Konkordia we could have been climbing the Fiescherhorn, but *c'est la vie*. Even the guardian and his wife abandoned the hut for a fine day out on the Ebnefluh in deep powder, at least until a helicopter disgorged a group of skiers who seemed likely to visit the hut on their way to the Lötschental. The guardian and his wife skied down to receive them, but when we returned from the peak we found them both disgruntled because the heli-skiers had gone straight past. In one of those ironies of mountain coincidence I was to bump into the guardian in May of that year on Denali in Alaska. There too he had the bad luck to miss out on a summit day. The following day more cloud and snow blew in with a bad weather forecast, so we forced a descent of the Lötschental in mixed snow conditions with poor visibility.

Beyond the first houses at Guggistafel, a huge avalanche had swept across the valley so we had to find our way between shattered tree-trunks sticking out of the snow at crazy angles. It had been a season of catastrophic avalanches, and on the bus journey from Blatten we passed along roads walled with avalanche debris twice the height of the bus and studded with the sawn-through stumps of 50cm diameter tree trunks.

With an unsettled weather forecast, we spent our remaining days in the relative luxury of the monastery on the Simplon Pass, managing a few simple day tours before the long drive home.

2. 2000

Having come so close to climbing all the Oberland 4000m peaks, I persuaded Jeff Harris to join me for another foray to knock off the Gross Fiescherhorn in 2000. I suppose the turn of the millennium had increased motivation to finish the 4000m project in both Jeff and myself.

Again we went before the Easter crowds, and took the Jungfraujoch railway in good weather, this time to access the Mönchsjoch hut. Bad weather closed in for two days, after which we'd had enough of shivering in the hut while snow blew past the darkening windows, so took the train back to Kleine Scheidegg. A half day of sunny piste skiing deteriorated into driven snow, and we spent the following day at the Sherlock Holmes museum in Meiringen before a better forecast tempted us up to the Mönchsjoch again.

Gross Fiescherhorn, 4048m. Ewigschneefeld, Fieschersattel, South-East Ridge: PD

As the train gained height, it emerged from dank valley cloud into bright, constant sunshine that dispelled our lingering doubts about the wisdom of shelling out for another expensive train ride. The hut was also a sight warmer without the snow-laden wind that seemed to have been sucking the heat out of its metal structure on our previous visit.

Next day the weather held. At 6 a.m. the guardian seemed half-asleep and forgot to put out the breakfast bread at first. Away by 7, we found beautiful snow as we skied into the upper bowl of the Ewigschneefeld, but cuttting across towards the Fiescherhorn the angle eased and we had to put in some unexpected poling through the new snow. After 300m of descent we intersected with a track from Konkordia near the foot of the spur that falls from the Hinter Fiescherhorn and followed it. With skins on we made good time swinging up around glacier shelves on the north-west flank of the spur.

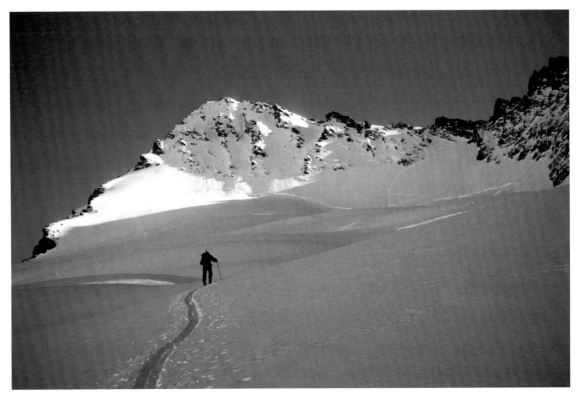

Skinning up to the Fieschersattel above right.

At the bergschrund we left our skis and a small cache of unnecessary gear. Three Swiss passed us, kicking fine steps up the headwall to exit a little left of the lowest point of the Fieschersattel, carrying their skis on their packs. They all had lightweight pin bindings. The steep headwall and our lack of acclimatisation meant we didn't catch up with them until they stopped to rope up on the ridge above. As we climbed, the unasked question, whether they had carried their skis to ski back down, teased my mind, together with the associated question about whether we should have done so.

From the Fieschersattel we climbed good snow on the east flank to gain the crest of the south-east ridge. There the snow was less reliable, becoming icy or rotten in places. The latter half of the ridge was a rocky scramble in crampons that was probably grade II in places and awkward with the snow. The Swiss roped up, but Jeff and I just took care, and pictures.

A sharp summit left little room for sitting about, but there were great views

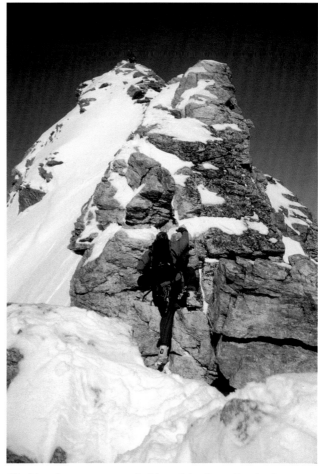

Climbing the snowy summit ridge of the Gross Fiescherhorn.

of the Finsteraarhorn and Grünhorn, allowing me to fill in details lost in the murk of my ascents in 1995 and 1999. To the south, snow mountains stretched to the horizon, while to the north, beyond the edge of the wall that drops from the Eiger, Mönch and Jungfrau, somewhere in the blue distance Interlaken and Luzern were hidden in the haze.

A steady descent brought us back to the saddle, 1 hour 40 minutes after we left, where we took a lunch break and talked to the Swiss team. They were skiing down to the Finsteraarhorn hut, which, contrary to the information we had, was staffed at the weekend. As they set off, we plodded across to the Hinter Fiescherhorn. We came to consider that a mistake, as for much of the way we sank knee-deep into snow softened by the afternoon sun.

After crossing the bergschrund I was tempted by a direct line up to the ridge that steepened enough to test the effectiveness of my lightweight axe and crampons. Above, the ridge was easy until just below the final rocks; there were no tracks, and my attempt to force a route on the right drew a blank amongst unstable flakes of rock. Jeff then found a way through on the left. It may have been spurned by other parties, but the mountain gave us fine views of its bigger brother to the north. Reversing the route, we were soon back at the saddle for more drinks and snacks. By then there were lots more skis and rucksacks at the depot, and people on the ridge or skiing off east towards Ochs.

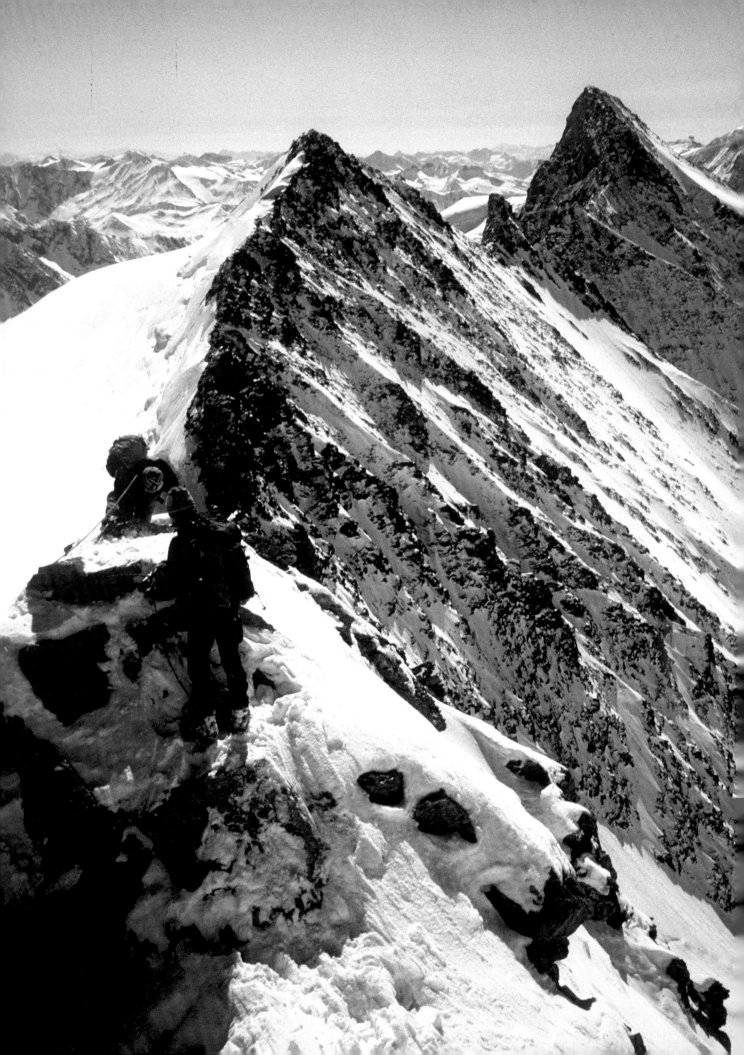

Care was needed on the descent to our skis as the snow was less stable than it had been in the cool of the morning. Steps collapsed and crampons balled up with sticky wet snow, especially worrying when we attempted to descend facing out. Just before we reached the skis, trickles of snow from above alerted us to a small team skiing down. We might have found skiing easier, but had allowed ourselves to be intimidated by the steepness of the slope that morning. On the other hand, when we did get on ski we found out just how tired we were and simply couldn't seem to get a good rhythm on the heat-softened snow. Other skiers passed us, apparently finding it all easier, while we tried not to do anything too adventurous and were invariably punished with a head-plant when we did.

It was 5.30 p.m. by the time we reached the ski depot on the glacier below the Konkordia hut. A new section of steps had replaced the builders' ladder of 1999. Plaques placed at stages on the way up informed us that the glacier had fallen by 53 metres from its height in 1877. The hut was crowded but not unpleasantly so, with good food and company at supper. I went out for a breath of air and the stars twinkled encouragingly in a deep purple sky.

At 6 a.m., cloud lifted for the morning to glow briefly on the summit of the Gletscherhorn, so we decided to make an attempt on it. By the time we had reached our skis, cloud had massed again. There was no improvement after crossing Konkordiaplatz, so we switched to an ascent of Kranzberg in hopes of the weather improving. It didn't. We climbed up a reasonable track as the weather closed in around us and it began snowing. When I couldn't see more than a metre ahead of me we bailed out, tentatively skiing down the track of our ascent. We were back at the hut by 10.30.

Next day threatened snow, so we decided to skin over to the Hollandia hut, but the weather held off and we could see the Lötschenlücke most of the way. The 3 hours 15 minutes hut to hut made a mockery of our three-hour struggle from snowhole to hut the previous year. We left our kit, drank a litre of tea each, and then, as the weather seemed to be holding, skinned on up the Ebnefluh. This time I reached the summit by its east ridge rather than the west, but the ski down was on perfect powder, as before.

With more uncertainty about the weather the following morning, Jeff and I decided to ski down the Lötschental and take the bus and train back to Grindelwald. A whiteout greeted us as we left the hut, but the snow was still good and it was such a disappointment not to have the visibility to enjoy it. Instead there was a weird absence of orientation that amounted to floating in cloud; at its worst, we snow-ploughed down the tracks of a guided group, hoping the guide had prior knowledge of crevasse distribution. Lower down the cloud lifted and we could cut loose on 25cm of powder on a firm base. Unfortunately where that base had been cut up by previous skiers it sprang a few surprises, one of which gave a nasty twist to my shoulder.

Arriving in Blatten, we plugged into the Swiss transport network with a post bus to Goppenstein then train to Grindelwald via Spiez and Interlaken. The only delay was at Grindelwald, for the Grund connection! We took a rest day in bad weather, then drove home.

To complete the Oberland 4000m peaks was a relief. The weather had never been kind although in 2011, I went back and traversed from Bettmeralp to Münster via the Konkordia, Finsteraarhorn and Oberaarjoch huts without missing a day's skiing. I made an ascent of the Grünneghorn with Iona Pawson, a fine young skier who was planning to join me on a ski expedition to Mongolia later

Descending the Gross Fiescherhorn with the Hinter Fiescherhorn and Grünhorn beyond.

that year, and we were almost tempted to continue to the Grünhorn as other skiers had done, but that would have meant our other team member, who had decided against the narrow ridge to the Grünneghorn summit, skiing down on his own. On the way in I caught up with a couple skinning up the Aletschgletscher to Konkordia; the guy turned out to be Jem. Arriving at the hut I bumped into Alistair Cairns who had been with me on my second Kyrgyzstan ski expedition. It was not one but two of those mountain coincidences that wouldn't be believed if you made them up.

18:
Health issues

Rescue helicopters waiting to be scrambled.

1. Acclimatisation

Acute Mountain Sickness (AMS) can begin to affect some people as low as 2000m, with symptoms including irritability, headache, dizziness and nausea. As height is gained atmospheric pressure is reduced, which makes it harder for your lungs to obtain the oxygen your body needs to operate at the cellular level. Short term, your body will adapt by increasing the rate and depth of your breathing and increasing your heart rate, which won't feel pleasant. Long term, the body will increase red blood cell production, although this brings associated problems with thickening of the blood and may result in circulation problems particularly where a pre-existing condition exists: most deaths in the Alps are

due to heart attacks. Left untreated, AMS can develop into High Altitude Pulmonary Edema (HAPE) affecting the lungs, or High Altitude Cerebral Edema (HACE) affecting the brain, both of which can be fatal, though relatively rarely in the Alps. Treatment is simple: reduce or reverse your rate of ascent. Acetozolamide (Diamox) and other drugs can treat the symptoms in extremis, but dependency on the drug to allow continued ascent can create its own problems.

To avoid AMS it is necessary to gain height gradually. Valley bases are usually around 1000m, so training walks to 2000m fulfil the 'climb high sleep low' formula, and can be followed by training climbs from huts around 2000m on peaks around 3000m before setting out from huts around 3000m for peaks of 4000m. Such acclimatisation enables your body to cope with the demands of altitude and to recognise those demands and respond more efficiently in future. Even then it's likely that your performance will be inferior to what you would expect at below 2000m, so it's worth adjusting your ambitions accordingly.

I remember Chris Astill saying he had never enjoyed alpine climbing while he only had two weeks' holiday because by the time he was acclimatised it was time to come home. On the other hand I've climbed with women friends who acclimatised in only a few days. You just have to listen to what your body is telling you and, as always, err on the side of caution.

2. Dehydration

Lower humidity and the increased breathing rate at altitude cause you to lose more moisture with exhalation than you would at lower levels. This can lead to dehydration, which can trigger AMS or produce very similar symptoms. The problems associated with thickening of the blood owing to increased red blood cell production are also linked to dehydration. You need to compensate by drinking more.

That's fair enough but the Hydrate or Die! slogan seems to be trying to make a fortune out of frightening people, and it's wrong. The case of a marathon runner who collapsed and died with ridiculously low sodium levels in his system makes it clear that hydration can be taken too far. I have a labelled water bottle that confidently asserts that I need 500ml per hour when climbing. For a 12-hour route that is six litres of water – six kilos of additional weight. If I carried that lot I'd never get up anything! Early experiments on Everest established that at altitude the body requires a minimum of three litres of water per day to operate. I've climbed 7000m peaks and never carried more than one litre of water, but make sure I drink at least a further litre at both the morning and evening camps. Of course it's necessary to have a bottle that you can check easily in order to ration your water, so hydration bladders can be a problem even if you escape their inconvenient habit of leaking into your rucksack. I've also climbed with Russians who carried no water at all at high altitude because they reckoned it just gets pissed straight out. They seemed to pace themselves well enough to avoid water loss through panting and sweating.

You will know you're dehydrated if you've stopped urinating or your urine is a dark yellow. Back at the hut you can easily rehydrate, if at some expense, until your urine is 'clear and copious'. Avoid alcohol and caffeine-based drinks, including 'energy' drinks, tea and coffee that act as diuretics. There is some evidence that small amounts of complex carbohydrate additives in water may help rehydration. Certainly after a lot of sweating it's a good idea to replace lost electrolyte salts. Maintaining hydration is one of the best ways of preventing altitude illness, and it is far easier to prevent AMS than to treat it once it has happened.

3. Sun damage

At higher altitude, a thinner atmosphere filters out less ultra violet radiation. With every 1000m increase in altitude UV levels increase by about 10 per cent. Exercise in strong sunshine can increase the effects of dehydration and damage skin and eyes. Early alpinists wore veils or smeared grease on their faces to protect their skin. Light-coloured wicking clothing can protect the skin and reduce sweating, but any exposed skin should be protected by sun-block to avoid sunburn and potential skin cancer. It's not just that you don't want a nose that looks as if it's had a close encounter with a blow-torch; melanoma can kill. If you develop any unusual raised moles, check them out with your doctor as soon as possible.

Eyes also need protection from ultra-violet light which accelerates cataract development. Sunglasses should be 100 per cent effective in blocking UVA and UVB radiation. Glacier glasses with leather side attachments or sports glasses with a wraparound style will also prevent reflected light reaching the eye from the side; 3mm polycarbonate lenses are recommended as highly impact and shatter-resistant.

4. Cold damage

High mountains involve lower temperatures, decreasing at a rate of between 5 and 10°C per 1000m of ascent, depending on moisture; dry air gets colder than moist air. High mountains are also more likely to be exposed to strong winds, producing a wind-chill factor that becomes more severe the lower the air temperature and the stronger the wind. Look up the NWS Windchill Chart for more details.

Frostbite damages the extremities – fingers, toes, ears and face. The body reacts to cold by constricting blood vessels in the extremities in order to retain heat and warm blood in the essential body core. Cooling of the extremities as a result can then cause tissue to freeze or become starved of oxygen. In extreme cases tissue dies and may have to be surgically removed to prevent infection and potential gangrene. Symptoms are progressive, beginning with pain and numbness (frostnip), continuing with a white waxy appearance to the affected areas, finally resulting in a hard frozen feel to underlying tissue with a very white or blueish tinge to the skin that may turn black if exposure to cold continues. Deep frostbite may include damage to bones or tendons and requires professional medical attention.

Frostbite has occurred when winter climbing in Snowdonia as well as in the Greater Ranges, so symptoms should never be ignored. Warming the body core can gradually reverse the process of shutting down circulation to the extremities, but rewarming the extremities should never be undertaken if there is a danger of them refreezing and causing more damage. It may also be less damaging and painful to walk out of the situation on frozen feet than it is on rewarmed feet. When the patient can continue to be kept warm, affected areas can be rewarmed with warm, not hot, water, although they may need painkillers to cope with the consequent severe 'hot aches'. Even with severe frostbite there is no hurry to amputate, antibiotics being the preferred option.

Sometimes the appearance of frostbite can seem more serious than it is in reality, as in the case of two of my team who summited Mt. Elbrus in a very strong cold wind, returning with black skin on their noses and cheekbones: within a few days the dead layer had peeled off, leaving sensitive pink

skin behind but no lasting damage. Numbness can last for some time without becoming serious, and there are cases of climbers, months after the event, suddenly suffering an attack of 'hot aches' in a frostnipped toe whilst dozing in front of a roaring fire. On the other hand long-term sufferers of frostbite have complained of continuing sensitivity to cold, impaired sense of touch, persistent numbness and/or pain in the affected parts.

Hypothermia is when the body core temperature drops from a normal 37°C to below 35°C. Symptoms develop progressively from shivering, goose bumps, numbness, through intense shivering, lack of coordination, sluggishness, violent shivering, difficulty speaking, mental confusion and stumbling, to slurred speech, difficulty seeing and finally unconsciousness and death.

Exercising in cold conditions requires conscious and careful thermoregulation to avoid hypothermia. Exercise generates heat which can stimulate sweating to cool the body, but it's a delicate balance to prevent over-heating or over-cooling. Wet clothing significantly increases heat loss, so wicking base layers and the removal or addition of insulating layers are ways of managing efficient thermoregulation; but it's also worth monitoring yourself and your climbing partners for symptoms of hypothermia to be sure you haven't made any mistakes. If the body core loses more heat than exercise can generate to compensate, the increased blood flow involved in exercise can continue to cool the body to a hypothermic level whilst you may still feel you are just 'running cool'. Monitoring oneself is made more difficult by the likelihood that hypothermia may involve mental confusion.

Dehydration affects the body's capacity to regulate temperature, yet cold drinks can be unacceptable so a flask of hot sweet juice can be effective both in maintaining hydration and blood sugar levels as well as directly adding warmth to the body core. Despite the legends of St. Bernard dogs with brandy barrels attached to their collars, alcohol can be a killer in cases of hypothermia since it may dilate the capillaries and increase heat loss from the skin, thus cooling the core even more.

Treatment of the hypothermia victim is simple in theory, but more difficult in a hostile environment: warm them. Having spare, warm clothing can make all the difference to a hypothermia victim. Techniques include drying the victim, re-insulation with dry insulation, insulation from ground cold, covering and protecting head, hands and feet from further heat loss, feeding warm sweet drinks if conscious and, if unconscious, evacuation with very careful handling. Surrounding the victim with a windproof and waterproof layer like a bivvi bag or bothy bag can create a warmer micro-climate, and placing another person or persons in there with them can significantly raise the temperature. If there is no sign of breathing or pulse and the victim is cyanotic, CPR should be added to rewarming. Remember: 'they are not dead until they are warm and dead'.

What follows is a note on heat loss from the head in this context since various myths and debunkings have rather muddied the waters. At rest, about 7 per cent of total body heat is lost from the head, but when exercise begins the increased cardiac demand increases blood flow to the brain, and heat loss also increases, to about 50 per cent of the total. As vasodilation responds to the demands of the muscles for more blood flow, the flow to the brain proportionately decreases and heat loss from the head reduces to about 10 per cent. However, a hypothermia victim who is shivering is exercising without any vasodilation, so the heat loss from the head is back up to around 50 per cent of total body heat loss, and consequently needs to be reduced by insulation; get out a woolly hat!

5. Osteo-arthritis

The oldest known remains of a mountaineer are those of Ötzi, the 5000-year-old ice-preserved body that emerged from the Similaun glacier in 1991 and redefined the Bronze Age in Europe; he was carrying a beautifully made bronze axe. Ötzi's joints show evidence of arthritis, and skin tattoos in the region of those joints suggest that tattooing may have been a form of treatment. Our bodies do their best to heal joint damage, but joints do wear out and high levels of use, such as in mountaineering, contribute to that. Cold conditions may also make a contribution.

The use of trekking poles cannot be recommended too highly to help avoid impact damage on leg joints that can lead to arthritis. It is a source of considerable regret to me that such information was not available when I began mountaineering, and indeed not widely known well into my mountaineering career; I can recall making long descents to the valley with a heavy rucksack full of climbing gear, wearing boots with little in the way of cushioning, having missed or been unable to afford any cablecar that might have been available, and racing to get down before full darkness. Sometimes that was a forlorn hope, but on many occasions I remember my knees were hot from the activity. I'm now unable to run without pain.

On the plus side, remaining active can reduce the pain of arthritis and increase joint mobility even for those with more damaged joints than sedentary sufferers. At the time of writing, there is no known cure, but there is some evidence of the benefits of taking glucosamine sulphate and cod liver oil tablets.

A lot of old climbers are hard of hearing, and we've all experienced that deep chill in the ear in bitter winds, so it's worth protecting the ears with a headband to avoid any chance of arthritis of the bones of the inner ear.

6. Diet

There is a lot of information and a wide range of specialist products that will provide for nutritional needs when mountaineering. Some of that information may seem confusing or simply an attempt to sell a particular product. Fortunately alpine climbing does not involve extended periods away from supplies of normal food. Complex carbohydrates and sugars in gel form may be fine for endurance trail runners but mountaineers are not under the same pressure. Essentially it's possible to tolerate a calorie deficiency for a day or two by accessing the body's reserves. Even the thinnest of climbers has enough reserves to survive for about three weeks without food, whereas we are unlikely to survive more than three days without water (and, to complete the 'rule of threes', no more than three minutes without oxygen.) In order to avoid overloading yourself with food it's only necessary to supply enough calories to enable your body to access its reserves. Those reserves can then always be topped up when returning to a hut or the valley.

We used to carry high-sugar rations, and I remember evaluating the difficulty of a route by the number of chocolate bars consumed while climbing it. Now we know more about nutrition and are aware that sugar concentrates will raise blood sugar levels too high too fast. A sugar spike stimulates insulin production which can reduce the blood sugar level to a point lower than it was before the sugar was ingested. That may account for some of the sudden mood swings that have been experienced in

teams of climbers. The way to avoid a 'sugar spike' is to include fibre in the input which 'spreads the burn' and avoids stimulating insulin production; blood sugar rises more slowly, over a longer period, to less extreme levels. Flapjacks don't freeze solid, and fulfil the role of hill rations more effectively for me now than my past dependency on chocolate bars.

7. Mental health

Climbing can be a stressful activity, both bodily and mentally. The mind is continually required to assess risk in what can be considered a hostile environment. There are also the strains that such stress can put upon a climbing relationship: you or your partner may react in ways that are difficult to anticipate under pressure of circumstances. Surviving depends as much upon keeping one's mental balance as on keeping the more obvious physical balance. DON'T PANIC. When difficulties are encountered it may be necessary to react quickly, but there will also be times when a hasty response can cause as many problems as it solves. I recall Gordon Nuttall's experience with a ski-tourer whose wife fell into a crevasse. The man kicked out of his skis and rushed back to the crevasse, screaming her name. Unfortunately he failed to assess the stability of the crevasse edge and pitched in after her. Both died before they could be rescued.

Familiarity with the route description can help anticipate where problems may arise, and sensitivity to your surroundings will mean fewer unpleasant surprises than plodding along in a world of your own. Snow conditions change during the course of an alpine day, as can the quality of the rock being climbed, and a seemingly simple snow ridge may hide lethal cornices. Respect any uneasiness you may have about your situation: your unconscious mind may be registering things your conscious mind has missed.

Self-awareness is also important. Not only about how tired or irritated you may have become, but also about whether your attitudes to risk have become modified by your drive to succeed. Summit fever is catching, but there are other heuristic traps for the mind that may be just as dangerous. Just because there are snow steps or ski tracks doesn't mean that those who made them were any more certain of the route than you are. Getting away with crossing a doubtful snow slope on one occasion doesn't mean you'll get away with it on another. Keep checking yourself and your partner for any oddness about your thinking. When in doubt stop, take stock, talk over the situation.

When I was climbing a steep snow slope in Kyrgyzstan in full sun, I discovered there was no resistance to the insertion of my ice axe shaft for its full depth. Below there was no safe run-out but a snow ledge before a drop over a cliff: I called a halt. Derek and John, both experienced alpinists, ahead of me on the rope, then admitted that they also had doubts about the slope's safety so we decided to retreat. Until I stopped, all three of us had kept our doubts to ourselves, perhaps in response to an unvoiced peer group pressure and/or an excessive focus on the objective – both potentially lethal heuristic traps.

On another occasion in the Caucasus, an avalanche swept across the line of the route ahead of us that my team was ascending on ski. Careful examination of the track of the avalanche, once the air cleared, revealed that it had been powder snow filling the very cold air: only a dusting of snow had actually been deposited, so the team was reassured enough to continue without anxiety, checking all the time of course.

Rest has an important place in alpine climbing. After two or three days of climbing, a day or two of sunbathing and catching up on sleep pays dividends for the next outing. There's also a question of balance here. The Alps are not only the rock and snow heights but also the picturesque valleys and alpine pastures. Many climbers have agreed with Ruskin that the best views of many mountains are from the valleys, and such diversity itself is a source of recuperation as much for the mind as the body. Those who experience only high alpine routes have not experienced the Alps.

Helicopter rescue of a climber with a broken leg.

19:
Loose ends

1996

The raid on the Oberland in 1995 had left me with just six 4000m mountains left to climb: the Fiescherhorn and Grünhorn (two Oberland peaks that I still thought of as ski objectives), Les Droites and the Grandes Jorasses in the Mont Blanc massif, and the outliers, Piz Bernina and the Grand Combin. In 1996 there was an AC/CC meet in Chamonix, and I was persuaded to go. It was my first attempt to tie up these loose ends. The persuasion came from Pam Caswell.

I had encountered Pam and her husband, Steve, on the meet in Grindelwald in 1993. She was extremely self-assured and possessed an accent posh enough to guarantee fast-tracking of her application for membership of the Alpine Club regardless of qualifications. I remember on one occasion Steve took vehement exception to the lack of kit I was packing for a climb next day: he was of the 'carry-bivvi-gear-for-safety' school whereas I was in the 'if-you-take-it-you'll-have-to-use-it' party, and had been concerned about how often Steve and Pam had descended glaciers too late in the day. Fortunately we were not planning to climb together, but in the aftermath of the argument I remember telling my wife they were 'an accident waiting to happen'. I think I was trying to reassure her.

On Sunday 7 August 1994, Pam and Steve traversed the Aiguille de Bionnassay from the Durier refuge with Simon, her 16-year-old son from a previous marriage. They had planned to continue over Mont Blanc, but had taken much longer than anticipated on the Bionnassay, so were attempting to descend to the Rifugio Gonella when the accident happened. Pam went through a snow bridge and, unable to arrest the fall, the others were pulled into the crevasse after her. Steve died of his injuries five hours later, and Pam and Simon were not to be rescued until the Tuesday following; bad weather kept climbers off the route. It was the 'silly season' for the British press, and inaccurate reports tended to sensationalise the details of the accident. Pam had recently found out she was pregnant but had not yet chosen the moment to tell Steve.

Pam and I met again in the autumn of 1995 at a hut in Patterdale, and talked at length about all that had happened to both of us. I was divorced by then. We climbed together, found that we had more in common than either of us had thought, and began a relationship that later led to her moving in with me together with her infant son, Stephen. Steve's parents were understandably keen to spend

time with their grandchild, which allowed Pam sufficient freedom from parental duties to take a few weeks' holiday during the summer: Chamonix was her preferred destination. The framework of the meet also allowed me to take my son, Rhys, now 14, and daughter, Rhian, 17. They were quite capable of taking care of themselves, but having other adults around would make that a lot less worrying for me.

The weather forecast was good when we arrived, so all four of us took the train to Montenvers and walked up to the Couvercle hut with huge sacks containing food and cooking equipment: self-catering was the only sensible option with two extra mouths to feed. A three-hour hut walk took five as Rhian and Rhys struggled to acclimatise. We planned to warm up with a training route traversing the Nonne, then give the kids a rest day while Pam and I climbed Les Droites. There was food for three days in case we tried another route before returning to the valley: all good acclimatisation!

The traverse of the Nonne went well, but took much longer than expected, belaying our juvenile partners pitch by pitch rather than moving together. I could understand their concern. Even Pam found the exposure intimidating on the knife-edge ridge beyond the summit. I thought they would follow my example and use the edge as a handrail, moving quickly from one small foothold to another on the rock below, but they 'joined the pony club' and shuffled along à cheval.

Evening was drawing in as we abseiled down to the snow beside the Brèche Nonne-Eveque, and by the time we had steamed back to the hut, eaten and turned in it was getting on for 10 p.m.

Pam and I woke at 2.30 a.m.

'How do you feel?' she whispered.

'Knackered … but then I usually do at two in the morning. Do you want to go for it?' I whispered back.

'Of course, after all the trouble we've taken to get up here. The weather might break if we take a day off.'

'Yes. You're right. Who was it said that no one is good-tempered on an alpine start? Never mind: it doesn't matter.'

Leaving the hut, we kept high, reaching the glacier and crossing to the upper edge of the Jardin de Talèfre. There we found a trail heading for the ascent couloir as it grew light, but the crevasses were more complex and took longer than expected to negotiate when the trail was lost on hard ice. The couloir, in an angle of the south ridge, was defended by an awkward bergschrund. I bridged across it into a corner on the left on steep brittle ice that tinkled into the yawning gap below as it cracked away from the pick of my ice axe. Kicking the front points of my crampons

Family party on the traverse of La Nonne.

195

Climbing out of the approach couloir on Les Droites.

into the ice became less urgent as the angle eased and steps appeared, hacked out by previous teams. I belayed to an ice screw and brought Pam up before we moved together up snow slopes between rocky ribs and out into the sunshine.

Our pleasure at the touch of the sun was soon qualified by the speed with which the snow began to deteriorate. With hindsight, we should have realised that it was not just the sun that was raising the temperature. At dawn there had been a 'storm cap' of cloud on the summit of Mont Blanc that had spread to cover the whole sky, then cleared to give us the sunshine we were enjoying. We should have heeded the warning.

The air is cloudless but warmth sidles in from the plains on the wings of a weather front. Moisture is infiltrating the atmosphere. Clean-cut edges of rock and snow turn hazy, distant vapour trails unravel, as millions upon millions of microscopic droplets begin to accumulate, rising on warm air currents to condense into cloud.

As condensation continues, droplets collide, with rising droplets or those that have risen into cold air and frozen, now falling as hailstones, now sleet, perhaps only to be caught in the updraft to gyre in suspension in the lower cloud or rise again to acquire another layer of ice.

Electrons split off by collisions accumulate in the lower cloud, creating a negative charge, adding to that of the frozen droplets, whilst all above them boil those unfrozen droplets imparting a positive charge to the upper cloud beneath the cold lid of altitude.

It's called extreme charge separation.

Soon the cloud generates an electrical field so powerful that electrons at the surface of the earth are repelled deeper into the ground that itself accumulates a more and more powerful positive charge.

When the charge becomes so intense that each square inch of cloud contains tens of thousands of volts, the surrounding air begins to break down at the molecular level, stripping negative electrons from

positive ions, ionising the air. And the freed electrons create plasma down which the charge can flow with all the conductive properties of metal.

It is nature's tool for neutralising charge separation.

But this is no uniform halo of ionisation. Dust or spindrift will break the air down more easily, creating shining pathways for fingers of force reaching along lines of least resistance, bending and turning, branching and glowing purple as the field builds.

The earth responds, flaring positive streamers from points and pinnacles, waiting patiently for those fingers of force, metre by metre to reach down, to connect.

Connecting, the current flows down a pathway of ionised air. Lightning strikes with a heat greater than the surface of the sun. Air expands so fast that it explodes with a sound of thunder.

All in a fraction of a second.

And the storm had been building all day in the Argentière basin, hidden from the west behind that wall of rock stretching from the Aiguille Verte to the Aiguille de Triolet.

Slowed by the softening snow and my lack of acclimatisation (Pam was always less affected than me in the first few days at altitude), we followed the ridge onto steepening and often loose rock. It was a less than obvious line, but occasionally a ribbon of sun-bleached nylon tape marked the site of a timeworn belay, and eventually we emerged onto a very soft upper snowfield.

Our feet sank knee-deep in the snow and there was little chance of ice axes encountering enough resistance to effect a self-arrest in the event of a slide. We kept close to any rocks, hoping to find solidity beneath the snow or rock spikes that might act as running belays, whilst trying to forget about the void below the snowfield. All the time the cloud had been thickening and it was clear that the weather was breaking, but we pressed on hoping to snatch the summit before it broke. We didn't. Less than 50 metres below the top, two teams were slipping and sliding in their haste to get off the summit ridge and the first rumbles of thunder reached us. There was a strange metal taste in the air, my ice axe was humming and someone was abseiling from pegs in a rock pillar just ahead.

A guide shouted to us that the steep couloir to the east was rigged for abseils, before following his client down. We didn't hang about debating the issue, just got the hell out of it, but as we completed the first abseil the storm broke like an artillery barrage, thunder rolled over us in a continuous wave and lightning cracked the dark sky, filled with hissing hailstones. The guide declined to let us use the double ropes that he and his client were using, so we were stuck with 25m abseils that didn't quite match the deployment of abseil points. By the time the first squall had cleared, the pair ahead was out of the couloir and tracking across the snow while we were only three abseils down.

A sense of being robbed of the summit almost turned us back up the couloir in the sudden sunshine, but common sense prevailed. It was only a lull in the storm. One tricky abseil after another took us over a rock lip and down to the edge of the snow slope below, which was when the storm hit us again. Lightning flashed close by and thunder rebounded off the enclosing rock walls. There was a complete whiteout as a mixture of hail and snow pounded down. We struggled into spare clothing and waterproofs, lashed by the wind, then huddled together while the debris of the storm built up around us.

I don't know how long we sat there, but I became so cold that as soon as the wind began to drop and the first patches of clarity to appear through the drifting cloud I decided to move. A snowslope, another abseil, an insecure traverse on loose snow and melting hailstones, like dissolving ball bearings, and we were wading across the huge expanse of snow below the col dominated by the Tour de Courtes. Neither of us wanted to think about avalanche or the consequences of a slip; we just had

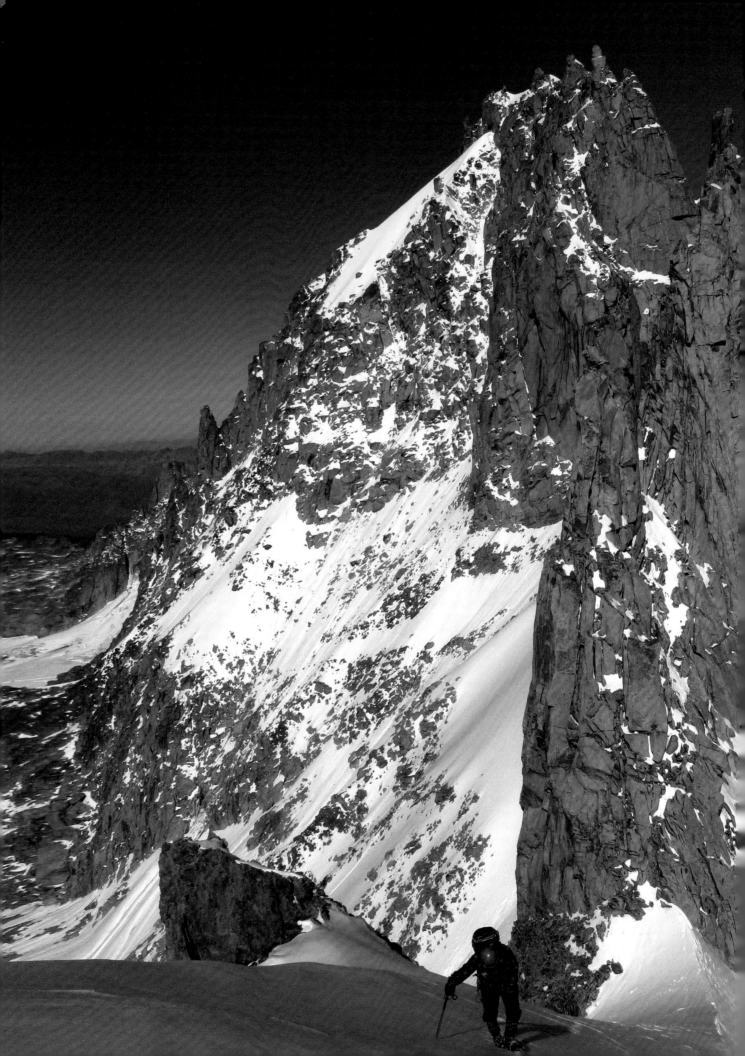

to get on with it. We cut back right (facing out) towards the Talèfre glacier, crossing some rock-strewn slabs and managing to snag the rope around a couple of blocks in the process. The tumbling rocks chewed up the sheath of the rope, but by then the glacier lay clear ahead of us and we knew we were going to get back to the hut, however late.

But it was later than we expected: unfamiliarity with the jumbled blocks of moraine while approaching the hut from below in fading light meant we came close to losing our way. The track we followed seemed so faint that there was more likelihood of ending up in a marmot burrow than a hut. Rhian and Rhys had been relieved to see us on the glacier some hours before, but had clearly been so worried or bored that they had eaten every scrap of the food we had carried up to the hut; Pam and I were reduced to cadging some soup and cheese leftovers from the kitchen, as the evening meal was long gone.

Next day we took a late breakfast, the nearest thing to a lie-in that we could get, then walked out in changeable weather. Caught by a squall on the short ladder section to the Mer de Glace, I belayed the kids down the wet steel rungs. Mid-glacier the sun came out, so we took turns to play around with two ice tools in an easily accessed crevasse, then regretted it as a storm came in whilst we climbed the ladders to Montenvers. Lightning strike was in the back of all our minds, and it was forcefully brought home to us a day or two later when Wil Hurford, a guide and friend who spent much of his time in Chamonix, told us of someone recently struck by lightning on those same ladders.

We had an early night, and it was next day before we realised that the storm had flooded Chamonix. The traffic island by the market square was under half a metre of water, cellars were overflowing and power was out in a wide area adjoining the railway station. Silt covered roads, sports courts and the golf course at La Praz, where they were not still flooded. Heavy duty diggers were grappling boulders out of the river bed in an attempt to deepen it and drain the floodwater.

And the forecast was for more rain. So we spent the best part of a week taking damp walks, including an ascent of Le Buet, visiting the Fondation Pierre Gianadda sculpture park in Martigny, and making a beer last for hours at the Yeti bar pool whenever there was a spell of sunshine.

Gran Combin, 4314m. West Ridge – North-West Face Traverse: AD

A forecast improvement in the weather encouraged Pam and me to walk up to the Valsorey hut in cold showery weather. The Torrent de Valsorey was in spate and reminded me of how it had thundered beneath the snow as I skinned up around its emerging boulders on skis one Easter.

By 3.30 next morning we were already climbing up through rocks towards snow-slopes that narrowed and steepened into the couloir leading to the Col du Meitin. Dawn came as we reached the col, with Mont Blanc and the Aiguille Verte rising out of shadow into the roseate light to the west while a full moon still shone small and bright just at the point where the sky shaded from blue to green.

The east face of Les Droites with the south ridge in profile and the line of the abseil piste following the steep couloir dropping from the summit (seen from the summit ridge of Les Courtes).

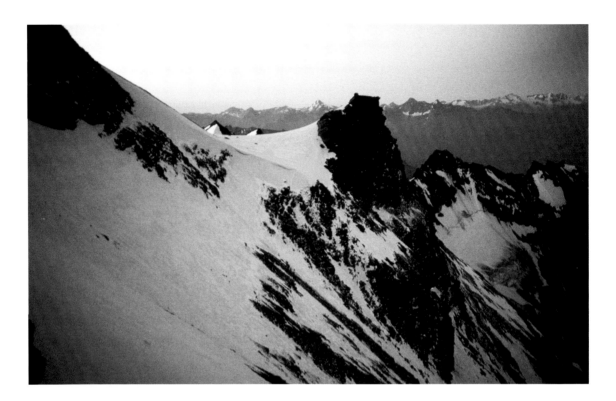

Top: At the Col du Meitin; start of the west ridge.

Bottom: Climbing on the west ridge of the Grand Combin.

There was some uncertainty about where to start on the west ridge, with few signs of any previous passage and more snow than expected. We traversed across to a snow saddle then climbed to the right of the main ridge, but the line wasn't obvious. The guidebook description of three distinct steps was lost on us as we meandered from ledge to ledge and rib to rib, always trying to orientate ourselves with reference to the edge on our left but all too often drifting onto easier ground to the right; easier ground that threatened to take us into unknown territory or, worse, all the way over to the melting snows of the south face. Where the ridge seemed more like a fin of rock jutting out from the body of the mountain and seepage had fringed overlaps with icicles, we tackled two steep pitches that were disturbingly loose. Holds cracked and shifted beneath hands and feet, and the rock was shiny and flaking like mica.

Eventually we broke out into the sunshine on a snowy shoulder and there was only the final step to the summit of the Combin de Valsorey. This we took

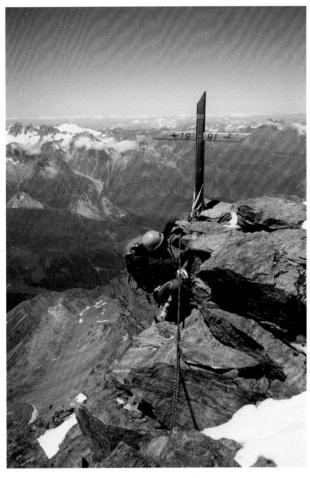

Gaining the summit of the Combin de Valsorey.

direct on more solid rock, although I irreverently clipped a sling around the wooden summit cross to protect Pam as I moved across to a more comfortable belay position. The tension eased: time for a break.

Ahead, an easy snow slope led from a slight saddle up to the main summit, the Combin de Grafeneire. The final 130m felt far from easy, though, toiling up in full sun, gasping for breath at more than 300m above our high point on Les Droites. Passing a curious solar panel structure, we met three Swiss descending who had come up from the Panossière hut via the north-west flank. They told us their route was steep but straightforward, with just one step of no more than 20m where two ice tools might be advisable. It sounded infinitely preferable to returning by the way we had come.

Reaching the summit, we paused briefly to take in the view, but afternoon haze was already obscuring details so there was no incentive to stay for long. Following the Swiss tracks down, at the steep step I belayed Pam on a body belay from a bucket seat excavated in the snow, then pulled up both ice axes tied to an end of the rope and down-climbed to join her. The rest of the descent eased off enough to be manageable with an axe each, so we moved together down to the upper reaches of the Corbassière glacier.

There we realised there was a sting in the tail: instead of a descent to the Panossière hut there was 200m of ascent to regain the Col du Meitin. It seemed a long way at the end of a long day. Descending

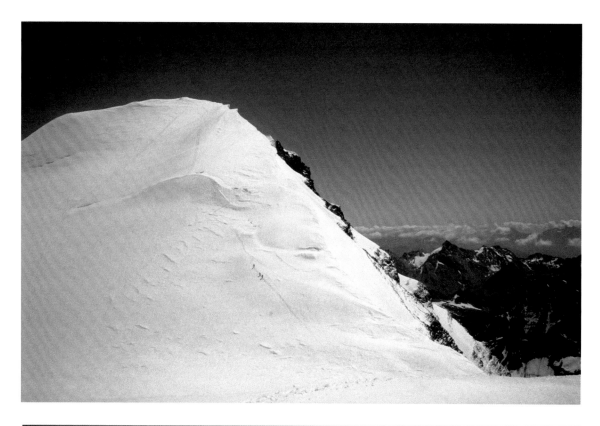

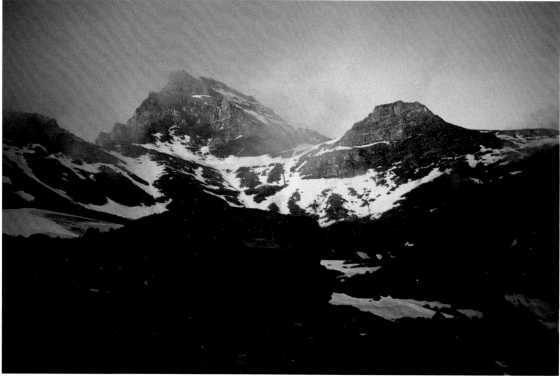

Top: The snow slope between the Combin de Valsorey and higher Combin de Grafeneire.

Bottom: West ridge of the Grand Combin in evening light.

to the Valsorey hut was a relief, but it was only as we arrived that we looked back to see the west ridge glowing in the setting sun.

It seemed sensible to walk out next morning.

A few days later Pam and I were back at the Couvercle hut for another attempt at Les Droites. I think she was actually keener on getting up it than I was by then. That night we were quick out of the hut and onto the Talèfre glacier, but there was no moon and crevasses loomed on all sides in the torchlight. There was still no clear track and hesitation grew into nervousness. Suddenly Pam burst into tears, hunkered down on the ice and sobbed that she just couldn't go on. The maze of crevasses had spooked her, and with good reason after all she had been through. There was no question of continuing. We turned and followed our crampon tracks back to the hut.

After that the weather continued unsettled and although we snatched a few short routes with Rhian and Rhys, the high mountains remained out of condition. Finally I took Rhys up the Petite Verte by the north face, direct, and he acquitted himself well in the use of two ice tools. It was a good ending.

2002

By 1999, sustained harassment in my workplace had led me to take early retirement for health reasons. Those factors, combined with Pam's increasing insecurity and associated health problems, had led to the break-up of our relationship. I had received support from Yvonne Holland, who had offered me a home when I needed it; we met when we climbed Denali together as part of an AC team that Bill Jones had put together, and as time went on began a serious relationship. We climbed in Spain and Ecuador, and in 2002 enrolled to climb Pik Lenin as part of Kyrgyzstan's celebrations of the International Year of Mountains. Before going to 7000m, however, we decided it would be helpful to have some alpine acclimatisation. Since neither of us had done much in the Bernina, that became our destination. Piz Bernina was one loose end, and perhaps we could get over to Courmayeur and Chamonix on the way back for others.

June was probably a bit early in the season, but we had an interesting time finding snow routes where none were recorded in the guidebook and walking tracks that sometimes disappeared under snow banks or had been swept away by avalanche. The local track repair teams were just starting to get out and make good the winter damage, although ski tourers were still departing from the Diavolezza lift for Piz Palü.

We had a superb day out on Piz Julier, then Charlie Kenwright came over for a weekend and we all climbed Piz Morteratsch from the Tschierva hut. I'd lost touch with Charlie since he'd moved to Basle, and he was then living in Munich. He had had to have a kidney removed the previous year and that had been an incentive to reconnect with people as it often is when someone is reminded of their mortality; there's an awareness that time is limited, after all. Morteratsch was the first peak he'd climbed since the operation and on the summit he turned and said quietly, 'I never expected to do this sort of thing again.'

With hindsight, Piz Morteratsch was probably a mistake. I gazed longingly at the sinuous snow-crest of the Biancograt on Piz Bernina, but the approach to the Fuorcla Prievlusa looked much more intimidating than from below. Yvonne was having none of it: we would climb the Spallagrat or nothing.

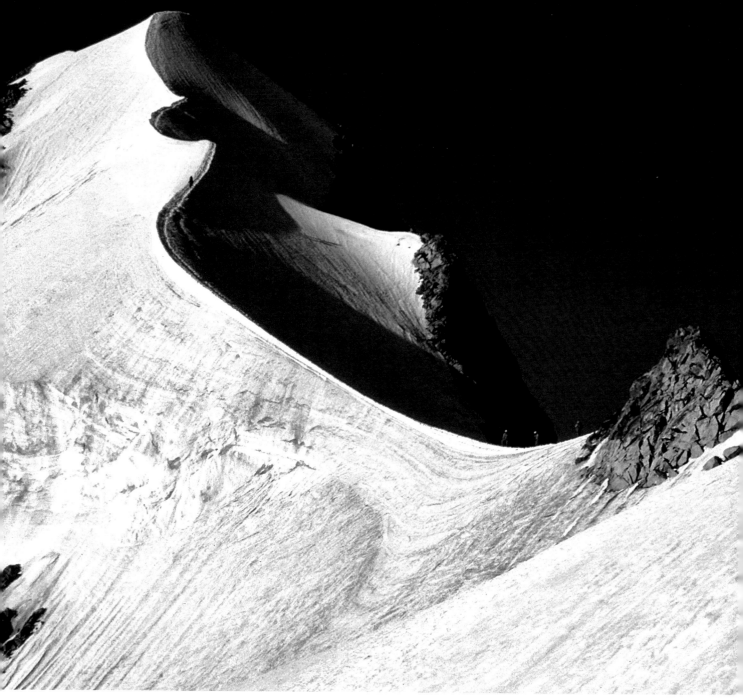

The Biancograt on Piz Bernina.

Piz Bernina, 4049m. South Ridge, Spallagrat: PD

On 25 June Yvonne and I took the cablecar to the Diavolezza hut with plenty of food, intending to traverse from Piz Palü to Piz Zupo then bivouac in the winterraum of the Marco e Rosa hut before climbing Piz Bernina. Learning that the Marco e Rosa hut was actually staffed, we phoned a booking, then stashed the food and cooking kit at the Diavolezza.

That night lots of fussy rucksack fiddling on all sides and a marked reluctance to get heads down meant that we had a poor night's sleep but were still away for 4 a.m. In bright moonlight, we climbed down to the glacier and followed an improbable trail through some spectacular crevasses and seracs. Passing an ice cliff that had spilled a jumble of blocks of ice across the line of the track sometime the previous day, we could see the snow summits of the frontier ridge tinged a rich pink. Daylight strengthened as we reached the east ridge of Piz Palü, which we climbed on the right to gain the

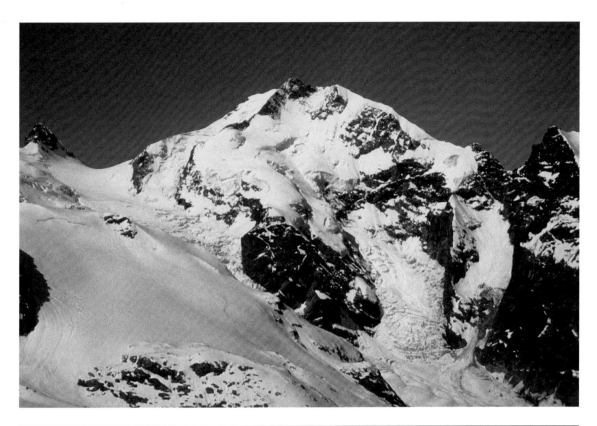

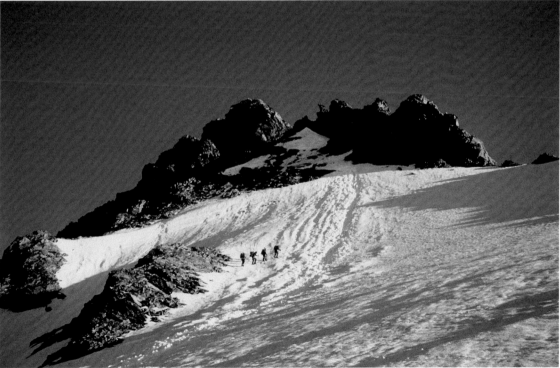

Top: Piz Bernina with the Biancograt on the right skyline and the Spallagrat on the left.

Bottom: Approaching the Spallagrat just after dawn.

east summit. Traversing the ridge onto the main summit we met Heinz, the warden of the Tschierva hut, with a client he had guided over the Biancograt the previous day. I couldn't help a twinge of envy.

We trod the snow crest under a clear blue sky while the valleys below were filled with cloud, continuing to the west summit where we removed our crampons to descend the blocky granite steps of the west ridge. Yvonne complained of feeling tired, so when we reached the Fuorcla Bellavista we abandoned the traverse and dodged around the side to the Bellavista terraces. Crossing them, we continued to descend seriously crevassed glacier before climbing up to the Fuorcla Crast'Agüzza and the Marco e Rosa hut. Lots of loud rock music and cheery staff preparing for the demolition of the hut marked it as unmistakeably Italian. Only the winterraum of the old hut would remain after that night, with a couple of portakabins helicoptered in to cater for visitors while the rebuilding took place. Despite the numbers in the dorm, I had the best night's sleep ever in a hut.

It was freezing when we left at 6 a.m. Zig-zagging fast up the shadowy snowfield was the best option to generate some heat, until we emerged into sunshine and coincidentally the wind dropped. A tiny moon still shone over Monte Disgrazia. Ahead, a steep slope above the bergschrund led to a brèche on the ridge where a slabby step gave onto a short snow ridge.

There we caught up with the four people ahead of us, belayed at the foot of the main rock step. Their leader was climbing very slowly, placing runners and carrying two ice tools and a snow stake, which seemed a bit excessive. I wasn't prepared for a long wait, so worked up the snow to the right until I found a rock ramp, easy enough to climb in crampons. It intersected with the line the other leader was taking, just above where he was setting up his belay. I completed the overtaking manoeuvre by belaying to a higher abseil ring cemented into the rock and bringing Yvonne up, then ran out another half-pitch to reach the snow and a protruding rock belay.

The snow ridge stretched, with one rocky outcrop, almost level to the summit rocks but it was very narrow and late descents on soft snow during the previous day had made a mess of steps kicked along the flank. Now it was crisp névé, frozen hard enough to crampon along the crest; a pair of skywalkers. At the summit rocks we took off our crampons and scrambled along the last 100m to the chiselled crosses, plaque and summit book. It was 8 a.m.

We sat for a while drinking in the view, then I noticed Yvonne was crying.

'Er … What's wrong?'

'I never thought I'd do this sort of thing again.' Her voice broke.

I was taken aback. These were almost the same words Charlie had used a week before. Yet he had been coping with the loss of a kidney. Yvonne had impressed Charlie with her fitness and competence on Morteratsch, but despite her undoubted ability she had been plagued throughout the previous weeks by sudden crises of confidence, and I now realised how deep-rooted those feelings were.

'Well there you are: you have, and you will,' I mumbled awkwardly, and gave her some time to get over her tears.

When she was ready we headed back, passing the party of four at the start of the summit rocks, who just grunted in response to my greeting, and another party of three on the snow ridge who were more cheerful. At the rock step someone had fixed a rope with knotted loops that meant we could swing down, hand over hand, without abseiling.

Beyond the bergschrund we struck off straight down to the Crast'Agüzza to intersect with the path to the hut. Then it was back across the Bellavista terraces, meeting three guys who had backed off

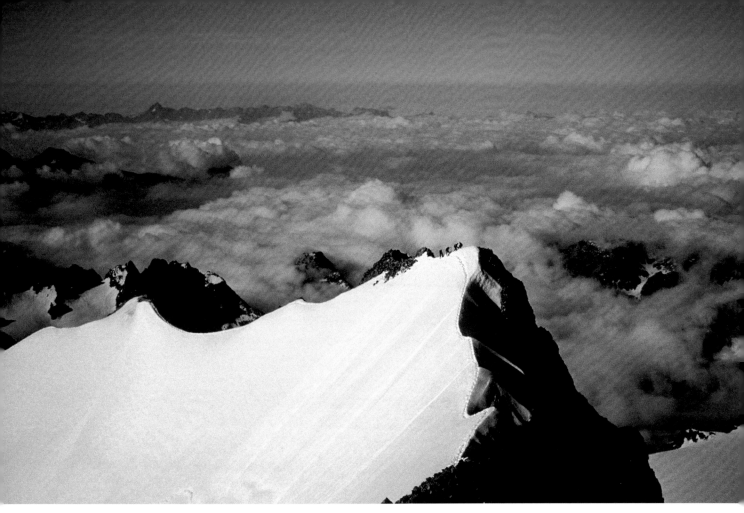

A team on the easy angled but very exposed snow ridge of the Spallagrat.

the frontier ridge on account of the wind. Stopping for a quick snack at the Fuorcla Bellavista, we too found the wind stronger and colder than it had been even on the summit of Piz Bernina.

The descent of the Fortezza ridge was straightforward snow to a rock section waymarked with orange paint and abseil rings; easy enough, although by now both of us were tired and tetchy. More snow, a short rock section, then it was snow all the way down to the ice of the Pers glacier. We crossed the glacier to the moraine path below the Diavolezza and a gruelling 40 minutes later had climbed back up to the hotel to reclaim our stashed kit. It had proved to be a nine-hour day, and there was absolutely no hesitation about taking the cablecar back to the valley. It was my last Swiss fourthousander.

Taking stock of our diminishing finances, we decided to make for Italy over the Maloja Pass with some idea of climbing Disgrazia. Finding a dead-end in a field to park the campervan, overnight we were treated to a nightingale in full-throated song in the trees above us and a moon that lit up the landscape like day. We talked late about what to do, and decided to go to Courmayeur instead.

Changeable weather at first kept us valley-bound but the flowers were remarkable this early in the season, with heady perfumes given an added intensity by the underlying sharp scent of pine rising from the forest. Then, with the first decent forecast, we walked up to the Boccalatte hut and made the acquaintance of Lucy and Luke, its guardians. The first night there was snowfall but on the second we set out for the Grandes Jorasses at 3 a.m. under a starlit sky.

Lack of tracks in the fresh snow of the glacier slowed us down, then reaching the Rocher de Reposoir Yvonne was convinced that we should keep to the snow on the right and take a slanting couloir back onto the rock crest. This was neither confirmed nor denied by the guidebook, so that's

what we did. The only couloir/ramp line back onto the rock proved looser and steeper than either of us was comfortable with and slowed our progress further. Even when the crest of the ridge was finally gained there was still a lot of snowed-up rock between us and the top, but we pressed on doggedly.

Where the Rocher de Reposoir abuts against the glacier bay that is traversed right to the Rocher Whymper, the ice looked very broken and unstable. On the plus side, it was still in shadow. Yvonne was finding the position intimidating: I heard her whisper, 'We're going to die,' as I started forward to work out a line. I stopped. We had taken five hours to get that far and there was still a lot of climbing left to do. There was no point in attempting to go on. In retrospect we should probably have stuck to the snow on the right and by-passed the Rocher de Reposoir completely, but it was too late for that. It was the right decision: we weren't going well and took half an hour longer to descend than the ascent had taken, but that didn't make me feel any better. We collected our kit and went all the way back to the valley.

The Italian side of Mont Blanc rears up like a wall of rock and snow, with little to offer in the way of short or easy routes suitable for the changeable weather conditions we found ourselves experiencing. The decision to go through the tunnel to Chamonix was easily made, but changed little. Any hopes that the weather might be better on that side of the range were disappointed: another dump of snow would come in just as it seemed the high mountain routes were coming into condition. We kept ourselves amused with short quick-drying rock routes in the Aiguilles Rouges, but Chamonix was becoming crowded with people with little to do. The Aravis chain to the south offered a change of scene with fine limestone scenery including a spectacular rock arch, the Trou de la Mouche. Soon there were only a few days left before we needed to travel home, but then a weather window seemed to be opening so Yvonne and I set off for the Couvercle hut.

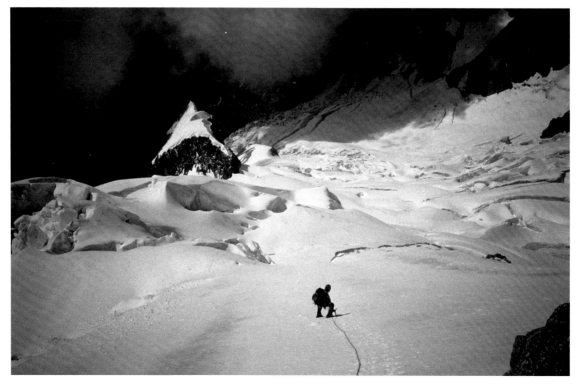

Descending from the Rochers de Reposoir to the Boccalatte hut.

Les Droites, 4000m. South Ridge of East Peak (East Spur): AD

The Mer de Glace was much changed. Glacial recession had reduced its volume significantly since 1996, and at Montenvers the moraine between the steel descent ladders and the ice was worryingly unstable, with the track passing too close for comfort to house-high boulders that seemed to have little holding them in place. Yet tourists were gaily trotting down to the ice in shorts and sandals, oblivious to the danger. Perhaps it was because of the pervasive proximity of the trappings of 'civilisation': railway station, hotel, souvenir shops.

There was no danger of falling into a crevasse on the bare ice of the glacier, but at the point where the kids had scrambled up rocky gullies and ledges aided by bits of old ironmongery and a few short ladders in 1996 there was now a sequence of long steel ladders bolted to sheer rock faces and linked by steel mesh 'landings'. The route to the Couvercle hut was now aspiring to Konkordia status, but with typical French panache it was designated a Via Ferrata. Teams were ascending and descending equipped with Zippers and ropes, whilst to make matters worse an afternoon storm was brewing.

It broke while we were still waiting for a gap in the descent traffic to get up the first flight of ladders. Rain slicked down the rock and claps of thunder followed hard upon bursts of intense white lightning. That was enough for Yvonne; she headed back down the glacier to Montenvers.

I hesitated. Was Les Droites going to be the wrong mountain for me again? Then the wet rungs were clenched in my fists and I was climbing. The ladders probably weren't vertical, just felt that way as the heavy rucksack hauled at my shoulders, but hanging around on a steel grating over empty space did nothing for my sense of security as the rain continued, thunder grumbled and roped parties jostled past. Once I was above the ladder pitches, the thunder ebbed as the route became the scramble I remembered, and by the time the hut came in sight the rain had stopped.

Inside there was a territorial tension about positioning wet clothing for maximum drying effect in the confusion of garments surrounding the stove. No one seemed very communicative. I asked the guardian what conditions were like on Les Droites and he replied; 'I don't know: no one has done it yet this season.' It was mid-July: early in the season but not that early. Well I'd have a go, solo, and just turn back as soon as I faced an unjustifiable risk. The decision made, I relaxed, tuning in to that sense of place which underpins my belief that you only climb a mountain if it lets you. I recalled again Jeremy saying: 'Mountains generally give fair warning before they kill you.'

Over the meal I fell into conversation with a young guide and his client. He confirmed my impressions of the acceleration of glacial recession and my anxieties about the state of the moraine at Montenvers; that morning he had been descending the very same moraine when a huge boulder had just rolled over onto a teenaged girl who was descending to the glacier to walk on the ice, he guessed for the first time in her life. He had attempted to free her and administer first aid, but she was too badly crushed and died before anyone could do much to help her.

I set out at 2 a.m,. scrambling down rocks onto the glacier de Talèfre by headtorch light, then trekking across ice flats to climb steepening ice alongside the Jardin de Talèfre. Above the Jardin, crevasses reared icy ribs, barring access to the south ridge, but despite the darkness I managed to find a way through without backtracking. Finally a narrow ice gangway led out into a snow bowl with the couloir that climbs to the crest of the ridge hanging above it. The couloir had avalanched, leaving

a big easy snow cone to climb up to the bergschrund at 3390m.

It looked like child's play to step off the lower lip of the bergschrund and climb up the avalanche runnel in the couloir above, but the upper lip overhung and the snow of the runnel was so unconsolidated that the pick of my ice axe simply pulled through a depth of 'cotton wool'. I backed off and tried to find a way up the rocks to the left and onto the ice at the edge of the couloir. Scraping up ice-scoured rock in crampons felt increasingly insecure as holds became scarce. There were a couple of those moments when you move up on faith and friction that run out all too quickly. A teetering retreat at the limits of adhesion saw me

The west flank of the south ridge in profile from the approach couloir to Les Droites east summit.

looking down at the possible landing site and realising that with no one else on this route it would be very easy to die down there. I heeded the warning.

It was light by then, and I had spent more than an hour trying to get into the couloir. I climbed back up to the lower lip of the bergschrund for a last look before turning back. The snow still felt like bottomless fluff to my probing axe. Then I had an idea: instead of seeing it as a snow gully, look at it as a cornice; perhaps I could tunnel into the upper lip far enough to be able to kick some steps. After hacking a chimney as high as my axe would reach, I plunged into it, back and footing up the collapsing snow but still making progress. Having thrutched up high enough to consider rolling out of my chimney, I buried the adze of my axe into the surface to steady the move long enough to make it. Then I was there: face down in the snow, spread-eagled, with my free hand punched into the softness and my feet buried. It didn't slide me off, spit me out into space. I couldn't quite believe it.

Cautiously I kicked one step, then another. The rest was technically easy, but physically arduous, kicking deep new steps up the runnel, then out onto the safer slope to the side where rock niches offered shelter from any slide. Soon I was climbing slopes opening onto the crest of the ridge. Ahead, trackless snow was interspersed with rock steps, classic mixed ground. There were cracks and shallow chimneys and loose ledges of snowy broken rock. It was just a question of reading the terrain and working out the line of least resistance. Sometimes the line would run into a dead end, an overhanging corner or a blank wall, and I'd have to backtrack, but then I'd unearth a ragged sling from the snow, which would confirm I was more or less on route. Perhaps I remembered something of the earlier attempt, but, immersed in the intense concentration of soloing, I was unaware of that.

The ridge turned to snow, taken on a rising rightwards traverse, linking rock 'islands of safety', to avoid the unstable crest. At the top of the snow ridge, just below a small buttress, a wind scoop offered a sheltered place for a break. To the right were pegs in the rock, and I realised this was the point from which Pam and I had begun our abseils in the storm six years earlier. The summit was just above.

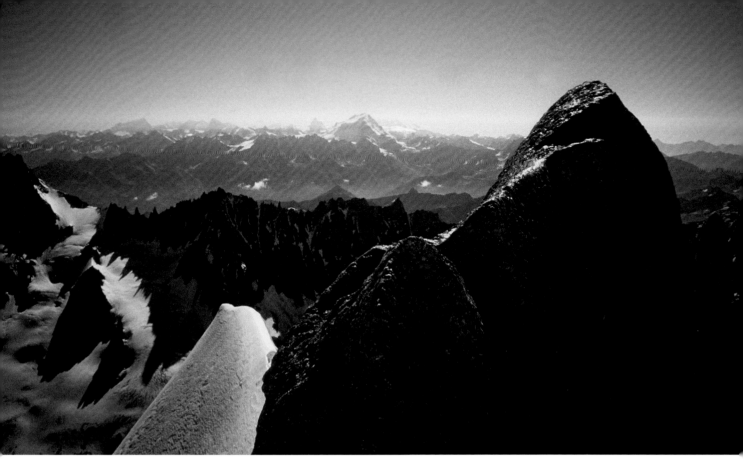

The view south-east from the east summit of Les Droites.

But first there was steep unconsolidated snow on the right to climb up to the summit ridge. I made one big zig and zag traverse, finishing delicately along the safe side of a cornice break line, gaining the crest where rock jutted from the snow. Beyond, a short snow crest was all that separated me from the summit block, but the snow remained deeply unstable. The summit was too close for me to back off again. I straddled the ridge and swam along it like a frog, plunging the shaft of the ice axe into any hoped-for solidity beneath and displacing little snow slides down the immensity of the north face into the Argentière basin. Moving awkwardly onto the rock, I climbed up to the summit; there at last.

To the north I could look down on the Aiguilles Argentière and Chardonnet while to the south lay that familiar panorama from the Grandes Jorasses to the Grand Charmoz, with its centrepiece, Mont Blanc, brooding over the Géant icefall. There was that sense of elation, of being at one with the mountains, that Wordsworth called 'the sublime', but this was no place to linger. I needed to be off the ridge by noon to avoid the risk of avalanche in the sun-softened couloir.

Descent seemed easy now altitude was on my side. Nearing the point at which the snow ridge turned mixed, I saw two figures coming up in my tracks. We shouted and waved, and as we drew closer the leader called out with surprise, 'A man alone?' I was able to reassure him that I hadn't lost my climbing partner, we shook hands and rapidly moved on.

There was water trickling down the rock steps, and snow that had provided icy footholds in corner cracks now sloughed wetly away to turn the descent into a controlled slide in places. But my tracks removed any route-finding difficulties and I was soon at the head of the couloir. It was still quiet, still stable. The steps were now more consolidated by the two Swiss climbers and in 20 minutes I was poised above the upper lip of the bergschrund. The snow chimney looked as though it would chute me down into the crevasse so I simply leapt for the lower lip. I seemed to be a long time in the air, and on landing the impetus carried me away down the slope of the avalanche cone, but I managed to arrest the slide with my ice axe and plod down the last few metres onto the glacier.

The mass of ice cooling the surface snows of the glacier meant that progress was easier and safer than expected, though there were times when I marvelled at the intricate line I had traced in that before-dawn darkness. Frequent backward glances yielded no sign of the Swiss pair, and a nagging worry surfaced at the back of my mind.

At the hut, the guardian shook my hand. 'You rest. I shall look out for them. With these.' He waved a pair of binoculars at me, then turned to scan the mountain with them. It had been an 11-hour day and the thought that the Swiss might be in trouble tipped the balance in favour of staying another night at the hut. Later, much later, they turned up, having taken the abseil piste towards the Tour de Courtes rather than risk a late descent of the south-west-facing couloir. They told me all about it as we shared a meal and a couple of celebratory beers.

Next morning I took a long last look at Les Droites from the terrace of the hut before turning away with a profound sense of rightness that lasted all the way to Chamonix, and beyond to Pik Lenin that I summited in August.

20:
4000m lists and criteria

by John Allen

Two seminal works in the classification of 4000m mountains.

Make a list of anything at all (even a shopping list) and someone will want to put the items in an order – alphabetical, numerical; age, distance, height. Perfectly normal human behaviour. Throw in human ambition and human endeavour, backed by money and/or possible fame and celebrity, and you can reach the South Pole (Amundsen, Scott, 1912), climb Everest (Hilary and Tenzing, 1953), walk on the moon (Armstrong, Aldrin, 1969), and so on. Or more modestly, focus on a to-do list of peaks in the Alps, of 4000m or otherwise, in a lifetime of alpinism.

Normal mortals show ambition and endeavour, have jobs, perhaps some spare money, limited free time, and a desire for success, which can result in well-being and fulfilment. To this end some of us climb mountains. A long list of reasons could be tabled for climbing mountains, but it's difficult to be definitive; easier to list the mountains themselves.

Or is it? When is a mountain not a mountain? Originally, before Charles Hutton (1737–1823) invented contours while working on Schiehallion in the Scottish Highlands in 1774, the main distinguishing feature of a mountain, apart from its obvious visible height and bulk, was its name, which appeared on early maps. By the end of the 18th century, Napoleon had decreed that the metre was to be the universal system of measurement in Europe, and as far as heights of alpine mountains were concerned, that was that. British pioneer alpinists still climbed in feet, the home mountains were small beer, but in the Alps Brits had to understand metres.

At the time of early alpinism, the competitive urge drove the Austrian Karl Blodig (1859–1956) to seek out 4000m summits as a lifetime objective. *Die Viertausender der Alpen*: K Blodig (1923) lists 61 summits. His contemporary, the Cambridgeshire-born Percy Farrar (1857–1929), was also ambitiously active, 'following a fascination that bordered, at times, on the obsessive' (B. Imeson in *Playing the Man*, 2011). Between 1881 and 1926, Farrar did a huge number of ascents in Europe and elsewhere, including 60 over 4000m in the Alps, some with guides, others guideless; and all the difficult ones. He recorded all of them. Of Collomb's definitive list (1971), Farrar only missed Castor. Imeson:

> Herbert Reade was of the view that … to Farrar mountaineering was not a 'mere pastime' but the main interest of his life. His list of climbs, his reputation as one of the greatest living Alpinists, his prodigious work for the *Alpine Journal* …

In the alpine world the influence of this man was immense.

When Eustace Thomas (1869–1960) adopted Farrar's list of 4000m peaks as a shopping list in 1923, in preference to Blodig's list, he became the first Brit to do them all (1923 –1929), including Castor twice. He added to them, reaching a total of 83 (RCJ 1929), and then went on to do all the pinnacles of the Diable ridge on Mont Blanc du Tacul in 1933. This lifetime tally, accomplished in a span of ten years between the two world wars, showed the possibilities if personal circumstances (ie wealth, a competent and enthusiastic guide in Joseph Knubel, and free time) allowed. To quote the first paragraph of Eustace Thomas's article in the *Rucksack Club Journal* ((RCJ) of 1929, entitled 'My Four-thousands':

> The above title was suggested by *Meine Viertausende* the title of a book in which Blodig described the completion of the first effort of this character. It is a good title, because there is no official list, and probably no one has covered every single arête and gendarme that lies above the 4000m line. Captain Farrar, however, had made out a list, and Joseph Knubel and I adopted this and made a few additions. In general the basis was that anything in the nature of a peak of 4000 metres or more which had a name or number on the official map should be included. In this way the Breithorn has three points to be visited and the Rimpfischhorn two. The list can be added to outside this basis, eg it is hoped next year to include the Aigs [*sic*] du Diable. Such lists always look rather artificial, but after all it is just a game. Rucksackers are well soaked in such ideas through the 'Twenty-Fives' of England and Wales and the 'Three-Thousands' of Scotland, which Corbett is so successfully pursuing. The list is given at the end of the article.

Thomas even suggests here the coverage of every arête and gendarme over 4000m! Martin Moran and Simon Jenkins must surely have come close to traversing every point above 4000m on their epic completion in the summer of 1993.

Thomas's *RCJ* 1933 article 'A Devilish Holiday' began,

> As members of our Club are aware, it has been an obsession with me for some years past to complete the ascent of all the peaks in the Alps which are above 4000 metres in height. As far as I have heard only four people have completed a similar quest – viz. Blödig [*sic*], Pfann, Horeschowski, and Blanchet; but their list was a shorter one and did not, for example, include the Aiguilles du Diable. It was desired to make the traverse of the five Aiguilles in one day, as had been done twice before; and this was considered to be possible only if they were dry and free from snow and ice.; and as two of them were climbed by the north face, this state seldom existed. The Aiguilles du Diable had been my principal object on four previous visits to the Alps, but during these visits the traverse had been impossible.

Almost another 40 years elapsed before the 4000m peak objectives for Brits surfaced again with the publication by Robin Collomb of *Mountains of the Alps Vol 1* in 1971. For another 20-odd years from 1971 this volume in English established the criteria, and became the definitive list for British mountaineers seeking ascents over 4000m in the Alps.

What were the definitive criteria in Collomb's book *Mountains of the Alps*?

1) Height

Following Percy Farrar's and Eustace Thomas's contributions, Collomb wrote:

> A starting point for classifying the major summits of the Alps is clearly debatable. Certainly, below 3500m, a student of the subject will run into tremendous problems. Resolving the exact nature of mountains, secondary tops or something less precise becomes more complicated as the altitude is lowered.

He had taken a fresh look at the topography and morphology of the whole of the Alps from the experience of a multitude of personal expeditions after World War II. He wrote and edited climbing guidebooks for the Alpine Club and his publishing business, West Col. My gut feeling is that he was deeply moved by mountains (see also his *Alpine Points of View*, 1961), preferred 3500m to 4000m as a contour line basis for classifying alpine mountains, and perhaps regretfully had to accept that after all the alpine summits had been climbed for the first time, 'the next oldest cult of the pastime is to climb mountains over 4000m … since the "game" commenced' (p.14). Intense though mountaineering can be at times, it's still a game within the modern climber's lifestyle. (cf. Eustace Thomas 'there is no official list' and '[s]uch lists always look rather artificial, but after all it is just a game.') Already the status of lists and the value of a single criterion of height at 3500m or 4000m or whatever are regarded as questionable. Why not 13,000ft?

Although lines drawn on maps and particularly contour lines make a very valuable contribution, they are still artificial constructs to enable ground of equal altitude to be represented in two dimensions on paper yet provide the reader with a notion of three-dimensional reality. Are we not

granting exaggerated status to one line (ie 4000m) if we focus all our mountaineering on it? Martin Moran thinks that 'the ultimate justification of tick lists is their popularity' and that 'we are irredeemably goal-oriented'. There is little doubt that he is right, yet the value of alpinism's wholesome appeal lies not just in the summit or the route, but also the inclusive processes that involve all the other non-focused 24-hour days, non-4000m days, rest days and so on, which add hugely to an overall well-being derived from our presence in mountains as the visible and metaphorical landscape for our excursions.

2) Distance, horizontal separation, isolation

Height is not everything in the Alps; the subtle difference between a peak and a mountain comes into play. The Oxford English Dictionary definition of 'mountain' is 'a natural elevation of the earth's surface rising notably above the surrounding land'. This is different from a peak, or a projecting high point like a pinnacle or tower, or a *pointe* or *aiguille* (French) or a *gipfel* (German), or even a large but lower hump some distance from the main summit. The question now arises about the minimum col depth that would satisfy a criterion for separate peak or mountain status. And what of distance between summits?

Collomb again, on mountains: 'essentially a separate mountain should have a drop of at least 200m on all sides' (*Mountains of the Alps*, p.16). He seems to see the highest summits as 'mountains' in the OED sense, yet includes in his list independent summits such as the Aiguille Blanche de Peuterey as mountains. This could be a nuisance to followers of his logic, because the col depth (Col de Peuterey) is only 179m below its neighbour (Mont Blanc de Courmayeur) and not the required 200m. However, he finds an escape route on behalf of separate mountain status for the Blanche and others (e.g. Schreckhorn and Lauteraarhorn) by adding a few qualitative conditions: 'the criteria adopted … consist of a mixture of topographical logic and assessment based on personal acquaintance'. And: 'Distinct impressions are left with the mountaineer as to the correct status of summits, and these not infrequently contradict the superficial appearance given by maps.' Not everybody will agree what is a mountain and what is just a peak, or outlier. Col depth comes into it. Additionally, what about distance between contending summits?

Crucially he adds: 'In cases like these a considerable horizontal distance usually serves to enhance separation.' Although he does not define 'a considerable horizontal distance', in fact a kilometre separates the Blanche from Mont Blanc, and the Lauteraarhorn from the Schreckhorn. Of the latter two he finds them to be 'the most plainly individual and individually striking mountains in the Alps'. My personal experience of having ascended both mountains from opposite ends, and of having seen each from the summit of the other, leads me to the same conclusion.

Perhaps that clinches the matter, namely a mountaineer's personal acquaintance and/or distinct impressions combined with something like a kilometre of distance between contenders for separate mountain status. Aspirant completers had better not attempt to deny the Blanche's qualification in a bar room of completers of Collomb's list of 52 on the grounds that it is only 179m below Mont Blanc de Courmayeur.

This personal ingredient adds something extra to quantitative criteria – namely the subjective impressions that affect the viewer; in fact the effect of a topographical feature of some independence, not overshadowed or subsidiary, on the observer. Despite a certain obsession with the quantitative, most alpinists or commentators seem to agree on the overall value of the personal and subjective criteria.

Further historical background

The influence of the Collomb volume *Mountains of the Alps* (1971) on alpinists in the period 1960–2000 has led to a preference for his list of 52 separate mountains as objectives in the Alps by British climbers. Post World War II and pre-1971 aspiring British mountaineers only came into contact with other language versions during meetings with European climbers at alpine huts, as competent parties locked onto the possibilities in the Alps for two-to-three-week holidays between June and September.

An article in *High* magazine (Spring 1983) listed 75 tops and alerted British climbers. Will McLewin had read the article, having begun climbing 4000m peaks in 1966. His book *In Monte Viso's Horizon* (1991) stimulated further interest. He had been following Blodig and Dumler's list (*Die Viertausender der Alpen*, 1923), and completed his personal list. In the same year, 1991, Diadem (Ken Wilson) published *The Alpine 4000m peaks by the Classic Routes* by Richard Goedeke, detailing 61 peaks, including summits not on Collomb's list of 52. This was republished in 1996, and took note of the UIAA 1994 determinations.

In 1993 Martin Moran and Simon Jenkins completed a list of 75, based on Thomas's and Collomb's lists, in a continuous enchainment lasting 52 days. Col depth applied was 35m minimum. Moran's guidebook for the Alpine Club (*The 4000m Peaks of the Alps – Selected Climbs*) now lists 50 major 4000m peaks.

In 1993 the UIAA appointed a working group from the national clubs of the three main alpine home countries (Italy, France, Switzerland) to come up with proposals for an official list, and such a list of 82 peaks was agreed in 1994. Criteria included topography, morphology, individuality, mountaineering and historical significance, and 'more subjective criteria which could change during the evolution of alpinism'. Col depth should be 30m minimum. In 1993 two members of the Club Alpino Italiano, Luciano Ratto and Franco Bianco, founded the Club 4000 'with the aim to serve as a reference guide and meeting point for all 'collectors' of summits higher than 4000m' (see www.club4000.it). The founders had been members of the UIAA working party, and at 17 January 2013 the club had 366 members, of whom 27 had done all 82 (18 Italians, 7 Swiss, 1 Belgian and 1 Hungarian). This total includes the first woman (the Swiss Jocelyne Gay), and a Swiss mother and son (Margareth Voide-Bumann and Gabriel Voide). To my knowledge 18 Brits have done the Collomb 52.

In 1996 Diadem (Ken Wilson) reprinted the 1993 coffee table classic and included the 1994 UIAA list of 82 (*The High Mountains of the Alps*, Dumler and Burkhardt). In 2008, Italians Diego Giovannini and Franco Nicolini did all UIAA 82 in 60 days.

It seems that there is still scope for future 'collectors' – make up your own list; for example, be a British traditionalist and work on all the 13,000ft peaks, which would include major mountains such as the Eiger, Meije, Bietschhorn, Gletscherhorn, Grivola, Fletschhorn and Schalihorn which are just under 4000m but over 13,000ft, or all Collomb's 273 separate mountains over 3500m.

What criteria really matter?
Lists, damned lists and statistics!

It is better to travel than to arrive, said a wise man. Although inexpressible in a few words to say what really matters in our mountaineering, the process (ie the travel bit) obviously counts for a lot. No-one, scientist, artist or philosopher, can ignore what happens within the mind of one who applies a sense

of curiosity to clambering about and investigating high and steep places and who sees the marvels of nature unfolding before his very eyes. Seasoned climbers will understand perfectly and would do well to impress this on the tyros, upstarts and unbelievers. The process surely includes mental, physical, emotional, visual, spiritual and even mystical experiences that affect individuals differently. Edward Wilson, a devout Christian, felt God in everything in Antarctica; Pope Pius XI, Achille Ratti, benighted on Monte Rosa and again on the Matterhorn, experienced 'that sense of receptive reverence' and 'the indescribable beauty of the surroundings'. More down to earth, Charles Darwin thought that our enjoyment of the open air results from our ancestry, 'the savage returning to his wild and native habits'. Despite a sense of awe and wonder, we use simple ideas to describe our aims – 'it's the view', or 'getting to the top' – as incentives to public understanding. A list is just another of those incentives, only important in seducing others into understanding the process. Of alpinism, Ken Wilson wrote: 'this is surely not an activity about which to become obsessive – it is the alpine odyssey that is important, rather than slavish list-ticking'.

Finally, W. H. Murray (from *The Evidence of Things Not Seen*, Bâton Wicks, 2002):

> Above everything I liked Geoffrey Young's attitude to mountains and mountaineering, for these attitudes were mine too, probably strengthened, at least in part, by my early reading of his books, both prose and poetry. The principles are simple: that the true joys of mountaineering are spiritual and only to be had when the climber, however high or low his skills, goes to the mountains because he loves and respects them and not just for the display of his own skills, or to compete for records or first ascents, or the collection of summits. These latter rewards are froth, none of them worth a man's life – or even his time. If the approach is right – for love not gain – mountains enrich life and are worth all the risks entailed.

To quote Eustace Thomas: 'Probably no-one would start his Alpine career with the intention of going for the Four-Thousands.' McLewin again: 'Fortunately there is no list of the 4000m peaks that is accepted as definitive. I say fortunately because it means that climbing them all is necessarily a personal affair. I assume nobody would begin their Alpine climbing with this intention because it would be a misguided approach.' Then in 1993 the rat race caught up, Moran and Jenkins became 'Olympians' with their 75 peaks in 52 days, followed in 2008 by the Italians Giovannini and Nicolini's UIAA 82 peaks in 60 days. Brian Cosby, writing in the *Rucksack Club Journal*, sounds a necessary cautionary note, 'It took me 36 years to complete Collomb's list.' And 24 years earlier; 'One thing needs stressing in this game, you must be careful and discreet. It is my ambition to become an old mountaineer and it's a waiting game.' (*RCJ*). Brian is four years nearer to eighty years of age than me. I will never catch up with him, or now complete the 4000m peaks, whatever they are.

The 18 known British completers, self-certified, based on Collomb, at 31 October 2013:

Colin Beechey, Brian Cosby, Peter Fleming, Jeff Harris, John Higham, Simon Jenkins, David Litherland, Will McLewin, John Mercer, Denis Mitchell, Martin Moran, Dave Penlington, Mike Pinney, Kate Ross, Les Swindin, Prof. Harold Taylor, Eustace Thomas, Dave Wynne-Jones.

Barbara Swindin did 51 of the Collomb list of 52.

21:
Completion

In the five years that followed my ascent of Les Droites in 2002, I returned to the Alps only once, with Adele Long in 2005, described in the postscript to Chapter 1. With only one 4000m mountain left to climb in the Alps, instead of getting on with it I found myself climbing and skiing in more remote locations like Nepal, Kyrgyzstan, China and the Yukon, simply because the opportunities became available. Opportunism was distracting me from my unfinished business.

Then in 2007 Mike Pinney alerted me to an AC/CC meet scheduled for Courmayeur. Gethin Howells, a student of half my age, had joined me on the ski expedition I'd led to Kyrgyzstan in March, and was keen to follow up with an alpine season. We drove to Chamonix before joining the meet so that both of us could catch up with friends who lived there: Vivi Seigneur was just back from humanitarian work in Afghanistan, still tense about the security issues and angry about the ineffectiveness of the UN, but glad to be home; Mark Jensen had just got down from climbing the Kuffner route on Mont Maudit but still met us for a drink that evening (he recommended Asia as a worthwhile rock climb on the Aiguille de Floria, and the north face of the Tour Ronde as being in good condition); and Françoise Call invited us to a party. I was back in the Alps.

Next day Gethin and I warmed up on Asia, then went on to Françoise's party where Victor Saunders wandered around barefoot in salopettes as though he had just come off the hill, which was probably the case, and the Burgess twins told tall stories. A little the worse for wear, we arrived in Courmayeur a day late, only to be bundled into a car by Mike Pinney and whisked off to climb some rock routes up-valley. He always ran a tight ship!

Acclimatisation continued to be a priority so Gethin and I took the cablecar up to the Torino hut. Reception was closed until 4 p.m., so we couldn't book in before tackling a short training climb, the east ridge, Aiguille de la Toule. This began on snow before pleasant rock scrambling led up to the north ridge, which we followed to the summit. Great swathes of cloud swept in and away, producing ghost images of the surrounding mountains that would suddenly sharpen into brief snapshots before disappearing again.

Back at the hut, we were told off for not making a reservation and informed that it was not possible to have breakfast before 4 a.m – yet at 3.45 next morning we found trays with flasks had been left out for earlier risers: clearly there was one set of rules for some and another for others! We ate quickly and rushed off into the dawn, arriving at the foot of the north face of the Tour Ronde at 6 a.m. Inevitably there were three other parties on the route, so we just took our place in line and admired the Gran Capucin, golden in the early light.

Four pitches of good névé overlaying hard ice took us up the first snowfield and into the linking couloir to the upper snowfield. The névé gave some substance for our crampon points to bite into

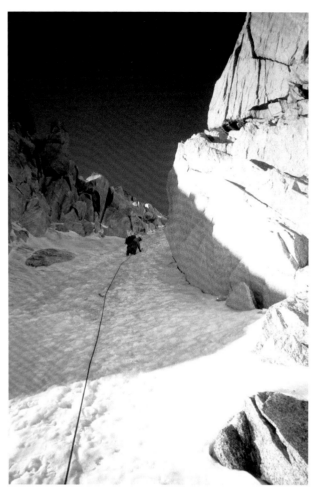

Climbing through the narrows on the north face of the Tour Ronde.

but was easily scraped away to find good placements for ice screws. The face was big enough to be intimidating but much less technical than winter cascade climbing, whilst the line up the snowfield was enough of a rising traverse for most of the debris from above to miss us; until we reached the couloir.

There, two pitches of ice led to a kind of headwall beneath a huge overhanging boulder. We told ourselves the boulder was solidly frozen in, then crossed the headwall to reach more ice pitches on the left above it. Throughout, chunks of ice broken off by those ahead whizzed past us. We dodged and ducked, but at one point I misjudged the bounce and was struck a glancing blow on the hip by a block the size of a small TV. I had to hang on to both ice tools until the feeling came back into my leg, swearing loudly enough for those above to be under no illusions about what I thought of their technique. Cursing has an amazing capacity to diminish pain, perhaps generating extra adrenaline.

We broke out of the continuation couloir on the right and climbed the upper snowfield near rocks on the left side where slings over spikes could supplement ice screws for runners. It was steeper than expected, but I suspect glacial recession has reduced the volume of ice on the face: as it has melted back towards the rock underneath, so the slope has become more concave.

We gave up the summit in hopes of descending quickly enough to catch the last cablecar down to the valley, but soon gave up hopes of that; teams of slow-moving novices stumbled down the south-east ridge in front of us, delaying our descent. We arrived back on the glacier just as another British team did so: Martin, Rick and Catherine turned out to be AC members and had plans for the Rochefort arête on the morrow. Since we had missed the cablecar by then, Gethin was keen not to waste another night in the hut, but to join them. I was less enthusiastic, limped back to the hut and got an early night.

Next morning Rick and Catherine had decided to go down, feeling unwell, but Martin was still keen to do the route with Gethin. I was undecided: 'I've done it before and really I'd like to traverse the Aiguille and Dôme de Rochefort en route to the Grandes Jorasses, but I'm nowhere near acclimatised enough for that. And there's the pain in my hip. It's better than yesterday but still not good.'

Dent du Géant and the start of the Rochefort arête.

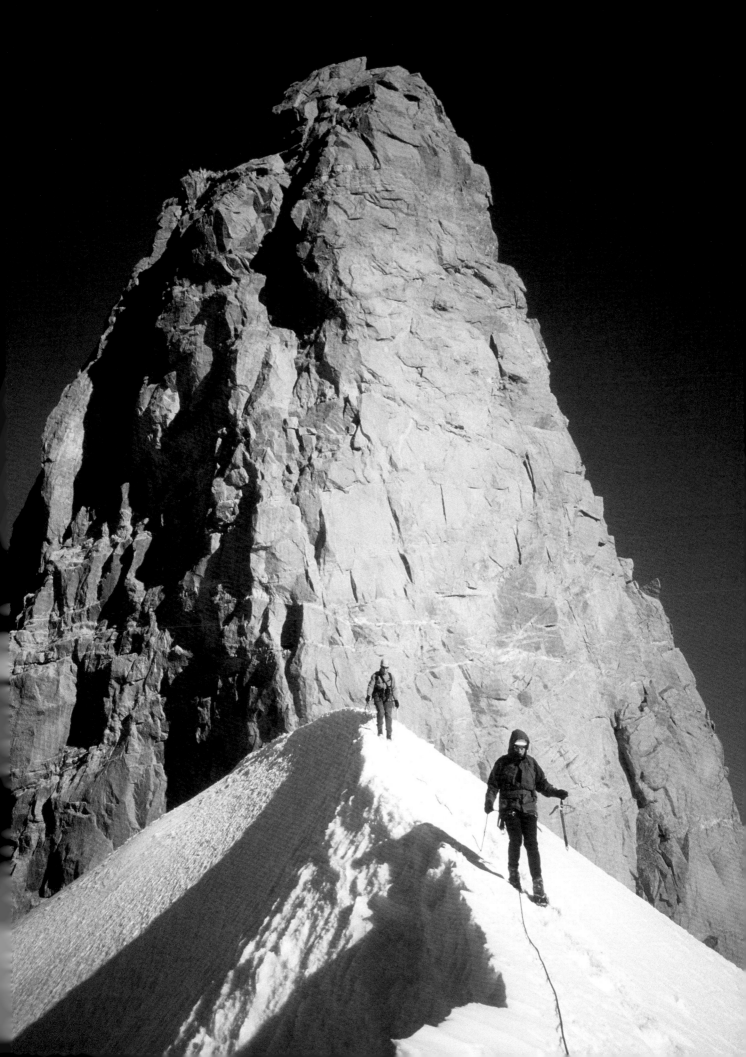

'You might find out more about what the Grandes Jorasses traverse would be like from this, though, and it would be good acclimatisation while we're up here.' Gethin was almost too encouraging.

'You could reach the Canzio hut from the French side and do the Grandes Jorasses traverse without repeating the Rochefort section if you wanted …' Even Martin was more positive than I'd expected about climbing with 'damaged goods', probably nearing their sell-by date.

'There'd be some good pictures if the weather holds, too.'

That was tempting. 'I may be slow, though.'

'We'll manage.'

We set off at 6 a.m.

I was slow on the snowy approach to the rocks below the Dent du Géant, but from there led up the mixed ground at a good pace, reading it like a book you can quote from memory. At the Salle à Manger a bitter wind was blowing, and a guide looked far from enthusiastic about the west face of the Dent, still deep in cold shadow. He was having one of those tense conversations with his client as we headed out onto the arête.

To our surprise there was less wind out there. Tracing a line at the apex of slopes that fell away to north and south, the arête undulated, pristine white, over the famous cornice that was more like a layer cake than a cream roll, and on over rocky outcrops that spiced the route with scrambling. The depth of space below that white edge concentrated the mind wonderfully on placing each boot precisely into every snowy foothold. This was no place to trip over your crampons.

Just after a short fixed rope down a rock staircase the ridge became more mixed, gradually steepening into a broken wall of about 150m topped by the summit. As one team noisily tackled the wall head-on, I slipped off to the right up a narrow icy gully to where cairns marked a sporting scramble back to the crest of the ridge above the shouting. The line of least resistance then ran left and diagonally back right to reach snow leading quickly to the narrow summit ridge. We stopped to eat and drink at the highest point.

'Fancy the Dôme?'

'Don't mind.'

'How long would it take?'

'At least an hour, then another back.'

'Looks easy though.'

'Yeah … but I'd rather not spend another night at that hut.'

'Good point. Leave it for another day?'

'I reckon so.'

I was almost disappointed as we down-climbed back to the arête.

Now a second helping of skywalking lay ahead, with new pleasure in differing aspects of those same views; but not the same as they changed in the changing light. It was still cold when we regained the Salle à Manger, but at least the sun had reached the west face of the Dent du Géant, where one climber was abseiling down like a spider on a thread past the great fixed hawsers that others were still climbing up. Even as we descended to the hut there were teams, whose objective can only have been the Dent du Géant, scrambling up the mixed ground.

Back at the hut we sorted our kit then took the cablecar to the valley.

It was an unusually snowy season: even in the first week of August ski-tourers were still attempting Mont Blanc du Tacul. The condition of the Rochefort arête was completely different from that of 1993, and I was so glad to have climbed and photographed it in good condition rather than living with the

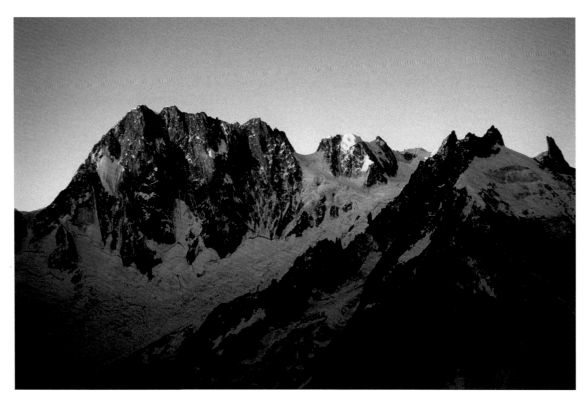

Grandes Jorasses north face.

memory of its former ugliness. Yet perhaps we should be more tolerant of the vicissitudes of alpine routes. Dorothy Pilley writes in *Climbing Days* of her enthusiasm for this route being questioned by Winifred Marples in the 1920s; 'Do you really like miles of dull rotten rock?' Pilley explains that it might well be described that way in 'a dry year'.

At the campsite in Val Ferret, others were back from other routes, including Ben Bamford, a talented young climber who had soloed the Shroud and found the traverse over the summit ridge of the Grandes Jorasses very icy. That made an immediate difference to my plans. To traverse the Grandes Jorasses would mean tackling the tricky rock pitches on Point Young and Point Marguerite early enough for it to be likely there would be verglas, probably also on the exposed crest of Pointe Hélène. The route would not be in condition. But I had no wish to delay climbing the mountain after taking so long to get round to it; so if it was to be done, the route would have to be the Voie Normale. Bad weather came in on cue to provide a good excuse for a rest day but following that, as Ben and his companion, Rick Eastwood, set off for the Gran Capucin, Gethin and I walked up from Planpincieux to the Boccalatte hut.

Grandes Jorasses, 4208m. South Face: AD

Heat and flies made the walk a trial, and it wasn't just the irritation of flies that simply want a taste of sweat. Oh no! There were horseflies the size of hornets, and I was bitten several times. Only after the second glacial torrent did altitude and cold deter them sufficiently for some respite. Just above the torrent a scramble up rocks, supplied with a fixed ladder at their most difficult point, led to a moraine

ridge. This was far more stable than it had been in 2002, with small flowering plants and grasses establishing themselves as the glacier confirmed its retreat, daily jettisoning rock and ice rubble down the smoothed slabs emerging to the right below the hut.

At the hut Lucy and Luke were gone, and the two guys who had replaced them as guardians didn't know where. Saturday night crowding was worse than usual because some teams were returning very late from their attempts of that day and stayed on. We spent the remains of the day snoozing and drinking, knowing that with dinner at 7.30 p.m. and breakfast at 1.30 a.m. there was little likelihood of having more than four hours' sleep that night. More than 30 people sat down in two sittings to the evening meal. Some were stowed in the rafters for the night.

Up at 1.15 a.m., we found breakfast a paltry affair with 'toast', one pat of butter and two of jam plus one bowl of coffee. At least it meant we were not tempted to delay departure. Gethin had scouted the start of the route, which was no different from the last time I had been there: swinging up the fixed ropes with headtorches splashing light over the rock, then trudging across snow to climb a scree treadmill to the glacier. A surprise was the warmth of the night: windless and with soft snow underfoot. We climbed stripped down to our thermals.

On and on up the glacier I set a steady pace, being overtaken by guides short-roping clients like dogs on leads. It was a stark reminder that I could no longer overtake almost everyone else on a route, although good technique might allow me to make up time on more challenging ground. At the Rocher de Reposoir the rock was demanding enough for Gethin and me to catch up and then pass those same guides nursing their jittery clients. Climbing without crampons I was aware of unusual reserves of snow hidden away in the depths of cracks and gullies. The climbing became more mixed, then snow and ice began to dominate so we once again clipped crampons onto our boots.

Looking back down the south ridge from near the summit of the Grandes Jorasses.

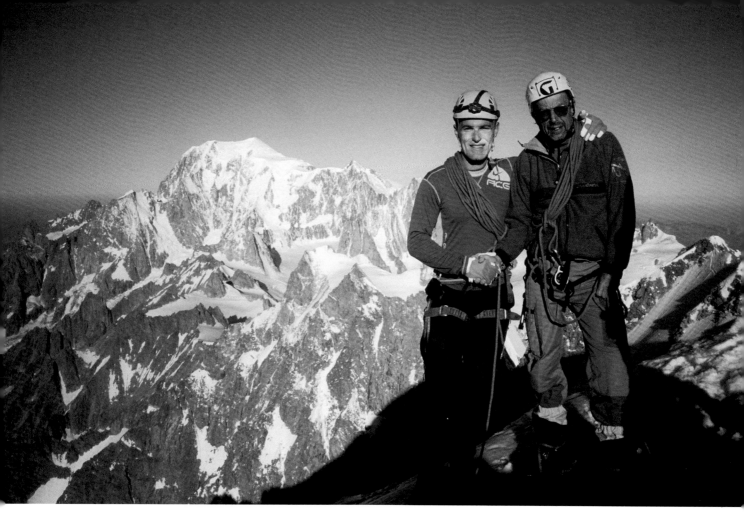

The author and Gethin Howells on the summit of Point Walker, Grandes Jorasses, with Mont Blanc in the background.

At the top of the rocks a steep traverse across the face of a serac led down right into the broad couloir which we crossed to reach the lower rocks of Rocher Whymper, the long rock rib that descends from Point Whymper. An occasional peg in the initial pitch of these rocks confirmed that we were on route and that the technical requirements were quite stiff, particularly with fingers chilled by cold rock. Above, about 150m of scrambling up gullies led to a shoulder.

It was decision time. Should we continue up the rocks to Point Whymper then traverse the ridge to Point Walker, or traverse the almost-level snow terrace beneath seracs to the right and climb a blunt mixed ridge direct to Point Walker? The guides favoured the latter, and the height gained to this point meant we were well above the 0° isotherm. We set off ahead of the guides, scurrying across to the base of the further ridge, but the seracs were quiet. Finding ourselves in sunshine, we warmed cold hands, taking time to snack and drink a little without chilling down too much.

The initial snow of the ridge steepened into thin gullies amongst the higher rocks, giving way to mixed rock and snow. We scrambled higher and higher with more than one break for me to get my breath back, panting like a dog, before emerging on the flank of a snow ridge that led up right to the summit.

It was so close, but I was very conscious of just how much the 1400m from the hut had taken out of me. Head down, kicking steps into the snow, I suddenly found the slope falling away in front of me and I looked up. I was there. We had done it – 15 minutes under guidebook time! The familiar Mont Blanc Massif lay spread out under a deep blue cloudless sky. Gazing across at Mont Blanc itself I thought: in my beginning is my end; in my end is my beginning.

On the summit, I think Gethin was more emotional than I was. We took pictures and one of the guides who had kept pace with us offered to take one of the two of us. Later, in that picture, for the first time in my life, I saw my father's face in mine.

I thanked the guide and told him, 'This is my last 4000m mountain.'

'Oh, but you have done so well,' he replied encouragingly.

'No … I mean … Oh never mind.'

I must have looked more wasted than I felt, or perhaps it was just lost in translation, but I was too deflated to put him straight; besides it might have led to more misunderstandings. We left the summit at 8.15 a.m.

Reversing the ridge was a little awkward as other teams were still coming up, but it was beautiful in the sunlight. On the way down, Gethin reckoned he heard the sound of a serac collapse and we could see that the sun was now touching the ice cliffs above the snow terrace. We raced across to the Rocher Whymper in just 10 minutes, skirting blocks of ice that hadn't been there before and skipping over furrows ploughed in the snow that showed just where it had been raked by falling ice that had disappeared over the edge of the terrace. It might have been safer to have returned via Point Whymper after all.

As we down-climbed the rocks I noticed a pair of climbers descending the centre of the couloir below, by-passing the Rocher de Reposoir. That could be a risky strategy. On the first ascent Whymper had come up that way but in descent had been avalanched as they attempted to traverse to the safety of the Rocher de Reposoir:

> No halt could be made, and we slid down slowly, but with accelerating motion, driving up waves of snow in front, with streams of the nasty stuff hissing all around. Luckily, the slope eased off at one place, the leading men cleverly jumped aside out of the moving snow, we others followed, and the young avalanche which we had started, continuing to pour down, fell into a yawning crevasse, and showed us where our grave would have been if we had remained in its company five seconds longer.

At the last belay on the Rochers Whymper someone had left a Rock 4, which would neatly replace the nut I'd hammered all too effectively into a belay on the Tour Ronde. Sometimes mountains give back what they take, and more. This was the point where we needed to make a decision. It was clear that we were early enough for safety: the couloir still lay in deep shade and not a fragment of ice or stone disturbed the quiet of the amphitheatre. The snow beneath our crampons was still crisp with frost. We followed the tracks of the pair below.

The sun found us just as we were abseiling the last awkward step level with the lowest rocks of the Rocher de Reposoir. The descent track in the snow was easily joined just ahead. Descending the glacier became unpleasantly hot until we found some relief in the shade of the ridge that divides the Glacier de Grandes Jorasses from the Glacier de Planpincieux. By then it was easy going, and we reached the hut by 11.30 a.m., well within guidebook time: 'not bad for an oldster', as I wrote in the hut book. A celebratory beer was in order, and some rest before the long hot walk back to the campsite.

There our tired elation was greeted with little interest; Rick Eastwood had been killed when his belay had snapped as he moved to take his turn to abseil off the Gran Capucin. There was a mood of shocked disbelief, and tears in the privacy of tents. Ben was devastated. Later I remember him asking me about abseiling with a prusik brake:

'Yes, I just put a French prusik on the doubled ropes below the abseil device. I prefer that because the weight is taken on the rope, rather than on the prusik if it's put on above. If you're hit by a stone or something and stop sliding it down, the prusik knot just locks on the ropes and stops you going any further.'

'Leaving both hands free?'

'Yeah.'

And then it came out.

'When Rick came sliding down the ropes, do you think I could have held him if I'd had a prusik on and used both hands to grab him? I tried to hold him with one when he smacked into me but he was torn out of my grasp.'

I took a deep breath.

'A prusik would have freed both hands, no doubt about it, but I seriously doubt that you could have held him, let alone made both of you safe on the rope. His hands would have been burnt useless by the friction sliding any distance and the forces involved in a fall like that are massive. You're lucky the shock-loading didn't snap the abseil anchor and take you down too. I really don't think there was anything you could do once he fell. Best not beat yourself up about it.'

It was the only occasion on which I recall a fatality on a meet that I attended.

Mike Pinney and Jeff Harris were up at the Eccles bivouac hut, making yet another attempt on the Aiguille Blanche de Peuterey. It was the last of their 4000m mountains. During the rest day following, suddenly several of us received the same text message from Mike: 'Help. Helicopter needed Col Eccles.' The consternation caused on the campsite was a nothing compared to that at home: he had messaged his entire phone book! He and Jeff had been hit by rockfall just below Pic Eccles on their way back from a successful ascent.

None of us spoke Italian, but we soon found an Italian who spoke good enough English to act as interpreter and contact the rescue services. Mike and Jeff were flown direct to Aosta hospital. Mike was kept in for observation as they had spotted a blood clot in his head, 'probably old'. But he knew all about this former injury and the hospital was happy to discharge him next day. Jeff was more seriously injured and it was a week before he was allowed to be driven home, only to have a major operation shortly afterwards.

Jeff was still in hospital when the end of meet dinner was held at a local restaurant. The mood was understandably sombre, despite Mike and me having completed ascents of all the 4000m mountains. I think it was then that I resolved to try to do something about rebalancing that feeling when Jeff was out of danger.

In the immediate aftermath I immersed myself in climbing. Gethin and I climbed Mont Dolent before I went on to the Écrins to climb alpine rock routes with Geoff Cohen, then to the Dolomites where Adele Long joined me for more rock routes. It was in Cortina that I realised I'd had enough of the relentless commercialisation of the Alps: when it was time to go home I felt no regret about leaving. Perhaps that was why I had been increasingly drawn to more remote mountains in the course of the 1990s and the noughties; during 2007 I not only completed my 4000m summits but made eight first ascents in Kyrgyzstan, India and China. There is no doubt that you can climb a lot more routes in a month in the Alps than you can in the Greater Ranges, but there is something very special about climbing where no one has climbed before, where you have not only the route but the range to yourselves. I suppose it's a question of balance.

Postscript: A Party

Later, I came back to the idea of resetting the mood of the completion of the mission for Jeff, Mike and me, by having a celebratory party for all the climbing partners who had helped us make it possible. It took months to organise, and of course not everyone could make it, but when it came off the accidents no longer dominated our thinking.

It was a grand opportunity to catch up. One of the ladies commented under her breath, 'We used to be married, and I nearly failed to recognise him.' And that wasn't the only partner swap that had gone on.

More complimentary, 'I don't know how you do it, Andrea; you don't look a day older than when we climbed in Grindelwald.'

And of course all those children who had formed a tribe playing around the campsites had to put up with, 'Who are you, then? … No, I don't believe it!'

And, worse, 'Haven't you grown!'

It was Jeff's daughter, Jenny, who first asked mischievously if the ascent of the Aiguille Blanche counted as they had been helicoptered off, but the idea was returned to more than once at the party. Who could resist the uncomfortable looks that flitted across the faces of Mike or Jeff in response, before the rueful grins? And were there rumours of a guided ascent on someone else's tally?

Some of us had not been in touch for years, but there is something special about a climbing partnership that can outlast the passage of time. With other completers, John Mercer and Dave Penlington, together with friends who were still on the quest for completion, there was a tremendous sense of camaraderie.

As I said at the time: 'It is our partners that make our climbing possible.'

Appendix 1:
The Collomb list of 4000m Alpine Mountains

1.	Mont Blanc	4807m	pp. 11-17, 21-3, 90
2.	Dufourspitze	4634m	pp. 140-142
3.	Nordend	4609m	pp. 139-141
4.	Zumsteinspitze	4563m	pp. 141, 143
5.	Signalkuppe	4556m	pp. 141, 143
6.	Dom	4545m	pp. 49-50
7.	Liskamm	4527m	pp. 145-146
8.	Weisshorn	4505m	pp. 51-55
9.	Täschhorn	4491m	pp. 47
10.	Matterhorn	4477m	pp. 77-82
11.	Mt. Maudit	4465m	pp. 42-43, 89
12.	Parrotspitze	4436m	pp. 145
13.	Dent Blanche	4357m	pp. 68-70
14.	Nadelhorn	4327m	pp. 67, 84
15.	Grand Combin de Grafeneire	4314m	pp. 199-203
16.	Lenzspitze	4294m	pp. 66
17.	Finsteraarhorn	4274m	pp. 157, 164-166
18.	Mt. Blanc du Tacul	4248m	pp. 87-89
19.	Castor	4226m	pp. 146-147
20.	Zinalrothorn	4221m	pp. 44-46
21.	Hohberghorn	4219m	pp. 84
22.	Pyramide Vincent	4215m	pp. 145
23.	Grandes Jorasses (Pte. Walker)	4208m	pp. 207-208, 223-226
24.	Alphubel	4206m	pp. 46-47
25.	Rimpfischhorn	4199m	pp. 101-103
26.	Aletschhorn	4195m	pp. 155, 160-164
27.	Strahlhorn	4190m	pp. 100
28.	Dent d'Hérens	4171m	pp. 71-74
29.	Breithorn (W.)	4165m	pp. 148-151
30.	Jungfrau	4158m	pp. 129-131
31.	Bishorn	4153m	pp. 51
32.	Aiguille Verte	4122m	pp. 112-115
33.	Aiguille Blanche de Peuterey	4107m	pp. 119-124, 227
34.	Barre des Écrins	4101m	pp. 32-36
35.	Mönch	4099m	pp. 131-133

Appendix 2:
Recommended Reading

Band – *Summit*, 2006

Bonatti – *On the Heights*, 1961, and *The Great Days*, 1971

Bonnington – *I Chose to Climb*, 1966

Braham – *When the Alps Cast their Spell*, 2004

T. Graham Brown – *Brenva*, 1945

Clark – *The Victorian Mountaineers*, 1953

Cliff – *Ski Mountaineering*, 1987

Conway – *The Alps from End to End*, 1900

Dent – *Mountaineering*, 1892

Diemburger – *Summits and Secrets*, 1970

Dumler and Burkhardt – *The High Mountains of the Alps Vol 1: The 4000m Peaks*, 1993

Finch – *The Making of a Mountaineer*, 1924

Fleming – *Killing Dragons*, 2000

Goedeke – *The Alpine 4000m Peaks*, 2003

Hinchcliff – *Summer Months Among the Alps*, 1857

Irving – *The Romance of Mountaineering*, 1935

Klucker – *The Adventures of an Alpine Guide*, 1932

Kugy – *Alpine Pilgrimage*, 1934

Longstaff – *This My Voyage*, 1951

McLewin – *In Monte Viso's Horizon*, 1991

Moore – *The Alps in 1864*, 1867

Moran – *Alps 4000*, 1994, and *The 4000m Peaks of the Alps: Selected Climbs*, 2007

Mummery – *My Climbs in the Alps and Caucasus*, 1895

Pilley – *Climbing Days*, 1935

Price – *Travail so Gladly Spent*, 2000

Ring – *How the English Made the Alps*, 2011

Smythe – *Climbs and Ski Runs*, 1929, *Mountaineering Holiday*, 1940

Stephen – *The Playground of Europe*, 1871

Swindin – *All but One*, 2012

Terray – *Conquistadores of the Useless*, 1961

Tyndall – *Hours of Exercise in the Alps*, 1871

Whymper – *Scrambles Amongst the Alps in the Years 1860–69*, 1871

Wills – *Wanderings amongst the High Alps*, 1856

Young – *On High Hills*, 1927

Appendix 3:
Some Climbing Grades

French adjectival

F: *facile* (easy). Straightforward, possibly a glacial approach; snow and ice will often be at an easy angle.

PD: *peu difficile* (slightly difficult). Routes may be longer at altitude, with snow and ice slopes up to 45°. Glaciers are more complex, scrambling is harder, climbing may require some belaying, descent may involve rappelling. More objective hazards.

AD: *assez difficile* (fairly difficult). Fairly hard, snow and ice at an angle of 45–65°, rock climbing up to UIAA Grade III, but not sustained, belayed climbing in addition to a large amount of exposed but easier terrain. Significant objective hazard.

D: *difficile* (difficult). Hard, more serious with rock climbing at IV and V, snow and ice slopes at 50–70°. Routes may be long and sustained or harder but shorter. Serious objective hazards.

TD: *très difficile* (very difficult). Very hard; routes at this grades are serious undertakings with high level of objective danger. Sustained snow and ice at an angle of 65–80°, rock climbing at Grades V and VI with possible aid, very long sections of hard climbing.

Often a + (written *Sup* for *supérieur*) or a − (written *Inf* for *inférieur*) is placed after the grade to indicate a climb at the lower or upper end of that grade (eg, a climb slightly harder than PD+ might be AD−).

Approximate grade comparisons (Rock)

British	UIAA
Moderate	I
Difficult	II
Very Difficult/Severe	III
Severe	IV
Hard Severe	IV+
Very Severe	V-/V
Hard Very Severe	V/V+
E1	VI

These lists have been adapted from the Wikipedia page on climbing grades, together with BMC sources.

Glossary

Abseil	a means of descent by sliding down the doubled rope on a friction brake attached to the harness (aka rappel).
Abseil point	a prepared attachment to the rock from which to abseil. This can range from twin bolts and chain to a loop of rope around a rock spike.
AC	Alpine Club.
À cheval	making progress along a narrow arête by straddling it, like riding a horse.
Arête	narrow ridge.
Avalanche runnel	the chute formed by the passage of an avalanche down a gulley.
Belay	a secure point of attachment to the rock or snow/ice from which the second climber pays out rope to the leader and brakes that rope in the event of a fall (hence 'to belay').
Bergschrund	large crevasse that opens up at the head of a glacier where it breaks away from the mountain slope above.
Boot crack	a crack in the rock that seems to be the exact width of a boot.
Boot-ski	the action of sliding downhill in soft snow on the soles of one's boots, imitating the action of skiing but without the skis. Aka standing glissade.
Bouchon	traffic jam (literally, cork bottle-stopper)
Bouquetin	ibex, aka steinbock
Breakable crust	a snow crust that cannot be relied upon to bear the weight of the skier.
To bridge, bridging	the action of bracing legs and/or arms against opposite sides of a chimney or diedre (like a bridge) in order to make progress.
Cascade climbing	climbing frozen waterfalls.
CC	Climbers' Club.
Climb clean	without using fixed ropes.
Col	a saddle or low point on a ridge, sometimes crossed to access the valley beyond.
Concretised snow	after an avalanche or even a small snowslide the snow may transform to the consistency of concrete.
Balled, balling (of crampons)	when snow is trapped by the points and frame of the crampon, effectively creating a slippery platform sole for the boot.
CAI	Club Alpino Italiano.

Choss	crumbling rock.
Couloir	a gully in the rock or snow.
Crampons	metal frameworks with sharp downward points, attached to climbing boots to facilitate progress in icy conditions.
Crevasse	crack in the surface of a glacier created by the movement of the ice over underlying obstructions.
Crux	crucial point of a climb; the most difficult section to be overcome.
Duvet (jacket)	padded jacket with high insulation values provided by down or synthetic fibre filling.
Dortoir	cheap dormitory accommodation in a hotel or hostel.
Exposure	the precariousness of the position of a climber as in 'an exposed move', the term also refers to suffering from exposure to the elements or hypothermia.
Gendarme	a tall pinnacle of rock.
Gneiss	good, rough, generally solid rock.
Gripped	tense fear that can cause the victim to have difficulty moving.
Grit	gritstone, a characteristically British rock of peculiar difficulty.
Harscheisen	ski crampons; hinged blades of metal that are pressed down into the snow on either side of the ski as the boots bear on them but flip up out of the way when unweighted. They enable ski-mountaineers to climb icy slopes.
Heavy (snow)	snow that contains a lot of water and impedes movement through it.
'Hot aches'	colloquial term for the pain that accompanies the return of warm blood to freezing fingers or toes. (American 'screaming barfies')
Ice axe	the essential tool of an alpinist, it has a shaft long enough to sink into snow to provide an improvised belay, an adze to chop out steps or handholds, and a pick to enable the climbing of steep steps by providing what amounts to an artificial handhold, whilst also being capable of arresting a slip on snow.
Ice peg or piton	older-style ice runners that were driven into the ice with an ice hammer.
Ice screw	a sharpened externally threaded tube of steel or titanium that can be screwed into ice with a means of attaching a karabiner in order to function as a runner or main belay when ice climbing.
Jump turns	ski turns when the skier attempts to leap clear of difficult or steep snow in order to effect a change of direction.
Kick-glide	the action of moving the ski forward when ascending on skins.
Lenticular cloud	cloud shaped like lenses, also known as 'fish clouds' or 'flying saucers'. A notorious sign of bad weather.
Micro-traxion	self-locking pulley to aid climbing a rope.
Moving together	a technique of alpine climbing when both climbers climb at the same time, putting their faith in each other's skills or running belays to avoid a fall.

Névé	good consolidated snow that can be climbed easily.
Nuts	derived from the original engineering nuts that had the threads machined out of them so that they could be threaded with a short rope sling and wedged into cracks in the rock. A karabiner would link the climbing rope to the rope sling attached to the nut to protect the progress of the leader (see RUNNER.) Now the term is applied to any wedge that fulfils that function.
OAV	Austrian Alpine Club.
Orographic	relating to mountains.
Pitons aka pegs	metal spikes with an 'eye' at the blunt end into which can be clipped to a karabiner. They can be driven into cracks in the rock to provide runners or main belays.
Piste	a prepared track, usually in snow; but also 'abseil piste' where one abseil leads directly to the next in a long sequence of abseil descents.
Pitch	a section of a climb between two main belays.
'Post-holing'	leaving deep holes at every step in soft snow (exhausting!).
Prusik (knot)	a closed loop of cord knotted to a rope so that it can be easily slipped along the rope until it comes under tension, when it locks (also the knot itself).
Rebuffat	French guide and author of a seminal guidebook to the Mont Blanc massif.
Rock 4	a make of nut, size 4.
Ropeman	self-locking pulley to aid climbing a rope.
Ropes as in '2 ropes of 3'	teams of climbers (two teams of three climbers on each rope.)
Runnel	see AVALANCHE RUNNEL.
Runner aka running belay	a temporary attachment to the rock or snow/ice, placed on lead, that limits the distance travelled by the leader in the event of a fall.
Run-out	1. an area at the foot of a slope where the angle eases and with no obstacles, as in 'a safe runout'. 2. interval between runner placements, as in 'a long run-out'.
Sastrugi	wind-sculpted structures of frozen snow found on the surface of snow-slopes, particularly in winter. They can be anything from a few cm to a metre in height.
Self-arrest	use of the ice axe to act as a brake and bring a sliding climber to a halt.
Serac	derived from the name of a crumbly white cheese, this word now refers to a semi-detached block of ice usually found breaking away from steep ice cliffs.
Sugar snow	unconsolidated granular snow offering insecure purchase for boots or tools.
Skins	self-adhesive strips of fabric attached to the bases of skis. They have a nap, allowing the ski to slide easily forward but resist backward movement when weighted. They enable skis to be used to ascend snow-slopes.

Skinning	the action of climbing on skins.
Soloing	climbing without being roped to a partner.
Steinbock	ibex, aka bouquetin.
Tat as in 'abseil tat'	pieces of rope or tape used to make a loop around an anchor through which an abseil rope can be threaded.
Thrutch	a strenuous, awkward sequence of moves.
Tools	as in 'ice tools': ice axe and/or ice hammer (with hammer head rather than adze).
Tracksters	Nora Batty tights for bashful Brits.
Verglas	almost invisible water-ice forming a thin coating on rock (very treacherous!).
Via Ferrata	a climbing route protected by in situ steel cables, which climbers can attach themselves to.
Wedels	the classic ski track; curves back and forth in a regular series.
Whiteout	a condition encountered in snowfall when all definition in the surrounding landscape is lost so that it can be very easy to drop off an unseen edge.
Winterraum	German for winter room; limited accommodation available in many huts when the main part is closed during the winter.
Zippers	slang term referring to Via Ferrata protection devices.

Following pages:

Winter nightfall, Argentiere; where it all began.

The author ski-mountaineering in Chile 2014